Gerard Manley Hopkins
and the
Victorian Visual World

Gerard Manley Hopkins
and the
Victorian Visual World

CATHERINE PHILLIPS

OXFORD
UNIVERSITY PRESS

OXFORD

UNIVERSITY PRESS

Great Clarendon Street, Oxford OX2 6DP

Oxford University Press is a department of the University of Oxford.
It furthers the University's objective of excellence in research, scholarship,
and education by publishing worldwide in

Oxford New York

Auckland Cape Town Dar es Salaam Hong Kong Karachi
Kuala Lumpur Madrid Melbourne Mexico City Nairobi
New Delhi Shanghai Taipei Toronto

With offices in

Argentina Austria Brazil Chile Czech Republic France Greece
Guatemala Hungary Italy Japan Poland Portugal Singapore
South Korea Switzerland Thailand Turkey Ukraine Vietnam

Oxford is a registered trade mark of Oxford University Press
in the UK and in certain other countries

Published in the United States
by Oxford University Press Inc., New York

British Library Cataloguing in Publication Data
Data available

Library of Congress Cataloging in Publication Data
Data available

Typeset by Laserwords Private Limited, Chennai, India
Printed in Great Britain
on acid-free paper by
Biddles Ltd., King's Lynn, Norfolk

ISBN 978–0–19–923080–8

1 3 5 7 9 10 8 6 4 2

PREFACE

Lacan asserted that vision is socialized. ... Infiltrated 'between the subject and the world is ... the entire sum of discourses which make up visuality, that cultural construct, and make visuality different from vision, the notion of unmediated visual experience.'[1] The visual world of Gerard Manley Hopkins (1844–89) was a very different one from ours with our global data bases, coloured reproductions of paintings, and our slick commercialism. Though middle-class Hopkins did not grow up among an aristocratic family's collections from the Grand Tour or the gallery of portraits by better and less well-known painters of past periods, he was fortunate artistically in a number of respects: the 1860s, when he was most interested in art, was a period of exceptionally fine black-and-white illustration, and he lived on the edge of London with ready access to galleries and museums. The latter part of the nineteenth century was a time of exceptional economic improvement for the middle classes, bringing artistic things within the grasp of his family. Manley Hopkins (1818–97), the children's father, was largely self-educated and bought handsome illustrated histories of Pompeii and England. He subscribed to *Once a Week*, one of the best of the illustrated journals of the 1860s, and contributed to it articles and poems. Production of engravings and lithographs flourished as did the burgeoning art of photography, so, for the middle classes there were affordable prints and photographs of Old Master and contemporary paintings produced by such entrepreneurs as Gambart, Hollyer, Agnews, and coloured reproductions by the Arundel Society.

Gerard was the eldest of nine children, of whom two became professional illustrators: Arthur (1847–1930) with whom he shared sketching expeditions in 1863, and Everard (1860–1928), sixteen years his junior. Their sister Kate was also a gifted artist. Arthur provided illustrations for a number of novels, including one by Hardy. He worked for three of the publishing phenomena of the day: the *Illustrated London News*, the *Graphic* with its enormous (A2) engravings, and *Punch*, and became a member of the Royal Society of Painters in Water-colour. The growing wealth of the middle class in the period led to an increase in the popularity of watercolour as more people could afford holidays and holiday pastimes, and from 1832 there were two main watercolour societies

in London as well as the Societies devoted to women artists. Among Gerard's many relatives outside his immediate family circle were several professional artists and a number of competent amateurs: his godmother was Frances Anne Hopkins, a respected painter of Canadian scenes, an 'uncle' Richard James Lane (1800–72) was a pioneer in lithography appointed to Queen Victoria, and Gerard's cousins Clara and Emily Lane were active in the societies for women artists.

Manley's spinster sister, Anne (1815–87), who spent many years living with the family, began Gerard's instruction in drawing and this was continued by his maternal aunt, Maria Giberne, who drew in a more sophisticated style.[2] Her husband, George Giberne (1797–1876), was not only a good amateur watercolourist but also an active member of the Royal Photographic Society, bringing Gerard into contact with new technology as it was in the process of transforming art.

Throughout his life Hopkins was attentive to contemporary artistic trends, reading cultural criticism in a number of the journals and papers of the day, attending art exhibitions, and making notes of what he saw. In 1864 he wrote to his friend Alexander William Baillie (1843–1921) saying, 'I have now a more rational hope than before of doing something—in poetry and painting' (20 July 1864, *LIII* 214). Over a period of five years he worked intensively at developing his artistic perception, not in fact as artists tend to do by living with their drawing pads in hand but by training his eye to analyse aesthetically what he looked at, using his sketches often to clarify when words failed, and resorting to words when his skill as a draughtsman was defeated. After that, as his goals shifted, art became a hobby, an interest, though the visual analysis which he honed for artistic purposes in those five years can be shown to have left its mark on his writing for the rest of his life.

In 1868 Hopkins entered the Society of Jesus. Something of the flavour of the moral environment within which he then lived can be seen in the Exhortations to Novices given by Father Peter Gallwey (1820–1906) while Hopkins was a novice: 'One necessary effect of chastity is a positive hatred of all the pleasures of the senses—a loathing of all that gratifies the body. Custody of the eyes is actually custody of the mind—we should keep remembrance of Christ crucified in our hearts. Everything around us should recall Him … the hills should recall Calvary, the trees the tree of the Cross, the streams the Jordan.'[3] Poems such as 'Spring', in which Hopkins celebrates with precision and vitality the beauties of the season in the octave and turns to exhorting Christ to save the souls of children in the sestet, have a subterranean

unity through the religious significance that each natural thing had acquired for him. But the balance was precarious; his response to beauty was intense and sensual. On several occasions his Journal shows him punishing himself by keeping his eyes downcast or willing himself to give up beauty until he felt he had God's leave for it (6 Nov. 1865).[4] He rerationalizes its existence and man's innate response again and again in such poems as 'Castara Victrix', 'Nondum', 'Easter', 'Spring', 'The Sea and the Skylark', 'For what serves Mortal Beauty?' and so on. Chastity is probably very much behind Hopkins's comment to Baillie from a letter announcing his intention of becoming a priest, when he says, 'You know I once wanted to be a painter. But even if I could I wd. not I think, now, for the fact is that the higher and more attractive parts of the art put a strain upon the passions which I shd. think it unsafe to encounter. I want to write still and as a priest I very likely can do that too, not so freely as I shd. have liked, e.g. nothing or little in the verse way, but no doubt what wd. best serve the cause of my religion' (12 Feb. 1868, *LIII* 231). He repeatedly urged his artist brothers Arthur and Everard (advice sent through their mother) to keep up their drawing from the nude and their anatomical studies; for example, he remarked to his mother when Arthur was in his first year as a professional illustrator, 'I hope ... he sticks to his metatarsals and studies from the nude, without which his work will not be thorough' (to their mother, 30 Aug. 1872, *LIII* 119–20). Such advice was generally approved by the academicians in the period but disputed by Ruskin, who disagreed in public with Poynter over the necessity of the life class because of a fear of passion similar to that which had led Hopkins to turn away from becoming an artist.[5]

Aesthetic appreciation was not encouraged among novices in the Society: of the seven places that scholastic novices could visit only with special leave from the Master, and for which it was noted 'leave rarely given', five were the places that housed fine art. They included the British Museum (except for certain sections), Art Gallery (presumably the National), the Tate Gallery, the National Portrait Gallery, and the Wallace Collection. The South Kensington Museum was excepted from the list[6] though it included the collection of contemporary British art. By 1872, when he had taken his vows, however, Hopkins was under less strict constraint and during the rest of his life he went to several Royal Academy and special exhibitions. Visiting the South Kensington Museum in 1882, while he was a Tertian, Hopkins remarked to his friend Robert Bridges (1844–1930), who was recuperating in Italy from a near-fatal attack of pneumonia:

I took two Frenchmen to the South Kensington museums ... Amidst the bewildering wealth of beautiful things my attention was fixed by the casts from Michael Angelo, the David, two figures of slaves for Julius II's tomb, a Madonna, and others. I thought of the advantage, for which nothing can completely make up, you have of seeing these things on the spot. In the arts of painting and sculpture I am, even when most I admire, always convinced of a great shortcoming: nothing has been done yet at all equal to what one can easily conceive being done. For instance for work to be perfect there ought to be a sense of beauty in the highest degree both in the artist and in the age, the style and keepings of which the artist employs. Now the keepings of the age in which for instance Raphael and Angelo lived were rich, but unsatisfactory in the extreme. And they were both far from having a pure sense of beauty. Besides which they have several other great shortcomings. But in poetry and perhaps in music *unbetterable* works have been produced. No room to go on nor time either. (1 Feb. 1882, *LI* 142)

There is in his statement to Bridges no sense of wrongdoing in looking at art, and he may only have been pursuing caution in not providing Bridges with more examples that might have led to dispute. Much of Hopkins's art criticism is of this sort, in which there is a restraining of sexual response that is careful, but no longer any felt need to articulate religious attitudes.

During the period of Hopkins's most intense interest in fine art, from 1863 to 1868, the British art world was in a state of exceptional flux. There were those who followed Ruskin's democratic criteria for assessing art in which he recommended testing paintings for their faithfulness to our impressions of the natural world. There were the Pre-Raphaelites, who were criticized for excessive realism enslaving the artist to years of minute brush strokes, for being suspiciously 'Catholic' in the physicality with which they depicted the holy family, or degrading religion when their models were less than idealistically beautiful. Aestheticism was emerging with artists such as Whistler and Albert Moore. The influence of foreign artists was also strong. Among the first and most successful of the independent dealer/printmakers was Ernest Gambart (1814–1902), a Belgian who maintained his links with continental artists, regularly holding shows of their work (the French, then the French and Flemish)—a number of which Hopkins saw—and distributing at low cost, reproductions of their work. Hopkins attended two of the international exhibitions of the period: that of 1862 in London and the Paris international of 1867, where he made several visits to the art gallery. The Paris Commune and Franco-Prussian war of 1870–1

brought an influx of French artists to London, among them Daubigny, Tissot, and the sculptor Jules Dalou. Among the other émigrés of the 1860s were Lawrence Alma-Tadema and Whistler, who was to come into direct conflict with Ruskin in 1878 when he denied the right of someone who was not a practising artist to pronounce upon the quality of painting, a stance that might be seen as the transition to 'professionalism' within the art world that was affecting so many other elements of late-Victorian England.[7] He did not dissuade the journalist-critics who strove independently to greater professionalism, using more technical terms and an increasing range of reference to Old Masters in reviews in the major journals. Hopkins was influenced by this, although he developed his own critical vocabulary applied to literature as well as art. He followed Ruskin and the Pre-Raphaelites in attention to 'Truth', and independent of but contemporary with the Impressionists, he was absorbed by movement and the relation of light and colour in nature. His artistic vocabulary developed from the undergraduate essays on, showing concern with patterning and composition (as an aspect of 'inscape', 'scaping'), with scales of colour and tonality ('chromatic' and 'diatonic'), with poetry (atmosphere) as well as a near-photographic capturing of realistic detail. His poems bring to mind a range of artistic styles from those like 'Spring' that call to mind the work of 'Bird's nest Hunt' and the vivid foliage of Pre-Raphaelite paintings, to 'Brothers' that seems akin to the genre pictures of William Mulready and William Collins, and 'The Blessed Virgin compared to the Air we Breathe' that recalls Guido. Reni's Virgins; 'The Wreck of the Deutschland' retains aspects of the illustrated press that provided its facts, and the Idealist painters such as Fred Walker and the New Sculpture of Hamo Thornycroft influence dynamic poems such as 'Harry Ploughman', in which we can see the sympathy with the working class that finds expression in Hopkins's 'Red' letter of 2 August 1871 (*LI* 27-8).

The influence of continental artistic traditions was also visible in buildings of the day and Gerard became interested in the resurgence of Gothic architecture. This had both political and religious associations. Born into the middle class and living most of his adult life within the structure of the Society of Jesus, Hopkins seems to have been unmoved by a nostalgia for the political conservatism of the feudal past, but alive to the links between Medieval Gothic and the Catholic religion in England. His favourite architect was William Butterfield, partly because he responded to the colour schemes Butterfield used, but also because

of the sensitivity to the religious significance of each part of the church evident in Butterfield's designs.

Another area to which Gerard applied himself was sketching. Manley Hopkins had taught himself to draw by copying illustrations from journals and books and, from 1862, Gerard seems to have followed the course set out by Ruskin in his *Elements of Drawing*, five years after the book's appearance. Ruskin's aim was the training of the eye, rather than the competent execution on the page. This was to prove a particularly valuable approach for Hopkins, whose ability to see nature gives his poems a vivid particularity that carries them beyond contemporary religious poetry on similar themes by John Henry Newman. Gerard's strong individuality and grasp of the visual aspect of metaphor also differentiates them from those by his father, who had many of the same concerns. As Hopkins developed his poetic abilities, he strove to capture more and more in his language, not just the visual impression of nature, but its evanescence and the fleeting religious experiences he had through it. His analogical picture of the world saw it as the communicating 'word' of God and Christ as the ideal type within man. A prey to what has been described as a manic depressive personality led, through successive disappointments and an inevitable decline in energy, to a grimmer picture of the world in which periods of despair were more frequent. Hopkins's poems of the mid-1880s show attempts to constrict the freedom of his innate response to beauty: 'To what serves Mortal Beauty?' confines beauty to giving glimpses of God on earth and 'Spelt from Sibyl's Leaves' depicts dappled beauty as a misleading veil over the reality of moral absolutes. The final chapter of this book, therefore, deals with some of the theories of vision that Hopkins referred to throughout his artistic life. They range from ideas gleaned through his father and the classical theories he encountered as an undergraduate, to those of contemporary science (being developed at Stonyhurst among other places),[8] the beliefs of Augustine, and contemporary scholarship on sibylline literature.

There are many other contexts on which this material impinges and many of them have already been explored. A lot has been said, for example, about Hopkins's sexuality.[9] The most substantial of the recent examples of this approach is Julia Saville's *A Queer Chivalry: The Homoerotic Asceticism of Gerard Manley Hopkins*.[10] Saville explains that she chooses 'queer' 'to articulate the combination of moral scrupulosity and subtle eroticism in Hopkins's poetry' (p. 7); 'the politics of liberation and conscious sexual subversion per se are foreign to Hopkins's writings,

which are committed to a dynamics of submission' (p. 6). She seeks instead to explore 'moments of sexual ambiguity in the poet's writing that suggest the presence of homosexual affect but resist appropriation by such an explicit term'.

I have concentrated on what Hopkins 'saw' through three social contexts of his life: his childhood circle, which was important in shaping his early vision; his friends at university and the criticism he absorbed that inflected his view as a young man; and his mature religious beliefs which came to govern his understanding of a visual world interconnected with an eternal one underlying and beyond the visible. His position as a middle-class man was central to what was available to him, and this was endorsed by public art criticism of the time in which there were aesthetic disputes reflecting the emerging power of the middle classes, the advance of photography, and the burgeoning professionalization characteristic of the day. The chapters attempt to enlarge that visual context, within which Hopkins's writing can be understood, established in particular by *The Journals and Notebooks* and *All My Eyes See*.

During this very enjoyable project I have visited many galleries and archives and always been welcomed and greatly assisted by their staff. I would especially like to thank the archivists of the National Gallery of Ireland, the National Gallery London, Simon Fenwick of the Society of Painters in Water-colour, Colin Harris and his staff in the Bodleian, John Atteberry, Robert O'Neill, Bob Bruns, and David Horn of the Burns Library, Boston College, the Harry Ransom Centre Texas, the Witt Library, Gainsborough House, Sudbury, the National Art Library and Victoria and Albert Museum, the Courtauld Institute of Art, the Walker Gallery Liverpool, the National Library of Ireland, the Department of Art in Trinity College Dublin, the Revd F. J. Turner, David Knight, and Terry Bell of Stonyhurst, Dr Jane Hamilton of Agnews, the British Museum Print Room, Mr Alan Tadiello and Professor Penny Bulloch of Balliol, Fathers Holt and Thomas McCoog of Farm St, the Society of Jesus, Lower Leeson Street Dublin, Camden Local Studies and Archives Centre, the Royal Academy Library, the Tate Gallery, Fathers Michael Suarez and Philip Endean of Campion Hall, the Royal Photographic Society, Stephanie Plowman of the archives of Gonzago, the Sault Saint Marie Gallery, and Thunder Bay Art Gallery Ontario, Herr Dr Immler of the Geheimes Hausarchiv, the Staatliche Archive Bayerns, the librarians of the Zentralinstitut für Kunstgeschichte, München and the Bayerisches Hauptstaatsarchiv, Dr Anthony Hamber for his information on nineteenth-century photography, Dr Jane Munro for

assistance in tracking down pictures, Dr Richard Luckett, Professor Warwick Gould, Professor Danny Karlin, Professor Howard Erskine-Hill, Professor R. K. R. Thornton, the late Leo Handley-Derry and his wife, Anne, for their encouragement and generous assistance, Mark Handley-Derry for permission to work on the papers in Boston College, the referees used by Oxford University Press for their stimulating advice, as well as the support and guidance of Andrew McNeillie, Tom Perridge, and Jacqueline Baker. I am grateful for the financial aid of the British Academy and for a Leverhulme Senior Research Fellowship, without which I would not have been able to carry out the research, and to Downing College. Anyone working on Hopkins and art is aware of the substantial groundwork provided by Humphry House and Graham Storey in the *Journals and Notebooks of Gerard Manley Hopkins*, Kelsey Thornton's excellent book of essays and illustrations of Hopkins's art, *All My Eyes See*, and Norman White's *Hopkins: A Literary Biography*. The poems, prose, and drawings of Hopkins are included here with the kind permission of the Society of Jesus and Oxford University Press, the Bodleian Library, Balliol College, and the Harry Ransom Center. The drawing by Maria Giberne and George Giberne's photograph of Manley Hopkins and two drawings by Gerard Manley Hopkins, *June, '68 Oak Hill*, and *Manor Farm, Shanklin. / Finished Sept. 21. 1863* are published courtesy of the Harry Ransom Humanities Research Center, The University of Texas at Austin; the drawing of *A Gully at Rathwaite* by Arthur Hopkins, Manley Hopkins's drawing 'W. Harvey. STORY without an END', and the photographic pun are reproduced through the kindness of the Burns Library, Boston College. Hamo Thornycroft's statue of *The Sower* is reproduced courtesy of the Conway Library, the Courtauld Institute of Art, Raffaelle Monti's statue in carved marble, *The Sleep of Sorrow and the Dream of Joy: An Allegory of the Italian Risorgimento* (1861), my photograph of John Gibson's *Pandora* (Marble 1851), and Jules Dalou's *Peasant woman nursing her baby* (terracotta 1873) and Millais's watercolour of *The Eve of St Agnes* appear with the permission of V&A Images of the Victoria and Albert Museum, and Millais's *Winter Fuel* through permission of Manchester Art Gallery, as does William Holman Hunt's *Shadow of Death*. Fred Walker's painting, *The Harbour of Refuge* is reproduced courtesy of the Tate, London 2006. Gerard Manley Hopkins's drawing, *Shanklin, Isle of Wight 1866* (MS Eng. Misc. a. 8, fo. 104), appears with the permission of the Bodleian Library, University of Oxford. The following drawings by Gerard Manley Hopkins are reproduced

courtesy of Balliol College, Oxford: *North Road, Highgate. March 12th. 1862*; *Celandine. Hampstead. 1862*; *Shanklin. Sept. 12* [1863]; heading, letter to his sister, Milicent; Hedgerow plants; clouds 'July 29 or 30', 'July 31'; Man reading in a punt; *Elsfied, [Elsfield] Oxon. April 13. 1864*; water flowing over rocks; *This is a glacier, though you wd. not think it. July 15, '68.* Robert Walker Macbeth's etching of Fred Walker's painting, *The Plough* appears courtesy of Agnews. Arthur Hopkins's engraved pictures, *The Paddling Season* (*Illustrated London News*, 3 Aug. 1872), *Iced Tea* (*Graphic*, Christmas Number, 25 Dec. 1875), and *Type of Beauty* no. XVIII (*Graphic*, 24 Nov. 1888), and Percy Macquoid's *September* (*Once a Week*, 8 Sept. 1860) are published by permission of the Syndics of Cambridge University Library. Frederic Leighton's painting, *Old Damascus, Jewish Quarter or Gathering Lemons'*, *c*.1873−4 oil on canvas, copyright Christie's Images, appears courtesy of the Bridgeman Art Library. Finally, I would like to thank my husband for the encouragement and assistance he has always given me.

CONTENTS

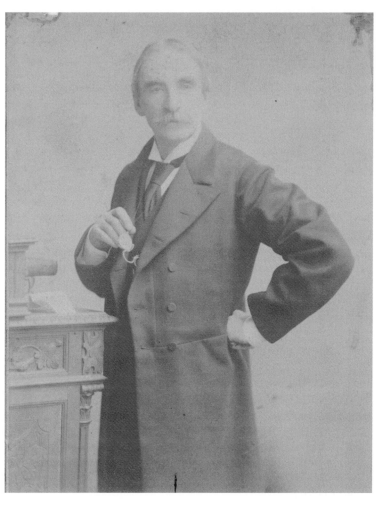

1. Manley Hopkins, photograph by George Giberne (*Harry Ransom Center*)

LIST OF ILLUSTRATIONS

SOURCES FOR THE SKETCHBOOKS

Sketchbooks A, B, and C are in the archives of Balliol College, Oxford. Sketchbook D is housed in Campion Hall, Oxford. There are also sketches in the Harry Ransom Center of the University of Texas, the Burns Library of Boston College, Massachussetts, and the Bodleian Library, Oxford.

LIST OF ABBREVIATIONS

The poems are quoted from *Gerard Manley Hopkins, The Major Works*, ed. Catherine Phillips (Oxford: Oxford University Press, 1986, 2002).

AMES	*All My Eyes See: The Visual World of Gerard Manley Hopkins*, ed. R. K. R. Thornton (Newcastle upon Tyne: Ceolfrith Press (Sunderland Arts Centre), 1975)
Facsimiles	*The Later Poetic Manuscripts of Gerard Manley Hopkins in Facsimile*, ed. Norman H. MacKenzie (New York and London: Garland Publishing, 1991)
HQ	*Hopkins Quarterly*
ILN	*Illustrated London News*
J	*The Journals and Papers of Gerard Manley Hopkins*, ed. Humphry House and completed by Graham Storey (London: Oxford University Press, 1959)
LI	*The Letters of Gerard Manley Hopkins to Robert Bridges*, ed. with notes and an Introduction by Claude Colleer Abbott (London: Oxford University Press, 1959)
LII	*The Correspondence of Gerard Manley Hopkins and Richard Watson Dixon*, ed. with notes and an Introduction by Claude Colleer Abbott (London: Oxford University Press, 1935, 2nd rev. impression 1955, repr. 1970)
LIII	*Further Letters of Gerard Manley Hopkins, including his correspondence with Coventry Patmore*, ed. with notes and an Introduction by Claude Colleer Abbott (London: Oxford University Press, 1938; 2nd edn. rev. and enlarged, 1956)
OET	*The Poetical works of Gerard Manley Hopkins*, ed. Norman H. MacKenzie, Oxford English Texts series (Oxford: Clarendon Press, 1990)
S	*The Sermons and Devotional Writings of Gerard Manley Hopkins*, ed. with an Introduction by Christopher Devlin (London: Oxford University Press, 1959)

1

Early Influences

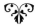

Of all the influences on Gerard Manley Hopkins, none is so important for his early creativity as that of his father. The only photograph by which students of Hopkins today know Gerard's father, Manley, is that in the *Further Letters*. It shows a slightly built man with sloping shoulders, rather querulous expression and pose, bushy beetlebrows, and full moustache. One would not guess from it the material one finds in his journals, articles, drawings, and poetry.

Manley Hopkins made ink drawings, sometimes as illustrations to his writing as in a story titled 'The King's Fool', where they parody the Bayeux Tapestry. Others are in a style his own but influential on both Gerard and Everard in the humour he finds in situations: Everard became an illustrator for *Punch* and Gerard's letters are full of verbal caricature and visually realized incidents. Manley was a 'self-made' man, whose mental energies were not sapped by his work. Apprenticed as an average adjustor, he advanced to set up his own company and write what became standard texts on marine insurance. Robbed of a university education by the disarray in which his father had left his affairs at the time of his early death, Manley strove by himself to acquire the knowledge and traits of mind of one who had enjoyed that privilege. More than this, Manley wanted to know about all sorts of things because he found them interesting. He had journals in which he transcribed passages from books he read and argued through in his mind to his own conclusions about issues that show breadth and a willingness to face uncomfortable ideas—the thoughts on the relation between nature and evolution and a literal faith in the Bible, for example. He also kept travel journals. An entry from one of these of 1875 from a trip to France reads:

On our way back to *Le Puy*, we alighted at the Village of *Espailly* or *Expailly*, and walked to the remarkable basaltic Cliff called from its parallel prisms

Les Orgues. They certainly resemble organ-pipes in being regular, close, and detached. In the centre they are perpendicular, whilst at one end they curve forward or rather to one side, like those lateral pipes seen in some modern organs which produce very percussive and trumpet-like notes. These columets may be forty-five feet in height; and are surmounted by a mass of rock much less crystallized. The prisms are all irregular pentagons, the diameters of each of the five sides usually differing, and the difference apparently arbitrary or accidental. Small gems are found in the basalt, principally zircons, sapphires & garnets: their angles are said to be all worn.

The passage is remarkably similar to ones written by the more privileged Gerard in 1868 when he was exploring Switzerland: 'At Grindelwald are two glaciers, the upper and lower, which are in fact two descending limbs of one. I shall speak of them from my knowledge since. Above where the mountains make hollows they lie saddle-wise in them and then shouldering through the gorges are broken up—but the question is whether by the pressure or the slope' (*J* 175).

Both accounts make comparisons with other things—Manley comparing Les Orgues with organ pipes in a way suggestive of the many hours he spent in church whereas Gerard harnesses the suspended images of an animal/human (limbs, shouldering) often found in his descriptions of landscape and the accepted adoption of riding terms for mountains (saddle-wise). Manley's description comprises accurate accumulation of detail whereas Gerard's pushes towards geological comprehension. Both derive some of their facts from other sources: Manley's list of gems 'their angles are said to be all worn' probably garnered from a contemporary journal and Gerard's 'knowledge since' reflecting the 1868 Baedeker he carried.

Other entries in Manley's travel diary reveal different facets of his personality. He watched with some anxiety the face of an innkeeper's daughter who served dinner to the family after a long day's travel. They had arrived so late at their destination that their appearance was no longer expected and the hospitable innkeeper provided them with food by giving them his family's dinner. Having feared resentment, Manley seeks to explain the girl's cheerful complacency by surmising that a flock of goats they had seen pass through the village suggested a plentiful supply of food. He writes on another occasion of the market stallholders who form a Sunday market beside a cathedral and abandon the chance of earning a little more in order to enter the cathedral to pray. It is the encounter of a middle-class businessman with a society whose values are less materialistic and in which the attention to money that earned the

comfortable circumstances in which Gerard grew up is balanced by a sensitivity to others and to other sets of values.

Drawings pasted into an album that are most probably by Manley show, as in his writing, interests in archaeology, religion, and architecture. The selection of cuttings also says something about his taste; there are classical buildings, lithographs cut from journals of rural scenes meant to evoke the months of the year. The collection is eclectic; there are two sentimental lithographs of drawings by Vidal of 'flowers' and 'fruit', for example, which are technically good but show two insipid young women adorned with roses and fruit respectively. Such compositions recall the more disturbing but technically superb later pictures by Dante Gabriel Rossetti that Hopkins was to admire in the house of George Rae (see pp. 183–4).

Manley was also interested in becoming a competent artist. In the 1840s he was evidently training himself to draw by copying illustrations or trying to reproduce lines from paintings, independent study I believe Gerard imitated though he followed Ruskin's tutelage in *The Elements of Drawing*. Manley made a number of ink copies of illustrations to works of literature, such as Archdeacon Wilberforce's *Agathos*, in which a young girl leans against a stile, her chin propped on her hand, gazing pensively at distant mountain scenery. Like many of the drawings in this album, it was copied from wood engravings in books of the day and is influenced by the manner in which areas are built up in wood engraving with parallel lines or crosshatching. In the year of his marriage Manley copied a picture by W. Boxall of a woman with three children: a six-month-old on her lap protected by her arm, a slightly older one with its arms around her neck and from whom she is evidently going to receive a kiss, and an older girl, around whom she places an affectionate arm, who sits against her knee and holds up some plant for the baby to see. The tight composition shows interrelations that are affectionate, with the mother clearly the fountain of love and protective guidance.

Manley liked French prints and copied a caricature of 'little red Riding-Hood' that shows her in an enormous hood, no doubt coloured red. His eye was evidently caught by the cocky stance of the inelegant young girl, which he captures. There are two female figures from *Gil Blas* where much of the interest is in their elaborate costumes, and an excellent one of a Frenchman, bordering on the humorous, in which the man scratches his hatted head in puzzlement. Another of a man riding in a wooded valley below a hilltop castle has a well-copied foreground tree and galloping horse. There are drawings of archaeological finds at

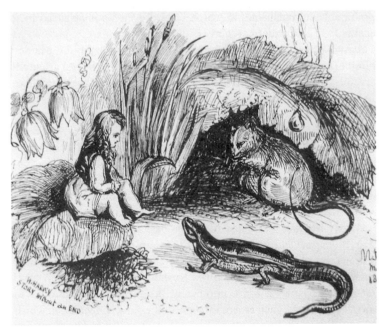

2. Manley Hopkins, 'W. Harvey/ STORY without an END', 'MH/ MAR/
184[?3]' (*Boston College*)

Pompeii and Herculaneum in pen and sepia, among the best of which
is a copy of an illustration of a classical statue of two whippets with a
ball, signed and dated Oct. 28 [1858]. Another is a generally faithful
copy of Penelope taken from a drawing by William Gell, engraved by
H. Moses of Penelope and Ulysses in vol. ii of Gell's *Pompeiana*,[1] a
volume the family owned. It is a little stiffer, less graceful than Gell's
figure who is tilted back slightly further, and inclines her head a little
more. The lines of the arm and hand are a bit clumsy in comparison
with the original. Gell wrote that 'By collecting the materials which
Pompeii and Herculaneum have already furnished and may hereafter
supply, we shall probably, ere long, have the means of forming editions
of the writers of antiquity, and decorating our classical and mythological
dictionaries with figures and illustrations which the ancients themselves
might have approved, but which have hitherto been attempted in vain'
(p. 70). Most of Gell's illustrations are of the ruins at Pompeii or are
imaginative reconstructions of what the buildings might have looked like

with figures suggesting how they would have been used. Gerard does not seem to have done much work influenced by them beyond his humorous Christmas box for Aunt Annie in 1853 (see Chapter 2)—Alma-Tadema would seem to have learnt rather more from the volumes—though Gerard's interest in the archaeological accuracy of paintings by Alma-Tadema and Poynter shows his awareness of the issue of historical truth that Gell raises.

Among Manley's other drawings are two fantasy pieces after William Harvey: one from 'STORY without an END' of a plump child sitting on a plant looking at a lizard while a rat sits under a leaf nearby, watching. The drawing fits into the Victorian interest in the fairies contributing to the popularity of *A Midsummer's Night's Dream* in the period and seen in the 1840s in the border whimsies in *Punch* and in the paintings of Francis Danby (*A Midsummer Night's Dream*, 1832), Robert Huskisson (*The Midsummer Night's Fairies*, 1847) and now best known in Richard Dadd's later oil, *The Fairy Feller's Master-Stroke* (1855–64). Hopkins's descriptions of nature in his Journal entries and in his poems sometimes show a similar interest—'Down in dim woods the diamond delves! the elves'-eyes' etc. ('Starlight Night') and juxtaposition of different scales of size, as for instance in the description of the moon that 'dwindled and thinned to the fringe of a fingernail held to the candle/Or paring of paradisaical fruit, lovely in waning but lustreless,/Stepped from the stool, drew back from the barrow, of dark Maenefa the mountain' ('Moonrise June 19/1876'). The second of Manley's fantasy pieces has resonances of the *Songs of Innocence*. In it a young, golden-haired girl stands looking at a tropical scene with flamingos peacefully feeding at the water's edge. She is being protectively embraced by a figure with long hair, who could be male or female, and they both stand beneath a plant with large, exotic leaves. Just behind them there is a lion in the shadow of a cave.

Manley also copied a woman in Turkish dress about to receive a sword that descends through the air to her, part of an illustration by William Harvey of 'The Story of the Second Royal Mendicant' in Edward Lane's translation of the *Arabian Nights*, another set owned by the family.[2] Edward Lane was Kate's uncle. As with Manley's copy of Penelope, the figure is more upright and consequently slightly less graceful though sufficiently accurately copied that its source is instantly recognizable. Apart from the attraction of the remarkable story of multiple transformations, it would seem that the flowing robes of the woman were of interest. Similarly, in Manley's copy of two angels by

Giotto, his attention seems principally to have been in the folds of their robes, which he lovingly imitated. Drapery was a technical problem that featured prominently in the art training of the day and a subject that Gerard was later to examine closely.

Manley's drawings are competent and clearly influenced by the illustrated volumes in his possession. However, his sons were more interested in contemporary genre pictures and drew in styles dating from their own period. For this it was the illustrated press of the day that was important. Gerard, Arthur, and Everard were fortunate in growing up in a household where there were not only illustrated books but also what is considered the best of the illustrated journals of the day, *Once a Week*. It contained a substantial range of pictorial styles, from caricatures by Phiz and reproductions of Japanese prints to the melodramatic poses and expression of Tenniel, Keene, and Leech and the genre pictures of Millais, Du Maurier, and Frederick Walker. Having such illustrations to pore over as a child may have had a formative and determining effect on Arthur, who later himself became an illustrator for *Punch*. The handling of the foreground foliage in Percy Maquoid's *September 1860* may have influenced Gerard's drawing of *Dandelion, Hemlock and Ivy … 1862* (*J*, plate 2) and *Hedgerow leaves and branches* (*J*, plate 9) where the foliage shows the same clear shapes and stark tonal contrasts. Gerard's sketches in his diary of waves (figs. 10 and 11, *J* 23) use the parallel lines to compose planes that was the necessary technique of wood engraving (cf. H. G. Hine's coastal scene of *Mount Orgueil* for 'Jottings in Jersey' in *Once a Week*).[3] Similarly, on occasion he constructs background skies in cloud drawings out of parallel lines, as in Journals, plate 13, 'Clouds. "July 29 or 30" and "July 31" (1863)'. He also crosshatches, another of the wood-engraving effects, as in the water in *J* plate 16, 'Coast-scene. "N.B. As time went on, after sunset, clouds richer and purple Edges redgold and living orange. Dabblings of gold *on* the clouds."'

Most of the pages of *Once a Week* were taken up with stories, serialized novels such as Reade's *A Good Fight*, Meredith's *Evan Harrington*, Mrs Henry Wood's *Verner's Pride*, Miss Braddon's *Eleanor's Victory*. These called for illustrations involving people and may have affected Gerard's few figure drawings (see especially the drawing of a girl May/June 1864, *J*, fig. 13). His artistic taste was clearly influenced by what he found in the journal. He had ample examples of Leech and Keene's work with their gifts of indicating attitude so that when he compared Arthur's boy's face in *The Paddling Season* with an

3. Percy Macquoid, *September, Once a Week*, 8 September 1860 (*University Library, Cambridge*)

illustration by Keene, he was not working simply with one example but the experience of dozens. Similarly, his admiration of Millais, although dominated by Millais's great oil paintings, was probably initially prompted by his graceful drawings for *Once a Week*. Among Millais's contributions was one in the first volume of an old woman seated with a young girl at her feet. It illustrates Tennyson's 'Grandmother's Apology', in which, as in Gerard's 'Spring and Fall', a young girl is addressed on the theme of growing emotional insensitivity as one ages. Another of Gerard's favourite artists was Frederick Walker, who was one of the best of the illustrators in the journal. He excelled at capturing personality, mood, and suggesting movement that looks as if it has been captured with the rapidity of a camera instead of being a frozen pose. One can well understand why Gerard thought so highly of him.

When Dickens scuppered *Household Words*, he took with him to his new journal, *All the Year Round*, 'the staff of writers with whom I

have laboured, and all the literary and business co-operation that can make my work a pleasure'.[4] It may, therefore, have been something of a necessity that *Once a Week* issued an 'open invitation to unknowns to contribute'. Among those unknowns was Manley Hopkins, who published there some twenty-three poems and articles, the poems under the pseudonym Berni.[5] The first volume contained two of his poems ('The Palimpsest' and 'Sad Words') and an article on 'Recent Volcanic Eruptions in Hawaii' illustrated by H. G. Hine. Manley was Consul-General for Hawaii in London, a post he obtained through his brother Charles, who was a government official in the islands. In that issue of December 1859 Clara Lane, a relative of the Hopkins family, did one of two illustrations to 'The Palimpsest'. Manley's poems in later volumes were illustrated by Phiz, Pinwell, and M. J. Lawless, who contributed a beautiful drawing to 'Broken Toys'. In it a mother is pictured seated beside a chest of drawers, one of which evidently contains the belongings of her dead son. She leans on the open drawer with one hand over her eyes and the other closed upon her lap. One wonders how much of Manley's grief for his son Felix, who lived for less than a year from 1852 to 1853, may lie behind the poem. Its final stanza reads:

> How weak I am! How changeful, how desolate, how lone!
> Bear with my faithless grief, O Thou, to whom all grief is known!
> I will think upon Thy story;
> I will think upon his glory
> Who from my arms is flown;
> And try to figure to myself the bliss that is my boy's:—
> But my heart is well-nigh broken by these broken toys!

It is not great poetry and suffers from the permeable borderline between pathos and bathos that Hopkins felt Bridges breached in his 'On a Dead Child' but, in both cases, the grief is evidently quite genuine.

Manley's poem of impatience while waiting for his wedding in 1843, 'Non Satis', was printed in the issue of 17 November 1861, accompanied by one of George Du Maurier's earliest illustrations for *Once a Week* and engraved by Swain. Leonée Ormond says of it that, like his drawing for 'On Her Deathbed', 'these … were the result of more time and thought than usual, and Whistler, who was a good judge of the arts, "went on about them" a great deal. In both these drawings the influence of the Pre-Raphaelites was uppermost, particularly in the firm shading of the figures. In "Non Satis" [Du Maurier] drew Emma [his wife]

standing among some flowers and ivy, and rendered the detail precisely, in obvious imitation of the work of Millais.'[6] No doubt the drawing was looked at with particular attention in the Hopkins household, though I do not think that the draughtsmanship would have satisfied Gerard for long. There is insufficient depth of perspective in the leaves of the ivy growing on the fence behind the woman and the leaves in the foreground are an unidentifiable jumble. The woman's hand is most awkwardly positioned to pick the rose, though there is no 'scribbling' in it, and the tree in the background performs admirably its job of giving a sense of depth.

The journal carried occasional travelogues, such as one on Nuremberg written by Manley Hopkins and illustrated by H. G. Hine, who did most of the landscapes. The article shows Manley's command of prose; his style is generally plain but ornamented by the occasional striking metaphor. He describes, for example, the 'graceless growth' around the beautiful Frauenkirche: 'It is to be regretted that round this noticeable church there is a parasitic growth of shops and stalls, clinging to its lower walls, which detracts much from its beauty.' Unfortunately the metaphor is mixed by the next sentence: 'It would require the strong file of public opinion to scrape away this rust of prescriptive rights' (p. 720). Gerard's logical and visual mind tended to eliminate such confusion and though father and son had much in common in their tastes and views, Gerard's prose, like his verse, was generally more strikingly individual and lively because of his stronger grasp of the visual dimension of the words he was using.

Among the illustrated books owned by the family was a large volume titled *Old England: A Pictorial Museum of Regal, Ecclesiastical, Baronial, Municipal, and Popular Antiquities*.[7] The book is lavishly illustrated, every other opening being a two-page spread of pictures in a style characteristic of the eighteenth and early nineteenth century with detailed conventionalized leaves on trees and some pictures exuding a sense that ruins could be picturesque (pp. 184–5, for example). From its well-thumbed condition Humphry House deduced that it had been popular with the children. It could have been a source for Manley's constructed picture of a scene in his comic story supposedly 'from a late Saxon MS. in Cotton Collection', 'The King's Fool. A tale of English patronymics'. The parodic nature of the story may have suggested to Gerard the possibility of a parody of one of his Oxford texts in 'The Legend of the Rape of the Scout' (*J* 6–8, 1863). The letter under the pseudonym Arthur Flash de Weyunhoe begging

more funds from his father and most probably penned by Gerard is illustrated with a jester whose headdress is a clever combination of academic mortarboard and belled cap as in drawings to his father's tale. Manley's drawing is in part an amusing modification of the scene from the Bayeux Tapestry of the Coronation of Harold, illustrated in *Old England*, p. 80.

Manley also made a series of political cartoons with simple telling lines, a style of drawing that Everard in particular inherited, and a number of watercolours of the standard of a fairly competent amateur. These were evidently records of holidays. There is one of the church at Benenden, Kent, that Gerard was later to draw, and another of a blustery day at the coast with figures fishing from rocks in the foreground, a hulk leaning over in the middle ground and a rather hurriedly added sky. As in many of Manley's other paintings, gouache is not very skilfully used. There are landscapes with houses among trees and a pleasing one of a yacht with warm burnt sienna sails on a lake with reflections of a centrally placed church framed by balancing groups of yellowing trees. The technique in all these is broader than Gerard would have approved but the rural subjects, the wreck, the evident love of trees and clouds were interests they shared and, although Gerard was to express his views of them in his own unique way, the interests were probably fostered by his father.

Manley was also evidently interested in art exhibitions. The opening poem, 'Le Soir', in his collection *Spicilegium Poeticum* was suggested by a picture by M. Tony Johannot in the Salon of 1848.[8] A copy of the painting forms the frontispiece to the book. Manley interprets it, speculatively but with some conviction, as a scene of two sisters, one of whose thoughts are on an absent lover while the other thinks of heaven.

> One of earth, and one of heaven
> Dreaming, in the silver even.
>
> Sisters sitting close together,
> In the calm of summer weather.
>
> All is silence deep and strong,
> Binding chains upon each tongue.
>
> As the poles, their thoughts are far.—
> One hath found the evening star;
>
> While the other's earthward sight
> Rests upon a glow-worm's light,

> Mountains raise their dim, blue crest
> 'Tween them and the fading west.
>
> With the rich, dark tresses, she
> Sends her wingèd thoughts to sea;
>
> Where there tosses on the foam
> One whose heart is her sweet home.
>
> But her gentle sister fair,
> Angel-eyed, of golden hair,
>
> Looks beyond the utmost wave
> That earth's sunniest strand doth lave,
>
> Gazing on a farther shore,
> Where is rest for evermore.
>
> Silently the deepening night
> Steals the picture from my sight.

(opp. 11–12)

Gerard wrote several poems in which pieces of art or potential pieces of art are the focus. There is the mysterious series on St Dorothea, 'Harry Ploughman' (discussed in Chapter 6) and 'Andromeda', a theme that attracted a number of painters in the period from the classicist Frederic Leighton to Edward Poynter (whose example was much praised at the RA in 1870) and Burne-Jones, as well as the poets Browning and Morris. Gerard's 'Andromeda', like his father's 'Le Soir', is allegorical and contrasts spiritual and earthly values but replaces his father's conventional language and straightforward story with more complex relationships:

> Now Time's Andromeda on this rock rude,
> With not her either beauty's equal or
> Her injury's, looks off by both horns of shore,
> Her flower, her piece of being, doomed dragon food.
>
> Time past she has been attempted and pursued
> By many blows and banes; but now hears roar
> A wilder beast from West than all were, more
> Rife in her wrongs, more lawless, and more lewd.
>
> Her Perseus linger and leave her to her extremes? —
> Pillowy air he treads a time and hangs
> His thoughts on her, forsaken that she seems,
>
> All while her patience, morselled into pangs,
> Mounts; then to alight disarming, no one dreams,
> With Gorgon's gear and barebill/thongs and fangs.

Gerard gave an 1881 version of the poem the title, 'The Catholic Church Andromeda', suggesting an allegory of the state of the Catholic Church threatened by growing secularism and awaiting the intervention of Christ.[9] Andomeda was a popular subject for the female nude at the time. As with his drawing of the Mermaids, Hopkins seems to position his Andromeda with her back to us—she 'looks off by both horns of shore', her corporeality reduced to 'her flower, her piece of being'. Placing so much of the octave from Andromeda's perspective has the effect of reducing the erotic potential of the subject. His response to the sexual element is deflected into his description of the new attacker as 'more lewd'. The grammar is ambiguous: 'her wrongs' could be taken as 'wrongs she suffers' but the other attributes, 'lawless' and 'lewd' suggest that what Hopkins intended was not 'wrongs suffered by her' but 'wrongs inflicted on her'. The break between tercets that splits the sentence similarly exacerbates the absent antecedent, momentarily leaving the reader casting about for the subject of 'alight', and in the process making mimetic the surprise of the unexpected appearance of a saviour.

How many art exhibitions Manley attended we don't know but, like his son after him, he evidently went to International Exhibitions and to shows of the Societies of painters in watercolour. Among his poems is one called, 'At the Water-Colour' which incorporates a description of a painting in a story about two 'cousins' who 'languidly admired' a sparsely attended watercolour exhibition and find, when they sit down to rest, that they are in front of a painting about two young married lovers, which prompts them to move towards declaration of their own love. The poem employs a casual diction, and jokey rhymes. The description of the painting opens,

> The work before us (I won't name the artist)
> Was not your *ad captandum*, nor the smartest;
> But it was one which paid for being studied:
> The more you looked, the more its beauties budded;
> Of inmost nature shrewed the painter's knowledge;
> And of the heart;—which you can't learn at college.

> (p. 113)

It would be surprising if there had not been some conflict between Gerard and his father over the university learning, the absence of which Manley was so conscious of and Gerard with his youthful inclination to superciliousness was no doubt tempted to flaunt. Both Manley and

Gerard wrote about fairness to the lower classes. Manley included in *Spicilegium Poeticum* a poem called 'Fair Drinking'. It has as an epigraph 'A little learning is a dangerous thing: | Drink deep, or taste not the Pierian spring'.

> There's an old Pope-ish legend going
> About the right of knowing;
> Which means, its [*sic*] only for the upper classes,
> Only for them the Muses' tap is flowing,
> And all below the salt must sit with empty glasses.
> 'Not so,' says Education,
> 'I brew for all the nation.
> 'Drink, he who thirsts. I sell by pint or barrel.'
> And this decides the quarrel.
>
> So ye, who wish to be as learnèd
> As St. Augustine or St. Bernard,
> Carden or Aristotle,
> Drink on (there's none prevents) your fill;
> Get boosy on the classic rill:
> But the Pierides declare
> The million waits to have its share;
> So drink,—*but pass the bottle!*

<div align="right">(p. 64)</div>

This is written by Manley as someone outside the privileged circle within which he placed Gerard. His son's most famous statements on the position of rich and poor occur in the 'Red' letter written to Robert Bridges in August 1871 (*LI* 27–8) and in his obscure poem 'Tom's Garland: upon the Unemployed', where his symbols recall the extended metaphors he set up in his sermons. Dixon and Bridges needed a crib. There is no evidence to suggest that Gerard ever wanted to dismantle the class or gender structure or abandon his place within it. The innovativeness of his thought was balanced by a need for a hierarchical system that, while it placed men in authority over him, equally gave him power over others. At times he used his position within the 'true' Church to wield a moral 'club' over others, such as Patmore and Bridges.

One of Manley's sonnets suggests influences on his son's early work. Titled 'The Greatest Hero', it runs:

> Prometheus, writhing, chain-bound, on his rock,
> Felt in each mortal pang that rent his heart,
> A something flush of joy; th'immortal part

Repelling fleshly agony; a shock
Of triumph, that for dark human flock,
 He had snatched light and fire.
 Some men are great
 For *one* large benefit conferred. Some through fate
Have torn the fruiting scion from its stock,
Leaving endeavour ruined. Greatest he
 Who to the million's hung'ring bosom brings
Million-fold daily blessings. Look and see
 How the high Sun life-giving largess flings
Not on one lone proud peak; but o'er Earth's space
Light to each tiny flower with upturned, joyous face.

<div align="right">(p. 116)</div>

The line, 'How the high Sun life-giving largess flings' is not Christian enough in its picturing of the relationship of the sun to the earth to be characteristic of Gerard, but brings to mind his lines 'joy ... whose smile | 'S not wrung, see you; unforseentimes rather—as skies | Betweenpie mountains—lights a lovely mile' from 'My own heart'. Manley's lines 12–13 are also technically interesting since the inclusion of spondees combined with the delayed direct object gives an impression of sprung rhythm. The alliteration and freedom with which the form is handled, although not as free as Gerard's would be, are more suggestive of his work than is that of most Victorian sonneteers. The subject too was shared: one of Gerard's early poetic exercises was a spirited translation of the opening passage from Aeschylus' *Prometheus* in which the god lies bound to the rocks in chains and, while the lines set out the situation dramatically for the audience, they show the god preparing himself psychologically for further tormentors by establishing in his mind his status as one of the old gods and the benefactor of mankind.

 There are a number of Manley's poems where ideas are expressed that seem likely to have influenced Gerard although the son's rendering of them is much more striking. A number of these concern observations of nature. Manley's 'To the Cuckoo' (For the Music of Haydn's Serenade) is one of those. Manley writes:

 Cuckoo, we have sought thee
 Through the leafless coppice;
 Watched along the fallow lea,
 Loved by summer poppies:
 But we cannot find the place

Of thy winter hiding,
Cannot, by one feather, trace
Where thou are abiding.

Let us hear thy air-borne voice,
O, most welcome comer;
Make the echoing hills rejoice
With thy promised summer.
Winter wanes. O, hither fly,
Near our homesteads hover;
Fill with joyous notes the sky
From thy secret cover.

(p. 123)

Of Gerard's many poems about or including references to birds, several are brought to mind by phrases here: the 'leafless coppice' recalls, 'thrush | Through the echoing timber does so rinse and wring | The ear, it strikes like lightnings to hear him sing', for example. The keen attention to sound in Gerard's poem suggests the limitations that he found in visual art; it simply could not convey all that he experienced and wanted to communicate. Manley's 'leafless coppice' is transformed by Gerard into 'goldengrove unleaving' ('Spring and Fall'). Manley's 'Rest' has resemblances to Gerard's 'Peace' but whereas the latter's heart is pictured as a dove, Manley's comparison is to a storm petrel. Manley uses the skylark in the course of an argument that heaven is not a place far off but within the heart. His stanza on the skylark again suggests comparison with Gerard's

The lark, that with delirious song
Sweeps o'er the sapphire sky's abyss,
Is still within the atmosphere,
And bears about his bliss.
'Tis not less aether where he floats
Than where gush far her faint-heard notes.

(p. 168)

Manley's sonnet, 'On the Wye. Tintern' has ideas shared with Gerard in 'Ribblesdale' where man defaces nature, and 'God's Grandeur', though it is Nature and God, not man's works, that endure. Manley's poem reads,

Destroying Man—injurious Time, have fought
A deadly fight with Tintern. But in vain
Have been their weapons; for the *almost slain*

Smiles on his foemen's graves. *They* now, are nought;
The desecrators die—the desecrate is sought
By troops of loving worshippers, again,
Marvelling at thy doubly-hallowed fame.

By these three signs is one great lesson taught;—
By the unchanging hills, with changeful hue;
By the fast fleeting, yet enduring river;
By the oft clouded sky's eternal blue
Before, around above thee; whispering ever
That though man, with his malice, cloud the day,
His works of faith and zeal and love live on for aye.

(p. 131)

One final example; there is some overlap in concept between Manley's 'Sonnet: Aureoles' and the sestet of Gerard's 'As kingfishers catch fire ...'. Manley comments upon the change in artistic style from an overtly symbolic one to the question of how one detects true Christianity within more realistic art. The poem then shifts quickly to the same question within life. Both poems exude Christian confidence.

The Saints of old, when Art dwelt near the shrine,
 Wore round their heads, a lambent, golden haze;
 Which when unlettered men, with reverent gaze,
Looked on, they knew the Painter's pious sign
Speechlessly speaking Him who was divine,
 Or His dear followers. Now, in other ways
Art pays her homage. If we seek like blaze
Of lambent glory, Christ's true servants shine
Still with a heavenly light where'er they tread.
The eye sees nought save a kind fellow man:
Yet all around his presence, there is shed
An influence circling forth from his small span
Making us silent, safe and happy, whilst within
The reach of eyes that smile, and sound of words that win.

(p. 172)

Manley gave to Gerard a daily example of Christian belief, sensitivity to the natural world, and constant, amateur, artistic endeavour. It was, he showed, not necessary to have formal instruction to experiment with poetry, music, or art. Poised upon that platform provided by his father, Gerard went further in his dedication to religious faith, and in the originality of his writing. In art, as suggested above, he was influenced

by the rise of landscape and the attention to nature of a later generation of artists than had affected his father.

⁓

Gerard is said to have received his first training in drawing and music from his Aunt Annie, his father's unmarried sister, who lived with the family until 1856.[10] Her art was of the sort that middle-class women were taught to produce: she made a couple of drawings touched in with watercolour of Gerard that have been dismissed as sentimental but which Gerard's mother hung in her bedroom. She was evidently knowledgeable about Eastern religion, of which she was said to talk 'rather learnedly'. The first example of a drawing by Gerard is his *Christmas box to Aunt Annie* from 1853, described in Chapter 2. He was fortunate, however, in growing up in a family within which there were professional and exceptional amateur artists for several generations. Gerard's godparents were his father's younger brother Edward Martin Hopkins (1820–93) and his second wife, Frances Ann Beechey (1838–1919). Edward Martin Hopkins was a competent watercolourist, but he was surpassed by Frances, whose work is part of the historical heritage of Canada. The couple were married on 31 August 1858, the service conducted by the Revd Thomas Marsland Hopkins, who had married Frances's elder sister Katherine some two years earlier. Edward had first worked as a parliamentary reporter, then in 1841 became a clerk in the Hudson's Bay Company and private secretary to Sir George Simpson, governor of Rupert's Land. He went with Simpson for part of his journey round the world in 1841–2. Simpson's eyesight was failing and it was Edward who wrote up the Governor's diary while travelling with him across Canada, down to California and to the Hawaiian Islands. That diary was turned into a book, a *Narrative of a Journey Round the World during the Years 1841 and 1842* and published in 1847, seen through the press by Manley Hopkins. Glimpses of what Edward was like at the time occur in the comments of two contemporary letters. The first of these was from Letitia Hargrave, wife of Chief Factor James Hargrave, who wrote to her family in Scotland from York Factory in 1842 saying, 'Mr Hopkins ... is or was a "reporter" but is as different from what I had imagined a Parliamentary reporter to be as can be conceived. He seems 23 or 24, very dandified or rather peculiar in his style of dress & uncommonly nice looking, but with a volubility of speech that I never heard equalled, & a willingness to communicate what he knows that surprised me, who am used to such reserve.'[11] The second comes from Chief Factor

John Rowand, who observed Edward during his homeward journey from the west coast of Canada to England with Governor Simpson's reports for the Hudson's Bay Company. He had, said Rowand, 'become a regular voyageur', eating 'horse flesh dog and every thing ... like one who has been travelling all his life'. His family, he believed, would find 'a great change (for the better)' in him (Johnson, 6). Edward married Annie Ogden, probably in 1847, and the couple had three boys. He became a chief trader in 1847, a promotion that gave him a share in the company's profits instead of a salary. Annie died from cholera in 1854 and Edward took his sons to England the following year, presumably with the intention of placing them in the care of his relatives. While there he probably met Frances Anne Beechey, whose elder sister Katherine married Edward's brother Thomas Marsland that year. Edward was back in England in 1857 on business and married Frances in 1858. They returned to Canada with the children early in December where they settled at Lachine, moving to Montreal in 1860 when Simpson died and Edward took control of the 'Lachine establishment'. Frances and Edward returned to England from August to mid-November in 1864, perhaps to see their eldest sons, who were by then at school in Brighton. Frances and Edward had three further children but one of their sons died early in 1864 at the age of 2 1/2. They were back in England the following year from March to June when Gerard entered Frances's address: 'Mrs Edward Hopkins, 7 Palace Gardens Terrace, Kensington' in his journal in mid-May. Edward 'managed to make a short visit to Brighton' to see his sons (Johnson, 11) but he was in England in order to reply to the 'severe criticisms' made by the company's board of the management of the Montreal department so he would have been under some strain and Frances seems to have been a supportive wife, who in Canada sometimes accompanied her husband on his tours of duty rather than stay at home. The couple's youngest child was under 2 and Frances would presumably also have been busy trying to further the bond with her stepsons. That this was of some concern to her is suggested by the fact that her sketchbooks, the first dating from before she married, and in which she drew the surroundings of their Lachine home and various family occasions, she dedicated to her stepson Manley ('This book is to be given to Manley—Frances A. Beechey, Feb 1 1858—from Mamma').[12] Given these other commitments it is not all that surprising that they do not seem to have had much to do with the Manley Hopkins family. Edward and Frances were back in London at the end of June 1867 but left shortly afterwards for the continent

where from Frances's sketches and watercolours we can deduce that they travelled in France as far as the Pyrenees. They did not return to London before mid-September 1867, and in November purchased 66 Great Cumberland Place, Hyde Park, with Edward's forthcoming retirement in mind. By 1869 Frances had had four sons, two of whom had died in 1864 and 1869, and a daughter. In July 1868 Edward asked to be relieved charge of his post in May 1869 and the ball that Hopkins mentions they held in Montreal was probably intended to be a farewell occasion. However, when Louis Riel rebelled in mid-1870 it was necessary that someone who knew the area help the British officials sent to quell the rebellion. The obvious person was Edward, whose retirement was delayed until September 1870. He settled his family in a house near Sevenoaks in Kent but whether Frances then accompanied him back to Canada or how much part Edward played in the military expedition is not clear. He was apparently in Montreal on 5 and 18 August.[13] By the end of September, however, the couple were permanently settled in England.

The above description shows that there were not many occasions when Frances and Gerard Manley Hopkins could have spent time together. Katherine, by contrast, lived nearby. She also seems to have gone out of her way to befriend Gerard, going again to Oxford to visit him when as an undergraduate he forgot to turn up for their first agreed meeting. It was with Katherine that he visited the French and Flemish exhibition in 1867. She was probably nearly twelve years older than Gerard; Frances was only six years his senior. Both sisters were handsome women. Frances, to judge by a photograph of 1863 and her self-portraits in various paintings, was a decidedly stylish dresser, which, as well as reflecting her own inclinations, would have been appropriate to her husband's social position as the chief official of the Hudson's Bay Company in Canada. A granddaughter remembered her as a dainty old lady who made wonderful dolls and was proud of her white hair; Hopkins had much to say against feminine vanity in correspondence with Coventry Patmore in 1884. It is difficult to unravel the degree of egotism in the fact that she included not only the bearded, pipe-smoking figure of her husband but also herself in so many of the paintings she made of Voyageur scenes. There are other possible reasons for these self-portraits, such as historical reportage either for company or for family records, or the urge to assert the veracity of the scenes depicted in those paintings submitted to the Royal Academy for instance, or perhaps even to claim female participation

in the last days of the reign of the canoe in Canadian trade. She was clearly an adventurous and somewhat independent woman, very much part of a family of explorers and geographers, travelling by canoe with her husband when she had no need to, visiting her son in South Africa between 1908 and 1910 when she was nearly 70, working as an artist to earn additional income from 1893, when her husband died, with 'her own studio, commissions, and sales', and sending 'work to commercial galleries' (Clark, 17). It is noticeable that Gerard had none of this pioneering spirit, he never worked for the Catholic Church abroad although *Letters and Notices* is full of accounts of Jesuits who did. Katherine, by contrast, was married to an Anglican cleric, had three children, and was widowed in 1862. She was friendly and followed an accepted pattern of female behaviour with which Gerard was comfortable.

However, Gerard referred to his godmother as Frances in his letter of 1869 and as her godson would certainly have spent time with her. He made two visits to the Royal Academy Exhibition of 1874 when her large oil painting *Canadian Voyageurs on Lake Superior starting at Sunrise (Morning, Canoe Bivouac)* was shown. It is less striking than *Canoes in a Fog—Lake Superior* of 1869 and it seems to me understandable that though he can hardly have missed it, he made no comment. He also saw the 1886 Royal Academy Exhibition in which Frances's picture *Autumn on the St. Lawrence, Canada; the first touch of frost on the maples* was shown. The foreign subjects and perhaps the technique, which was broader than that favoured by Ruskin, were not ones in which he had been interested in 1864–6. But Frances was far from a negligible artist; her reputation exceeds the historical record she provides, and is still growing, as are the prices of her work. She was the granddaughter of Sir William Beechey (1753–1839), who was portrait painter to Queen Charlotte. A large equestrian painting of George III with the Prince of Wales and the Duke of York reviewing the 10th hussars and 3rd dragoons brought him a knighthood, membership of the Royal Academy, and made him well known, and he painted many of the aristocrats and celebrities of the day. His wife was a miniaturist with a similar clientele. Frances inherited a self-portrait of Sir William and *The Blind Fiddler ([Six] Beechey Children with Nurse)*, showing her father and uncles and aunts. Frances's father, Rear Admiral Frederick William Beechey (1796–1856), was godson to William IV and became a naval officer and geographer. He entered the navy at the age of 12, serving first in the Channel, off the coast of Portugal, and in the

East Indies. By 1814 he was a midshipman in North America and, in 1815, engaged in the fighting in the Lower Mississippi, which brought him promotion to lieutenant. From 1818 to 1819 he participated in Franklin's and Parry's expeditions to the Arctic, an account of the first of which he later published as a *Voyage of Discovery towards the North Pole, performed in his Majesty's ships Dorothea and Trent* ... (1843). Beechey was also involved in the attempts to rescue Franklin. He then spent 1821–2 surveying the north coast of Africa in conjunction with a land-based team in which one of his brothers was employed. They published jointly *Proceedings of the Expedition to explore the northern Coast of Africa from Tripoli Eastward, in 1821–2* (1828). He was promoted to the rank of commander in 1822 and for four years from 1825 was engaged in attempts to penetrate the Bering Strait from the west to link up with polar expeditions from the east, an account of which he published in 1831. Paintings from his time in the Arctic are in the Scott Polar Research Institute in Cambridge. A new venture, to survey part of the coast of South America was cut short by ill-health and from 1837 to 1847 he was engaged instead in the mapping of the coast of Ireland. In 1853 Beechey was the British representative at the first International Meteorological Conference in Brussels convened to agree 'standards in maritime meteorology'. The proposal Frederick put forward, which was unanimously approved, was the Beaufort Scale, which had been mandatory on board every vessel of the Royal Navy since 1838 and from henceforth replaced the wind scales used elsewhere.[14] In 1855 he was elected President of the Royal Geographical Society. Throughout his career he made numerous illustrative drawings and watercolour paintings, which required careful accuracy of historical detail, something that he may have passed on to Frances, whose work is remarkable in its grasp of the equipment and techniques of the voyageurs.

Frances also had three uncles who were noted artists—George Beechey, who initially adhered to his father's style and profession, sending portraits to the Royal Academy from 1817 but after 1830, when his popularity declined, emigrated to India where he became court painter and controller of the household of the king of Oudh. There was also Henry William Beechey, who, after making documentary illustrations of Belzoni's Egyptian excavations, collaborated with Frances's father in the exploration of the northern coast of Africa. He exhibited marine subjects at the Royal Academy in 1829 and the British Institution in 1838 and wrote a memoir of Sir Joshua Reynolds, prefaced to the artist's *Literary*

Works (1835). He emigrated to New Zealand in 1855. Richard Brydges Beechey (1808–95) was a superb marine painter. Like Frances's father, he entered the navy (in 1822), serving under his brother in 1825 in the Pacific and gradually rising to become an admiral. He sent a number of paintings of historic naval disasters to the Royal Academy, including *The Burning of the H.M.S. Bombay, the Flagship of the South East Atlantic Station, on December 22nd 1864, off Montevideo*, which Hopkins might have seen in the Royal Academy Exhibition of 1866. More striking are his paintings of storms at sea such as *H.M.S. Acheron Captain J. Lort Stokes riding out a terrific gale between the South Islands of New Zealand, 1849* of 1862 and *The Rescue: A British Frigate Going to the Rescue of a Demastered Merchantman* of 1863. The handling of the clouds and especially the sea in these is highly dramatic, technically extremely good, and very beautiful. Beechey lived at Monkstown and Dublin but spent his last years in Plymouth, frequently exhibiting in the major London galleries.

Humphry House suggested that Frances had little training but inherited artistic ability and developed into a 'very competent painter' (*J* 336 n. 62). Frances herself in the introduction to a one-man show she had in the late 1890s said that she had studied in Paris; when and for how long I do not know, though there are three main periods when it would have been possible: in the 1850s before her marriage, for a brief period in 1867, or after 1870. What is clear is that even her early sketches and watercolours in Canada show confident and highly competent draughtsmanship (including that of figures) beyond the sort of training given young middle-class women. It is difficult to know how much advice she received from her various Royal Academician relations; her step-grandson remarked that his 'impression [was] that her own family disapproved of a woman "taking up art" in any but the most genteel and amateurish ways, a common enough attitude in Victorian days' (Clark, 15) but her oil paintings, simply in size and technique, well exceed average female accomplishment. Frances said of her own work that she followed 'the traditions of the French rather than of the English School. Her pictures are frankly impressionist.' Her 'impressionism' is not that associated with Monet, since in her depiction of boats and their occupants she shows crisp and accurate detail, but lies in a relaxing in the scenery from the extremely detailed handling characteristic of English painting earlier in the century, as seen in Constable or early Turner, for example. Her second Lachine sketchbook dated 1865 shows 'an interest in the use of colour to unify the composition'. It may

have been this compositional use of colour that prompted someone to remark that her work resembled that of Corot, which she considered the highest compliment she received. Frances was clearly fascinated by the movement of water, in reflections, in the human body hard at work; her paintings of voyageurs are by far the most dramatic, atmospheric, and convincing handling of the subject by any artist of the period. She also possessed a rather unusual and lovely sense of colour—her favourite palate is a warm one, ranging through brown and orange to more unusual shades of pink and purple. It seems to me possible that Gerard learnt something from her way of expressing the speed of water rushing over rocks which he uses in his sketch of 'the Baths at Rosenlaui' of 1868.

Frances is first known to have exhibited in England in 1860, perhaps a picture connected with the tour of the Prince of Wales in Canada for which she was among the official guests. The Hudson's Bay Company gave him one of her watercolours of his visit to Caughnawagah. Frances exhibited an oil from the same trip at the Royal Academy in 1902, the year following Edward's accession to the throne (*The visit of the Prince of Wales to Lachine Rapids, Canada, 1860*). Her 1865 sketchbook shows 'considerable use of gouache or "body colour," as it was referred to by Victorian water colourists, which gives them an opaque quality that is closer in effect to oil painting' (Clark, 19). In 1869 she had the oil version of 'Canoes in a Fog, Lake Superior' accepted by the Royal Academy and from that date, although she continued to produce watercolours, made a number of large oil paintings, probably not only because, as the sketchbook suggests, it was a medium she had a natural liking for but also because oil was more highly esteemed by buyers as well as the Royal Academy. In 1870 Frances exhibited sixteen paintings in the Sixth Exhibition of the Art Association of Montreal. Her subjects were all Canadian in contrast to many of those around hers, which had titles such as *Welsh Steam in Autumn, Interior Christ Church, Oxford, Square at Berne, Zermatt, Switzerland, On the Arno, Bridge of Sighs.* Between 1869 and 1918 Frances had thirteen pictures accepted by the Royal Academy, most reworkings in oils of Canadian subjects she had previously painted as watercolours. In 1873 Charles Mottram, who produced engravings of such popular paintings as Sir Edwin Landseer's *The Stag at Bay*, made an engraving of *Canoes ... Lake Superior*, titled *Lake Superior* and apparently it sold well although exact figures are not available. By 1874 Frances and Edward were living at 3 Upper Berkeley Street, where a daughter of Governor Dallas, whom the Hopkinses had known in

Canada, recalled birthday parties being held in Frances's large studio. She also remembered her father sitting for Mrs Hopkins in that studio for a 'large picture of canoes going down the rapids'. This was the oil version of a trip down the Lachine Rapids they had made to entertain Governor Dallas and his wife on Saturday, 25 July 1863. The large painting of *The Red River Expedition at Kakabeka Falls* (1877), which has been used to suggest that she went with the British forces, may well be a working up from watercolour sketches of the site made by Frances in 1869 with information from a photograph and written accounts. She also probably altered the composition for aesthetic reasons.

The Exhibition in the 1890s, 'Water Colours: Woods and Waterways by Mrs F. A. Hopkins at the Graves Galleries, Pall Mall[15] is of sixty-eight pictures; of these, five are of Canadian subjects while most of the rest are French—Fontainebleau, Normandy, Dieppe, Brittany, Neufchâtel, Dinant, Sark. She also displayed paintings from Belgium, Holland, *Beaconsfield Churchyard*, *Moonlight on the Thames*, *Hampstead Parish Church*, and *On Womack Water—Norfolk*. She contributed about a dozen paintings to an Exhibition of Water Colours at the Doré Gallery in 1906 under the title 'Untrodden Ways in French Fields and Forests',[16] and in 1914, in an exhibition at Walkers' Galleries,[17] in addition to sections on 'Canada in the Days of the Bark Canoe' and 'Pleasant Landscapes in France', she had a number which she had done in South Africa. Her final painting to be exhibited in the Royal Academy was *Approach to a Village in France* in 1918, the year before her death.[18]

In Frances Gerard had an example of someone who used art to record a way of life and the relationship between nature and man. Similar interests are evident in his championship of working men such as the sailor of 'The Loss of the Eurydice', his admiration for Hamo Thornycroft's *The Sower*, and his poems 'Felix Randal' and 'Harry Ploughman'. Her attention to the power of nature and sensitivity to the beauty of trees and water and colour were all things also true of Gerard. I do not think one can claim a single source of influence for these aspects of Gerard's vision but Frances did provide for him an example of them.

∼

Gerard's mother's next youngest sister, Maria, married George Giberne on 28 July 1846. George Giberne (1797–1876) had worked for the East India Company, becoming Judge in the Bombay Presidency. He married

on his retirement and the couple lived at Epsom. He was a competent painter in watercolour, who tackled landscape, city scenes, and portraits. His skies are technically his best subjects; like Gerard, he was fascinated by clouds, but his style in general is too loose to have appealed to his nephew.

However, more influential on Gerard than George's watercolours were his photographs of buildings. Some of these will be discussed in Chapter 3. Perhaps it was partly the beautiful photographs of a wooded lane at Midhurst and the ruins of Cowdray Castle taken by George and later preserved in the Hopkins family's 'Wander Book' that helped Gerard to choose Midhurst for the long vacation reading party with Garrett and Macfarlane in July 1866 that became such a significant time for him. On 17 July he noted in his Journal, 'It was this night I believe but possibly the next that I saw clearly the impossibility of staying in the Church of England, but resolved to say nothing to anyone till three months are over, that is the end of the Long, and then of course to take no step till after my Degree', resolves he was unable to keep (*J* 146).

It is not known when George Giberne became a member of the Royal Photographic Society though he was certainly listed there by 1873. By 1867 he was contributing articles advocating the Ackland Collodio-Albumen process to the Society's journal. The articles are plainly and pleasantly written. That for 1867 begins, for example, 'As I have frequently derived much useful information from many of the correspondents in *The British Journal of Photography*, I consider it partly a duty, or it may be a pleasure, to contribute to the Almanac the results of my practice, which, if not conveying anything new, may still add to the evidence already given on certain points.' Not all the contributors were so modest. The process of development he used looks to modern eyes like an alchemist's recipe:

First wash the exposed plate with alcohol and water half and half, then pour over it some rain water until it rests evenly on the plate; if this be omitted the film will either rise in blisters or split off the plate; drain and pour on a 10 × 8 plate nine drachms of a solution of carbonate ammonia two grains to the ounce of distilled water, in which add one drachm of a solution of pyrogallic acid three grains to the ounce of distilled water, and nine drops of a solution of bromide of potassium five grains to the ounce of distilled water; pour this off and on, and gradually the picture comes forward. When the details are fully out wash well and drain, and pour on the pyrogallic acid solution with fifteen or sixteen drops of a citric acid solution sixty grains to the ounce of distilled water to correct the alkaline, and afterwards add fifteen or sixteen drops of a nitrate solution sixty

grains to the ounce of distilled water; when sufficiently intense, wash and fix as usual. (p. 79)

He began to exhibit with the Society in 1870, when he entered *Rocks at Ilfracombe, Waterfall at Malham, Yorkshire, Three Views of Fountain's Abbey*, and *Glaisedale, near Whitby*. With all four items he added in brackets '(Ackland's collodio-albumen)' drawing attention to someone else whose method he was using rather than inviting credit for his artistry.

His entries for 1871 were *Looking up the Derwent, Borrowdale, Kenilworth Castle, The Celebrated Yews of Borrowdale, The Grange and Bridge, Borrowdale, View near Keswick*, and *Tintern Abbey*. The last two were praised in a review of the show as 'admirable specimens of dry-plate work'. The exhibition was extensively reviewed in the *British Journal of Photography*. The sixteenth annual show, it attracted well over five hundred entries despite competition from the International Exhibition at South Kensington which ran for longer, attracted large crowds, and demanded exclusive exposure of work. It included both amateurs like George Giberne and professionals such as the Heliotype Company, who exhibited 'Illustrations to Mr. Ruskin's Lectures on Art' and 'Reproductions of Oil-paintings'. Although most of the contributors were British and most of the landscapes of Britain, there were contributions from Lafon de Camarsac, Blanchard, by Americans, and Rejlander, Alfieri. The subjects included views of devastation caused to Paris by the Prussians, Chinese and Indian scenes, Swiss and Spanish, and a panorama of Moscow.

The six articles on the Royal Society's show reveal the intermediate position of photography at the time between art and a reproductive process like lithography. It brought into question Ruskinian advocacy of paintings that were faithful copies of scenery and was employed by some photographers as a mechanical means of reproducing the art done by others, replacing engravings and like them restricted to black and white. Like the art exhibitions at the Royal Academy, the photographs were crowded onto the walls; on the line, skied, or placed low. The same was true of the photographs in the contemporary International Exhibition which were also deliberately hung like pictures in a gallery.[19]

In addition to the landscapes such as George Giberne exhibited, there were 'genre' photographs such as Adam Diston's *A Wee Customer*, *The Smithy, An Old Bookstall*, and *The Fisherman's Home*, and picture portraits, such R. T. Crawshay's of whom the reviewer remarked, 'The

paucity of his female models ... is apparent by the fact that several have had to do duty in a multifold capacity. For instance: his *Aurora* (no. 1), *Listening* (3), *The Black Diamond* (5), *Contemplation* (11), *The First Bridesmaid* (12) and *Earth or Heaven* (19), are all represented by the same person; and so on with others. Mr Crawshay's reputation as an artist would have stood much higher had he been content to exhibit fewer pictures.'[20] The heavy retouching of portraits was criticized: 'the general public may like their portraits to have a delicate, waxy texture in the flesh—and in some cases it is certainly beautiful—but it is a power to be used with much caution.' The reviewer provocatively suggested placing a notice or distinctive mark 'so that the uninitiated might at first sight be able to discern whether any picture owed its excellence to the skill of the photographer or to that of his artistic retoucher' (pp. 552–3). A Mr W. E. Debenham exhibited six portraits which at the time were generally called 'Rembrandt' portraits, being 'in shadow'. The use of the term shows the influence that fine art exerted. The criteria by which the judgements were made were partly technical and partly those that would have been applied to paintings; for instance, statements such as 'With a few clouds Mr Ferneley's views of Melton Church would have been improved'[21] or 'He has avoided a fault which is exceedingly prominent in this exhibition, viz., sensational cloud effects. His skies are really skies.'[22]

There were, on the other hand, more utilitarian exhibits: 'The War Department of Woolwich contributes an instructive series of views of targets; guns, burst and unburst; and of Royal Artillery horse-equipment.'[23] As well as a number of reproductions of oil paintings, there were a collection of *cartes de visite*, cameo and cabinet pictures, and enamels ('by which we mean burnt-in photographs'). Julia Cameron had entered one of the latter, with 'an intimation ... that it was burnt-in in Germany'. The reviewer reported that 'to us it appeared that the picture was not burnt-in at all, and this suspicion was afterwards confirmed when we saw that some inquisitive spectator, who had apparently entertained a similar opinion, had removed his doubts by the very rough, although satisfactory, test of scratching with a knife one end of the picture which was exposed, the picture being thus scraped off the plate of opal glass on which it had been printed'.[24]

In 1872 George Giberne exhibited *The Bathing Cove, Ilfracombe, Lyn-mouth*, and two of *Fountain Abbey*. The following year, the last in which he is listed as participating, he showed *Whitby Harbour, Borrowdale, The old Foot-bridge, Haddon Hall, Tintern Abbey, Hustmonceux Castle*, and *Near Whitby*. Whitby was a favourite place for Hopkins family

holidays in the 1870s and Arthur filled several sketchbooks with beautiful drawings there. In the catalogue Giberne's photographs of Tintern and Hustmonceux Castle follow G. Buxton's Swiss scenes, which in turn follow Julia Cameron's *The Stray Cupid*, *The Childhood of Endymion*, and *Gretchen*. It is clear from the entries that George did not think of himself as primarily a photographer of architecture, although Gerard's use of his architectural photographs has emphasized that element of his work. Nor did he display at the exhibitions what are now the most famous examples of his art, his photographs of various members of the Hopkins family. With exposures of probably well over twenty minutes given the lighting conditions inside, it is scarcely surprising that Victorians appear a grim lot.

Humphry House notes that the Hopkins family possessed an album of letters and *carte de visite* photographs of famous men including Bishop Samuel Wilberforce, Cardinal Wiseman, Newman, Max Müller, with whom Manley discussed Hawaiian dialect, Keble, and Froude. In another album they had photographs of composers: Mozart, Handel, Bach, Gluck, Haydn, Beethoven, Schubert, Cherubini, Weber, Chopin, Mendelssohn-Bartholdy, Meyerbeer, Hérold, Verdi, Gounod, Wagner, and Anton Rubinstein.[25] When Hopkins went up to Oxford he took with him to decorate his room a 'coloured sketch by Clara Lane' and 'portraits of Raphael, Tennyson, Shelley, Keats, Shakespere—Milton, Dante, Albrecht Dürer' (*J* 9). The list is probably not so much a collection of those poets and artists he considered the greatest but a compromise between those he esteemed and those whose 'likenesses' he could obtain. It was a signal to his visitors of his interests and aspirations. He forgot and asked his mother to send him if possible his book of engraved reproductions of the Raphael cartoons housed in the South Kensington Museum. (Among the museum's collection of early photographs are some remarkable ones of the enormous task of transferring the cartoons in their protective crates from Hampton Court to the museum on horse-drawn carts in 1865.) Hopkins received as presents a photographic reproduction of Millais's *Huguenots* from his mother and one of the panel of the birth of Eve from Ghiberti's doors to the Florence Baptistry. He lamented losing the former and tearing the latter. Between 1859 and 1863 the South Kensington Museum sold nearly 36,000 photographic reproductions of works of art, almost at cost. The demand became so large that the enterprise had to be dropped, to the relief of commercial photographers, who had been highly critical of the competition. The museum made extensive use

of photographs for managing its collections, for research, and for education. The South Kensington Museum, 'intended as the showcase of the Department of Science and Art'[26] was also the home of the Schools of Art and had a Circulation Collection of two- and three-dimensional reproductions of works of art that were loaned to various provincial art schools. Photographs were an important part of this collection. The Department of Science and Art selected in the 1860s and 1870s one of the art unions, the Arundel Society, to reproduce its photographic series 'Examples of Art Workmanship of Various Ages'. The Arundel Society had a room in the South Kensington Museum in which it displayed and sold its products. We know that Hopkins used these on at least two occasions. In June 1864 he wrote in his Journal, 'Note. Curious instance of early application of local colour. In Byzantine-school casket of ivory (preserved in cathedral of Sens, a facsimile of which is in possession of Arundel Society) has a representation of Joseph in Egyptian dress, headdress in particular' (*J* 27). Within a couple of weeks he was experimenting with his dramatic monologue 'The Soliloquy of One of the Spies Left in the Wilderness', a poetic example of local colour.

The second occasion on which we can deduce that he used the Arundel prints was in September 1873, when he mentions both the 'Standard portfolios of Indian architecture' by Samuel Fergusson and 'Michael Angelo's paintings at the Vatican' (*J* 237). Of the latter he wrote, 'the might, with which I was more deeply struck than ever before, though this was in the dark side courts and I could not see well, seems to come not merely from the simplifying and then amplifying or emphasising of parts but from a masterly realism in the simplification, both these things: there is the simplifying and strong emphasising of anatomy in Rubens, the emphasising and great simplifying in Raphael for instance, and on the other hand the realism in Velasquez, but here force came together from both sides.' This analysis helps to explain his otherwise obscure comment on the 'hammer realism' of Michelangelo's *Entombment*, which he saw for the first time in February 1874, and which, partly because it is incomplete, is simpler than it might have become and has the same large, anatomically realistic figures as those in the Vatican.

The Hopkins family had two 'Wander Books', one started in 1859 and a second in 1874. These are interesting indicators of the family's tastes. Clara Lane's illustrations to Mrs Alfred Gaty's *Aunt Judy's Tales* (1859) are included, as are photographs of Lichfield, the photos of Midhurst by George Giberne already mentioned, and various photographs that were

evidently purchased on holidays abroad. Manley's journal of a visit to
France in September 1875 makes cross-reference to a 'Wander-book' for
the relevant photos. There are photos of olive tree palms at Monte Carlo,
brick archways on the Riviera, Arabs on the Island of Ste Marguérite
Cannes, but also of a storks' nest on a chimney top at Baden-Baden,
excellent Defregger Tyrolean scenes of picturesque Swiss peasants at
home, women displaying the costume of Arles and Madeira, one of a
naked baby titled 'Pocket Hercules'. These photographs produced for
tourists are symptomatic of middle-class continental travel in its rapid
evolution during the nineteenth century. The Hopkinses purchased too
reproductions of Correggio's *The Reading Magdalen*, paintings of the
virgin and child by Murillo and Carlo Dolce, Vandyke—cavalier on
horseback with hat and whip and dog (Genoa), Vandyke of a woman in
a rich robe with gold thread edging and a parrot on chair (Genoa).

One important part of the change from Grand Tourism to tourism
was an alteration in attitudes to the picturesque. This is evident in a
passage in Manley's journal of his visit in 1875 to Polignac. He writes:

Lovers of Mediaeval architecture and of the aesthetic in Art; travellers tinged
with sentiment for Ages bathed in the purpling atmosphere of the past, are
moved at the sight of desolated *Polignac*, and of the stern fragments of ancient
castles scattered everywhere, ruined chiefly by the hand of man. They regret
bitterly the destruction which has lost to our age many great and fair houses,
instances of the architecture of ages full of poetry and the sense of beauty;
in whatsoever else those centuries may have been wanting. But the lover of
liberty and of his race rejoices with his heart of hearts at the overthrow of these
fortresses of tyranny, these menaces to human freedom. He breathes with full
inspirations among these relics, whose beauty remains whilst their dark power
has departed. He thanks God that the open sky smiles down where scenes
of cruelty were enacted in deep secret chambers. He loves to hear the breeze
blow at its will among walls where once human wills were crushed by force,
and yells of agony from the tortured were smothered in vaults of massy stone.
These subterranean prisons now lie exposed, and attract our curiosity or our
admiration. Their power is gone.
 The destroyer of picturesque buildings, like the iconoclast, is not a favourite
character in history: Nevertheless, there is an interest in the well-being of
our race higher than the mere interest in art and beautiful outline; an
interest in human liberty, against which these castles, now in ruins, waged
war.[27]

The paragraph that follows suggests what he might have liked to paint
had time permitted:

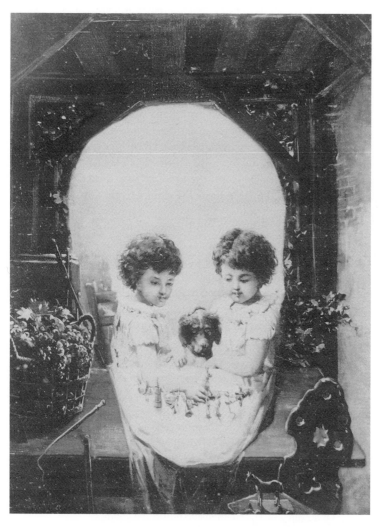

4. Compositional photographic pun *(Boston College)*

The view from the Chateau is magnificent. The valley of the Loire, with its *puys* and domes forms the middle distance, enclosed on every side by bounding mountain chains; while scattered over the sides of the wide valley are the white houses and chalets of vine-cultivators and herdsmen.

There was in the album also an extraordinary composition photograph that from a distance looks like a skull but from close to is the picture of two beautiful young children with dark curly hair, a boy and girl, perhaps twins, looking through an extraordinary shaped window into a room from which the photograph has been taken. The girl pets a spaniel, the boy looks at a toy rabbit with which he is playing. The heads of the children and their pet form the eye and nose sockets of the skull; toys on a cloth on the table form the skull's teeth. On the table is a basket piled high with grapes. The skull is a traditional memento mori, the basket of grapes could refer to Revelation in which the people are trodden as grapes or to communion with its promise of eternal life. It is possible that Gerard knew the photo and that its Christian imagery combined in his mind with the portrait of the Irish children who were the immediate inspiration for his poem 'On the Portrait of Two Beautiful Young People'. If so, it helps to explain the surface celebration of the two children with the latent awareness of mortality and corruption that gives the poem its particular tone:

> O I admire and sorrow! The heart's eye grieves
> Discovering you, dark tramplers, tyrant years.
> A juice rides rich through bluebells, in vine leaves,
> And beauty's dearest veriest vein is tears.
>
> Happy the father, mother of these! Too fast:
> Not that, but thus far, all with frailty, blest
> In one fair fall; but, for time's aftercast,
> Creatures all heft, hope, hazard, interest.
>
>
> But ah, bright forelock, cluster that you are
> Of favoured make and mind and health and youth,
> Where lies your landmark, seamark, or soul's star?
> There's none but truth can stead you. Christ is truth.
>
>
> Worst will the best. What worm was here, we cry,
> To have havoc-pocked so, see, the hung-heavenward boughs?
>
> Enough: corruption was the world's first woe.

A draft shows that 'bluebells' was once 'violets', both were flowers that Hopkins associated with Christ, writing that by the bluebell he knew

the 'beauty of our lord' and that his religious life, though hard, was like 'violets knee-deep' (10 Apr. 1871, *J* 199, *LIII* 235).

When in 1884 'a dear old French Father, very clever and learned and a great photographer' (*LIII* 165) wanted Gerard to take up photography with him Gerard would have had anecdotes from his childhood of interest to someone working in that area in the 1880s, by which time methods had moved on a long way from his uncle's experience, though the quality of many nineteenth-century photographs is not to be sneered at. He had had unusual contact with one of the most revolutionary branches of art of the century.

∽

George's sister, Maria Rosina, also painted and drew. There is a painting by her of the Newman family and a self-portrait in her niece Isabel Giberne Sieveking's biography of Francis W. Newman. They are competent, lady's art but not in the same class as work by the other family artists. Maria was devoted to John Henry Newman and loved by Francis Newman, who twice asked her to marry him. As a young woman she was striking. She became a Catholic nun, Sister Maria Pia, and spent twenty years in Rome studying art and copying pictures for the use of English chapels.[28] There is a photograph of her and a portrait by her of Cardinal Newman in the archives of the National Portrait Gallery. It has been suggested that she may have influenced Gerard's Catholic leanings; certainly her friendship with and devotion to John Henry Newman would have interested him greatly. Her early drawing style would not have influenced him, though what she did after her years of training I do not know.

The same is not true of George Giberne's wife, Maria, for whom there is convincing evidence that she helped Gerard with his drawing in the 1850s. There are extant a number of her sketches of trees at Epsom and some done while she was staying at Hampstead in June 1863, when Gerard wrote from Oxford enquiring whether she was still there. One of her drawings done 'from my window' at Hampstead shows that from the house it was possible to see a considerable distance over the tall trees to fields and beyond them to London. Maria made sketches of some of the beautiful old trees in the garden at Hampstead; elms, oak, and an ash. They are good drawings and show that she passed on two techniques to Gerard. She outlines the overall shape of the tree's foliage and she used white paper very well to show the shape of clusters of leaves. This he was to take further. It seems possible that Gerard studied photographs of scenery very closely. This might have taught him the importance of

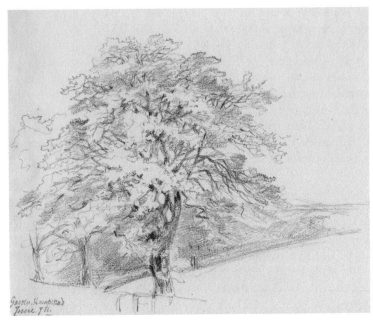

5. Maria Giberne, *Garden, Hampstead / June 8th (Harry Ransom Center)*

the white areas in indicating shape. As in early photographs he carries the stark tonal contrast so far that the pattern of light and dark becomes prominent. Like Gerard, Maria responds to sinuous tree trunks and graceful branches. She is much less interested in how the trees grow out of the ground and in some of the larger sketches made at Epsom the 'engineering' of the foreground tree is unconvincing. Where her style deviates from his is in her casual filling in of the background. She simply crosshatches or shades it whereas he more rigorously patterns the different shapes of all he includes in his drawing or simply leaves the page incomplete. This tends to flatten the perspective except where the composition has obvious depth but it also adds great energy to his drawings and a very strong sense of the individuality of all that he includes. It is inscape in practice, felt and used in his drawings before he included the term in his notes. It also privileges line over tonal spaces, a preference that he shows too in preferring polyphonic over harmonic music. Indeed it may be that in his famous drawing of *Shanklin, Isle of Wight 1866* (which he had photographically reproduced for his family in 1886) that we can deduce what he had in mind in the accompanying comment, 'the

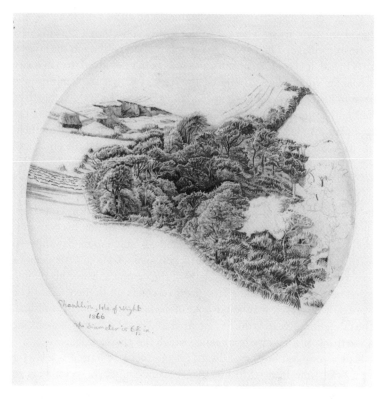

6. Gerard Manley Hopkins, *Shanklin, Isle of Wight 1866 (The Bodleian)*

drawing appears to me unique in its kind'.[29] One of the striking things
about the drawing is the tension between pattern in the middle ground
that tends to flatten the composition although it retains the individual
identity of each of the trees there and the great depth suggested by the
background cliffs. The interplay between pattern and conveying recog-
nizable physical reality is characteristic of the poems. It was evident to
Gerard in his statement to Bridges that 'as air, melody, is what strikes
me most of all in music and design in painting, so design, pattern or
what I am in the habit of calling "inscape" is what I above all aim at in
poetry. Now it is the virtue of design, pattern, or inscape to be distinctive
and it is the vice of distinctiveness to become queer. This vice I cannot
have escaped' (15 Feb. 1879, *LI* 66). It may be that critics' emphasis
upon inscape as the defining essence of a thing has underestimated the
importance in Hopkins's concept of the artistic value of pattern.

Maria's closest sister in age was Matilda, known as Tilly. She too was a good amateur artist. There is in the family collection a drawing of a Germanic village. The perspective is complex and although the style is fairly broad, it is competent and gouache is better deployed than in many of Manley's paintings. A note on the back says that the painting was given to Kate in 1839. Tilly married James Birkett. Laura, the fourth of the Smith sisters, wrote several letters to Kate, decorating the top of the page with ink sketches of flowers or leaves, occasionally touching them in with colour or gold paint. Doubtless Kate appreciated the effort and Gerard may have liked the idea too since he decorated a number of his letters to his siblings. Laura's drawings are not as skilful or as imaginative as Gerard's. For example, at the top of one letter to Arthur is a drawing of the devil felled by a puck-like gnome who sits on the devil and eats from a bowl. The felled demon lies, with his gown awry so that his bottom is bare—shades of birching?—and his hands, which end in claws, flexed in frustration but his face is curiously resigned. A file of little demons perched in a cloud—a thought-cloud of the demon's, hence his remote expression?—weep, holding large handkerchiefs up to their faces. The expressions are all clear although none of the faces is particularly finished. The salutation, 'Dear Arthur' is incorporated in the drawing as a carving in the trunk of a massive tree against which the gnome leans.

Kate's youngest brother, Edward (1833–1900), practised as a lawyer for a brief time from 1859 but then became an artist, specializing in watercolour. He spent much of his time in Capri and Rome, occasionally exhibiting paintings in London. Eleven years older than Gerard, he was already working as an artist when in 1868 he entertained Gerard at his Club, the United University in Pall Mall East (*J* 159, 380).

～

Richard James Lane (1800–72) was Gerard's great-uncle. Lane was apprenticed at the age of 16 to Heath, a line-engraver and, despite the encouragement of Sir Thomas Lawrence, declined to move to oil. It was an engraving of Lawrence's Little Red Riding Hood which, alone, ensured Lane the position of associate engraver to the Royal Academy. Lane discovered lithography, the art of drawing onto stone, in 1824, when the technique was in its infancy. Despite the difficulty of producing crisp drawings, Lane adopted the method, partly because of its comparative ease and speed. Lithography does not require any lines to be incised but relies on the repellent relation of grease and water. A design is drawn on prepared limestone, which is then wetted. Ink smeared over the

surface adheres to the drawing and is repelled by the damp limestone. The process was used for coloured illustrations where the difficulty lay in repositioning the paper accurately for each colour. In 1829 Lane produced a drawing of Victoria, then a princess aged 10. It was to be the first of many drawings he did of the royal family resulting in his appointment as lithographer to Queen Victoria in 1837 and to the Prince Consort three years later. Lane was friendly with various actors. In 1844 he lent Charles Kemble his copy of Hartman's quarto of Shakespeare's plays in preparation for the actor's royal and then public readings of cut versions of the plays designed to be completed within three hours. In 1855 Kemble wanted to make a book for schools and family readings from his performances and Lane edited it, incorporating Kemble's stresses from the actor's preparatory marking up of the text and from his own attentive listening to the performance. Lane also wrote two books: *Life at a Water-Cure*, an account of his experience at Malvern in the company of his beloved 16-year-old son in 1846, when years of overwork had undermined his constitution, and *Spirits and Water*, a collection of short stories, a number of them with autobiographical substance, such as the account of a walking tour in Wales with Ned in the year before his teenage son's death. Lane's writing reads easily, revealing the influence of the Dickens of *Pickwick Papers* to whom the former is dedicated, and suggesting the tolerant, modest personality praised in obituaries and the diaries of Queen Victoria. Lane prefaced the third edition of a *Month at Malvern* with the note, 'The appearance of this Edition is a result, rather of generous consideration and friendship on the part of the Publisher, than of any extraordinary demand on the part of a discerning Public'. It would seem to be a characteristic statement. Lane was clearly a family man, forming close bonds with his children, especially Ned, and Clara, who was four years Ned's senior. A photograph of Lane with Clara when she was an adult, their arms entwined, shows the affectionate understanding between father and daughter. Clara became an artist, exhibiting with the Society of Female Artists and in the late 1850s at the Royal Academy. She illustrated Margaret Gatty's *Aunt Judy's Tales* in a style that is expressive, reminiscent of Phiz in its favouring of expression over realistic detail. She also did the wood engraving of a 'Cascade in the Waialua Valley' drawn by W. J. Linton for the title page of Manley Hopkins's *Hawaii: The Past, Present, and Future of its Island-Kingdom* (1862).[30] Portraits in the book of King Kamehameha IV and Queen Emma were lithographed by Richard James Lane from Daguerreotypes. It was with Clara or her two sisters, Laura and Emily, that Gerard

proposed to 'do the pictures in the Exhibition' in 1862. In 1850 she produced a drawing, now in the National Portrait Gallery, of her uncle Edward Lane, the famous Arabic scholar characteristically at work at his desk on the Arab lexicon. Richard Lane's mother was widowed when Richard was 14 and supported her four children by running a small school for girls. She was Gainsborough's niece and executor of his daughter Margaret's will. One of Lane's early projects was the making of a superb collection of lithographs of Gainsborough's sketches inherited by his friend Henry Briggs called *Studies of Figures*. Lane owned a number of Gainsborough's paintings, some of which he sold at a Christie's auction, along with the originals of his lithographs, in 1831. Near the end of his life, he was to inherit several more of Gainsborough's paintings and seven of these he instructed his daughters to bequeath to the nation, which they did in 1896; five of these are now in the Tate, two in the National Portrait Gallery. Hopkins would consequently have seen original Gainsboroughs in the Lanes' house at a time when there were few on view in the National Gallery and he very probably knew something more of Gainsborough's work through his uncle's lithographs. From 1864 Lane was director of the etching class in the science and art department at South Kensington and in 1871 he completed his thousandth lithograph, sixty-seven of which were exhibited at the Royal Academy. His subjects included Dickens, Paganini, Florence Nightingale, Jenny Lind, many members of the German and English royal families, numerous actors or actresses, in lithographs printed by J. Graf and published by John Mitchell or Colnaghi and Puckle. Some of the lithographs were his own portraits, others were copies of paintings by Winterhalter, Eden Upton Eddis, Landseer, Chalon, and Lesley, among others. Clearly a large part of Lane's business was in response to the contemporary craving for reproductions of popular celebrities that is evident in the Hopkins family's photograph album and in Gerard's selection from it for his room at Oxford. This work, as well as his membership of the Royal Academy brought Lane into contact with many of the artists of the day. Among his friends were Frederic Burton, the Eastlakes, Eden Upton Eddis, Macready, and Millais. On paper with a watermark of 1861 Millais wrote thanking Lane for a favour. In a second letter, he writes, 'Dear Lane, I'm a brute I know to call upon your society in the middle of your after dinner nap but I am a brute in pain, with a thorn in my paw ?(pawfelcer), take no notice of this—so come like a good Christian and lighten the burden of my song of agony—Just a little consolation to say happy is the man who has his

garner full etc, or large families always succeed and their parents prosper etc etc Yours JEM'. So if Hopkins did not meet Millais at the Lanes' he could have heard him talked about by friends. Clara was the model for the nun in Millais's *Vale of Rest*. Holman Hunt was a guest of the Lanes at a party on 4 July 1865. Hunt's letter of acceptance, which is in the National Portrait Gallery, suggests that Hunt knew the Lanes, but not well. Lane was also friendly with Edwin Landseer. In fact it may have been Lane who encouraged Landseer to have the famous photograph taken of him by Watkins, which he was to make such strenuous efforts to suppress. Lane wrote in 1853/4 to Landseer suggesting that he have a photograph taken from which to paint a self-portrait; the composition of the photograph, with Landseer holding a sketching board and looking fixedly at the viewer, is suggestive of material for a self-portrait. Lane also tried to persuade Sir Edwin to give fair acknowledgement of another lithographer, J. W. Giles's, contribution to a publication of Landseer's work. The Old Master's exhibition that Hopkins went to see in 1873 was a memorial show devoted to Landseer's paintings.

It may have been from Lane that Hopkins gathered some of the reservation about Ruskin as a critic which he expressed to Baillie in 1863 (6 Sept., *LIII* 203–5). In a verse account of the private view of the Royal Academy of 1855 Lane wrote of 'Buskin',

> Hereafter, " 'twill be known, when I
> Attack a picture, policy
> Should teach the Artist and his friends,
> That the weak creature who defends
> That work, but seals the painter's fate,
> And then discovers, all too late,
> How others rose, and how I licked 'em,
> For daring to dispute my dictum."
> "hereafter!" quota; Shall such stuff
> E'er find a future? Nonsense—Puff[31]
>
>
>
> When he lately trimmed his burner,
> He put forth a plea,
> That if Nature's not like TURNER,
> Nature *ought to be*;[32]

The same piece expresses slight disdain for Frederic Leighton, then a new exhibitor, and a dislike of the Pre-Raphaelites. Both probably met with a more favourable response in later years. Lane died in 1872 of a heart attack brought on by trying to stop a man beating a dog.

Honourable, a gentleman, his 'powers of recitation and marvellous memory, and his fine tenor voice'[33]—these were the personal qualities that obituaries mention. Lane was also praised for the 'delicacy and tenderness of touch' of his pencil sketches. While there is no evidence that he taught Gerard, Arthur, or Kate, the same qualities are true of the drawing done by all three.

2

Hopkins's Drawings

We have very few sketches or paintings of Gerard's before 1862. What is extant is *Gerard's Christmas box to Aunt Annie 1853*, a page of 'impromptus' of 1854 consisting of a butterfly on a plant, a talkative parrot, a mouse, and a rabbit nibbling a carrot while keeping a wary eye on its observer. From 1857 there is more formal work: a warrior from the British Museum in watercolour (dated 1857), a fountain with birds, watercolour 1857, and from 1858 a garnet Humming Bird (dated Nov. 1858) and a pencil drawing of *The Staircase at Edenbridge*.

Gerard's Christmas box to Aunt Annie 1853 covers both sides of a double sheet of cream paper. It comprises a number of maps of various areas of the world, enclosed in boxes. There are drawings of finds from Herculaneum and Pompeii: bangles, robes, and ruined columns or gates. There are also three humorous drawings, one of a lion mincing along, another of a goddess placing a wreath on a man sprawled across a rock, and a third of a duel between a small man wielding a sword and a large, sword-carrying skeleton, who wears a bearskin and has the hind legs of a bear. They are competent drawings for a 9-year-old and were probably designed to give Aunt Annie pleasure from the progress of her pupil.

Gerard was also experimenting with watercolour in the 1850s. The warrior has the stiffness that marks it as being drawn from a statue or copied from a book illustration of a statue rather than being an imaginative incarnation of a live warrior. The chosen viewpoint places the viewer low so that he looks up to the impassive face, which seems to have its eyes hooded, almost closed, the left arm is raised so that if it held a javelin, it would point just to the right of the viewer. The shield is held against the left shoulder so that it could be moved into a position of self-defence. The whole study is painted in shades of brown, with

touches of gold on the helmet and a guard that protects the right hand. There is an impression of threat created by the low viewpoint and the inscrutable readiness suggested by the position of the figure. It may well have been done as part of Gerard's school study of the classical world: the style is imitative of textbook illustration, with clear detailing of the armour rather than liveliness as the prime aim.

The painting of the birds around the fountain, on the other hand, has a marked aesthetic rhythm to it with the birds so positioned as to leave room for a jet of water to ascend in their midst. The birds as well as the birdbath are painted green, suggesting that they are bronze rather than meant to be realistic. The composition is reminiscent of the famous mosaic of Doves by Sosus in the Capitoline Museum (Rome).

The garnet humming bird looks as if, like the warrior, it is a drawing that deliberately displays characteristics rather than being imagined as real. It seems to have been copied from a stuffed bird arranged to show off its colours as it would in a courtship display. And Hopkins is sufficiently accurate in this as in all three watercolours to leave no ambiguity as to the 'educational' nature of his source. It might well have been the brilliant colours and sheeny softness of the bird as well as its tiny size that attracted him. He was gentle, and responsive to smooth, soft, as well as to shiny surfaces; years later at Stonyhurst, in 1872, he recorded in his journal, 'A goldencrested wren had got into my room at night and circled round dazzled by the gaslight on the white cieling [*sic*]; when caught even and put out it would come in again. Ruffling the crest which is mounted over the crown and eyes like beetlebrows, I smoothed and fingered the little orange and yellow feathers which are hidden in it' (5 Oct. 1872, *J*227). The shiny flanks of horses were caught as the 'stallion stalwart, very violet sweet' of 'Hurrahing in Harvest' and the opalescent colour of a peacock's tail in the fragment:

> Mark you how the peacock's eye
> Winks away its ring of green,
> Barter'd for an azure dye,
> And the piece that's like a bean,
> The pupil, plays its liquid jet
> To win a look of violet.

The staircase at Edenbridge shows that the source of interest here was the substantial carved banister. The frame of the sketch is unfinished: the foreground is difficult to interpret but looks as if a large cloth/sheet has been left rumpled across the floor. There is a tension between the

barrier of the lumped cloth and the invitation to explore up the ascending stairs, the corner of a picture seen on the back wall of the staircase in the upper right of the framing doorway suggesting interesting things to see.

What is clear in all these early pieces is that they are far from Gerard's first attempts. His next group of extant drawings are in the first of four sketchbooks and date from March 1862 and again, there is clearly a great deal of material (between the 1858 drawing and those of 1862) that is missing. The sketch of *North Road, Highgate, March 12th, 1862* has been done with a pencil held for drawing, not writing. The strokes are confident, the grasp of perspective sure, the buildings recede convincingly and are set firmly on the ground. The composition is good with the foreground detail unambiguous, even that of the fence in front of the hedge is clear and the receding plane of the hedge linking the foreground and background has been caught despite the difficulty of the slope of the fence that provides the foreground interest. The semicircular line that frames the lower part of the drawing suggests the influence of journals rather than fine art. A sketch of celandine made at Hampstead the same year also suggests that Hopkins was receiving instruction. For these he probably had two teachers: Maria Giberne, whose assistance is described in Chapter 1, and John Ruskin, most probably in his *Elements of Drawing*, published in 1857.[1]

Whatever his uncle's reservations about Ruskin, Gerard would seem to have been following his advice at least by 1862. Ruskin began his *Elements of Drawing* with criticism of contemporary drawing manuals for the tricks and systems they gave their pupils to achieve either apparently sophisticated drawings with little observation of what they were trying to capture or to inculcate accurate reproduction of mathematical forms necessary for the carrying out of rapid and cheap manufacturing designs. He had been given similar tricks by his first drawing master, Runciman, and describes in *Praeterita* the occasion in 1842 on which along a sandy road near Fontainebleau he first found it more satisfying to draw directly from nature:

Lying on the bank of a cart-road in the sand, with no prospect whatever but [a] small aspen tree against the blue sky … Languidly, but not idly, I began to draw it; and as I drew, the languor passed away: the beautiful lines insisted on being traced,—without weariness. More and more beautiful they became, as each rose out of the rest, and took its place in the air. With wonder increasing every instant, I saw that they 'composed' themselves, by finer laws than any known of men. At last, the tree was there, and everything that I had thought before about trees, nowhere.[2]

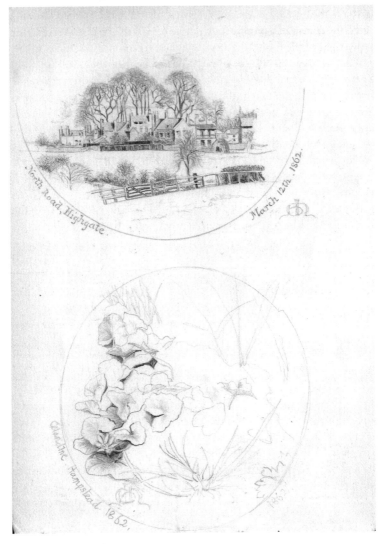

7. Gerard Manley Hopkins, *North Road, Highgate. March 12th. 1862*

8. Gerard Manley Hopkins, *Celandine. Hampstead. 1862*
(both Balliol College)

He had consequently advocated in the first volume of *Modern Painters* that all landscape artists should 'go to Nature in all singleness of heart, and walk with her laboriously and trustingly, having no other thoughts but how best to penetrate her meaning, and remembering her instruction; rejecting nothing, selecting nothing, and scorning nothing; believing all things to be right and good, and rejoicing always in the truth' (iii. 624). One way in which we can place Ruskin's statement is by considering the division of drawings in the eighteenth and nineteenth centuries. For professional artists, drawings were not generally financially rewarding and were usually the first stage in the process of producing an oil painting. Watercolour often either replaced the initial sketch or was added early on in the process. A few hasty sketches setting out the main masses were done at the scene and the detail of foliage added in the studio. Gainsborough, for example, often worked in this way. However, in addition to artists producing saleable pictures, there were the topo-graphical artists. Topographical work was considered an inferior branch of the artistic profession because it involved less imagination. However, many artists did some topographical work in order to earn enough to live on — Turner, for example, did a lot. The topographical work frequently involved the drawing of buildings and these had to be done with enough attention to detail to be convincing representations of place. The effect of what Ruskin advised was to give nature similar attention; it was a significant contribution to the development of British art.

Since Gerard's ultimate destiny was as a writer rather than an artist, it is perhaps not simply coincidental that he should admire someone who set out as his aim, 'I would rather teach drawing that my pupils may learn to love Nature, than teach the looking at Nature that they may learn to draw' (*Elements*, 14). In 1862 and 1863 Hopkins seems to have been earnestly practising the exercises that Ruskin set in the three letters that compose the book. His sketches of nature at this time — the architectural drawings have different masters — are seldom complete; he seems to run out of energy or patience, perhaps adhering to Ruskin's advice, 'always remember that a little bit perfected is worth more than many scrawls' (p. 63) and 'the real difficulty and masterliness is in never letting the hand *be* free, but keeping it under entire control at every part of the line ... It is not required of your drawing that it should be free, but that it should be right; in time you will be able to do right easily, but then your work will be free in the best sense' (p. 16). Hopkins's drawings of the 1860s are not free, the product of a sharp pencil and considerable

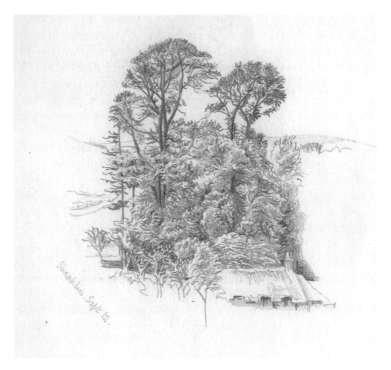

9. Gerard Manley Hopkins, *Shanklin. Sept. 12* (1863) *(Boston College)*

care, they are very detailed and subtle. Ruskin urged: 'all great art ... is delicate art. Coarse art is always bad art' (p. 27).

The majority of the subjects found in Hopkins's Sketchbook A, covering the period from 12 March 1862 to 8 August 1863, could loosely be described in the words of Ruskin's list of the best subjects with which to begin: 'in woods, one or two trunks, with flowery ground below, are at once the richest and easiest kind of study, a not very thick trunk, say nine inches or a foot in diameter, with ivy running up it sparingly, is an easy, and always rewarding subject ... large nests of buildings in the middle distance are always beautiful ... Any old English village, or cluster of farm-houses' (p. 154), and the caution to 'make intimate friends with all the brooks in your neighbourhood, and study them ripple by ripple' (p. 154). Hopkins has, for example, the sketch of a rock titled *Longstone, Mottistone, July 23, 1863*, which could in its careful shading and attention to line be a response to Ruskin's command;

'Be resolved, in the first place, to draw a piece of round rock, with its variegated lichens quite rightly, getting its complete roundings, and all the patterns of the lichen in true local colour. Till you can do this it is of no use your thinking of sketching among hills; but when once you have done this the forms of distant hills will be comparatively easy' (p. 82). In his drawing, *Shanklin. Sept. 12* (1863), Hopkins seems to follow Ruskin's advice that 'the forms of distant trees in groups are defined, for the most part, by the light edge of the rounded mass of the nearer one being shown against the darker part of the round mass of a more distant one' (p. 110). Hopkins makes a number of studies of groups of leaves, something Ruskin advises as 'careful studies of ... one bough of every common tree' (p. 85) though he did not do as many as Ruskin recommended. He did however, pay attention to one natural shape after another as is explicit in his enthusiastic statement to Baillie, 'I think I have told you that I have particular periods of admiration for particular things in Nature; for a certain time I am astonished at the beauty of a tree, shape, effect etc, then when the passion, so to speak, has subsided, it is consigned to my treasury of explored beauty, and acknowledged with admiration and interest ever after, while something new takes its place in my enthusiasm. The present fury is the ash, and perhaps barley and two shapes of growth in leaves and one in tree boughs and also a conformation of fine-weather cloud' (13 July 1963, *LIII* 202). He gave similar attention to oaks and elms. The comparisons that Norman White displays in his article 'The Context of Hopkins' Drawings' in *All My Eyes See* between Hopkins's detailed sketches of leaves or groups of trees and those by such artists as Gainsborough, Millais, and Ruskin by no means make clear that Hopkins could not have proceeded to a career as an artist had he persevered.[3]

There are other sketches, of skies, in Hopkins's diaries in which the following admonishment seems to have been influential: 'though you cannot produce finished colour drawings of any value, you may give yourself much pleasure, and be of great use to other people, by occasionally sketching with a view to colour only; and preserving distinct statements of certain colour facts—as that the harvest moon at rising was of such and such a red, and surrounded by clouds of such and such a rosy grey; that the mountains of evening were in truth so deep in purple; and the waves by the boat's side were indeed of that incredible green' (p. 196). Though not reproduced here, Hopkins does have a drawing of a sunset in which he notes the different shades of green, blue, purple, and gold in the sky and clouds (Coast-scene, *J*, pl. 16, 1863). Such

standard practice by artists can be seen in Arthur's later sketchbooks once he made art his profession in the 1870s. Ruskin relates the accuracy of perceiving colour to the problem of depicting depth by observing that 'a highly accomplished artist has always reduced himself as nearly as possible to [the] condition of infantine sight. He sees the colours of nature exactly as they are, and therefore perceives at once in the sunlit grass the precise relation between the two colours that form its shade and light. To him it does not seem shade and light, but bluish green barred with gold' (pp. 18–19). Hopkins certainly possessed the acute and intensely appreciative sense of colour that Ruskin saw as necessary for an artist. He told Dixon that he remembered 'that crimson and pure blues seemed to me spiritual and heavenly sights fit to draw tears once' (22 Dec. 1880, *LII* 38), though his religious associations with the colours were clearly important here. Ruskin had remarked in the *Elements*, 'You *ought* to love colour, and to think nothing quite beautiful or perfect without it; and if you really do love it, for its own sake, and are not merely desirous to colour because you think painting a finer thing than drawing, there is some chance you may colour well' (Letter III, opening paragraph). Ruskin's influence on the following description by Hopkins is clear in its analysis of the actual colours of something under a variety of conditions:

Aug 24 1867 Bright.—In the middle of, I think, this day Lionel had a piece of sky-blue gauze for butterfly-nets lying on the grass in the garden. It was a graceful mixture of square folds and winding tube-folds. But the point was the colour as seen by sunlight in a transparent material. The folds, which of course doubled the stuff, were on the sun's side bright light blue and on the other deep blue—*not shadow-modified*, but real blue, as in tapestries and some paintings. Then the shadowed sides had cobweb-streaks of paler colour across, and in other parts became transparent and shewed the grass below, which was lit by the sun through the gauze (*J* 152–3)

That Hopkins was thinking about the scenes he saw in terms of painting is clear in the following entry of 10 July 1866, for example: 'Distances in shades of blue but quite without haze. So too trees at some distance pale and almost colourless in the glare, yet distinct. The wheat-fields blue underneath but now warm green in the ear' (*J* 144). This is the beginning of painterly observation, aware of differences but not yet able to specify which colours are to be used. Take too the following passage from his diary written in Switzerland: 'From the top the lake of Brienz was of the richest opaque green modulated with an emotional instress

to blue. What is likest it is turquoise discoloured by wet Richness of the greens—nearest the hollow of the Bättenalp below us, then the blue-green of the lake, then again the grass-green of the heights beyond, and to add a further note the sun coming out accented the forward brows and edges of the Bättenalp with a butter-bright lustre' (17 July 1868, *J* 176). The mention of 'turquoise discoloured by wet' opens questions as to whether he was referring to the gem—he made a point of looking at the collection in the South Kensington Museum—or whether he is speaking of paint, in which case it is possible that he produced watercolours that are unknown. In 1873 he described 'the plain about Clitheroe' as being 'sponged out by a tall white storm of rain' (*J* 236), suggesting familiarity with watercolour technique; the observations in 1868 of colour not yet made with specific colour names suggests that he might well have been able to paint. There is also a strong element of simply enjoying the colours as well as an almost sensuous feel of articulating the descriptive words: 'turquoise ... butter-bright'. Hopkins experimented with such perceptions in early poems such as 'Richard' (iv):

> There was a meadow level almost
>
>
>
> ... The grass was red
> And long, the trees were colour'd, but the o'er-head,
> Milky and dark, with an attuning stress
> Controll'd them to a grey-green temperateness,
> Making the shadow sweeter
>
> (ll. 1–15)

The problem he faced in such passages was how to give landscape descriptions significance. From personifications such as that of 'the rainbow' he moved to similes as in 'Floris in Italy' where natural observations were used, for example, 'Tighten, O sleep, | Thy impalpable oppression | Ply fold on fold across his dangerous eyes, | Lodge his eyes fast; but as easy and light | As the laid gossamers of Michaelmas | Whose silver skins lie level and thick in field' (ll. 16–21) or 'I find I am as ready with my tears | As the fine morsels of a dwindling cloud | That piece themselves into a race of drops | To spill o'er fields of lilies' (ll. 30–3), and metaphors such as in 'I am like a slip of comet' in which detailed, scientific analysis of the comet over a period of time is made a metaphor for the speaker's life and love. Once the natural features of the landscape were suffused for him with the presence of Christ the problem was largely solved. An example using blue, to

which Hopkins seems to have been especially sensitive even before the
colour became associated for him with the Virgin Mary, introduces other
aspects of colour that show an artist's analysis of which colour will be
needed in order to suggest a particular surface under certain conditions
of light: 'Putting my hand up against the sky whilst we lay on the grass I
saw more richness and beauty in the blue than I had known of before, not
brilliance but glow and colour. It was not transparent and sapphire-like
but turquoise-like, swarming and blushing round the edge of the hand
and in the pieces clipped in by the fingers, the flesh being sometimes
sunlit, sometimes glassy with reflected light, sometimes lightly shad-
owed in that violet one makes with cobalt and Indian red' (30 Aug.
1867, *J* 154). The observation was to be used in several poems on the
relationship of the Holy Family and the world: 'The glassy peartree
leaves and blooms, they brush | The descending blue; that blue is all in
a rush | With richness' from 'Spring' (ll. 6–8) where he urges Christ to
win the innocent before they can 'sour with sinning', and, from 'The
Blessed Virgin Compared to the Air we Breathe', where he compares
Mary's presence around us to the sky around a raised hand seen against
the blue sky that surrounds it without altering its colour:

> Again, look overhead
> How air is azurèd;
> O how! Nay do but stand
> Where you can lift your hand
> Skywards: rich, rich it laps
> Round the four fingergaps.

> (ll. 73–8)

Entries such as the following from 22 April 1871 show Hopkins moving
in a single passage from the storing of observations for artistic use to
the construction of description as an end in itself: 'But such a lovely
damasking in the sky as today I never felt before. The blue was charged
with simple instress, the higher, zenith sky earnest and frowning, lower
more light and sweet. High up again, breathing through woolly coats of
cloud or on the quains and branches of the flying pieces it was the true
exchange of crimson, nearer the earth/against the sun/it was turquoise,
and in the opposite south-western bay below the sun it was like clear oil
but just as full of colour, shaken over with slanted flashing "travellers",
all in flight, stepping one behind the other, their edges tossed with
bright ravelling, as if white napkins were thrown up in the sun but
not quite at the same moment so that they were all in a scale down

the air falling one after the other to the ground' (*J* 207). One might here recall not just the influence of Ruskin but also that disciplined and individual response to experience inculcated in his pupils by Walter Pater, who had tutored Hopkins in 1866. Pater insisted that 'in aesthetic criticism the first step towards seeing one's object as it really is, is to know one's own impression as it really is, to discriminate it, to realise it distinctly'. Conveying that impression in words that were both individual and convincingly the 'right' ones, was a necessary proof of the authenticity of the observation.[4] One might think of Hopkins's poem, 'What being in rank-old nature', which depicts a response to music; Norman MacKenzie suggests convincingly that it is organ music.[5]

> What being in rank-old nature should earlier have that breath been
> That here personal tells off these heart-song powerful peals?—
> A bush-browed beetle-browed billow is it?
> With a south-westerly wind blustering, with a tide rolls reels
> Of crumbling, fore-foundering, thundering all-surfy seas in; seen
> Underneath, their glassy barrel, of a fairy green.
>
> Or a jaunting vaunting vaulting assaulting trumpet telling.

The poem has similarities with 'Henry Purcell' in its emphasis on individuality expressed through music. Here the response, one of being within waves that are both overpowering and enchantingly beautiful, uses observations drawing on sight, touch, and sound to convey the psychological effect of the music. Hopkins goes beyond most painterly descriptions in his understanding of the cause of the waves, mentioning the south-westerly wind and the tide rolling in, foreshadowed by the use of 'beetle-browed', which he often uses for clouds and for the surf upon wind-tossed waves. He combines this with the Keatsian 'fairy' green, a gesturing towards something imaginary not to be as tightly tied down as the scientific observation. There is kinship too between this fragment and the two poems about wrecks in the acknowledged power of the waves. It may not be coincidental that Hopkins repeats the same inverted question in describing an emotional outburst in 'The Wreck of the Deutschland' at the thought of the tall nun's response to Christ:

> Ah, touched in your bower of bone
> Are you! turned for an exquisite smart,
> Have you! make words break from me here all alone,
> Do you!—mother of being in me, heart.
> O unteachably after evil, but uttering truth,
> Why, tears! is it? tears; such a melting, a madrigal start!

Never-eldering revel and river of youth,
What can it be, this glee? The good you have there of your own?

(st. 18)

The extent to which Hopkins mastered a knowledge of artists' colours
of the day can be seen in his letter to *Nature* of 30 October 1884, when
he comments of the sunsets:

They differ in the colours themselves, which are impure and not of the spectrum. The
first orange and the last crimson flush are perhaps pure, or nearly so, but the two
most remarkable glows, the green and the red, are not. The green is between
an apple-green or pea-green (which are pure greens) and an olive (which is a
tertiary colour): it is vivid and beautiful, but not pure. The red is very impure,
and not evenly laid on. On the 4th it appeared brown, like a strong light behind
tortoiseshell, or Derbyshire alabaster. It has been well compared to the colour of
incandescent iron. Sometimes it appears like a mixture of chalk with sand and
muddy earths. The pigments for it would be ochre and Indian red.

Now the yellows, oranges, crimsons, purples, and greens of bright sunsets are
beautifully pure. Tertiary colours may of course also be found in certain cases
and places

A bright glow had been round the sun all day and became more remarkable
towards sunset. It then had a silvery or steely look, with soft radiating streamers
and little colour; its shape was mainly elliptical, the slightly longer axis being
vertical; the size about 20° from the sun each way. There was a pale gold colour,
brightening and fading by turns for ten minutes as the sun went down. After
the sunset the horizon was, by 4.10, lined a long way by a glowing tawny light,
not very pure in colour and distinctly textured in hummocks, bodies like a shoal
of dolphins, or in what are called gadroons, or as the Japanese conventionally
represent waves. The glowing vapour above this was as yet colourless; then this
took a beautiful olive or celadon green, not so vivid as the previous day's, and
delicately fluted; the green belt was broader than the orange, and pressed down
on and contracted it. Above the green in turn appeared a red glow, broader and
burlier in make; it was softly brindled, and in the ribs or bars the colour was
rosier, in the channels where the blue of the sky shone through it was a mallow
colour. (Stonyhurst College, 21 Dec. 1883)[6]

Ruskin remarks in *The Elements of Drawing* that 'many things (sea
foam, for instance) cannot be drawn at all, only the idea of them more
or less suggested' (p. 36). Hopkins's sketched attempts at such subjects
are usually accompanied by descriptions in which he analyses the main
features, as for example, 'Lasher from a canal at Wolvercote. The water
running down the lasher violently swells in a massy wave against the
opposite bank, which, to resist its force, is defended by a piece of brick

wall. The shape of wave of course bossy, smooth and globy. Full of bubble and air, very liquid.—For the rest of the lasher, all except the shoulder where it first sweeps over it is covered with a kind of silver links. Running like a wind or element at the shoulder' (1864, *J* 19 and fig. 8). This does strive to observe 'the ruling organic law' which Ruskin called 'the first distinction between good artists and bad artists' (p. 85). In the *Elements* he urges that trees be drawn over and again in order to learn the 'vital truth, [of the] chief lines [which] are always expressive of the past history and present action of the thing ... Your dunce thinks they [all things] are standing still, and draws them all fixed; your wise man sees the change or changing in them, and draws them so—the animal in its motion, the tree in its growth, the cloud in its course, the mountain in its wearing away' (p. 70). The argument remained in Hopkins's mind. Many years later in 1888, arguing with Bridges about lines from 'St Alphonsus Rodriguez', he was to say, 'it is true continents are partly made by "trickling incre-ment"; but what is on the whole truest and most strikes us about them and mountains is that they are made what now we see them by trickling *de*crements, by detrition, weathering and the like' (*LI* 296). His drawings of trees such as *In hollow between Apse and the American Woods. Near Shanklin. August 8* (1863) and *Beech, Godshill Church behind. Fr. Apple-durcombe. July 25* (1863) or of water such as *On the Bollen, Cheshire* or *At the Baths of Rosenlaui—July 18* (1868) show movement very well. Hopkins incorporated such understanding in his ideas of inscape:

In the snow flat-topped hillocks and shoulders outlined with wavy edges, ridge below ridge, very like the grain of wood in line and in projection like relief maps. These the wind makes I think and of course drifts, which are in fact snow waves. The sharp nape of a drift is sometimes broken by slant flutes or channels. I think this must be when the wind after shaping the drift first has changed and cast waves in the body of the wave itself. All the world is full of inscape and chance left free to act falls into an order as well as purpose: looking out of my window I caught it in the random clods and broken heaps of snow made by the cast of a broom. The same of the path trenched by footsteps in ankledeep snow across the fields leading to Hodder wood through which we went to see the river. (24 Feb. 1873, *J* 230)

Four years later he defined the inscape of the windhover from its characteristic movement as much as from its physical appearance ('The Windhover', ll.3, 7, and 9).[7]

As a number of critics have noted, Hopkins seems to have kept Ruskin's various 'laws' in mind in his drawing of ash branches of July 1863, for example, where he drew faint circles that show what Ruskin in

the *Elements* calls the 'law of radiation', the circular arrangement of the leaves. But he also experimented with Ruskin's other laws. For example, his drawing of a lily, although less graceful than Arthur's made two days later when the buds had opened, shows him experimenting on the central stem with Ruskin's 'law of interchange', the way in which Nature 'will darken a tree trunk as long as it comes against light sky, and throw sunlight on it precisely at the spot where it comes against a dark hill, and similarly treat all her masses of shade and colour'. Ruskin suggested that 'the appearance of intentional artifice' with which Nature places these contrasts 'is so great, that if you only follow her closely, every one who looks at your drawing with attention will think that you have been inventing the most artificially and unnaturally delightful interchanges of shadow that could possibly be devised by human wit' (p. 148). Perhaps it was having his attention drawn to such contrasts that eventually produced the simile in 'My own heart let me more have pity on':

> [God] whose smile
> 'S not wrung, see you; unforseentimes rather—as skies
> Betweenpie mountains—lights a lovely mile.
>
> (ll. 12–14)

Ruskin's advice on the drawing of clouds stresses first their subtlety of shape and colour and the impossibility of catching their rapid changes accurately. They are 'definite and very beautiful forms of sculptured mist; sculptured is a perfectly accurate word; they are not more *drifted* into form than they are *carved* into form' (p. 97). He suggests that 'you must try ... to help what memory you have, by sketching at the utmost possible speed the whole range of the clouds; marking, by any shorthand or symbolic work you can hit upon, the peculiar character of each, as transparent, or fleecy, or linear, or undulatory; giving afterwards such completion to the parts as your recollection will enable you to do' (p. 97). Hopkins, in four successive sketches made on 30 June 1864, tellingly resorts to words, among commonplace phrases producing fragments of far more striking description than he was able to draw:

On this day the clouds were lovely. Opposite the sun between 10 and 11 was the disshevelled [*sic*] cloud on page opposite. The clouds were repeatedly formed in horizontal ribs. At a distance their straightness of line was wonderful. In passing overhead they were something as in the (now) opposite page, the ribs granulated delicately the splits fretted with lacy curves and honeycomb work, the laws of which were exquisitely traced. They in the zenith thus. There were squared odd disconnected pieces of cloud now and then seen thus [*drawing*], as if cut out from

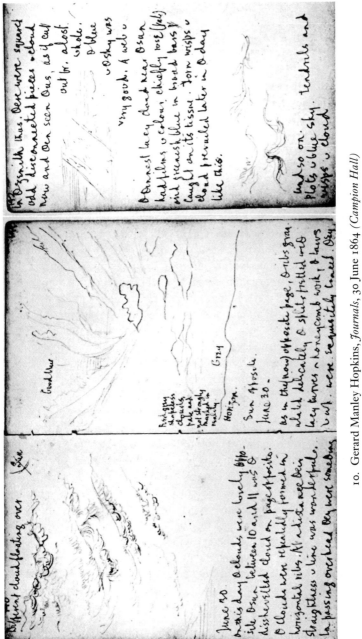

10. Gerard Manley Hopkins, *Journals*, 30 June 1864 (*Campion Hall*)

a lost whole. The blue of the sky was very good. A web of the thinnest lacy cloud near the sun had films of colour chiefly rose (pale) and greenish blue in broad bars caught on its tissue. Torn wisps of cloud prevailed later in the day like this [*drawing*] and so on./Plots of blue sky. Tendrils and wisps of cloud. (*J* 27, fig. 17)

Neither drawing nor words quite convey a distinct effect, a struggle that remains in the poems to the end.

We tend to think of clouds as having been classified a very long time ago but much of the system we know was only proposed in 1803 by Luke Howard in an essay *On the Modifications of Clouds*.[8] Out of Howard's work there emerged a realization that clouds could be understood. Richard Hamblyn praises Howard for being the first meteorologist systematically to 'apply recent electrical theories in an attempt to explain everyday atmospheric events' when he claimed that 'there are three simple and distinct modifications, in any one of which the aggregate of minute drops called a cloud may be formed, increase to its greatest extent, and finally decrease and disappear'. His most essential observation was that 'the same aggregate which has been formed in one modification, upon a change in the attendant circumstances, may pass into another' (p. 123). In other words, clouds could evolve from one type into another, virtually without restriction: 'cumuliform clouds might spread themselves out to become stratiform clouds; or then again, they might evaporate and rise through convection to form higher ciriform structures. The shapes made by vapour merge and demerge, rising through convection, falling through gravity, yet nephrology can chart every stage of their progress' (p. 124). Howard used the model of Linnean classification to name the various forms 'so that, on the one hand, it gave order to the visible phenomena, while on the other it supplied the intermediate forms which allowed changes in their familial patterns to be accounted for' (p. 122). One artist who made clouds the emotional keynote to his pictures and knew of Howard's system was John Constable, who in 1821–2 lived in Hampstead and methodically observed and painted cloudscapes from the heath day after day (p. 223). One of his pictures from this period, *The Haywain*, was exhibited at the Salon in Paris in 1824. Hopkins repeated to Bridges the well-known comment about it: 'they say the French trace their whole modern school of landscape to a single piece of Constable's exhibited at the Salon early this century' (18 Oct. 1882, *LI* 154). Constable also influenced mid-nineteenth-century German landscapists.

Hopkins, affected by the science course that was part of his training at St Mary's Hall, Lancashire, and by the meteorology of those running the

Observatory at Stonyhurst, began to make observations of clouds that became more exacting and scientifically speculative. The famous passage on steam rising from 'our Lenten chocolate' shows analysis bearing out Howard's more scientific theory about the common substance and modulation between shapes expressed in the passage above. Hopkins does not, however, show evidence of knowing Howard's specific classifications:

I have been watching clouds this spring and evaporation, for instance over our Lenten chocolate. It seems as if the heat by *aestus*, throes/one after another threw films of vapour off as boiling water throws off steam under films of water, that is bubbles. One query then is whether these films contain gas or no. The film seems to be set with tiny bubbles which gives it a grey and grained look. By throes perhaps which represent the moments at which the evener stress of the heat has overcome the resistance of the surface or of the whole liquid. It would be reasonable then to consider the films as the shell of gas-bubbles and the grain on them as a network of bubbles condensed by the air as the gas rises ... They seem to be drawn off the chocolate as you might take up a napkin between your fingers that covered something, not so much from here or there as from the whole surface at one reech, so that the film is perceived at the edges and makes in fact a collar or ring just within the walls all round the cup; it then draws together in a cowl like a candleflame but not regularly or without a break: the question is why. Perhaps in perfect stillness it would not but the air breathing it aside entangles it with itself. The film seems to rise not quite simultaneously but to peel off as if you were tearing cloth; then giving an end forward like the corner of a handkerchief and beginning to coil it makes a long wavy hose you may sometimes look down, as a ribbon or a carpenter's shaving may be made to do. Higher running into frets and silvering in the sun with the endless coiling, the soft bound of the general motion and yet the side lurches sliding into some particular pitch it makes a baffling and charming sight.—Clouds however solid they may look far off are I think wholly made of film in the sheet or in the tuft. The bright woolpacks that pelt before a gale in a clear sky are in the tuft and you can see the wind unravelling and rending them finer than any sponge till within one easy reach overhead they are morselled to nothing and consumed—it depends of course on their size. Possibly each tuft in forepitch or in origin is quained and a crystal. Rarer and wilder packs have sometimes film in the sheet, which may be caught as it turns on the edge of the cloud like an outlying eyebrow. The one in which I saw this was in a north-east wind, solid but not crisp, white like the white of egg, and bloated-looking. (Mar. 1871, *J* 203–4)

The comparison that Hopkins makes between the behaviour of clouds, steam above chocolate, and candle smoke, which 'goes by just the same laws, the visible film being here of unconsumed substance, not hollow bubbles' shows him here reaching towards scientific laws and beyond

the acute observation that Patricia Ball calls the 'science of aspects' and finds generally characteristic of him.

Howard himself probably placed too much emphasis on the mechanism of electricity in the formation and dissolution of clouds but the arguments he put forward are still under discussion. Hopkins's description of the sudden squall that sunk the *Eurydice* as a 'black Boreas' who 'came equipped, deadly-electric ... there did storms not mingle? and | Hailropes hustle and grind their | Heavengravel?' would seem to combine traditional classical personification with such contemporary scientific understanding. Since he was at Stonyhurst with its meterological station when it appeared in 1870, he may also have been aware of at least the gist of an article by Professor Poey of Havana in the first volume of *Nature*, which proposed a 'New Classification of Clouds' that modified Howard's system by adding more intermediate types and using the movement of the clouds in their classification. Poey followed Howard's ideas though not his terminology in asserting that 'the stratum of *Pallio-cirrus* is first formed, and some hours or some days afterwards that of *Pallio-cumulus* is formed under it. These two strata remain in view at a certain distance from each other, and by their reciprocal action and reaction produce storms and the heavier rains, accompanied with considerable electric discharges. They are electrified, but with contrary signs; the superior stratum of Cirrus is negative, and the inferior one of Cumulus is positive, the same as the rain which it disengages; while the electricity of the air, at the surface of the earth, is negative. But when these two strata attract each other a discharge is produced; and the inferior stratum continues to pour out the surplus water it contained without giving any sign of electricity, no more than the air in contact with the earth. This state continues until the inferior stratum opens up, the superior afterward, they then disappear, the one after the other. Fine weather then returns.'[9] One might compare this with a passage by Hopkins in his journal showing Ruskinian description harnessed to an interest in testing connections between types of clouds and weather, though he invents his own terms rather than using conventional ones:

April 21 we have had other such afternoons, one today—the sky a beautiful grained blue, silky lingering clouds in flat-bottomed loaves, others a little browner in ropes or in burly-shouldered ridges swanny and lustrous, more in the Zenith stray packs of a sort of violet paleness. White-rose cloud formed fast, not in the same density—some caked and swimming in a wan whiteness, the rest soaked with the blue and like the leaf of a flower held against the light and

diapered out by the worm or veining of deeper blue between rosette and rosette. Later/moulding, which brought rain: in perspective it was vaulted in very regular ribs with fretting between: but these are not ribs; they are a 'wracking' install made of these two realities—the frets, which are scarves of rotten cloud bellying upwards and drooping at their ends and shaded darkest at the brow or tropic where they double to the eye, and the whiter field of sky shewing between: the illusion looking down the 'waggon' is complete. The swaths of fretted cloud move in rank, not in file. (1871, *J* 207)

Here Hopkins uses an architectural term, 'waggon', an 'inverted wagon'-shaped wooden ceiling found in chapels. He transmuted detailed observation of clouds into poetic lines on two striking occasions: 'what lovely behaviour | Of silk-sack clouds! has wilder, wilful-wavier | Meal-drift moulded ever and melted across skies?' from 'Hurrahing in Harvest' where the description of the clouds as sacks and meal-drift links to the dominant theme of harvest.[10] In the second example they are part of the wonderful but perishable world in 'That Nature is a Heraclitean Fire and of the Comfort of the Resurrection', where one reason for mentioning Heraclitus in the title might have been to emphasize the momentary quality of each elemental state:

> Cloud-puffball, torn tufts, tossed pillows flaunt forth, then chevy on an air-
> Built thoroughfare: heaven-roysterers, in gay-gangs they throng; they
> glitter in marches.

<div align="right">(ll. 1–2)</div>

The description of the party-goers oblivious of their mortality and peril recalls the medieval lyric 'Ubi Sunt qui ante Nos Fuerunt?' or Traini's mural in the Campo Santo on the same theme. Hopkins could have learnt about Howard's classification from his godmother, Frances Anne Hopkins, née Beechey, whose father had successfully presented the scheme for international adoption at the first International Meteorological Conference in Brussels in 1853. Some, though not all of what he knew could have been gleaned from Ruskin, who was evidently aware of Howard's later modified system based on the height of clouds; he divided his discussion of clouds in both the *Elements* and *Modern Painters* into lower, mid, and high and sometimes used the technical names. In *Modern Painters* he combines, in one example, the scientific with treating a sunset as a painting:

If you watch for the next sunset when there are a considerable number of these cirri in the sky, you will see, especially at the zenith, that the sky does not remain of the same colour for two inches together. One cloud has a dark side of cold

blue, and a fringe of milky white; another, above it, has a dark side of purple
and an edge of red; another, nearer the sun, has an under side of orange and an
edge of gold: these you will find mingled with, and passing into, the blue of the
sky, which in places you will not be able to distinguish from the cool grey of
the darker clouds, and which will be itself full of gradation, now pure and deep,
now faint and feeble.[11]

For Ruskin and Hopkins the challenge, as Patricia Ball notes, was 'one of
fixing transitory fact without robbing it of that impermanence which is
part of its character'.[12] She gives an example from Ruskin's *Diaries*: 'The
clouds were rising gradually from the Apennines ... Fragments of cloud
entangled here and there in the ravines, catching the level sunlight like
so many tongues of fire; the dark blue outline of the hills clear as crystal
against a pale, distant, purity of green sky, the sun touching here and
there upon their turfy precipices and the white, square villages along
the gulph gleaming like silver to the north-west;—a mass of higher
mountains, plunging down into broad valleys dark with olive, their
summits at first grey with rain, then deep blue with flying showers—the
sun suddenly catching the near woods at their base, already coloured
exquisitely by the autumn, with such a burst of robing, penetrating
glow as Turner only could even imagine, set off by the grey storm
behind' (4 Nov. 1840, Diaries I, 103).[13] She remarks that Ruskin seems
to have been 'particularly drawn to scenes whose forms and colours are
dominated by atmospheric features, qualities of light and cloud, merging
into the range of watery influences, mist, rain, spray or dew. Mountains
in shifting mist, passing showers, spots of sunlight or light fading—all
these demand to the full his powers of "eager watchfulness", and
stimulate his efforts at verbal precision. Colours must be distinct, caught
to the exact shade, yet the continual blending, diluting, or heightening
of tones reported with equal fidelity' (p. 89). Hopkins, she says, has a
power like Ruskin's, that lies in his ability to keep us in the presence
of the thing itself while he demonstrates its properties and exposes the
laws of its being' (p. 123). She comments on the effort of concentration
Hopkins demanded to understand the seizing of the 'individual essence'
of things he observed and how that full sympathizing produced a love
for the revealed object. 'All the intensity which the Romantics brought
to the study of personal identity, Hopkins inherits, and it goes', she
concludes, 'into his concept of inscape'. Hopkins copied out a passage
from an essay by J. C. Shairp on Wordsworth's 'spots of time' printed
in the *North British Review* in 1864 that shows a relationship between
Wordsworth's ideas and his notions of 'inscape' and 'instress':

Each scene in nature has in it a power of awakening, in every beholder of sensibility, an impression peculiar to itself, such as no other scene can exactly call up. This may be called the 'heart' or 'character' of that scene. It is quite analogous to, if somewhat vaguer than, the particular impression produced upon us by the presence of each individual man. Now the aggregate of the impressions produced by many scenes in nature, or rather the power in nature on a large scale of producing such impressions; is what, for want of another name, I have called the 'heart' of nature.

Tom Zaniello points out that Hopkins would have called the impression made by each scene in nature its 'inscape' and the 'power in nature ... of producing such impressions' 'instress',[14] though in neither case would Wordsworth's description have covered all the uses to which Hopkins puts his terms. An incident he describes in his journal shows something of the concentration to which Patricia Ball alludes:

One day early in March when long streamers were rising from over Kemble End one large flake loop-shaped, not a streamer but belonging to the string, moving too slowly to be seen, seemed to cap and fill the zenith with a white shire of cloud. I looked long up at it till the tall height and the beauty of the scaping—regularly curled knots springing if I remember from fine stems, like foliation in wood or stone—had strongly grown on me. It changed beautiful changes, growing more into ribs and one stretch of running into branching like coral. Unless you refresh the mind from time to time you cannot always remember or believe how deep the inscape in things is. (Mar. 1871, *J* 204–5)

I suspect that Hopkins reread *The Elements* in 1865/6 when he was preparing that remarkable essay, 'On the Origin of Beauty: A Platonic Dialogue' (*J* 86–114). The long dialogue purports to be in New College between a newly appointed professor of aesthetics whose lectures have been poorly attended (partly modelled on Ruskin?), a student called Hanbury and a Pre-Raphaelite artist, Middleton, who is in Oxford to complete the frescos in the Union. Rossetti was invited to return for that purpose but declined. Much of the argument about visual beauty seems to have been drawn from Ruskin's book, taking not primarily now the practical advice but the theoretical arguments behind it, such as the idea that the 'laws'—a word Ruskin uses—of complex beauty are a combination of 'consistency and variety' (see *Elements*, 149–50, the 'law of consistency') and of subtle balance of masses, the point Ruskin illustrates with Perugino, quoted below. Hopkins goes on to develop Ruskin's idea that an artist must be aware of whether the colours or light and shade he is reproducing in a painting contrast abruptly or gradate into an argument about chromatic (gradated) and diatonic

(contrasting) beauty, applying it to poetry. He asserts that clear and 'objective' qualities such as metaphor, simile, and antithesis are diatonic whereas 'emphasis, expression (in the sense it has in Music), tone, intensity, climax and so on', which are more dependent on individual interpretation, are chromatic. The ability to apply the terms of one art to more general aesthetic discussion is characteristic of Pater's thought.

One of the interesting things about the essay, which may have been written for the undergraduate discussion group Hexameron, is, towards the end, the lucid articulation of principles that characterize Hopkins's mature poetry. Speaking of Dryden, Hopkins's 'professor' explains, 'that is what one feels before all things besides in Dryden, who seems to take thoughts that are not by nature poetical,—stubborn, and opaque, but under a kind of living force like fire they are powerfully changed and incandescent ... The poem is artificial, you see, but with that exquisite artifice which does not in truth belong to artificial but to simple expression, and which, except in point of polish, is found in natural and national ballad-making I seemed to feel [Patmore's 'The Nix'] was what a poet expressed as a poet, in the transparent, almost spontaneous, artifice which alone can make a genuinely simple subject palatable,—for where this is not used so openly, as in some of Wordsworth's seemingly much more simple pieces, we shall find if we look a subtle complexity of emotion at the bottom, not simplicity, which is the secret of their beauty' (*J* 112). Hopkins's poem 'Felix Randal', for example, combines such qualities. Initially it has a simplicity of diction that gives the impression of musing that flows out of a conversational remark, yet the poem develops into a complexity of feelings of pity and self-esteem, of envy at the young man's physique and perhaps attraction channelled into priestly paternalism, all generated by his relationship with the dying man.

> Felix Randal the farrier, O is he dead then? my duty all ended,
> Who have watched his mould of man, big-boned and hardy-handsome
> Pining, pining, till time when reason rambled in it and some
> Fatal four disorders, fleshed there, all contended?
>
> Sickness broke him. Impatient, he cursed at first, but mended
> Being anointed and all; though a heavenlier heart began some
> Months earlier, since I had our sweet reprieve and ransom
> Tendered to him. Ah well, God rest him all road ever he offended!
>
> This seeing the sick endears them to us, us too it endears.
> My tongue had taught thee comfort, touch had quenched thy tears,
> Thy tears that touched my heart, child, Felix, poor Felix Randal;

How far from then forethought of, all thy more boisterous years,
When thou at the random grim forge, powerful amidst peers,
Didst fettle for the great grey drayhorse his bright and battering sandal!

Line 9 originally read: 'this seeing the sick endears them, me too it endears', a still more explicit consideration of Hopkins's awareness of the moral balance-sheet with which he lived.

Hopkins's drawings in the Sketchbook of 1865 are still, remarkably, the subjects suggested by Ruskin, evidently those that also moved Hopkins and which would provide metaphors and background in his poems: flowing water, plants, and trees. There are few drawings of people or animals and none of sacred objects (apart from architectural detail) or figures. Most surprisingly for someone intending to become an artist, there are no watercolours or oils extant belonging to the period of his most intense artistic interest (1864–7). The despondency about becoming an artist found among his confession notes may reflect his awareness that he simply was not spending enough time and effort on art to succeed. He also learnt that he could ruin his sketches by finishing them; rather a lot are incomplete. Like the majority of his poems, they show fine detail in small compass.

One of the most important ideas contributed by *The Elements of Drawing* is Ruskin's 'leading lines'. He says of them, 'it is by seizing these leading lines, when we cannot seize all, that likeness and expression are given to a portrait, and grace and a kind of vital truth to the rendering of every natural form' (p. 69). In *Modern Painters*, vol. iv (1856) he said, 'I call these leading lines or governing lines, not because they are the first which strike the eye but because, like those of the grain of the wood in a tree-trunk, they rule the swell and fall and change of all the mass.' These ideas have a lot in common with some of Hopkins's early uses of inscape, as when he says, 'rushing streams may be described as inscaped ordinarily in pillows—and upturned troughs' (18 July 1868, *J* 176) or *Daydream* by Millais, in which he remarked on the 'intense expression of face, expression of character, not mood, true inscape' (23 May 1874, *J* 245). Hopkins included *Modern Painters* in a list of books to be read in a journal entry of February–March 1865 (*J* 56) and quotes from vol. iv in his journal of 14 September 1871 (*J* 215). He may too have read the introduction to Ruskin's *The Stones of Venice*. His comment on the development of Romanesque architecture (1863, *J* 13) might have a source in Ruskin, though there are other possibilities which I explore in Chapter 3.

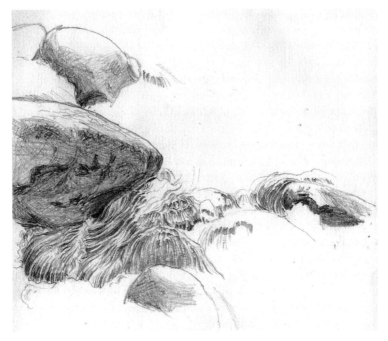

11. Gerard Manley Hopkins, water flowing over rocks [1865] (*Balliol College*)

Norman White divides Hopkins's art into initial pictorial notes, which he calls sketches, and more complete work which he designates drawings. We know that from 1866 Hopkins kept a fuller Journal, which has survived, and he refers in it to notes made in a diary. It seems likely that he was already following a similar practice in the preceding years. The diaries contain poetic drafts and prose descriptions written up more fully elsewhere. There are, however, no extant examples of sketches that can be seen as preparatory for any of the surviving drawings. And, after the first few drawings, Hopkins seems to have used his sketchbook for both sketches and drawings.

THE SKETCHBOOKS

Sketchbook A is, apart from the child's letter on the birth of his brother Felix, a few early drawings, and 'The Escorial', the earliest record we have of Gerard's vision. It pre-dates by a couple of months his letters to

Luxmore and Coleridge, by a couple of months his classics notebook, and by some eighteen months the extant diaries. The first of the drawings is dated 12 March 1862 and is of the North Road, Highgate. It already shows many of the characteristics of Gerard's best drawings of the Shanklin holiday of over a year later. The lines are strong and sure and the overall composition good, although later pictures are better: here the circle and placing of the date and title do aid the balance. The effect of the semicircle around a scene which, from the incomplete building on the right clearly continues, might be thought to be a view seen through a telescope, though such enclosing frames were very common in the period in illustrations in books and journals.

The technique is that of the later drawings: a gradation of black to white, the subtlety of which no reproductions I have seen has captured. The camera overemphasizes the extreme ends of the tonal scale, robbing the middle greys. Gerard reinforced the places he wanted darkest with touches of ink or a very soft, dark pencil—part of a line here, a dot or two there. This was a practice recommended by Ruskin.[15] Some of these are detectable in photographs. He practised using ink or the dark pencil to emphasize shape in his Classics notebook (Campion Hall MS BII) started on 23 May 1862. Here he wrote some of his notes in pencil and then clarified the shapes of letters with darker touches. It may be that the pencil he was using was soft or that in revising later, he drew his attention to words by touching bits of them in with ink. In *The Elements of Drawing* Ruskin wrote: 'the forms of distant trees in groups are defined, for the most part, by the light edge of the rounded mass of the nearer one being shown against the darker part of the rounded mass of a more distant one' (*Elements*, 110). Ruskin's own drawings do not often show this and his handling of the foliage of trees is either to make them virtually in a flat plane by shading across in straight lines or using an unvarying wash, or to draw individual leaves. Gerard also seems to have followed Ruskin's advice in modelling aspects of his technique on engraving and photographic effects (*Elements*, 140–1). For instance, the awareness of lines composing grey areas is a necessity of engraving, not watercolour, and the recording of scenes in terms of tonal gradation bereft of colour is characteristic of photography. The importance of white in indicating shape is also evident in landscape photographs of the day; drawing is more usually a matter of outline. Gerard very lightly marks out the edges of an area of white and then shades to that line, leaving the white to mark the outer edges of foreground masses against darker background.

It is clear that there must have been many drawings between the early attempts at animals and Sketchbook A. It is said that Gerard seldom attempted figures or faces. There are comic and caricatured figures in the letter headings he drew for his brothers and sisters. And, in the Classics notebook on the versos, there are numerous soft pencil sketches of faces, the visual evidence of Gerard's statements to Bridges:

Do you know Bradley? Yesterday at St. Alban's I saw him serving in some way in choir, and I saw too another Oxford man, whose name I do not know, with a delightful face (not handsome), altogether aquiline features, a sanguine complexion, rather tall, slight, and eager-looking: I did not know he was one of the faithful before. His face was fascinating me last term: I generally have one fascination or another on. Sometimes I dislike the faces wh. fascinate me but sometimes much the reverse, as is the present case. (24 Sept. 1866, *LI* 8)

It curiously happens that I have seen two people we were talking about. The first is the Corpus man whose name I wanted to know. I met him riding in one of our roads a few days ago and I stared at him in order to note his features but not very comfortably, for he plainly recognised my face. As far as I can give it this is the description of him: he has plenty of thick rather curly dark auburn hair parted in the middle and εὐφυέας [shapely] whiskers of the same; his eyes are deep set and I think rather near together; the fault of his face is that the features are too broad and depressed; his forehead is wide across and narrow upwards to the hair; he looks happy. I drew him when I got home but some touches destroyed the likeness at last. (28 Sept. 1866, *LI* 9)

These are important statements for they show Gerard's interest in the puzzle of translating what he saw into lines on paper and that the interest was not always the recording of an attraction. The latter drawing, apparently more detailed than the quick sketches in the Classics notebook and which just might have been of J. B. Reid, is not extant. Gerard's drawing of Jowett from the Classics notebook has been reproduced a number of times but there are others, of a girl with long hair, the silhouette of a woman standing, faint drawings of girls' and men's faces, of a man in a peaked hat, silhouettes of faces and two heads with woolly hats, and what might well have been a self-portrait, as well as the sketches of trees, and church windows, subjects found elsewhere. The copying of maps at school ensured that he was accustomed to using a pen for drawing.

In a scrapbook in which sketches by a number of members of the family were stored there is a pen drawing by Gerard on the flap of an envelope of *Lady Clare* in which the interest is in conveying her personality. The scrapbook was originally used for photographs, quite

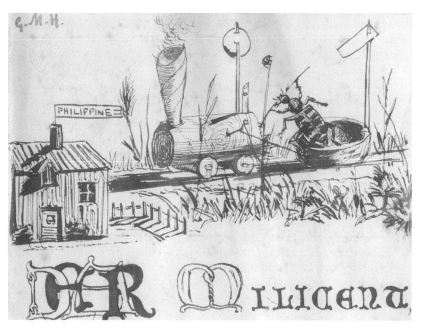

12. Gerard Manley Hopkins, heading for a letter to his sister Milicent *(Balliol College)*

possibly including those of George Giberne. The drawings in it were done over many years and pasted in out of chronological sequence. They include a sketch of a grumpy man by Lionel in 1870, various figures by Arthur including some of his favourite female model, photogenic drawings of leaves and coloured photographs by Maria, a very fine pencil drawing of a rose by Laura Hodges in 1842, and a sketch by Everard in 1873 *From the table in the nursery looking out of [the] window.* The view Gerard and his brothers had as children at Oak Hill was over the tree tops with only a couple of chimneys indicating the presence of nearby houses. The book also includes Gerard's amusing heading in a letter to Milicent of a beetle in a walnut shell being pulled by a wooden train whose construction is clear but which has magically become capable of running—it has smoke coming out of its funnel (*J* pl. 5),[16] and a pencil sketch titled *Nr Pangbourne. Aug.t 1875 GMH* in writing more like his mother's than Gerard's hand though the style of the picture suggests that it is his. The subject is a group of trees with graceful trunks; the masses are isolated by white edges achieved in the manner of the sketches

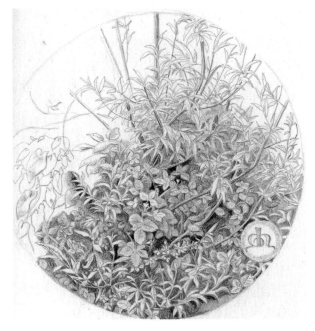

13. Gerard Manley Hopkins, *Hedgerow leaves and branches* [1863] *(Balliol College)*

of the early 1860s and the lines have a strong rhythm. There are very few drawings extant by GMH in the 1870s.

Among the drawings in Sketchbook A one of the most beautiful is a detailed study of hedgerow plants, mistitled in *AMES* as *In a Wood of Oak and Ash, Shanklin, July 11, 1863* (*J* pl. 9).[17] The picture is a more developed version of the sort of subject found in *Celandine, Hampstead, 1862*. Given that Gerard started Sketchbook A in 1862, left some pages blank and then used most of it on his holiday at Shanklin in 1863, the sketch could belong to either year. As with his diary, he did not find it necessary to use pages systematically from cover to cover but left spaces to finish entries and filled in where he had left blanks. The drawing of the plants might owe something to the engravings of T. R. Maquoid's illustrations of 'The Seasons' in *Once a Week* (1860). The reproductions of *Hedgerow leaves* in *AMES* and *J* are both darker than the original. The darkest places in the drawing were touched in with black ink but there are fewer of these than the reproductions suggest. Because reproductive processes cannot capture the range of greys in the

picture, they underplay the subtlety of its tonal perspective. There is in the picture an intense appreciation of graceful line and a sensitive following through of the shapes of the various types of leaves. It is very much in keeping with such a poetic line as 'rich runs the juice in violets and fresh leaves' of a draft of 'On the Portrait of Two Beautiful Young People' or from a diary fragment, 'the shallow folds of the wood | We found were dabbled with a colouring growth, | In lakes of bluebells, pieced with primroses' (p. 32).[18] The bluebell had special resonance for Hopkins since he associated its beauty with Christ, but the lines have a similar intensity of vision. Gerard was interested in the bluebell in all phases of its development from bud to fully open flower. In the drawing of the lily he was similarly attending to the various stages of the bud from tightly closed to opening. It is more of a botanical study than Arthur's graceful picture, just as his study of the waves from the cliff top (J, pl. 12) is an aid to understanding rather than a picture.[19] Gerard was also drawing at a considerable pace: there are at least eleven drawings that belong to the period between 19 July and 25 July.

The holiday at Shanklin, for at least part of which 'all the clan' were present, was one of Gerard's most productive artistic periods. It lasted from July to September 1863 and from it we have certainly twenty-two drawings and another fourteen probably done there, though, unlike the first group they do not have either titles that make them certain or the year included in their dates. It may be that one reason for not drawing the lily in flower on 19 July is that he had drawn an iris in full flower on 8 July (J, pl. 10). The lines used for the leaves became habitual shapes which he used four days later in drawing the waves from the cliff above Freshwater Gate on 23 July (J, pl. 12) where, below the drawing he wrote: 'Note. The curves of the returning wave overlap, the angular space between is smooth but covered with a network of foam. The advancing wave, already broken, and now only a mass of foam, upon the point of encountering the reflux of the former.' What he learnt for the drawing, he remembered. Nine years later he added to his observation:

I was looking at high waves. The breakers always are parallel to the coast and shape themselves to it except where the curve is sharp however the wind blows. They are rolled out by the shallowing shore just as a piece of putty between the palms whatever its shape runs into a long roll. The slant ruck or crease one sees in them shows the way of the wind. The regularity of the barrels surprised and charmed the eye; the edge behind the comb or crest was as smooth and bright as glass. It may be noticed to be green behind and silver white in front: the silver marks where the air begins, the pure white is foam, the green/solid water.

Then looked at to the right or left they are scrolled over like mouldboards or feathers or jibsails seen by the edge. It is pretty to see the hollow of the barrel disappearing as the white combs on each side run along the wave gaining ground till the two meet at a pitch and crush and overlap each other.[20]

About all the turns of the scaping from the break and flooding of wave to its run out again I have not yet satisfied myself. The shores are swimming and the eyes have before them a region of milky surf but it is hard for them to unpack the huddling and gnarls of the water and law out the shapes and the sequence of the running: I catch however the looped or forked wisp made by every big pebble the backwater runs over—if it were clear and smooth there would be a network from their overlapping, such as can in fact be seen on smooth sand after the tide is out—; then I saw it run browner, the foam dwindling and twitched into long chains of suds, while the strength of the backdraught shrugged the stones together and clocked them one against another.

Looking from the cliff I saw well that work of dimpled foamlaps—strings of short loops or halfmoons—which I studied at Freshwater years ago. (10 Aug. [1872], _J_ 223)

The observation made six days later was incorporated into 'The Wreck of the Deutschland', stanzas 1 and 32: 'In the channel I saw (as everywhere in surfy water) how the laps of foam mouthed upon one another. In watching the sea one should be alive to the oneness which all its motion and tumult receives from its perpetual balance and falling this way and that to its level' (_J_ 225). One might compare Arthur's notes made at Whitby in the 1870s and which he used for his illustration, 'The Paddling Subject':

The foam of waves is very white & wrinkled, but the 'soapsuds' it leaves on the sheen, are hardly perceptible in parts, so much do they lose their whiteness.

Sometimes, as where the soapsuds lie underneath an approaching breaker they actually tell darker than their sheen, because there the sheen is a yellowish white, under the reflection of the breaker.

A very good effect for the long principal sheen driving onto the sand in the front, will be a very glassy look in the sheen, lighting up under lip of big breaker to a clean bright yellow drab, a good bit lower in tone than the foam. On this part sharp little clean gray lips pick themselves out.[21]

Arthur's comments show his experience as an artist having to convey realistic effects ultimately in wood engraving. There is a practical precision of detail in his notes that simply is not present in Gerard's. This does not mean that Gerard would not have been able to become an illustrator—he too might, with necessary work, have joined the ranks of the professional artists of the day; he certainly possessed a marked

sense of design that was promising. The question is not so much one of talent—Arthur was talented, especially in his drawings and, though his illustrations are now considered of the second rank, they attracted the praise of an artist of the stature of Van Gogh. Gerard was probably less talented but, more importantly, did not keep up the necessary labour that ultimately made Arthur a professional. The training Gerard gave his eye before becoming a novice had its effect instead in the precision of description within his poems, something that is crucial to their success.

During the holiday Gerard wrote to Baillie twice, on both occasions making important statements. On 13 July 1863 he announced, 'I am sketching (in pencil chiefly) a good deal. I venture to hope you will approve of some of the sketches in a Ruskinese point of view:—if you do not, who will, my sole congenial thinker on art? There are the most deliciously graceful Giottesque ashes ... here—I do not mean Giottesque though, Peruginesque, Fra-Angelical (!), in Raphael's earlier manner.' (*LIII* 202). The source of Hopkins's description of the ashes may owe something to the *Elements* where Ruskin comments,

In many sacred compositions, living symmetry, the balance of harmonious opposites, is one of the profoundest sources of their power: almost any works of the early painters, Angelico, Perugino, Giotto, etc., will furnish you with notable instances of it. The Madonna of Perugino in the National Gallery, with the angel Michael on one side and Raphael on the other, is as beautiful an example as you can have.

In landscape, the principle of balance is more or less carried out, in proportion to the wish of the painter to express disciplined calmness. (p. 131)

The National Gallery had Perugino's *Virgin and Child* [NG 181] with graceful trees flanking the figures and *The Virgin and Child with an Angel* [NG 288.1] with similarly placed background trees. These Hopkins could well have seen but whether any of their graceful trees might be identified confidently as ashes, I doubt. Ruskin included a sketch of the latter with its flanking panels in *The Elements of Drawing*. The point he made about it, however, was the success of the composition when the three panels are seen together. If Hopkins was remembering Ruskin's concatenation of names, the quality he may have had in mind is the complex balance of the ash from the paired leaves to the often double trunk such trees develop. In his Journal for 22 August 1867 he expressed his pleasure in making a 'perfect' ash by aligning the tree's two trunks with their respective counterbalancing foliage.

Walked to Finchley ... what most struck me was a pair of ashes The further one was the finer—a globeish just-sided head with one launching-out member on the right; the nearer one was more naked and horny. By taking a few steps one could pass the further behind the nearer or make the stems close, either coincidingly, so far as disagreeing outlines will coincide, or allowing a slit on either side, or again on either side making a broader stem than either would make alone. It was this which was so beautiful—making a noble shaft and base to the double tree, which was crested by the horns of the nearer ash and shaped on the right by the bosom of the hinder one with its springing bough. The outline of the double stem was beautiful to whichever of the two sides you slid the hinder tree—in one (not I think, in both) shaft-like and narrowing at the ground. Besides I saw how great the richness and subtlety is of the curves in the clusters, both in the forward bow mentioned before and in some most graceful hangers on the other side: it combines somewhat-slanted outward strokes with rounding, but I cannot very well characterise it now. (*J* 151–2)

He captured something very similar in the beautiful sketch of trees, *June, '68 Oak Hill*.

The second important statement he sent to Baillie was on 6 September 1863: 'I am sorry to say I cannot send you a sketch. All my pencil sketches are in a book, coloured sketches I have none, and I have not the time to copy one in ink. However though I have not the opportunity of sending you anything now, I will try and keep something for you' (*LIII* 205). The statement, 'I have not the time to copy one in ink', comes as a surprise since ink is really too clumsy a medium to capture the subtlety of his drawings; many artists faced similar problems with engravings of their work. There are actually very few extant drawings in ink by him and what there is extant is not landscape. Although Gerard seems not to have done any watercolours on the holiday, there is a beautiful watercolour painting of trees from the trip, probably done by George Giberne, in whose hand, I think, place and date are identified on the verso. The Head of Shanklin Chine, which both Gerard and Arthur chose to draw, has provoked comparison between the two styles (see *AMES* 74, where both drawings are reproduced). Gerard chose a lower vantage point and captured a sense of the drop and the water falling onto the rock below. It is almost a suggestion of the sound. His drawing is more complete than reproductions suggest since the usual problems with the restricted tonal latitude simply fail to capture much of his shading. Arthur's version shows that he had more interest in the variety of foliage, from the trees in the background that occupy nearly half his picture's height to the leaves drenched by the falling water. Gerard's

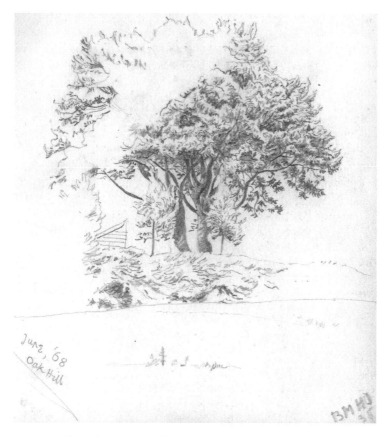

14. Gerard Manley Hopkins, *June, '68 Oak Hill (Balliol College)*

interest in sound within a landscape is clear in his poems and in some of
the journal descriptions:

> I hear a noise of waters drawn away,
> And, headed always downwards, with less sounding
> Work through a cover'd copse whose hollow rounding
> Rather to ear than eye shews where they stray,
> Making them double-musical. And they
> Low-covered pass, and brace the woodland clods
> With shining-hilted curves, that they may stay
> The bluebells up whose crystal-ending rods
> in their natural sods
>
> ('I hear a noise of waters')

One has to wonder what Hopkins was writing during the holiday. Was his creativity solely channelled into drawing? The regular diary entries start at the end of the holiday and none of the few known letters seem to have contained verse. There is a considerable step forward in individuality from 'A windy day in summer' (3 Sept. 1862) to 'the wind, that passes by so fleet' (late 1863) with a line such as 'tingling between dusk and silver' (fragments I) which has complex associations in words such as 'tingling' suggesting touch or rapid alternation, and 'dusk' implying perhaps in combination with silver the colour or softened tonality of that time of day.

> *A windy day in summer*
> The vex'd elm-heads are pale with the view
> Of a mastering heaven utterly blue;
> Swoll'n is the wind that in argent billows
> Rolls across the labouring willows;
> The chestnut-fans are loosely flirting,
> And bared is the aspen's silky skirting;
> The sapphire pools are smit with white
> And silver-shot with gusty light;
> While the breeze by rank and measure
> Paves the clouds on the swept azure.
>
> *
>
> The wind, that passes by so fleet,
> Runs his fingers through the wheat,
> And leaves the blades, where'er he will veer,
> Tingling between dusk and silver.

The effects of the wind seem to have fascinated Hopkins. He drew trees with their boughs bent and leaves tossed by strong wind: *In the hollow between Apse and the American Woods. / Near Shanklin*, August 8. and *Beech. Godshill Church behind. Fr. Appledurcombe. July 25. 1863*. The subject recurred in his verse as, for example, the winds that blew across the Isle of Wight to capsize the *Eurydice*, for the description of which he was undoubtedly casting back to his three months' experience there. His poems often describe nature in motion, even suggesting more movement than is realistic: the 'stooks rise around' as if filled with energy, the silk sack clouds mould and melt as if in the speeded up sequence of a television documentary. That sense of intense life is clear in drawings such as *Manor Farm, Shanklin. | Finished Sept. 21 1863*, in which the bushes and trees are all drawn in lines rather than planes. The tree in the foreground has been given a few leaves rather like Ruskin's

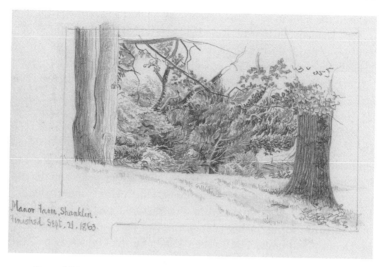

Manor farm, Shanklin.
finished Sept. 21. 1863

15. Gerard Manley Hopkins, *Manor Farm, Shanklin. Finished Sept. 21. 1863*
(*Boston College*)

exercise fig. 25 (*Elements*, 85) and the foreground trunk has ivy climbing
it. It is interesting that Hopkins signs the piece as 'Finished' when the
foreground tree clearly has not been. More foreground foliage would
have made the background trees less easy to interpret. It would also
have transferred the balance of interest from the middle group to the
foreground tree that in the incomplete composition has more of a role
as a frame; *Shanklin Sept 10* is a sketch from a height looking down on
one of those tree-filled little valleys that he so loved and then beyond
it over a plain to a distant horizon above which a towering cloud is
just appearing, much as he describes in the 'Loss of the Eurydice'.
Shanklin Sept 12 (see above, p. 46, fig. 9) is more tranquil though
even here the trees are composed of energetic lines. Only three types
of tree seem distinguishable: the elms that tower above the rest, the
pine, and what are probably fruit trees in the foreground. The rest
have no identifying inscape though the drawing has great rhythmic
patterning. The composition is complex with the two elms forming
the tops of overlapping ellipses whose lines are suggested by branches.
The contrasting horizontal lines of the pine on the left are echoed in the
lower right corner by the eaves and roofline of the house. He was to
write about a similar group of elms four years later: 'Bright.—I saw
some tall young slender wych-elms of thin growth the leaves of which

enclosed the light in successive eyebrows ... [and] a row of viol-headed or flask-shaped elms—not rounded merely but squared—of much beauty—dense leafing, rich dark colour, ribs and spandrils of timber garlanded with leaf between tree and tree' (22 Aug. 1867, *J* 151).

Compositions in which the central vertical field is of less interest than left or right loading appealed to him. *In Lord Yarborough's place ... July 22*; *Manor Farm ... Sept 21, 1863*; *Aug. 27 Croydon*; *Ash. Hendon Sept 14*; *Shanklin Sept 10* in which the split is lateral, are all of this type where Arthur's corresponding drawings are far more unified. Such compositions call for more complex counterbalancing of elements, and draw attention to contrast between the emphasized elements and the gap or more amorphous space between them. One might wonder whether there is any relationship between this pictorial preference and the often bipartite forms in his poems: the two parts of 'The Wreck of the Deutschland' and 'The Leaden Echo and the Golden Echo', the octave/sestet division of his Petrarchan sonnets, for example.

Sketchbook B contains sketches from September 1863 to Ascension Day 1866. It thus covers the majority of his time as an undergraduate. It contains a study of window in Elsfield church, sketches of bluebells, twelve studies of trees, leaves and tree trunks, and that of the ash at Hendon (14 Sept., *AMES* 129, bottom left) which emphasizes the tips of the branches, a subject he returned to many times. There are two promising incomplete sketches of men reading, in both cases the faces are hidden, in one by the subject's hands holding his book, in the other case Hopkins probably felt that he had not captured the facial features to his satisfaction and scribbled over them. All that we can see is that the man had large ears, a beard, and was smoking a pipe. There is a quick sketch of *Floods on Port meadow. End of Feb. 1865* about which he may have written his Latin poem, 'Inundatio Oxoniana'. There are two of sleeping sheep, one of which he crossed out but the other shows that attention to the flow of the lines in the coat or 'fell' that was one of his artistic interests. It appears as analysis of folds in robes, in the play of spots on leopards, glaciers, and the arrangement of dots on the dress of one of the sisters in D. G. Rossetti's illustration to Christina's 'Goblin Market', of which Gerard remarked on how much more effective three dots were than triangles would have been. Six of the drawings are of flowing water. Two of these are beautifully accomplished: the study of water flowing over rocks (see p. 64) in which the left-hand rock is convincing and *On the Bollen, Cheshire* (*J*, pl. 23), one of the most

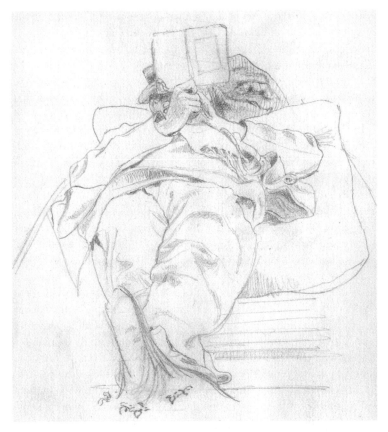

16. Gerard Manley Hopkins, *Man reading in a punt* [?1865] *(Balliol College)*

charming of Gerard's drawings. Again no reproduction does justice to its subtlety. The slight current is disrupted by a stalk sticking out of the water providing foreground interest while the foliage on the bank, the grass and celandines, such as he had practised drawing on earlier occasions, are carefully and gently outlined. The sketch of a tree of 'Sept. 1865' (*J*, pl. 20 on a sheet of paper different from that of the sketchbook and simply kept in it) has its rafts of leaves virtually hovering in the air, the shape of the masses almost water-like in the wavy lines used (seen more clearly in *AMES* 129, bottom right). The vision was later expressed in 'Epithalamion', where it was expanded into a fairy woodland experienced from below the branches as well as from

a distance: 'Rafts and rafts of flake-leaves light, dealt so, painted on the air, | Hang as still as hawk or hawkmoth, as the stars or as the angels there, | Like the thing that never knew the earth, never off roots | Rose' ('Epithalamion', ll. 25–8). *St Bartholomew. Aug. 24. '65. Betw. Ashburton and Newton Abbot*, is a sketch of late afternoon, the shadows from the highlighted trees stretching long over the ground. One imagines that Hopkins would have liked to paint the golden glow of the foliage.

In volume v of *Modern Painters* Ruskin distinguished between the motivations propelling various artists to make sketches and the consequent degree of finish in them. But Ruskin's three categories of sketch for experimenting with visual effect, for noting things the artist did not want to have to remember, or for making a record of details that he must get right in his finished picture do not seem relevant to Hopkins's annotation that his sketch of a tree 'Hendon' was 'Finished Oct. 7'. Here it seems that what is 'finished' is his grasp of the causes of his emotional reaction to the relation of the various masses and grace of the lines that he had found beautiful, and which are visible in the drawing. It comprises a study of masses of leaves and of trunks and branches but of their outline shapes rather than the relationship between the branches and the masses of leaves. It is thus less an act of trying to comprehend a particular type of tree than an analysis of his aesthetic reaction to it. In a couple of the sketches Hopkins has used a foreground tree trunk to mark the boundary of the scene (*Near Maentwrog. Aug. 1864* and especially *On the Cherwell. April*), so that we have a keener sense of looking at something he regarded as a special scene, rather like Alice looking through the keyhole at the wonderful garden. Some of the poems Hopkins wrote about Oxford in 1865 show the same feeling; he describes Oxford as 'my park, my pleasaunce ... quiet-wallèd grove, | The window-circles, these may all be sought | By other eyes, and other suitors move, | And all like me may boast, impeachèd not, | Their special-general title to thy love'.

The final sketch in the book, *Fyfield Ascension Day 1866* (*AMES* 130, bottom right) is, I think, one of his best. It is freer than many of the earlier ones yet has immense rhythm and a unified composition. The difficulty of capturing the middle tones in the reproduction means that a large part of the picture simply cannot be seen. Some fourteen leaves were cut out of the sketchbook. Among those removed may have been *Benenden, Kent, fr. Hemsted Park. Oct. 11. 1863*; *April 8. Day of the Boat race. On the Cherwell*; *May 12. Nr. Oxford* (a graceful study of leaves);

Aug. 27. Croydon, and *Limes in the Dugmores' Garden. Oct. 12, 1865.* These are now in the archives of the University of Texas.

Sketchbook C was inscribed 'G. M. Hopkins/Aug. 15 '66'and contains sketches made between 16 August 1866 and 24 July 1868. The book opens with a delicate drawing of leaves (?birch) followed by a number of branches or parts of trees. This was the sort of exercise that Ruskin had daily set himself. The most successful of these is *June, '68 Oak Hill*, which, though incomplete, is the most patient. Clearly the two trees were beautiful and Hopkins has captured their full and graceful shape. The remaining sixteen sketches in the book were all made in Switzerland. The best of these are reminiscent of Ruskin's own sketches on his trips to the country in the 1830s and 1840s, though they are less detailed.[22] Among them are *Side of the Rossberg fr. the Rigi, July 8. Huddling and precipitation of the fir-woods down the cleft.* In 1808 following torrential rain, part of the Rossberg broke away from the mountain and crashed down on the village of Goldau, destroying all but a few houses. Hopkins has drawn the face of the Rossberg as it was left by the avalanche. His use of 'huddling' and 'precipitation' to describe the fir-woods resonates with his knowledge of the catastrophe. The sketch, which judging from the angle of the top of the Rossberg, must have been from partway up the Rigi, was rapid but is an effective aide-memoire for anyone familiar with the area, and has convincing recessional planes. The elegant pyramidal top of the Silberhorn, 16 July, is also recognizable. He described it in his journal: 'The mountains and in particular the Silberhorn are shaped and nippled like the sand in an hourglass and the Silberhorn has a subsidiary pyramidal peak naped sharply down the sides. Then one of their beauties is in nearly vertical places the fine pleatings of the snow running to or from one another, like the newness of lawn in an alb and sometimes cut off short as crisp as celery' (*J* 174). This he tried to draw: *On the Silberhorn July 15* (*AMES* 135, upper right) and possibly *July 15 Little Scheidegg* but the verbal description is clearer. The glacier *July 15* is the best of the rest, most of which are hurried and very incomplete. Hopkins resorted to words with characteristic success. In place of 'This is a glacier, though you wd. not think it. July 15, '68', he wrote:

There are round one of the heights of the Jungfrau two ends or falls of a glacier. If you took the skin of a white tiger or the deep fell of some other animal and swung it tossing high in the air and then cast it out before you it would fall and so clasp and lap round anything in its way just as this glacier does and the fleece would part in the same rifts: you must suppose a lazuli under-flix to appear.

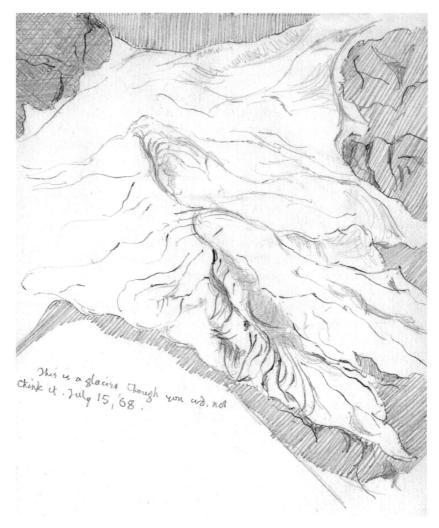

This is a glacier though you wd. not think it. July 15, '68.

17. Gerard Manley Hopkins, 'This is a glacier, though you wd. not think it. July 15, '68' *(Balliol College)*

The spraying out of one end I tried to catch but it would have taken hours: it was this which first made me think of a tiger-skin, and it ends in tongues and points like the tail and claws: indeed the ends of the glaciers are knotted or knuckled like talons. Above, in a plane nearly parallel to the eye, becoming thus foreshortened, it forms saddle-curves with dips and swells. (*J* 174)

It is a description that can be clearly placed in its period. It lacks the sense of horror or the sublime of many Romantic reactions to the Alps, replacing it with the description that presumably recalls an animal rug in one of the houses he knew, an object deriving from the British Empire. Today the Oberer Grindelwald Gletscher shows how apt the visual comparison is. Some of the other entries in Hopkins's journal reveal the greater geological and generally scientific interest in the Alps during the nineteenth century. For example, from 16 July 1868: 'In slanted brooks the bias keeps falling from bank to bank across and so knits the stream and glaciers also are cross-hatched with their crevasses but they form waves which lie regularly and in horizontals across the current. (So water does in fact, wimpling, but these wimplings have the air of being only resultants or accumulations; perhaps they too are a real inscape here seen descending and vanishing)' (*J* 175), and

We lunched at Guttannen, where there was that strange party of Americans.
 I was arguing about the planing of rocks and made a sketch of two in the Aar, and after that it was strange, for Nature became Nemesis, so precise they were, and E.B. [Edward Bond, with whom Hopkins was travelling] himself pointed out two which looked, he said, as if they had been sawn. And of the hills themselves it could sometimes be seen, but on the other hand the sides of the valley often descended in trending sweeps of vertical section and so met at the bottom.
 At times the valley opened in *cirques*, amphitheatres, enclosing levels of plain, and the river then ran between flaky flat-fish isles made of cindery lily-white stones. (*J* 177–8)

Patricia Ball comments that: 'Where Coleridge sought to press his enquiry as far as possible in his quest for scientific fundamentals and used his observations of the specific object to that end, Hopkins remains much more tied to his immediate experience, his detailed grasp of the particular. His attention is held by the individual object even when he relates one to another: he concentrates his gaze on vapour from a cup or vapour in the sky and the resemblances he finds sharpen his sense of the behaviour and nature of each', though the laws he sees in common are, I believe, not just a 'science of aspects'. Ball continues. 'In his Journals we find summarized the history of the nineteenth-century regard for fact: the initial Romantic alertness to the world of sense, incorporating

a scientific curiosity, maintained by Ruskin but converted also into a keener awareness of the thing itself, the qualities which express its being.'[23] Ruskin intended to write a geological study of Switzerland but was forestalled by Sassure's mighty four volumes.

The final sketchbook, D, covers the rest of Hopkins's life, from 24 August 1868 to at least April 1889. The last dated sketch is dated 22 April 1889 and there is one more in the book after that, though, given Hopkins's way of using pages out of sequence, it may not post-date it. The work in it would seem to show Hopkins finding in other ways—poems, prose descriptions, and music—expression of his artistic impulse. A letter of 12 February 1868 to Baillie suggests that it was not just a matter of finding himself outclassed in art but a deliberate decision to avoid going further down that road. He wrote to his friend, 'You know I once wanted to be a painter. But even if I could I wd. not I think, now, for the fact is that the higher and more attractive parts of the art put a strain upon the passions which I shd. think it unsafe to encounter. I want to write still and as a priest I very likely can do that too, not so freely as I shd. have liked, e.g. nothing or little in the verse way, but no doubt what wd. best serve the cause of my religion' (*LIII* 231). Hopkins was explaining in the letter the changes that his decision to enter the Society of Jesus would have on his previous artistic ambitions. He had in 1863 addressed Baillie as my 'sole congenial thinker on art'. Probably a large part of what Hopkins feared must have been the necessity of drawing from the nude. On several occasions he recommended or sent through his mother the advice to his artistic brothers that they must continue to draw from live models and make sure that their knowledge of anatomy was sound. But this was not the only motivation; though undoubtedly the urge to subdue the unruly sexuality of young manhood, to which Julia Saville draws attention in her study, *A Queer Chivalry*, would seem to have been important, the impetus towards conversion, accelerated by his Romanizing friends, too diverted his path.

Sketchbook D has a brown cloth cover imitating leather. Like sketch-book C, it was made by Higgins and measures 4.5 × 5.5 inches with 'Sketches' impressed in gold on the front cover. Inside the front cover (recto) Hopkins has written Gerard M. Hopkins | Aug. 24 '68. The book opens with two sketches of ash trees. In the first, dated 'Sept. 4. '68', Hopkins was evidently attracted by the graceful branching off the main bifurcated trunk and in both sketches, by the tips of the branches with their fine and flexible leaves (fos. 1 and 3). The book also contains

a branch of leaves, perhaps from an ash, where Hopkins has made the background dark to emphasize the curving shapes of the branch and individual leaves, dated 'Kirk Braddan | Aug. 7 '73' (fo. 17) Such observations were to culminate in lines of poetry:

Not of all my eyes see, wándering on the world,
Is anything a milk to the mind so, só sighs déep
Poetry to it, as a tree whose boughs break in the sky.
Say it is áshboughs: whether on a December day and furled
Fast or they in clammyish láshtender combs creep
Apart wide and new-nestle at heaven most high.
They touch heaven, tabour on it; how their talons sweep
The smouldering enormous winter welkin! May
Mells blue and snowwhite through them, a fringe and fray
Of greenery: it is old earth's groping towards the steep
Heaven whom she childs us by.

('Ashboughs') 1887?

The rest of the book includes two sketches of clouds and a seascape that are very rough and quick—clearly aide-memoires of something beautiful seen (fos. 5, 32), the rather unsuccessful beginnings of a sketch of water flowing over a weir (fo. 13) and one of a tree trunk—crossed out (fo. 7)—both of which are rather harried work, two more successful but small sketches of water flowing over rocks, one towards the viewer (fos. 8 and 10), trees, crossed out; beginnings of a study of the head of a man in a hat that is rather firmly stuck on, but only the outline of the hat is complete (fo. 11). There are rough aide-memoires of tracery in stone (fo. 15) and 'I think Bp. Marshall's tomb, 1206—Exeter Cathedral' (fo. 16) and the beginnings of the shapes of two church windows, one above the other and a sliced corbel as in Parker but, running out of time, Hopkins has written on the page: 'These windows (the 8 bays of nave) and the East window and two plain 3 light lancets with round head in Θ clerestory of one transept and 3 beautiful windows in Θ chapter house most noticeable' (fo. 14). There are some sketches more like the early work but still not quite careful enough to be as good as the best of the early drawings. Among these is fo. 21—trees with a gate, where the technique is still there but again, because of hurry, the drawing is not sufficiently careful to give the distinction of each tree's own shape—the inscape is missing. Perhaps it was replaced by the following journal entry:

April 20 [1874]—Young elmleaves lash and lip the sprays. This has been a very beautiful day—fields about us deep green lighted underneath with white

daisies, yellower fresh green of leaves above which bathes the skirts of the elms, and their tops are touched and worded with leaf too. Looked at the big limb of that elm that hangs over into the Park at the swinggate/further out than where the leaves were open and saw beautiful inscape, home-coiling wiry bushes of spray, touched with bud to point them. Blue shadows fell all up the meadow at sunset and then standing at the far Park corner my eye was struck by such a sense of green in the tufts and pashes of grass, with purple shadow thrown back on the dry black mould behind them, as I do not remember ever to have been exceeded in looking at green grass. I marked this down on a slip of paper at the time, because the eye for colour, rather the zest in the mind, seems to weaken with years, but now the paper is mislaid. (*J* 242–3)

Belonging to this group that have clear affinities with the earlier work is a pencil sketch on fo. 27 of a seated woman who might be driving a carriage. It was not given a title or date by Hopkins, and another on fo. 29 of leaves, that is careful, rather graceful and beautiful. This page also has the incomplete sketch of the head of a dog that looks like the family's pet, Rover; Hopkins's eye seems more 'in'; perhaps the page was done on holiday at his family's home. The leaf shapes are drawn in bits but each line is set down confidently, the result of careful observation. There are a couple of sketches of hay stooks. There is also, on fo. 33, the early stages of a drawing of trees next to houses that is much less precise than his earlier work of a similar sort. Here white spaces are not always left, shapes are not clear, Hopkins has simply shaded in a bush over the doorway instead of sorting out what could be seen and drawing only that. There is a sketch made at Balaglas, Isle of Man, on 12 August 1873, which is hurried and explained in his Journal:

We passed the beautiful little mill-hamlet of Balaglas in the glen ... The rock is limestone, smooth and pale white ... stained red where the water runs and smoothly and vertically hewed by the force of the brook into highwalled channels with deep pools ... Round holes are scooped in the rocks smooth and true like turning: they look like the hollow of a vault or bowl. I saw and sketched as well as in the rain I could one of them that was in the making: a blade of water played on it and shaping to it spun off making a bold big white bow coiling its edge over and splaying into ribs. But from the position it is not easy to see how the water could in this way have scooped all of them. (*J* 235)

The verbal description is invaluable in deciphering the sketch. The sketchbook contains a few very rough sketches not reproduced in *AMES*: fo. 19 the almost indecipherable beginning of a sketch of a cliff, or overhang; fos. 25–8, which show two faces—one with bushy eyebrows, moustache and beard, crossed out; the other with round

spectacles and bumpy nose; a very rough sketch of a yacht, cancelled (fo. 25); church windows (fo. 26); flowers hanging in bunches resembling bluebells but the sketch is difficult to decipher (fo. 28); and fos. 72–3 which have pencil drawings of some sort of mechanism with loose thread and pulley? Weaving? Apart from the only industrial sketch, which is separated by thirty-two unused pages from the rest, the last few pages show subjects to which Hopkins had always turned: rocks, trees (*Monasterevan Dec. 29 '88*), and a stream flowing in *Lord Massey's domain, Co. Dublin April 22 1889*. Two months later he was dead.

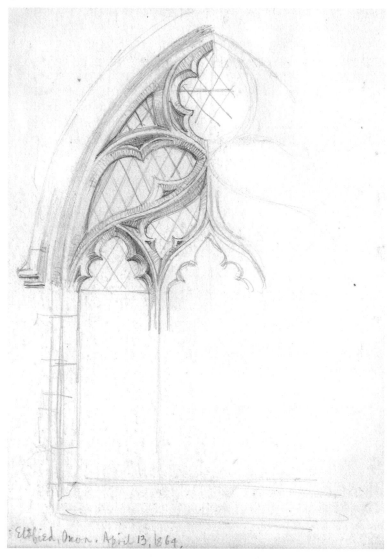

18. Gerard Manley Hopkins, *Elsfied, [Elsfield] Oxon. April 13. 1864*
(Balliol College)

3

'Dapple': Hopkins and Architecture

Another of the early influences on Gerard with lasting consequences was George Giberne's photography. His descendant, Lance de Sieveking Giberne, suggests that his grandfather began to experiment with photography in 1849. In an article in the *British Journal Photographic Almanac* George wrote that in 1858 'I first started clear from the difficulties of a beginner, and could depend upon obtaining satisfactory results from my endeavours'. He was then using the waxed-paper process that had succeeded Talbotype.[1] He included in the article 'the notes of a few days' photographic tour in 1858', adding, 'I wish some of your contributors would give similar notes of their tours in search of the picturesque, for the benefit of myself and others, for mine are nearly exhausted'.[2] The notes suggest that by 'picturesque' he meant aesthetically pleasing ruins.

July 29th.—Left London for Leeds by rail. Drove thence to Kirkstall, and at once took five negatives of the ruins of the abbey and developed them in one tray at the same time. All were very good.

July 30th.—Took one view of Kirkstall Abbey, breakfasted, and proceeded by rail and carriage to Bolton Abbey, and the same day took seven negatives of the ruins. Developed the whole the same evening—four in each tray of gallic acid at the same time. There was something peculiar in the water of the river close to the 'Devonshire Arms,' for the solutions made with it acted with surprising rapidity. [Hopefully they did not take their drinking water from the same source.]

July 31st.—Left Bolton early, and drove to the Brimham Rocks. Took two negatives at 10 a.m., and from thence drove to Fountains Abbey. Commenced work at 1.30, took six negatives, and thence drove to the railway station at Ripon, and by rail to Thirsk, where I developed the negatives—four in each tray, all excellent—and sensitised twelve more sheets.

August 2nd.—Drove from Thirsk to Rievaulx Abbey. Commenced work at 10.15, and took nine negatives. Developed them in two trays at the same time at Helmsley, where I slept.

August 3rd.—Drove from Helmsley to Bydal Abbey. At 11 a.m. took three negatives, and went on to York by rail. Took one negative of St. Mary's Abbey.

August 4th.—This morning took three negatives of York Cathedral and two of St. Mary's Abbey, and proceeded to London and home. Developed the nine negatives in two trays. All very good.

One wonders what the proprietors of the various inns made of his processing. The dedication needed for photography at the time was considerable. George wrote that in the late 1860s he would prepare some fifty photographic plates for one of his photographic tours only to encounter such wet weather that he might well return with two-thirds of the plates unused. A note he made later when using the dry-collodio-albumen process shows how dependent he would have been on reasonably good weather: 'a well-lighted landscape with buildings and trees, in summer, taken with a triplet or a view lens for a picture 10 × 8 and stop half-inch diameter, would require from fifteen to twenty minutes. By this process I do not remember a case of over-exposure, but in many a want of it.'[3]

In the 1860s Gerard was using his uncle's photographs as a source from which to draw architectural details and his diaries contain a number of examples of windows and doors. What he was doing was to excerpt from the complete composition of George's photographs examples of detail such as were used in *Parker's Glossary* or Ruskin's *Seven Ages of Architecture* or *The Stones of Venice* to indicate characteristics of particular styles. Gerard's mother gave him a copy of Parker's *Introduction to the Study of Gothic Architecture* at Christmas 1857. The beautiful little book was the result of a lecture series that Parker had delivered at Oxford in 1849. In it one can find the same admonition to study nature that Ruskin advocated. Writing of pillars in the Decorated style, Parker says, 'the flat surfaces in niches and monuments, on screens, and in other situations, are covered with delicately carved patterns, called diaper-work, representing foliage and flowers, among which are introduced birds and insects, and sometimes dogs or other animals, all executed with much care and accuracy, and proving that the artists of that time drew largely from nature, the fountain-head of all perfection in art, to which all who are not content to be mere copyists of their predecessors must apply themselves.'[4] Hopkins, influenced by Ruskin's 'laws',

sometimes reverses the process in his journal descriptions, expressing an understanding of natural objects almost as if they were carved sculptures or columns; for example:

Oaks: the organisation of this tree is difficult. Speaking generally no doubt the determining planes are concentric, a system of brief contiguous and continuous tangents, whereas those of the cedar would roughly be called horizontals and those of the beech radiating but modified by droop and by a screw-set towards jutting points. But beyond this since the normal growth of the boughs is radiating and the leaves grow some way in there is of course a system of spoke-wise clubs of green—sleeve-pieces. And since the end shoots curl and carry young and scanty leaf-stars these clubs are tapered, and I have seen also the pieces in profile with chiselled outlines, the blocks thus made detached and lessening towards the end. However the star knot is the chief thing: it is whorled, worked round a little and this is what keeps up the illusion of the tree: the leaves are rounded inwards and figure out ball-knots. Oaks differ much, and much turns on the broadness of the leaf, the narrower giving the crisped and starry and Catherine-wheel forms, the broader the flat-pieced mailed or shard-covered ones, in which it is possible to see composition in dips etc on wider bases than the single knot or cluster. But I shall study them further. (11 July 1866, *J* 144)

As Norman White has noted, Gerard adopted a number of the architectural terms in Parker, using them in his landscape descriptions.[5] For example, 'ribs and spandrils of timber garlanded with leaf between tree and tree ... It was this which was so beautiful—making a noble shaft and base to the double tree' (22 Aug. 1867, *J* 151–2), 'Firs very tall, with the swell of the branching on the outer side of the slope so that the peaks seem to point inwards to the mountain peak, like the lines of the Parthenon, and the outline melodious and moving on many focuses' (11 July 1868, *J* 172).

Among the terms most frequently used are Bay and Boss, which Parker defines as follows: '**Bay** ... a principal compartment or division in the architectural arrangement of a building, marked either by the buttresses or pilasters on the walls, by the disposition of the main ribs of the vaulting of the interior, by the main arches and pillars, the principals of the roof, or by any other leading features that separate it into corresponding portions' (*Introduction*, i. 50–1). Hopkins's best-known example is probably from 'The Wreck of the Deutschland', 'Yet did the dark side of the bay of thy blessing | Not vault them ... in?' (st.12, ll. 7–8). Here the use of 'vault' in conjunction with 'bay' shows how exactly Hopkins has pictured the architecture of his metaphor. '**Boss** ... a projecting ornament placed at the intersections of the ribs of ceilings, whether vaulted or flat; also used

as a termination to weather-mouldings of doors, windows, &c., and in various other situations, either as an ornamental stop, or finishing, to mouldings, or to cover them where they intersect each other; but their principal application is to vaulted ceilings' (*Introduction*, i. 58) In a 'Note on water coming through a lock' Hopkins wrote: 'There are openings near the bottom of the gates ... The water strikes through these with great force and extends itself into three fans ... The end of these fans is not seen for they strike [the openings] under a mass of yellowish boiling foam which runs down between the fans, and meeting covers the whole space of the lock-entrance. Being heaped up in globes and bosses and round masses the fans disappear under it' (late 1863, *J* 8). The use of 'fan' here would seem to have architectural significance. Parker noted that 'Fan-tracery Vaulting' was 'a kind of vaulting used in late Perpendicular work, in which all the ribs that rise from the springing of the vault have the same curve, and diverge equally in every direction, producing an effect something like that of the bones of a fan' (p. 160). Again, Hopkins is combining terms to produce an extended comparison rather like the 'underthought' he later detected in Greek drama in which a succession of images form a picture additional to that on the surface (see letter to Baillie, 14 Jan. 1883, *LIII* 252–3).

Among Parker's terms is Fret, which he defines as 'an ornament used in Classical architecture, formed by small fillets intersecting each other at right angles; the varieties are very numerous ... The term (as an adjective) is applied to anything set with precious stones, especially to a coronet, which is often called *a fret*, and to embossed work or minute carving, and, indeed, to almost any ornamental work which roughens the surface' (pp. 174–5). Hopkins uses the word in his poems, sometimes obscurely. 'The Bugler's First Communion', for example, contains the following image: 'freshyouth fretted in a bloomfall all portending | That sweet's sweeter ending' (line 30). Literally, 'fretted in a bloomfall' pictures the falling of the blossom which is a necessary step on the way to the tree's fruiting, as the mortality of the physical is a necessary stage in the obtaining of the perfect body in eternal life. 'Sweet' refers back to the communion wafer, the 'treat' that the priest fetches in stanza 3; 'bloomfall' is foreshadowed in several places, most clearly in the simile for the lad's acceptance of his moral instruction, 'yields tender as a pushed peach'. (Milton's 'On my three and twentieth year' provides a source of related ideas.) The line earlier read 'youth all fretted in a with the flower of fruit for the ending'. This was revised to 'not all so strains | Us: boyboughs fretted in a flowerfall', and ultimately to 'Us—freshyouth

fretted' (Facsimile ii. 181, 184). The revisions call on different meanings of 'fret' as the comparison changes from the youth as being like a tree decorated with fruit-tree flowers to being like a tree in which a viewer's attention is no longer caught by flowers but by the pattern of branches evident after the blossom has fallen (suggestive of more mature masculinity). The line could, therefore, draw more deeply on Hopkins's experience of observing trees and his knowledge of architectural terms than a casual reading might suppose.

Gerard does not appear to have copied any of the illustrations in Parker's books. At the end of his *Introduction to the Study of Gothic Architecture*, Parker mentions the 'revival which has taken so glorious a start in our own day, and to the improved character of which "The Oxford Society for Promoting the Study of Gothic Architecture," has materially contributed, by acting on the minds both of the architects and of their patrons, and enforcing upon them the necessity for the careful study of ancient examples' (p. 201). In a note, however, after remarking on how the movement has flourished, with growing numbers of societies devoted to Gothic architecture, he laments the destruction caused by enthusiastic but ignorant young men 'restoring' their local churches so that 'many valuable specimens of ancient art have been irreparably destroyed, instead of being carefully preserved as models for future ages' (p. 201).

The Hopkins family also owned James Fergusson's *Illustrated Handbook of Architecture* (2 vols., 1855), a more authoritative though classically biased history than Parker's, as well as his *Rude Stone Monuments* (1872), a present from Kate to Manley. When Gerard visited the South Kensington Museum in 1873, his eye was caught by the 'Standard portfolios of Indian architecture'. These were by Fergusson, who mentions in the introduction to his volume of Indian architecture, in which most of the illustrations are wood engravings done from his photographs, that he possessed some three thousand photographs of Indian monuments. Hopkins's interest in India, unsurprising at a time when a number of the people he would have known or known of at Oxford entered the Indian civil service or missionary societies, was keenest some years later in the 1880s when he exchanged with Baillie speculation about mythological and etymological links between Greece, Egypt, and India (11 Feb. 1886–6 Apr. 1887, *LIII* 257–86).

Hopkins went up to Oxford on 10 April 1863. His college, Balliol, had been founded at the end of the thirteenth century although by Hopkins's time the earliest remains dated from the fifteenth century. The chapel,

the fourth used by the college since its foundation, had been rebuilt in
1856–7 to a design by William Butterfield in the 'early Gothic style
of Lombardy'.[6] In a contemporary guidebook, John Henry and James
Parker described it as follows:

It is very lofty and handsome, has a fine east window and good side window,
and is fitted up in the most tasteful manner with Derbyshire alabaster at the east
end, and an elaborate screen at the west, parting off a small ante-chapel. The
lower part of this screen is of stone, solid, with sunk panels, the upper part of
light iron-work. The roof is of open timber, excepting over the altar-platform,
where it is ceiled and painted.

 The upper part of the walls is also painted in patterns, as are the sunk
panels between the windows. The side windows are filled with painted glass
preserved from the old chapel; two in the cinque-cento style of the time of
Henry VIII., representing the chief events of the Passion, the Crucifixion, and
the Resurrection of our Lord; two are filled with figures of saints, also in painted
glass, of about the same period; and four with later glass, by Abraham Van
Linge, the gift of Peter Wentworth, Fellow of the college, in 1637: the subjects
of two of these in the ante-chapel are the conversion and baptism of the Eunuch
by St. Philip.

 The walls are built with alternate streaks of red and white stone, after the
fashion of Italy; and horizontal strings of carved foliage are introduced on a
level with the springing of the east window, on the exterior,—a novel feature
in England. On the north side is a very tall and narrow campanile. There is a
brass eagle, now used as a reading-desk, the gift of Edw. Wilson, in the time of
Charles II.; also, against the western wall of the ante-chapel, a very beautifully
enamelled brass, in memory of J. B. Seymour, Esq., a Scholar of this college,
who died abroad in 1843. (pp. 197–8)

Describing the college to his mother Hopkins said, 'Balliol is the
friendliest and snuggest of colleges, our inner quad is delicious and has
a grove of fine trees and lawns where bowls are the order of the evening.
Sunk below the level of the quad, from which it is separated by a pretty
stone parapet, is the Fellows' garden, kept very trim, and abutting on it
our graceful chapel, which cost only one fourth as much as Exeter and
did *not*, as that did, run us into debt. We have no choir, organ or music
of any kind, but then the chapel is beautiful and two of our windows
contain the finest old glass in Oxford' (22 Apr. 1863, *LIII* 74). The style
is a quaint mixture of Gerard's bubbling enthusiasm and guidebook
description no doubt gleaned from the college handbook.

 Balliol had also had in hand plans for new buildings in the Gothic
style designed by Anthony Salvin. One of these had been opened in
1853 and Gerard chose a set of rooms in it in October 1863. They were,

he explained contentedly to his 'Mama', 'four steps higher than the ground floor, an arrangement which gives me the advantages without the disadvantages of a ground floor room for I am able to run in and out without climbing a flight of stairs, while my window is too high to be looked into and yet comfortably placed so as to look and talk out of' (19 Oct. 1863, *LIII* 82). Undergraduates were allowed to change rooms only once during their degree. The room in which Hopkins started was one of the cheaper attic ones.

Between 1850 and 1874 there were two new buildings in Oxford described by the Parkers as being in 'Grecian and Mixed Styles' (Worcester College, Painting of Chapel (Burges)) and the Oxford Corn Exchange opened in April 1863. By way of contrast there were in the same period twenty-six in 'Modern Gothic'.[7] These were: Magdalen College, Schoolroom (Buckler), 1851, Balliol College, Northern Building (Salvin), 1852, Balliol College, Chapel (Butterfield), 1856, The 'Union' Society's Debating Room (Woodward), 1856, Exeter College, Library, and Broad Street Front (Scott), 1856, Jesus College, East Front (Buckler), 1856, Exeter College, Chapel, and North Quadrangle (Scott), 1858, University Museum of Natural Science (Woodward and Deane), 1860, University College, New Library (Scott), 1861, St Alban's Hall, Chapel (Gibbs), 1863, The 'Union' Society's Rooms, Library, etc. (Deane), 1864, Christ Church, New Buildings (Deane), 1865, Merton College, New Buildings (Butterfield), 1865, Church of SS. Philip and James (Street), 1865, the Randolph Hotel (Wilkinson), 1866, Radcliffe Infirmary, Chapel (Blomfield), 1867, Savings' Bank (Buckeridge), 1867, Balliol, New Front to Broad Street (Waterhouse), 1868, London and County Bank (Pearson), 1868, St Barnabas Church, Jericho (Blomfield), 1868, Keble College (Butterfield), 1870, the Clarendon Laboratory (Deane), 1869, St Frideswide's Church 1872, New St Peter-le-Bailey Church (Champneys), 1874, Keble College, Chapel (Butterfield), 1874, New Buildings at New College (Scott), 1874.

It is hardly surprising that seeing the buildings going up around him and the talk of more that Hopkins should in December 1863 have made the following note in his journal:

There is now going on what has no parallel that I know of in [the] history of art. Byzantine or Romanesque Architecture [which] started from [the] ruins of Roman [architecture], became itself [a] beautiful style, and died, as Ruskin says, only in giving birth to another more beautiful than itself, Gothic. The Renaissance appears now to be in the process of being succeeded by a spontaneous Byzantinesque style, retaining still some of [the] bad features (such as pilasters,

rustic-work etc) of the Renaissance. These it will throw aside. Its capitals are already, as in Romanesque art, most beautiful. Whether then modern Gothic or this spontaneous style conquer does not so much matter, for it is only natural for [the] latter to lead to a modern spontaneous Gothic, as in [the] middle ages, only that the latter is putting off what we might be or rather are doing now. Or the two may coalesce. (J 13)

The larger historical picture that he sketches here is a simplified version of that laid out by Ruskin in *The Stones of Venice* and *The Seven Ages of Architecture* but the observations were his own, not just a transcription from the older critic. Nor was Hopkins's statement a parochial one. In June 1863 the *Saturday Review*, a paper that Hopkins frequently read, carried an article on 'The Architectural Exhibitions of 1863'. The prevalence of Gothic taste that Hopkins found at Oxford was fully evident here too, justifying his generalization. William Burges's design for the Church for Cork was described as combining his preference for Early French with Italian Gothic to produce a 'very dignified building ... We have no hesitation in saying that the design is one of the best specimens of ecclesiastical architecture which have been produced in England since the Gothic revival' (p. 792). The reviewer went on to comment on the unsuccessful designs in the competition for the Church at Cork and these too were 'Early Pointed' or like 'large and dignified collegiate churches with which the fourteenth and fifteenth centuries endowed the Flemish and German cities'. Among the other designs noted were 'Mr Seddon's tender for the Langham Hotel, in Pure Pointed', 'Mr Scott's Gothic Kelham Hall', Mr E. W. Godwin's Gothic Town Hall (Northampton), Mr Stapleton's 'half-Byzantine central hall' for an Hotel de Ville at Tourcoing, which 'is likely to be a successful advocate in favour of civic Gothic', and Mr Crace's restoration of the Guildhall in which 'he thoroughly caught the spirit of the fifteenth century' (p. 793). Scarcely anything is mentioned other than Gothic designs and although this may in part have been the result of the reviewer's preferences, it was both what Hopkins would have read and shows the prevalence in important commissions of Gothic designs.

 Among the leaders of the style was George Street, who wrote in the preface to his *Notes of a Tour in Northern Italy* (1855), that the 'supporters [of the Gothic] assert that pointed architecture is so essentially the effort of a particular age, and marked by certain peculiarities so decided, as to be filled, even in its most noble works, with a kind of spirit which in this age it is vain to attempt again to evoke. The old Gothic spirit is, they say, dead; and, glorious as it was, its flight was but meteor-like, and, having

passed across the horizon of the world in its rapid course, it has sunk beyond all possibility of revival' (p. xv). However, he asserted, when people 'talk of the virtues of Roman and Romanesque architecture, of the repose and the simplicity which distinguish them, of their grandeur and their general breadth and nobility of effect—in all these things they do but sing the praises of the best Italian architecture of the thirteenth and fourteenth centuries, and that in studying the style we may well be guided by it in what we do, not to the forgetfulness of the glories of our own land, but to the development in a forward direction of what we inherit from our forefathers of that architecture which, after a lapse of three centuries, we now see on all sides reviving with fresh vigour from its temporary grave, and which requires only prudence and skill on the part of its professors to make even more perfect than before' (p. xvii). When in September 1866 Hopkins volunteered to help Bridges in having a cruet designed and made as a gift for his elder sister, it was to Street that Hopkins turned for advice (see *LI* 4, 7–16).

Hopkins's interest in architecture flourished while he was at Oxford. As he had for drawing, he evidently tried to educate himself by reading; an entry in his diary for February–March 1865 includes among a list of books to be read: Beresford Hope's *English Cathedral*[8] and E[dmund] B[eckett] Denison's book on church-restoring (*Lectures on Gothic Architecture, chiefly in relation to St George's Church at Doncaster* (1855)) 'or something of the kind'(*J* 56). A. J. Beresford Hope was Butterfield's patron for All Saint's, Margaret Street. And as with art, Hopkins found a good friend in Baillie who, as Hopkins mentioned in a letter of 23 January 1864, introduced him to Alexander 'Wood of Trinity', whose attraction was that he 'has some beautiful architectural photographs' (*LIII* 87). The friendship with Wood was to last for most of the rest of Hopkins's life.

By Easter 1864 Hopkins seems to have worked out a tour of Oxford on which he could take his visitors that combined buildings recommended by guidebooks of the period with contemporary buildings. The list in his diary reads: 'New College Chapel and Gardens; Trinity, S. John's, Wadham, ditto. The Radclyffe. The Bodleian. Christ Church Meadows. The Barges. The Tow Path. Merton new buildings. Christ Church new buildings. The Botanical Gardens. The Museum' (*J* 21). The question is why he chose these and not others: was it their religious significance or their architectural style that appealed, or a combination? The colleges reflected the history of the Catholic Church at the time of the Reformation. The aesthetic element becomes clear in comparing

the 1858 and 1875 editions of the Parkers' guide to Oxford. In 1858 they asserted, 'that it may be said with perfect truth that Oxford, as a whole, is one of the most remarkable and most picturesque cities in Europe … Perhaps no other place affords for its size so great a choice of excellent subjects for the pencil of the artist, whether we look at the distant and general views, the streets, or the separate buildings, even to their minute details' (1858, p. xvii). By the time of John Parker's new edition of 1875 the celebration of the city as full of artistry had been replaced by a very different paragraph in which it was remarked,

Oxford has been made the field for experiments, and as the fashion of the day has been to look for novelty rather than for harmony, the new buildings are not only incongruous with each other, but appear quite out of place amidst the buildings which were previously here, and disturb the repose which has been so frequently referred to as the characteristic of Oxford. We had, it is true, two rival styles, the Palladian and the late Gothic, side by side, but both were treated with severity and a certain amount of simplicity; hence the contrast was not so displeasing even where they were brought together. But the many and varied novelties displayed in the new meadow-fronts of Christ Church and Merton, in the New Museum, in the new front to Balliol, and especially in the brickwork of Keble College, form a contrast very far from pleasing amidst the regular masonry, the simple outlines, and the unobtrusive ornament of the buildings previously in existence. (1875, p. xxvii)

With some of these experiments Hopkins would have been in favour though he was to lament the 'base and brickish skirt' that 'sours | That neighbour-nature thy grey beauty is grounded | Best in' ('Duns Scotus' Oxford'). This may refer to some of the college buildings and churches as well as the flourishing brick suburbs of the mid-1870s regretted by William Morris and John Ruskin.

New College Chapel, first on Hopkins's list, was opened in 1386. The college had been founded by William of Wykeham to train clergy to replenish the stock of those depleted by the Black Death. It was to combine ecclesiastical and educational functions, something evident in its design. It is celebrated as an early educational use of Gothic style, which had previously in England been used largely for churches. New College Chapel was described by the Parkers as:

the pride not only of the college, but of the University, in which it forms one of the most distinguished ornaments. The entrance is by a short cloister into the elegantly proportioned ante-chapel; in which are still to be seen some of the original painted windows of the time of the founder, representing figures of the saints and martyrs … The great west window was painted … from finished

cartoons furnished by Sir Joshua Reynolds and begun in 1777 … . The carvings under the seats, or misereres … are a very curious series, many of them extremely grotesque, and are of the time of the founder. (pp. 141–5)

One can see how a taste formed by Ruskin would appreciate the preserved Gothic style with its individual grotesque ornament. The Garden, which was 'beautifully laid out with trees, shrubs, and flowers' was surrounded by 'the old city wall, with its alure or walk on the top, within the parapet, and the bastions, with their loopholes for arrows, commanding the approach to the postern gate: all these are in the most perfect state possible, according to the agreement of William of Wykeham with the city at the time of the foundation of his college, by which he bound the society for ever to keep them in good repair' (pp. 148–9). It was in this garden that Hopkins set his 'Platonic Dialogue' titled 'On the Origin of Beauty'. The new buildings to which Hopkins refers may have been those designed by Deane, which were in Gothic style and opened in 1865.

The next place on Hopkins's tour, Trinity College, which had a common boundary on the east side with Balliol, was the first college to be founded after the dissolution of the monasteries. Built upon the grounds of the Benedictine Durham College, it was 'founded at the close of the thirteenth century, as a nursery for the Benedictine priory at Durham' (p. 214) and subsequently suppressed by Henry VIII. Bishop Angerville de Bury had bequeathed his famously extensive library to Durham College on terms that made it 'the first public library in Oxford'. Some of these books, scattered at the Reformation, were said to have found their way to Balliol, though by Hopkins's time no examples were extant. The stained glass in the windows was said to be fifteenth century, manufactured at York, which was for its colouring 'the finest in Europe'[9] and interesting, particularly the figures of the Evangelists, of Edward III and Philippa, St Cuthbert, and St Thomas à Becket, who is represented with a fragment of Fitz Urse's dagger in his forehead. It is probable that these were brought from the old chapel, 'whose admirable Gothic painted glass in the windows is mentioned by Aubrey' (*Handbook*, 217–18). The chapel, consecrated in 1694, was 'according to the prevailing taste of the day, after the Grecian school, the former being of the Ionic, the latter of the Corinthian order, both very favourable specimens of their class. The interior is deservedly much admired for its beauty of proportion, but more particularly for the exquisite carving of its screen and altar-piece, where with the cedar is also a mixture of lime, in the best style of [Grinling] Gibbons' (pp. 216–17).

St John's College, on the other side of Balliol, dating from 1555, had an entrance gateway built *c*.1440 and originally belonging to a Cistercian foundation, St Bernard's College, on the site. It was commented upon by Parker as a unique example of true Gothic work that contravened one of the 'acknowledged characteristics of Gothic work, that all the mouldings and shafts, except the dripstone, are within the opening or receded from the face of the wall' (pp. 236–7). The gate has triple shafts projecting from the face of the wall that carry the weight of the dripstone. Parker remarks that the gate and tower to which it belongs 'speak of the better days of architectural design' (pp. 236–7). The college was noted for the refusal of two of its Presidents to take the Oath of Supremacy and its adherence to the Stuart cause; the funeral oration of its re-founder, Sir Thomas White, in 1566 was given by Edmund Campion, about whom Hopkins later wrote an ode that has not survived. The gardens of St John's extend to three acres and have beautiful trees. They offer 'choice views of the library (its face designed by Inigo Jones), Wadham College and buildings of the University (pp. 239, 240).

Leaving St John's College through the back gate Hopkins and his guests would then have proceeded to Wadham College, a seventeenth-century foundation on the site of an earlier Augustine or 'Austin' (as Hopkins often writes it) institution. The chapel, like the hall dating from the college's foundation, 'exhibits great taste and purity of style [Gothic] in the character of its architecture', with an English oak roof and seventeenth-century glass. The college gave most of its beautiful silver to supporting Charles I, and the Warden and Fellows were consequently expelled by Parliament. The buildings were praised by Parker for being 'particularly uniform and pleasing, and, with one or two exceptions, in admirable taste throughout' (pp. 124–5). Letters written from Oxford to his mother and friends show that Hopkins absorbed this descriptive manner.

There were several buildings called the Radcliffe but Hopkins is most likely to have been referring to the Radcliffe Camera, an eighteenth-century construction with a basement in a double octagonal shape and a tower some hundred feet in diameter above. From the open parapet at the top of the walls a panorama of Oxford unfolds, described by the Parkers as 'unrivalled by any city in Europe' (1858 edn., p. 78). Beside the Radcliffe is the Bodleian, which occupied the whole of one wing of a quadrangle known as the Schools and the upper story of another. It was originally built in the mid-fifteenth century and refurbished between 1597 and 1602 through the efforts of Sir Thomas Bodley. Its treasures

by Hopkins's day included hundreds of Greek and Latin and Oriental manuscripts, the collection of early English poetry and plays made by Malone (who produced editions of Shakespeare), and the topographical works of Richard Gough.

Hopkins's tour then took him through the Christ Church Meadow and along the river, seeing the Barges and the Tow Path before returning to view Merton's new accommodation designed by William Butterfield and opened in 1864 and that of Christ Church by Sir Thomas Deane. Of Merton Hopkins commented sardonically to his mother, 'The new buildings at Merton are finished externally and are beautiful and of course universally maligned' (23 Jan. 1864, *LIII* 87). In 1872 Charles Eastlake wrote that 'Mr. Butterfield's additions to Merton College are chiefly remarkable for their studied simplicity. But here, as in almost every work carried out by this architect, one may note his inclination to oddities. The corbelling of the chimney shaft on a wall facing the meadow is extremely whimsical, but it has the advantage of setting his seal on the design. No one else would have attempted so bold an experiment' (p. 287).[10] Hopkins was also interested in the chapel. 'I was wrong about Merton,' he noted in his diary (Mar./Apr. 1865, *J* 59).

The sexton says the font, with its cover and bracket, the reredos, the choir-screen, gates and metal-work, everything in fact except the pulpit were designed by Butterfield. The quatrefoils etc in the stalls at first to have been open. Of the *sedilia* only the two first bays, that is a walled-up door and a narrow arch, and the spring of the next arch are old: the rest was razed to the level of the wall and blocked up by the monument now placed in the bay of the intended S. aisle. All but the parts named above therefore are by Butterfield, carefully following out the old work. The tiling is by him too. In the same way the font and other things are in keeping. There was once much more ornament (fleurs-de-lys etc) in the red altar-cloth which was taken away by order of the college. The altar-piece is by Tintoret. The transept-roof also must be by Butterfield.

Hopkins's comment on the removal of the altar-cloth suggests the tussle between Anglican and Anglo-Catholic factions that characterized Hopkins's time at Oxford. A few minutes' walk north of Merton, having passed through the Botanical Gardens, Hopkins's visitors would have arrived at the Oxford Museum, built 1856–8 in early Gothic style by Deane and Woodward and strongly influenced by Ruskin. The Museum, a landmark in the development of science at Oxford, brought together many of the science departments of the University and its construction was a curious mixture of Gothic carving and iron structural supports. Its façade included fanciful stone carvings of foliage

and animals around the windows and, inside, a courtyard was covered in glass held up by iron pillars with capitals decorated in leaf designs. Cloisters around the courtyard had pillars of various types of stone showing the main geological formations of the British Isles. Hopkins's tour thus encompassed genuine Medieval Gothic collegiate buildings with Catholic significance, contemporary extensions of the style, places that for Hopkins would have been part of his life in Oxford—such as the river bank—and one or two famous university facilities, such as the Bodleian and Oxford Museum.

In his diary of 14 May 1866 Hopkins wrote with disgust, 'Waterhouse is to do the new buildings of the college. Ernest Geldart [a pupil of Waterhouse] is up on the business. Jowett [the Master of Balliol] had him and the other man in to his rooms and held forth about proportion—after rejecting Butterfield' (J 136). There had been lengthy discussions in Balliol about whether to lengthen or widen the chapel. Butterfield's view was that he would have liked to do both had the budget allowed but, given the choice, he opted to widen and heighten the chapel, keeping within its old length: 'I felt', he explained, 'that by giving the Chapel extra length and height, and the latter I feel must be given in any case, without extra width, we gain undesirable proportions.'[11] A letter from Jowett to Thomas Woolner explains the rejection of Butterfield: 'in choosing Mr. Waterhouse we hope to avoid eccentricity and Unenglish styles and fancies. Simplicity and proportion[;] such (not colour) always seem to me the great merits of Architecture.'[12] The counter-argument was made by George Street, who claimed that, 'at the present day there is, I think, absolutely no one point in which we fail so much, and about which the world in general has so little feeling, as that of colour. Our buildings are, in nine cases out of ten, cold, colourless, insipid, academical studies, and our people have no conception of the necessity of obtaining rich colour, and no sufficient love for it when successfully obtained. The task and duty of architects at the present day is mainly that of awakening and then satisfying this feeling; and one of the best and most ready vehicles for doing this exists, no doubt, in the rich-coloured brick so easily manufactured in this country, which, if properly used, may become so effective and admirable a material.'[13] Hopkins's pair of sonnets 'To Oxford' of June 1865 describes a chapel. Although it is difficult to find a chapel in Oxford at the time that fits all the details that he gives, the 'vigorous horizontals' suggest the banding of red and white stone that Butterfield had used for Balliol; the 'window-circles' and 'steep-up roof ... behind the small | Eclipsing parapet' would also fit.

This is my park, my pleasaunce; this to me
As public is my greater privacy,
All mine, yet common to my every peer.

Those charms accepted of my inmost thought,
The towers musical, quiet-wallèd grove,
The window-circles, these may all be sought
By other eyes, and other suitors move,
And all like me may boast, impeachèd not,
Their special-general title to thy love.

Thus I come underneath this chapel-side,
So that the mason's levels, courses, all
The vigorous horizontals, each way fall
In bows above my head, as falsified
By visual compulsion, till I hide
The steep-up roof at last behind the small
Eclipsing parapet; yet above the wall
The sumptuous ridge-crest leave to poise and ride

None besides me this bye-ways beauty try.
Or if they try it, I am happier then:
The shapen flags and drillèd holes of sky,
Just seen, may be [to] many unknown men
The one peculiar of their pleasured eye,
And I have only set the same to pen.

It is clear that by 1866 Hopkins was a staunch admirer of Butterfield. The first indications we have that he had noticed his work date from 22 April 1863, when he remarked to his mother that it was a pity that 'Margaret St. Church [All Saints'] could not have borrowed something from' Littlemore Church 'which Newman's mother built ... It is quite dark when you enter, but the eye soon becomes accustomed to it. Every window is of the richest stained glass; the east end, east window, altar and reredos are exquisite; the decorations being on a small scale, but most elaborate and perfect' (*LIII* 74). All Saints' was the model church of the Tractarian Ecclesiological Society, which had been founded as the Cambridge-Camden Society in 1839, to revive the traditions of ceremonial Anglican worship, restore medieval churches and build new ones.[14] It had been commissioned by them in 1841 as a 'model' church in the Gothic style of the late thirteenth and early fourteenth centuries, built of 'solid materials', constructed and decorated to proclaim Tractarian beliefs. Among the criteria for selecting the architect were his 'Christian qualities'. Butterfield was less Tractarian than his patrons but

proportioned the church so that almost a third of its length was given
to the chancel, thereby fulfilling the Tractarian requirement that the
Sacraments be seen to be more important than the Word (p. 16). The
church became the 'flagship' of the movement, establishing the cele-
bration of the Eucharist on Sundays, 'the regular recitation of morning
and evening prayer, providing spiritual counselling, the sacrament of
penance and reconciliation' and appealing to the senses with incense,
lights, vestments and the elevation of the sacrament (p. 2).

In building All Saints', Butterfield had faced a number of practical
difficulties. The site was only 100 feet square and had to accommodate,
in addition to the church, its choir school with classrooms, dormitory,
kitchen, and dining room, as well as a house for the vicar, his two curates,
and their servants (Thompson, 321). Since the back of the site would
have been miserably dark for a school and house, Butterfield placed
the church along the back of the site and had the house and school
at the sides jutting forward to the street front and conforming to the
cornice and roofline of the adjacent Georgian buildings. By placing the
connecting corridor between school and house in a basement, Butterfield
was able to construct an entrance courtyard that allowed a good view of
the church. Today as well as the church, the courtyard is well used, its
benches and gardens making it a welcome lunchtime retreat for nearby
office workers. The east end of the church could have no windows, since
on three sides the site was hemmed in by other buildings with unbroken
brick walls. The difficulty was met by a rich, gilded fresco, commissioned
from William Dyce in fifteenth-century Italian style with incised and
moulded contours that caught the light from the side window, enabling
it to combine the functions of a stained glass window with a medieval
reredos.[15]

By 1869 Hopkins had another connection with All Saints' because
his sister Milicent became an 'out-sister' of the All Saints' Home, a
sisterhood founded in 1851 by the vicar William Upton Richards to
run a hospital, orphanage, and convalescent home. Maria Francesca
Rossetti was a full Sister in the same order from 1873 and Milicent
followed her five years later (*J* 361). A. J. Beresford Hope, in his *The
English Cathedral of the Nineteenth Century*,[16] which Hopkins reminded
himself to read, declared of All Saints', Margaret Street, for which
he had been Butterfield's patron, 'It was the first decided experiment
in London of building in polychromatic material; and the numerous
brood of imitations which has followed its path attests the vitality of the
attempt' (p. 234). Thompson, placing the church in a larger context,

says that, 'It was at All Saints' that constructional colour in brick and marble, the hallmark of High Victorian architecture, was first displayed' marking Butterfield as the 'pioneer of the original High Victorian phase of the Gothic Revival' (p. 4). Butterfield modelled the vaulted interior upon the church of S. Francesco at Assisi, the source he later used for Keble. Thompson suggests that Butterfield was also strongly influenced by Ruskin's *Seven Lamps* in deciding upon 'a church whose character and beauty and effect of colour shall arise from *construction* and not from *superaddition*, namely that the pillars shall be *made of granite*, and ... the diaper be an encrustation of tiles, and not the track of a paintbrush'.[17] However, Butterfield developed the idea of constructional decoration along his own lines both in the use of tiles (while Ruskin preferred marble), and in making the pattern clearly related to the basic plan of the church. Thompson suggests that the vibrant use of colour offended Victorians morally as well as aesthetically (p. 229). Ruskin, as with the Pre-Raphaelites, sought to counter the argument, claiming in *The Stones of Venice* that, 'None of us enough appreciate the nobleness and sacredness of colour ... All good colour is in some degree pensive, the loveliest is melancholy, and the purest and most thoughtful minds are those which love colour the most.'[18] Even today visitors do not always like the coloured interior. Thompson explains that All Saints'

took many years to complete, so that in form as well as colour many of the details belong to Butterfield's later tastes and do not easily match the first intention. The tile painting of the aisle walls and tower arch, for example, used the maroon and apple green of the 1870s and 1880s and at present clash with the crisper, more jewelled effect of the tiling over the arcades. Complete cleaning would lessen the contrasts, but even so there is no doubt that All Saints' suffered from its chequered history, and it will always require imagination to understand the scheme as Butterfield first conceived it, a brilliant reflection of the coloured interiors of Italy, of Assisi and Orvieto, which he wished to recapture in the cold monotony of Early Victorian London.

The essential effect can nevertheless be glimpsed on a bright summer day, or in the evening fully lit: the cooler cream and pink nave, with its patches of black and highlights of rich yellow and green, a prelude to the darker vaulted chancel and the gorgeous east wall, tiers of bright blue and red figures standing under great gilded crocketed canopies. It is unforgettable, as if suddenly an overwhelming and triumphant chorus of praise had broken the monotonous rumble of the streets. (p. 235)

All Saints' won the praise of George Street and Ruskin for its beauty, originality and vigour.

As an undergraduate Hopkins was clearly accumulating information about Butterfield from a variety of sources. He recorded, probably from a newspaper in October? 1864 that 'Butterfield's new church [St Sebastian's, Wokingham]' has been 'built for £800 on the Nine Mile Road between Finchampstead and Ascot' (*J* 49). Paul Thompson comments that 'Butterfield was probably more skilled in cheap church building than any of his well known contemporaries; Wokingham, for instance, was given him when Blomfield had not seen his way to cut his designs to the available funds' (p. 381). In February/March 1865 Hopkins noted that Wootton Church had just been restored by Butterfield (*J* 56). Here Butterfield's main job had been to extend the chancel into the nave and add a new porch (Thompson, 446). The following month Hopkins recorded that 'Butterfield built Lavington church [St Mary Magdalen's] in Sussex (where, April 7, Mr. Cobden was buried), and the Parsonage house, I believe' (Apr. 1865, *J* 60). Butterfield had been building them for Archdeacon Manning of Chichester and curate Laprimaudaye but both became Catholic converts before they could occupy them (Thompson, 31). From his friend, E. H. Coleridge, Hopkins may have gleaned that 'Butterfield has restored Ottery St. Mary church for John Duke Coleridge [E. H.'s cousin] and painted his drawing-room, whom he knows. Bill high' (Mar./Apr. 1865, *J* 59). Coleridge was evidently pleased with the work and commissioned Butterfield to carry out substantial reconstruction of his home in the 1880s (Thompson, 407–8). The church at Ottery St Mary Thompson considers 'Perhaps the supreme example of this first phase' with its 'wonderfully light and creamy brown stone interior ... medieval vaulting in blue, red and gold' and windows glowing with the same primary colours (p. 232).

In September 1867 Hopkins visited Butterfield's new church at Babbacombe (*J* 156), which was not yet complete. The main body of the church was consecrated on 1 November 1867.[19] Seven years later, the year in which the completed church was opened, he returned, as he wrote in his Journal, 'with John Lynch, who had come to meet me'. This time his reaction to the church was evidently more critical:

It is odd and the oddness at first sight outweighed the beauty. It is long and low, only a foot or so, just to mark the break, between the nave and aisle (lean-to) roofs (I am nearly sure I remember there being once a wider interval with quaterfoil fanlights); the windows scattered; the steeple rather detached, not, I thought, very impressive, with an odd openwork diaper of freestone over marble pieces on the tower/and on the spire scale-work, and with turrets at

corners. There is a hood of the same diaper at the east-end gable from the spring of the arch of the east window about upward. Tracery all simple. Inside chancel-arch much as at St. Alban's, Holborn—a cross and lozenges in freestone enclosing black-and-white patterned tiles set in chequer and the pattern, more by suggestion than outright, passing from one to the other—something of this sort: I am not so sure of the tiles being squarehung—they may have been lozenges. Same sort of thing down the nave above and in the spandrils of the arches—diamonds and tiles but also seven-foiled blind tracery in the spandrils meant to contain mosaic, the foils not symmetrical but somehow thus. And in other places were other such openings, whether lights of windows or blind and enclosing mosaics, as in the reredos and each side of the choir, some six-foiled fishes, some otherwise. In two of them he makes use of the split or spiked cusp (I call it)— . Much marble is employed—pillars, font, pulpit, choir pavement, reredos, medallions round east window etc—and everything very solid and perfect. Pulpit beautiful, like a church or shrine and in three storeys, basement, triforium etc. Medallions by east window/alternate inscapes—all five-spoked wheels or roses—odd. Some of these patterns in the marble, as on the floor and on the stage or block by the font, were large and simple but not very striking. There was a more quarried look about the designing than he commonly has (in the ceiling for instance). The nave roof-timbers and choir cieling were remarkably flattened: I liked this. The enrichment grows towards the altar, the choir ceiling having two degrees of it. Rafters there fluted and striped, webs between sown with bigger and smaller stars or rowels on pale sea-green ground. Wrought brass chancel gates with a running inscape not quite satisfying, continued by deep marble party-wall (as at Margaret Street) pierced by quarterfoils. Very graceful gasjets from the walls. (18 Aug. 1874, *J* 253–5)

Much of the marble was local.

Thompson explains that 'System in Butterfield's ornament can always be found if one looks for it'. He takes the nave at Babbacombe as an example: 'The ribbed diagonal web across the walls should be read as a play against the continuous wall surface behind it. Set within the wall surface is an apparently irregular and partial chequer of white stones inlaid with black patterns. Their half-sketched black and white lines form a third element, weaving behind the diagonal ribs, in Gerard Manley Hopkins' words, "more by suggestion than outright, passing from one to the other".' Thompson praises Hopkins for 'his sense of line and instinctive search for the integrity of form', which, he claims enabled him to grasp that Butterfield's decorative patterns are always linked to the architectural form of a building: 'circles to

stabilize the horizontals, for example, or running tendrils picking up the spring of an arch. In the same way the seven-foiled blind medallions in the spandrels of the Babbacombe arches—another detail admired by Hopkins—lead the eye upwards towards the diagonals. The effect softens the meeting of web and arch. Had Butterfield wished to emphasize the mass of the loadbearing arch, he would have used a circle in the spandrel combined with simplified arch mouldings, as he had at Penarth' (p. 267).

There are in Hopkins's landscape descriptions signs of the taste that evidently attracted him to Butterfield's work. For example, 'The day was rainy … The clouds westwards were a pied piece—sail-coloured brown and milky blue … far in the south spread a bluish damp, but all the nearer valley was showered with tapered diamond flakes of fields in purple and brown and green' (19 Oct. [1874], *J* 261); not only is the pieing characteristic of Butterfield but the palette is one that he used a number of times. The same thing is evident in the poem, 'Pied Beauty' with its praise of 'dappled things': 'skies of couple-colour as a brinded cow', 'rose-moles all in stipple upon trout that swim', 'fresh-firecoal chestnut-falls' scattered on the ground, banded 'finches' wings', 'landscape plotted and pieced', 'all things counter, original, spare, strange; | Whatever is fickle, frecklèd'; these things 'He fathers-forth whose beauty is past change: | Praise him.' 'Pied Beauty' is the most concentrated example of such taste but snippets of it occur throughout Hopkins's writing.

Hopkins's liking for coloured interiors such as that at Babbacombe, often achieved through tiling, may also help to explain the warmth of his reaction to Frederic Leighton's painting *Old Damascus: Jews' Quarter* (see cover illustration), displayed in the Royal Academy Summer Exhibition of 1874. He wrote that it 'seemed to me the gem of the exhibition. Marble paved striped court of house, striped pillar, delicately capitalled brace of corbel-pillars springing from the channelled half-architrave Arab capital, vault of arch as well as heads or lintels of doors covered with inlaid roundels of all sorts of designs, the nearest arch however not in roundels but in more highly wrought arabesque patterns', analysis that derives ultimately from his long-established interest in architecture: 'Clever rich shading … of the brown marble in the head of the two pairs of lights. There was in the picture a luscious chord of colour (which grew on me)—glaucous (blue, with green and purple sidings) × browns (with reds to match). … in the blue scale, which was dominant or predominant in the whole picture were the inlaid blue-panelled door,

which struck the keynote, and the panelling in the shade of the arches within the [portico], some of the roundels, mosaics in the vault of the arch etc In the red scale were ... some mosaic and the brown marble framing of the braced windows, in which, as I have said there was a beautiful flush of dark' (J 246).

After visiting the Royal Academy Exhibition, Hopkins and Brother Bampton went to All Saints' Margaret Street. Hopkins wrote, 'I wanted to see if my old enthusiasm was a mistake, I recognised certainly more than before Butterfield's want of rhetoric and telling, almost to dullness, and even of enthusiasm and zest in his work—thought the wall-mosaic rather tiresome for instance. Still the rich nobility of the tracery in the open arches of the sanctuary and the touching and passionate curves of the lilyings in the ironwork under the baptistery arch marked his genius to me as before. But my eye was fagged with looking at pictures' (12 June 1874, J 248). Eastlake commented that 'Butterfield's iron-work was almost from the first original. In All Saints' and afterwards in St. Alban's Church he adopted for his screens that strap-like treatment of foliation, which was then a novelty in the Revival, but which is not without precedent and is unquestionably justified by the nature of the material used'.[20] It presages the more elaborate coils of Art Nouveau. Eastlake concluded that, 'The truth is that the design [for All Saints' Margaret St] was a bold and magnificent endeavour to shake off the trammels of antiquarian precedent, which had long fettered the progress of the Revival, to create not a new style, but a development of previous styles; to carry the enrichment of ecclesiastical Gothic to an extent which even in the Middle Ages had been rare in England; to add the colour of natural material to pictorial decoration; to let marbles and mosaic take the place of stone and plaster; to adorn the walls with surface ornament of an enduring kind; to spare, in short, neither skill, nor pains, nor cost in making this church the model church of its day—such a building as should take a notable position in the history of modern architecture.'[21]

Thompson comments that 'in Butterfield's compositions we see not merely a search for harmony, a desire to please the eye, but also a conscious and systematic exploration of form. It might not be thought that for an architect working in the Puginist tradition of picturesque rationalism any such system was necessary. 'An architect should exhibit his skill', Pugin had written, 'by turning the difficulties which occur in raising an elevation from a convenient plan into so many picturesque beauties.' Gerard Manley Hopkins, whose admiration for

Butterfield continued for longer than is often realized, perhaps most clearly expressed the distinction between Butterfield's interpretation of the Gothic and its vulgarization when, in 1877, he wrote to Butterfield from St Beuno's to thank him for sending a list of buildings, which he had asked for:

Dear Sir, I am exceedingly obliged to you for your kind compliance with my wish, but now that your lists are in my hands I feel ashamed to have asked so much: I did not well realise how long the catalogue would have to be.

Keble College I am very likely to see and those of your buildings in London which I did not know of, the others I shall visit as chance puts me in the way. I hope you will long continue to work out yr beautiful and original style. I do not think this generation will ever much admire it. They do not understand how to look at a Pointed building as a whole having a single form governing it throughout, which they *would* perhaps see in a Greek temple: they like it to be a sort of farmyard and medley of ricks and roofs and dovecots. And very few people seem to care for pure beauty of line, at least till they are taught to.[22]

With this letter in mind, Thomson comments that, 'it is in the sympathetic spirit of Hopkins, rather than with the jaundiced eye of most recent critics, that we are most likely to reach understanding of Butterfield's architectural composition' (pp. 304–5).

Hopkins's views were also expressed by George Street, who had written some twenty years earlier, 'It appears to me that [many people] confound the accidents with the elements of the true Gothic architecture of the Middle Ages, and mistake altogether the object which, I trust, most architects would propose to themselves in striving for its revival. The elements are the adoption of the best principles of construction, and the ornamentation naturally and properly, and without concealment, of the construction; the accidents are, as it appears to me, the particular character which individual minds may have given to their work, the savageness, or the grotesquesness as it has been called, which is mainly to be discovered in the elaboration of particular features by some particular sculptor or architect, and which in the noblest works—and, indeed, I might say, in most works—one sees no trace of. The true Gothic architects of the Middle Ages had … an intense love of nature grafted on an equally intense love of reality and truth, and to this it is that we owe the true nobility and abiding beauty of their works; nor need we in this age despond, for if we be really earnest in our work, there is nothing in this which we need fear to miss, nothing which we may not ourselves possess if we will, and nothing therefore to prevent our working

in the same spirit, and with the same results, as our forefathers'.[23] There are here a number of Hopkins's artistic touchstones: the insistence on faithful representation of nature, in which Hopkins had been encouraged by Ruskin's admonitions, the uniting of form with content, advocated by Pater in his 'School of Giorgione', the need for patterning to have significance. All these required the serious, 'earnest', commitment of the artist or architect. What Street here condemns, and which is not in Hopkins's writing, is the political or social interpretation of Gothic that Ruskin emphasizes in 'The Nature of Gothic', where the individual eccentricity suggests to him the expression of individual personality. Hopkins's mature understanding replaces that cultural element of the famous critic with one of religious significance.

Along with his enthusiasm for Butterfield, Hopkins retained his admiration of Medieval Gothic architecture. On 16 June 1866 he recorded 'Wells Cathedral with great pleasure in morning' (*J* 140). Wells was not constructed around Saxon or Norman ruins but replaced them, becoming the first English cathedral to be conceived entirely in a Gothic style. Paul Johnson says that it 'must come close to the ideal cathedral in the English manner'.[24] Three months after revisiting All Saints' in 1874 Hopkins noted on a visit to Bristol with Mr Foley and Considine:

St. Mary Redcliff—narrow and so looks high; spire just lately completed—it had been truncated, one storey only. It is under restoration by Godwin and so the choir boxed off as Exeter Cathedral. It is mostly good and rich early Third-Pointed but the steeple and North Porch are Middle-Pointed rich and terminal (split cusps etc), some parts are First-Pointed and the whole shell of the church I believe is so. This north porch is striking: it is a hexagon, if I remember; the windows richly foiled but the cusps not split, though the effect is much the same: buttresses run up and end in a wedge upon their mullions, with odd effect. Within, opening on the church, two beautiful First-Pointed arcades with the heartfelt grace and flush in the foliation of the capitals that belongs to that keeping. Odd windows in transepts with a band of quaterfoils enclosing the rest (Third-Pointed). Third-Pointed finely proportioned tomb behind altar, in two compartments with canopy. The Geometrical windows at the west end of aisle and in basement of tower are modern. Here and at the Cathedral tombs with fine rich remarkably designed Middle-Pointed canopies. Of the Cathedral we could not see much. Street is adding a nave to it: designs cold, not pleasing. (20 Aug. 1874, *J* 256)

Hopkins's taste in architecture can, therefore, be seen to be an admiration of Gothic, which in Pugin's writing was given associations

with Catholicism. He also, in keeping with his love of Pre-Raphaelitism, welcomed the rich colouring, and prominence of pattern that, as in his drawing, has implications of form rather than being just decorative. Hopkins's poem, 'Who shaped these walls has shewn | the music of his mind', for a long time mistakenly titled 'On a Piece of Music', grows out of architectural comment. In it Hopkins praises a building that reveals the mind of its architect or builder. It seems likely to have been a church or chapel made of stone with unified design:

> Who shaped these walls has shewn
> The music of his mind,
> Made known, though thick through stone,
> What beauty beat behind.
>
> How all's to one thing wrought!
> The members, how they sit!
> O what a tune the thought
> Must be that fancied it.
>
> (*OET* 159)

Though the poem goes on to place the aesthetic qualities that he notes below the moral attributes of Christianity, these architectural features are ones that he had admired in Butterfield's work.

4
Art Criticism

Between 1862 and 1886 Gerard Manley Hopkins attended two inter-
national shows (one in England and one in France); some sixteen
exhibitions ranging from those at the Royal Academy, the two Societies
of Painters in Water-colours, the Grosvenor, to several Old Masters, and
a number of Gambart's annual French and Flemish shows, in addition
to visiting the National Gallery, the South Kensington Museum (which
housed contemporary British painting), the Basle Museum with its
Holbeins and Dürers, and the home of a private collector, George Rae
of Liverpool. Investigating such attendance at exhibitions is more infor-
mative about Hopkins's knowledge of art than it would be for one of our
contemporaries because the Victorians lacked our cheap and plentiful
art books and catalogues full of coloured illustrations (not to mention the
web) that provide us with diverse sources of information. Had he lived
a generation earlier, such attendance would be more informative still
since Hopkins had access to the products of numerous printmakers and
to black and white photographic reproductions of popular pictures; not
only were engravings included in art journals but there were individual
prints available from entrepreneurs such as Ernest Gambart, who held
shows of foreign and English paintings for sale and sold prints from those
paintings for which he had also bought the copyright. The South Kens-
ington Museum produced photographs intended to broaden knowledge
of fine art and in 1848 they set up the Arundel Society to publish
coloured prints, some of which Hopkins certainly saw at Stonyhurst.
Hopkins's family owned a few art photographs; we know that Hopkins
had one of Ghiberti's *Eve* from the Gate panels in the Duomo and was
given one of Millais's *Huguenots* by his mother.[1] He wrote to Baillie,
'Do you know Titan's *Tribute Money*? I never could receive it: now I am

doing so, slowly, from a bad lithograph. It is a black truism—there is nothing like the great masters.'² But seeing originals, where the colours and the actual size of the picture tell, is another matter and the number and diversity of shows Hopkins made the effort to see gave him exposure to the work of more artists than are usually associated with him. He evidently also read art criticism in *The Times*, the *Saturday Review*, the *Art Journal*, *Blackwood's*, *Fraser's*, and the *Spectator*, absorbing some of the current concerns during an important period in Britain for the number and fluidity of artistic movements.

A lot has been written about the Victorian insistence on the moral didacticism of art, but it is important not to let what is generally only conventional attitudes to gender and sexuality obscure the fact that what is most evident in art reviews in the mainstream press is a battle over style. When, on rare occasions, a socially provocative picture is discussed, it is rarely applauded for its concern. For example, the *Saturday Review* writes about Fred Walker's *Vagrants* (1868) that it leaves an 'unpleasant impression', and *The Times* calls Luke Fildes's *The Casual Ward* (1874) an 'unsavoury dish', which though it has 'some breath of real life', is vitiated by falsity in the use as models of men who prefer their vagrant existence to the charitable institutions put in place to assist them. Such ideas would, doubtless, be comforting to the middle-class readers of the papers. Elizabeth Prettejohn points out that the interest in aesthetic judgement is a new feature in the 1860s connected with the drive towards professionalism among art critics. The overt criteria for judging pictures that Hopkins uses in his notes are generally also largely amoral.³

The first indication we have of his attending an art exhibition dates from 1862, when he wrote to his friend E. H. Coleridge, grandson of the poet, saying, 'I have deliberated whether to go down to Brompton, call on the Lanes of Thurloe Square, my cousins, with whom I think you are a little acquainted, and get one of them to do the pictures in the Exhibition with me' (3 Sept. 1862, *LIII* 5). C. C. Abbott, who edited the letters, does not identify the 'Exhibition' but in 1862 Hopkins was almost certainly referring to the International Exhibition. The Lanes lived just round the corner from it and Richard James Lane was a member of the small Committee charged with selecting what should be exhibited in 'Class XL: Etchings and Engravings'. His daughters Clara and Emily were rather older than Hopkins and both were artists. Although now, unlike the exhibition of 1851, that of 1862 is almost unknown, it was in fact bigger than its predecessor. The building was across Exhibition Road from the South Kensington Museum, on the site

where the Natural History Museum stands and it covered some twenty-four and a half acres, of which the picture gallery took up more than an acre. The South Kensington Museum (now the Victoria and Albert Museum) had been established after the 1851 International Exhibition when it was realized that British manufactures were inferior to those of other European countries and it housed a number of schools for skills involved in making artistic goods. In the 1860s it was part of a complex including a complete building devoted to India. The new International Exhibition Hall was inevitably compared with that of 1851: 'Glass and iron are no longer the main features of the design, but are succeeded by lofty walls of brickwork, which surround the ground on all sides, and form the walls of the fine arts galleries.' The building extended the arcades to the north and south of the gardens and added a second story to the northern one. The enclosed space was 'covered in by roofs of various heights ... divided into nave, transepts, aisles, and open courts; the latter, occupying comparatively a very small portion of the space, are roofed with glass as in 1851, but the other parts have opaque roofs, and are lighted by clerestory windows'.[4] In order to justify the cost, it was intended that sixteen of the twenty-four acres would be preserved to house the 1872 exhibition as well, but the building had to be demolished before it could fulfil that purpose (p. 128).

The 1862 Exhibition included a wide range of both British and foreign manufactured goods, from foodstuffs, pharmaceutical products, raw pigments for the manufacture of artists' colours, and carpets, to a range of engines including marine ones such as that for the *Achilles* whose seventeen-ton crankshaft was on display. There were substantial displays of Indian work, British railway plant, locomotive engines and carriages, manufacturing machines and tools, civil engineering, and architectural and building instruments in a room fitted up to provide steam power. 'A single line of railway [ran] from end to end on each side; six double-flue boilers, thirty feet long by six feet and a half in diameter, [were] built in at the north end, communicating with a chimney which was seventy-five feet high, and which had a diameter of ten feet at the base. Two hundred elegant iron columns, of the Doric order, [have] been raised at intervals ten feet apart, and ten feet high above the floor, supporting two thousand feet of shafting, two inches and a half in diameter' (p. 77). The Exhibition of 1851 had not included paintings but the Manchester Exhibition of 1857 had been so successful that there were substantial collections on show in 1862. The picture space, which occupied the whole of the upper story of the front face of the exhibition building

and upper galleries along both sides, was intended to provide another permanent gallery for art, a purpose it was unable to fulfil. Considerable effort was made to light the picture galleries in such a way as to reduce to a minimum reflected light. Skylights with louvres and translucent calico were used, which it was expected would later be replaced by ground glass. The exterior had two large mosaic pictures illustrating Industry, Science, and Art and a series of smaller ones including *Agriculture* by Holman Hunt, *Navigation* by J. E. Millais, *Jewellery* by D. G. Rossetti, *Hunting* by Frederick Leighton, and the various branches of fine art by W. Mulready (p. 154).

The display of paintings was divided into two equal parts, half for foreign artists and half for two centuries of British ones from Hogarth, who died in 1764. The classical British paintings were selected by Richard Redgrave, RA, Inspector-General for Art at the South Kensington Museum, and contemporary ones were chosen by a committee of the presidents of the several British art societies. The walls were entirely covered by paintings in oil and watercolour, and drawings. Nearly two hundred pieces of contemporary sculpture were placed around the building, with one room devoted to work of deceased sculptors such as Banks, Flaxman, Chantrey, Westmacott, and Wyatt (pp. 108–9). There was also a beautiful display of Japanese decorative objects belonging to Rutherford Alcock, first British Consul-General to Japan. This fashionable area of art later attracted Hopkins's interest; he commented on paintings with an Oriental flavour in the 1860s and borrowed books on Japanese art from a friend in the 1880s.

At the time when Hopkins was writing his own art criticism there was not just a conflict between modern medievalism and the art establishment as represented by the Royal Academy but also a growing distinction between an increasing number of critics who wished to be seen as knowledgeable professionals and those journalists who were happily amateur and who presented themselves as the voice of the public.[5] A lot of the criticism of the period is anonymous or simply initialled. 'W.G.C.', who wrote for *Fraser's Magazine*, is an extreme example of the latter type ('O, captious reader, do not we, the ignorant public, hold the purse strings?'). He was not as ignorant as he pretended. Tom Taylor and J. B. Atkinson, on the other hand, saw themselves as professional art critics and wrote, generally anonymously, for periodicals through most of their working lives. Atkinson probably had no other source of income though Tom Taylor was in the civil service, on the staff of *Punch*, and was also a particularly popular playwright (Hopkins enjoyed a performance of *Our*

American Cousin in 1862; 3 Sept. 1862, to E. H. Coleridge, *LIII* 8). They and William Michael Rossetti increasingly used technical terms and referred to an ever wider range of past masters' styles. The same is true of Ruskin's writing, though his early criticism tries to make art available to all classes.[6] Hopkins developed his own battery of critical terms that is nearly as extensive as that used by the most professional of the critics, though it is idiosyncratic and, unlike theirs, clearly not intended for the general public. The range of reference to other artists in his criticism also grew so that by the mid-1870s he talks about a portrait (Millais's *Daydream*) as a 'Millais-Gainsborough' and refers to 'colouring quite (Italian) classical—black, two siennas, green, blue (both Raphael-like), etc' (Maclaren's *Girls playing at knuckle-bones*, Royal Academy 1874, *J* 245, 247). The background from which art critics came also affected their critical approach; so, for example, F. T. Palgrave, who wrote one of the two books on the pictures in the International Exhibition of 1862 (Taylor wrote the other) and was the editor of the famous poetry anthology, explains the development of British art by relating it to British literature over the same period. Hopkins's writing on art would seem to have been influenced by several critics; the most important of these was Ruskin, leading him to compare artists' success in rendering nature with his own knowledge of it, a democratic test available to all. However, his consideration of the relation between subject and picture goes beyond an emphasis on technical accuracy to questions of composition, and for this Tom Taylor's approach and terminology seem to have been influential. As with professional critics such as Atkinson and Taylor, Hopkins rarely introduces into his criticism consideration of the morality of the subject matter.

Francis Palgrave's art criticism was widely read in the mid-century. His handbook to the fine art collections in the 1862 International Exhibition was sufficiently popular to be reprinted that year. In it his criteria are not entirely consistent, partly because he espouses a range of values from those of Reynolds to Ruskin: 'Good art is straightforward and intelligible in its first elements to all who approach with ears to hear or eyes to see, whilst, like the Nature it imitates, every advance in comprehending it which we make, opens further avenues to pleasure and admiration.'[7] Two pages later he states that 'the aim of Art is to give us noble pleasure, and its means of so doing the representing sweet or lofty thoughts by Form or Colour'. Part of the pressure on Palgrave's definitions comes from his desire to distinguish what can be

given the viewer by art from the faithfulness to nature of photography: 'great artists ... give back to the age its forms and feelings; they embody national tastes and passions; the mirror they hold up is not so much to Nature, as to Human Nature' (p. 7). Three more pages into the argument and Palgrave can be seen, in the course of asserting the value of British art, to challenge the traditional hierarchy of genres: 'At the beginning of the last century, when wealth and peace began to create a class of buyers, there was an absolute disbelief in the ability of England to produce anything valuable in art. It was then supposed that this power, by some law of Nature, was confined to Italy ... Art was divided into 'High' and 'Low'; High Art meant painting subjects which the artist had never seen, and had not skill or genius enough to imagine; Low Art was the name for pictures of real life, represented as they actually looked to the artist'; 'any artist who ventured to think for himself and follow Nature had to fight his way through criticism and ridicule' (p. 9). He condemns the painting of antique subjects rather than contemporary historical ones and the depicting of Victorians either naked or in classical garb (p. 9). This heralds a brief history of the development of the English school of painting as displayed in the Exhibition; Palgrave's account is, like Vasari's *Italian Painters*, a mixture of anecdote and contextualization of paintings described with unquestioning confidence. 'What I most wish any readers of these notes to feel, is how much Painting is the "child of its age"'. Our first national artist' is Hogarth, before whom 'no one had put a moral into painting, or made it tell anything like a distinct tale of contemporary manners' (p. 9), qualities he selects as characteristic of the rise of the novel at that time. Palgrave praises Gainsborough for producing landscape that is 'far the purest in that century; yet ... only reflected the spirit which, at the same period, led our Poets to the first attempts in simple description of Nature' (p. 18). 'Both the Landscape and the Incident style ... mark this century not less distinctly than religious subjects mark that of the fourteenth' (p. 24), something he explains as a social phenomenon: 'the growth of the Incident style in painting runs parallel with the great outburst of novel writing from about 1790 onwards, with the social change which gave the patronage of art rather to the mercantile than to the educated classes, and with that fusion of ranks and interests which (in another sphere) found expression in Burns, Scott, Crabbe, and Wordsworth' (p. 25). 'We no longer', he claims, 'see trees and mountains through the imperfect eyes of Claude or Poussin; we do not measure the waterfall by the standard of Ruysdael, or the twilight after the proportions of Rembrandt. That by which we

unconsciously test Landscape painting is rather the written landscape of ... Scott, Keats, Shelley, Byron, Wordsworth.' Palgrave is certainly right in finding a change in perception of nature during the Romantic period. Whether the English Romantic writers initiated or reflected that change is less clear. Showing how the Romantics provide a subjective rather than objective realism such as that of photography, he says that Turner, like Wordsworth, 'contrasts the fate of man, his passions, and his achievements, with the landscape around him, or makes the landscape itself a reflection of the drama of life on the more august theatre of nature' (p. 30). Influenced perhaps by Palgrave, certainly by comparative criticism of this sort, Hopkins repeatedly took such a historical approach to the arts as, for example to the Pre-Raphaelites, to the Romantic poets and artists whom he grouped into 'schools' (1 Dec. 1881, *LII* 98) and in his later assertion to Bridges that theirs was an age great in 'wordpainting' especially in modern novels (6 Nov. 1887, *LI* 267).

The following year, 1863, before he went up to Oxford, Hopkins attended the annual summer exhibition of the Royal Academy. The Academy was in something of a crisis at the time following a government inquiry. It had been founded in 1768 to establish a 'well-regulated School or Academy of Design', and hold an annual exhibition 'open to all artists of distinguished merit', and this specifically included women and foreign artists. The profits arising from the shows were to fund the art school and to distribute to needy artists and their families. By 1863 there was significant discontent with the way in which the Royal Academy operated. Its membership was limited so it was generally necessary for one Academician to die before another could be appointed, although there were a number of Associate Members. The standards of tuition given by the Academicians in the school of art were criticized and the quality of their work on display in the annual shows was generally condemned. Resentment was generated because the Academicians were entitled to hang their pictures 'on the line' and did not face selection, as everyone else did. Reviewing the Exhibition of 1863 for *The Times*, Tom Taylor commented, 'the weakest works "on the line" are, in almost every instance those of Academicians. If the rule exempting the works of Academicians and Associates from the judgment of the Council, which receives and rejects pictures, is to continue ... either Academicians must cease to exhibit after a certain time, or their ranks must be so enlarged by the admission of young and rising talent that the worst productions of its members may be swamped in the large influx of good ones which the free infusion of new blood would bring with it. ... If the Royal

Commission now inquiring into the relations of the Academy to English art should venture on any suggestions of this kind they might enforce it strikingly by reference to the present Exhibition' (2 May 1863). This became a regular feature of reviews throughout the time that Hopkins attended the Royal Academy exhibitions, along with the complaints that no artist specializing in landscape had been elected to the Academy in decades, and that there were, in comparison with what was available in many continental countries, so few government projects like the rebuilt Houses of Parliament that required artists to work on a grand scale.[8] Clearly the art critics of the press had considerable power to challenge the art establishment. Taylor assumes that the role of the critic is the education of the public so that it patronizes artists whose work is approved by the critics. His values are elaborated elsewhere in his praise of a national British tendency to increasing 'truthfulness' in rendering nature in which Ruskin and the Pre-Raphaelites were important, and his admiration of continental polish or finish, which British painters were learning from exhibitions of foreign paintings in Britain and from the resident, continentally trained artists such as Leighton and Tissot. When in 1874 Hopkins wrote in his diary of Fred Walker's *Harbour of Refuge*, 'the background of the long line of almshouse rather heavy and inartistic: there seems to remain in his work a clod of rawness not wrought into perfect art, which in a Frenchman would not be' (*J* 240), his comment shows his absorption of such contemporary criticism as Taylor's.

The Summer Exhibition of 1863 contained Arthur Hughes's *Home from Sea*, four paintings by Frederic Leighton, who did not yet have a position in the Academy, George Mason's *Catch*, Frederick Walker's *The Lost Path*, and landscapes from artists whom Hopkins was later to notice. The subjects included a number of scenes from Shakespeare, perhaps with an eye to the celebrations of 1864, several inspired by Tennyson's recently published *Idylls of the King*, scenes from history often with marked sympathies either royalist or Protestant, landscapes British and international, and portraits. Many of the sculptures were commissioned memorials. But the comments we have from Hopkins were of the three paintings by John Everett Millais: *The Eve of St Agnes*, *In the Wolf's Den*, and *My First Sermon*. They are a quintessential collection of Victorian subjects, paintings on a literary subject, children, and an image of female piety. Millais became an Associate Academician that year. Hopkins's comments, written in response to a question from Baillie, suggest that his esteem for Millais, though largely based on the

'realism' created by his superb technique, also derived from what he saw as a comprehension of Keats. With gush characteristic of his youthful correspondence with Baillie, Hopkins admitted, 'About Millais' Eve of S. Agnes, you ought to have known me well enough to be sure I should like it. Of course I do intensely—not wholly perhaps as Keats' Madeline but as the conception of her by a genius. I think over this picture, which I could only unhappily see once, and it, or the memory of it, grows upon me. Those three pictures by Millais in this year's Academy have opened my eyes. I see that he is the greatest English painter, one of the greatest of the world' (10 July, *LIII* 201). This view of Millais's exceptional talent exceeds that expressed in the press, though Millais's pictures were those with which Tom Taylor began the first of his sequence of reviews in *The Times*. The pictures in the exhibition show Millais's versatility. *The Eve of St Agnes* was praised for capturing moonlight. The setting was not faithful to Keats's poem, which had a medieval backdrop that Millais replaced with a Jacobean one painted at Knole, and a number of the details do not follow Keats's poem, such as the fact that the bed is in front rather than behind Madeleine. She is undressing for bed and has allowed her rich blue velvet dress to sag around her knees. Not bothering to finish removing it, as an impatient lover might leave it while moving on to undo the next layer, she is dreamily untying her petticoat. While in no way nude, the figure is sensual: her soft, auburn hair hangs loosely down her back; her shoulders are bare, the petticoat nips in her waist from which her full hips swell out, and her ample breasts appear constrained only by the chemise she is undoing. She is clearly thinking about something else and the viewer is in the position of her peeping lover. Using as the model his wife, Effie, formerly married to John Ruskin, Millais had completed the painting in less than a week. The following lines from Keats's 'Eve of St Agnes' were quoted in the catalogue:

> Full on this casement shone the wintry moon,
>
>
>
> her vespers done,
> Of all its wreathed pearls her hair she frees;
> Unclasps her warmed jewels one by one;
> Loosens her fragrant bodice; by degrees
> Her rich attire creeps rustling to her knees:
> Half-hidden, like a mermaid in sea-weed,
> Pensive awhile she dreams awake, and sees,
> In fancy, fair St. Agnes in her bed,
> But dares not look behind, or all the charm is fled.

19. John Everett Millais, *The Eve of St Agnes (Victoria and Albert Museum)*

Keats describes Madeline's undressing with a double perspective: a sequence of actions from Madeline's 'innocent' consciousness but also a sensuous external picture of her which is Porphyro's impression from his hiding place. Was it the alteration in the balance between these aspects, caused by the change from word to picture, that Hopkins had in mind in his comment—'not wholly perhaps as Keats' Madeline but as the conception of her by a genius'? Keats's poem was one that had a special place in the Hopkins' household where Manley had given Kate an elegantly handwritten transcription surrounded by flowers painted in rich reds and purples with intense green leaves.

My First Sermon had been singled out by the Archbishop of Canterbury at the Academy banquet that followed the private view as exemplifying 'the piety of childhood'. Tom Taylor in *The Times* said of it, 'no more delicious and unaffected picture of childhood was ever painted. There is no trace of peculiarity in the mode of painting which is simple, firm, and large, with great force, but no exaggeration of colour;

but the crowning charm of the picture lies in its innocent beauty of childhood. No mother of a little girl can look at it without wishing to have her child so painted.'[9] The comment on the colour is contextualized by contemporary criticism of Pre-Raphaelite paintings as being too gaudy. Hopkins, with three younger sisters and three younger brothers, had a sensitive appreciation of the beauty of childhood and its innocence. In his poetry there is a reiterated stress on childhood innocence and the necessity of dedicating that purity to God: 'Spring', 'Spring and Fall', 'Morning, Midday and Evening Sacrifice', 'The Bugler's First Communion', 'To what serves Mortal Beauty?' all touch on the subject. In his picture, Millais shows a little girl whose attention seems to have been riveted by the words of the sermon, which are taking root in her serious little mind. Beside her on the padded bench is the prayer book, the cross prominent on its front cover. Outside the frame of the picture is her mother, whose presence may be signified by the coat and prominent kid gloves in the foreground. Hopkins was in no way revolutionary in his expectations of women's piety and role in inculcating that in their children. The anecdote of his daily reading of the Bible at his mother's behest when he was a boarder at school suggests the expectations that his upbringing had instilled.

Hopkins's acquaintance with Millais's work was not new—he had seen his illustrations in *Once a Week* since 1859 where he was hardly likely to have overlooked Millais's illustration to a poem by Tennyson. By 1862 he was forming his own initials in emulation of Millais's signature and would have known of his uncle Richard Lane's friendship with the artist and his cousin Clara's modelling for him as the seated nun in *The Vale of Rest* (1858). Millais's illustration to Harriet Martineau's *The Hampdens* faced the printing of Gerard's poem, 'Winter with the Gulf Stream' in *Once a Week* in February 1863 (*J* 386). Hopkins's enthusiasm, overstated as it is, was in keeping with the mood in which the Summer Exhibition was publicized. In addition to the three pictures by Millais, which were not shown together but scattered through the rooms, there were also three engravings by the Brothers Dalziel of his Bible drawings and J. E. Boehm had chosen a statuette of Millais as one of his exhibits. Our knowledge of Hopkins's response to the Exhibition is skewed by the fact that the only mention we have of it from him is his reply to Baillie's praise of Millais. Norman White points out that 'such admiration shows Hopkins's inexperience in looking at pictures: he had insufficient knowledge of foreign painters to judge Millais',[10] which is true, and yet there is something striking about Hopkins's selection of

Millais from the more than one thousand exhibits at the 1863 Royal
Academy Exhibition: looking through the catalogue, it becomes clear
that of the artists exhibiting, Millais is today probably one of the best
known. So, though Hopkins may not have been able to place him in the
larger frame, within the context he had, his view has stood the test of
time. Hopkins scoffed at the opinion of Eden Upton Eddis, whom he
may have met through his uncle and who had a portrait in the Exhibition,
that some of the 'best men—he instanced Millais—were leaving the
school', which grammatically would be taken to refer to an English
school but is more likely to refer to Pre-Raphaelitism. Hopkins wrote, 'if
Millais drops his mannerisms and becomes only so far prominent from
others' styles as high excellence stands out from mediocrity, then how
unfair to say he is leaving his school, when that school, represented in
the greatest perfection by him, passing through stage after stage, is at last
arriving at Nature's self, which is of no school—inasmuch as different
schools represent Nature in their own more or less truthful ways,
Nature meanwhile having only one way' (10 July 1863, *LIII* 201–2).
Hopkins's assessment was probably based not just on Millais's paintings
in the 1863 Royal Academy but on his wider knowledge of Millais's
work.[11] Lying behind Hopkins's assertion there may also be Ruskin's
conviction, expressed in *Modern Painters*, vol. ii, that Turner was 'the
greatest painter of all time' because he conveyed so much truth about the
world around us, a world which, at this time, Ruskin saw as the way in
which God 'most abundantly and immediately' shows us his love.[12] That
Nature had theological significance was Hopkins's understanding of the
natural world through most of his adult life. Thus, just as for Ruskin,
Turner's 'realism' allowed God to be 'the final guarantor of value in
Turner's art', so, finding in Millais still more 'photographic' realism,
Hopkins placed him as one of the greatest painters in the world. This
is a position in flat contradiction to Palgrave's fear that art needed to be
distinguished from the imitativeness of photography in order to retain a
place in modern society. Although Hopkins was to develop criteria that
required of art qualities beyond those of realism, his judgement seems
to have been independent of such material fears.

 Hopkins's knowledge of fine art is evident even in his first extant
poem 'The Escorial'. Written for a school competition in 1860, the poem
includes descriptions of the history and architecture of the Spanish
palace for which he evidently drew on William H. Prescott's *Reign of
Philip the Second* (London, 1859) and vol. ii of Richard Ford's *Hand-book
for Travellers in Spain* (1845).[13] He also included brief descriptions of

pictures by Raphael, Claude, and Titian, some with just one attributive adjective—'dreamy Claude', 'Titian's mellow gloom'—though he gave more space to Raphael, describing a painting of the Holy Family in which there 'play'd the virgin mother with her Child | In some broad palmy mead, and saintly smiled'. Details like this did not come from Prescott's history but perhaps from another travel guide, journal article, or one of his relatives.

When Hopkins went up to Oxford in December 1863 he took with him to decorate his room maps, a coloured sketch by Clara Lane, portraits of Raphael, Tennyson, Shelley, Keats, Shakespeare, Milton, Dante, and Albrecht Dürer. Clearly the choice would have been constrained by what was to hand from the family's collection of pictures of famous people[14] so what the selection tells us about Hopkins's tastes is limited. He shared the Victorian worship of Shakespeare and had not yet begun to 'doubt Tennyson'. Keats is an obvious influence on his early verse and he later appealed to Milton's authority as a precedent for his modification of sonnet form. We do not know whether Hopkins saw the excellent collection of paintings in Christ Church, where General Guise and the Hon. W. H. T. Foxe-Strangways had left the college a superb range of Italian paintings, but it could have been the fragments of Raphael's lost Cartoons there that prompted Hopkins to ask his mother to send him his book of Raphael's Cartoons, most probably Cattermole's beautiful edition of 1845. It stated that there was in the Picture Gallery at Oxford a set of the cartoons executed by James Thornhill, given to the University by the Duke of Marlborough.[15] Christ Church's collection ranged from 'a more complete display of the very early artists (Cimabue, Margaritone, Giotto di Bondone, Gaddi, and Duccio di Buoninsegna) than can be found in more splendid collections' to Botticelli, Fra Fillippo Lippi, Raphael, Leonardo da Vinci, Titian, Andrea del Sarto, the Carracci and Salvator Rosa as well as several Holbeins and Vandykes. The presence of early Italian paintings is interesting: official appreciation of them was comparatively recent: the National Gallery had only begun to collect them seriously in 1857.

Of the Pre-Raphaelites' art by 1863 Hopkins would already have known black-and-white illustrations in journals such as *Once a Week* and would have met advocacy of their work from a number of quarters, such as Ruskin's in *The Elements of Drawing* and *Modern Painters* as well as various articles defending particular Pre-Raphaelite paintings. He doubtless responded to their vivid depiction of nature and he was evidently rather sympathetic to a lush, neo-Gothic medievalizing evident

at the time in art, architecture, and literature. At Oxford Hopkins was able to share his enthusiasm with a number of other students such as William Mowbray Baillie and Frederick and Alfred Gurney, with whom he had become friendly by May 1863. The Gurneys' mother having died in 1857 and their father John Hampden Gurney in 1862, they were under the guardianship of Russell Gurney, Recorder of London. The family owned more than sixty pictures, many of them by British artists, including contemporaries such as William Hunt, of whose work they had *Primroses, White grapes, strawberries and a peach*, and *The Monk*. They possessed Gainsborough's *Portrait of Mrs Sparrow* and Old Crome's *View of Old Hethel-hall, Norfolk* as well as landscapes by Linnell (*Heath and Common*) and E. W. Cooke (*The Thames at Milwall*), a number of landscapes by Thomas Creswick, Prout's *The Cross at Rouen*, Reynold's *Female Contemplation*, Frith and Ansdell's *Dream of the Future*.[16]

In the essays that Hopkins wrote as an undergraduate he developed aesthetic criteria, some of which underlie the analysis he made of paintings he saw in exhibitions. The most concise of these essays is 'On the Signs of Health and Decay in the Arts' of 1864. It is an attempt to cover a wide range of types of art, producing a discursive rather than tightly structured essay. In it Hopkins defines successful art as that which has as its end Truth and Beauty, a change from his earlier remarks to Baillie in which Nature and Truth were aligned. 'Art differs from Nature in presenting Truth; Nature presents only Beauty ... The pleasure given by the presence of Truth in Art ... lies in a (not sensuous but purely intellectual) comparison of the representation in art with the memory of the true thing'; something that is 'implied in the spectator, not ... intrinsic, as the deliberate beauty of composition, form, melody etc.'. The emphasis on the importance of composition is an aspect of 'inscape/scaping' and something that he later exhorted his brothers to heed. Hopkins also recognizes 'lower' arts 'such as those of making arabesques, diapers etc' which 'need neither imitate Nature nor express anything beyond the beauty appreciable not by the intellect ... but by the senses'. Developing the idea of comparison between art and nature, Hopkins makes an interestingly complex argument. The relation is not one of representation that is as exact as technically possible but a matter of 'proportion', a painter's instinctive relating of subject and representation: 'it is plain that in some cases likeness may be enforced between things unduly differing, contrast made between things unduly near, relations established at wrong distances, and that in either case, in one or other of the many forms of failure,—monotony or extravagance

or some other,—pain will result: it is plain also that between these lies a golden mean at which comparison, contrast, the enforcement of likeness, is just and pleasurable. And this is reached by proportion. Now though this golden mean must be reached by intuition, and that success in doing so is the production of beauty and is the power of genius, it is not the less true that science is or might be concerned in it as well', as, most conspicuously in music and architecture (\mathcal{J} 74–5). He aligns Truth in art with 'Realism', and beauty with 'Idealism'. Hopkins then equates 'proportion' with beauty, and subdivides it into 'chromatic' and 'intervallary'.[17] He defines 'chromatic' as gradual, continuous beauty and 'intervallary' as abrupt and parallelistic. He realizes that 'art ... combines the two kinds of beauty' and suggests that different eras and types of art can be seen to have a preponderance of one or the other: 'Greek architecture is rather of the quantitative or intervallary kind, Teutonic of the qualitative or chromatic' (\mathcal{J} 76). Continuing his argument in a second part of the essay, he examines Assyrian, Egyptian, and Greek art, making distinctions between convention and technical inability to produce Realism. In Assyrian and Egyptian art he gives examples that 'shew a remarkably clear conception of Art as Art using its own language and appealing to a critical body of its own state of civilization to accept and allow its conventionalities' (\mathcal{J} 77). Showing that he had looked carefully at the missals in the South Kensington Museum, Hopkins compares the relation of realism and convention in the treatment of trees from the Middle Ages to more modern art: 'the former represents a tree by a firm bounding line, giving the shape of the tree pretty correctly but typically, and within that from twenty to forty leaves correct in shape, carefully drawn, but not grouped or in any way perspectively treated. This is what is to be seen in missal-painting. In late Art (that is, Art in which subordination of parts has been reached and established) trees are represented not typically but with the irregularity of Nature, the outline is a rough furry touch, mass is given and projection or solidity, but without truth of detail' (\mathcal{J} 77–8). He concludes by distinguishing between the avowedly conventional early work and later, degenerate art that instead of giving careful but selective realism and conventionalizing what is considered less important, 'conventionalises its subject as a whole by a general carelessness of treatment'. He warns that 'the realism which it may lose is much harder to restore to Art than it is to acquire in the other case' (\mathcal{J} 78). A second continuation of the argument introduces the idea of 'perfection' in Renaissance art. Following a Pre-Raphaelite set of preferences, he suggests that the drive for 'perfection' produced

art that was made harmonious by presenting a realism which kept 'all
things in the due mutual proportions of nature', undermining realism
because 'details are subordinated, neglected, falsified, till all is true
and all is untrue'. He defines perfection as 'established harmony' and
remarks that such 'perfection is dangerous because it is deceptive. Art
slips back while bearing, in its distribution of tone, or harmony, the
look of a high civilization towards barbarism. Recovery must be by a
breaking up, a violence, such as was the Preraphaelite school' (J 78–9).
In this he would seem to be advocating aspects of Pre-Raphaelite style
that received contemporary criticism, such as that their colour was too
glaring and that their pictures did not have a gradation of detail that
left only the principal areas fully articulated. He finishes by suggesting
that a preference for the picturesque and suggestive to the exclusion of
the 'purely beautiful' is a 'sure sign of decay and weakness; it is found
in the melancholy epigrams of the Greek Anthologies, in the landscape
of Claude, and most remarkably in the novels and poetry of the United
States' (J 79).[18]

By June 1864 Hopkins was struggling to write an essay on 'Some
aspects of Modern Mediaevalism' perhaps for Hexameron, the discus-
sion society to which he belonged, though the records of the society
suggest that he may not have completed it. The paper was evident-
ly intended to contextualize the English Pre-Raphaelite movement by
relating it to the German Nazarenes ('Tieck etc.', J 26), the Schlegels,
and Goethe, of whom he wrote confusingly, 'Goethe, whose balanced
mind must not be considered as the ideal of the century, representing
the most desired union of the classical and mediaeval'.[19] The antithesis
of classical and Gothic/medieval is a widespread contemporary simpli-
fication of the historical situation also evident in Hopkins's remarks on
the development of architecture. Here he seems to suggest that he was
himself at odds with the nineteenth century in seeing a union of classical
and medieval qualities as ideal but Hopkins's knowledge of Goethe was
not extensive and the preferences he expresses most often place him
firmly in the 'medieval'/Gothic/Pre-Raphaelite camp.

Hopkins probably first saw one of Dante Gabriel Rossetti's paintings
among the Arthurian murals on the walls of the Oxford Union (1857).
He alluded to it in his essay, 'On the Origin of Beauty' (J 91). Rossetti,
who had led the decorative scheme for the debating hall, had chosen to
paint *Sir Lancelot's Vision of the Sanc Grael* in which Guinevere stands
between Lancelot and the grail, blocking his access to it. Hopkins's poem
'Guinevere' dates from the second half of 1864. Norman H. MacKenzie

places it as part of 'Floris in Italy', where it leads on convincingly from Gabriel's comparison of his situation to that of Arthur;[20] the poem is dramatic rather than a lyrical response to the story. In the thirteen lines of his poem, Hopkins describes the effects of Guinevere's adultery in physical similes, just as Rossetti's painting depicts Lancelot's moral state by placing Guinevere spatially blocking his way to the grail:

> —O Guinevere
> I read that the recital of thy sin
> Like knocking thunder all round Britain's welkin,
> Jarr'd down the balanced storm; the bleeding heavens
> Left not a rood with curses unimpregnate;
> There was no crease or gather in the clouds
> But dropp'd its coil of woes: and Arthur's Britain
> The mint of current courtesies, the forge
> Where all the virtues were illustrated
> In blazon, gilt and mail'd shapes of bronze,
> Abandon'd by her saints, turn'd black and blasted,
> Like scalded banks topp'd once with principal flowers:
> Such heathenish misadventure dogg'd one sin.

Rossetti held a number of important beliefs about qualities necessary in good art that Hopkins was also to develop. One of the most striking of these is expressed in a letter to William Allingham in 1855 where he says that 'great richness of arrangement—a quality which, when really existing, as it does in the best old masters, and perhaps hitherto in no living man—at any rate English—ranks among the great qualities'.[21] This prioritizing of composition is an important element of 'inscape' as Hopkins uses it in assessing pictures. Hopkins, however, never met Dante Gabriel Rossetti and, although he could have gleaned information about him from journals such as *Fraser's*, he is more likely initially to have learnt about him from his friends at Oxford who were interested in contemporary art and poetry. Most important among these were the Gurneys, who introduced Hopkins to some of the celebrities of the day such as Jenny Lind and George Macdonald. More significantly for Hopkins's interest in art, he also met at a party at the Gurneys in July 1864 'Miss and Miss Christina Rossetti' and Holman Hunt (20 July 1864, *LIII* 214). It may have been from conversation at that party that he noted in his Journal:

Dixon. The Brownings. Miss Rossetti. D.G. Rossetti.
The Preraphaelite brotherhood. Consisting of DGR, Millais, Holman Hunt, Woolner, and three others. One of these three went out to Australia. (*J* 30)

Interest in the group was not confined to Hopkins's fellow students but was shared by some of their tutors. Between 14 August and 7 September 1864 Hopkins was working out in his journal his categories of poetic language. The highest he called Poetry proper, the language of inspiration; then there was Parnassian, which could only be written by poets but when they were not inspired, and finally there was the lowest, which was poetical language, which almost anyone can use but only as someone who is not a musician finds notes on a piano. As he thought about examples for each of these categories, he found that he needed more and more distinctions and so his terms multiplied, and among the terms, added almost as an afterthought, is 'Olympian', which he defined in a letter to his friend Alexander William Mowbray Baillie as 'the language of strange masculine genius which suddenly, as it were, forces its way into the domain of poetry, without naturally having a right there. [William Hart] Milman's poetry is of this kind I think, and Rossetti's *Blessèd Damozel*. But unusual poetry has a tendency to seem so at first' (*LIII* 220). Now the 'Blessèd Damozel' had been published in *The Germ*, the short-lived little magazine of the Pre-Raphaelite Brotherhood and reprinted in *The Oxford and Cambridge Magazine*, which they had produced only during the year 1856. It seems that Hopkins didn't see the poem in either of these rare sources but transcribed it into his unpublished commonplace book from a manuscript lent to him by Robinson Ellis, who was his tutor in Latin Composition in 1864. Hopkins also copied in the sonnets 'Lost Days' and 'Sudden Light' and transcribed 'Sibylla Palmifera', 'Venus Verticordia', and 'Lady Lillith' onto a couple of sheets of paper found enclosed in one of his Oxford notebooks.[22] How much else was in Ellis's manuscript we don't know. (Robinson Ellis was ten years older than Hopkins and a Fellow of Trinity College. He later became Professor of Latin at University College London in 1870 and Corpus Professor of Latin Literature at Oxford in 1893 (*LIII* 224 n).) 'The Blessèd Damozel' probably had some of the attraction for Hopkins of Christina Rossetti's 'The Convent Threshold'. These poems, like 'The Eve of St Agnes' entertwine sexual and spiritual love in complex ways. Between June 1864 and January 1865 he wrote a response to the latter called 'A Voice from the World'.[23] This has to a lesser degree the same combination of sensuality/sexuality and religious angst. That combining of physicality with spirituality, which exists in most of Hopkins's poems, was distasteful to his more Protestant friends such as Robert Bridges and also caused uneasy contemporary responses to Tennyson, Swinburne, Morris, and Pre-Raphaelite poetry

and paintings where Robert Buchanan's critical review, 'The Fleshly School', expresses the objections: 'We get very weary of this protracted hankering after a person of the other sex; it seems meat, drink, thought, sinew, religion for the fleshly school. There is no limit to the fleshliness, and Mr. Rossetti finds in it its own religious justification ... Whether he is writing of the holy Damozel, or of the Virgin herself, or of Lilith, or Helen, or of Dante, or of Jenny the street-walker, he is fleshly all over, from the roots of his hair to the tip of his toes.'[24]

Like Palgrave, Hopkins saw the school of Pre-Raphaelitism as both literary and artistic. He was introducing the poetry of Richard Watson Dixon, the first name on his list, to his new friends at Oxford. Dixon had been in the group around Rossetti at Oxford at the time of the painting of the murals in the Students' Union and had subsequently taught Hopkins while he was at school at Highgate. A copy of his volume of poems, *Christ's Company*, which he had left with another master, was noticed by Gerard and read by him when he went up to Oxford. In 1878 he wrote retrospectively to Dixon about the experience: 'At first I was surprised at it,' he said, 'then pleased, at last I became so fond of it that I made it, so far as that could be, a part of my own mind.' He told Dixon that he had obtained his *Historical Odes and Other Poems* (published in 1864) and *St John in Patmos* (1863), and transcribed poems from them into his commonplace book (4 June 1878, *LII* 1–2). He commented that Dixon's poems had a 'medieval colouring like Wm. Morris's and the Rossetti's [*sic*] and others but none seemed to me to have it so unaffectedly', an opinion he later elaborated on when dividing poets into three schools. Of these he considered that the modern medieval school was descended from the Romantic poets such as Keats, Leigh Hunt, Thomas Hood, and Scott. They had in common the use of medieval imagery and subjects as modified by Shakespeare and his contemporaries. They were, he added, also great realists and observers of nature (1 Dec. 1881, *LII* 98). Hopkins's early dramatic fragment, 'Floris in Italy', fits much of this description and attests to this admiration of Dixon. When towards the end of his life Hopkins wrote the entry on Dixon for Thomas Arnold's *Manual of English Literature*, he crystallized what he valued about his verse: Dixon, he said, had a 'richness of image [that], matched with the deep feeling which flushes his work throughout, gives rise to effects we look for rather from music than from verse. And there is, as in music, a sequence, seeming necessary and yet unforeseen, of feeling, acting often with magical strokes.' The point improves upon Pater's dictum that all art aspires to the condition of music. Not only are form and

content organically related, but Hopkins emphasizes the importance of evoking a convincing sequence of emotions. His criticism of Dixon was of obscurity and an archaic style 'now common' and which would be 'vicious' if it were not for the 'mastery' and 'dramatic point' with which he used it (*LII* 177–8).

On 19 July 1864 Hopkins went, so he told Baillie, to the Junior Water Colours and the British Institution, where there was a display of Old Masters. By 'Junior' watercolours Hopkins was referring to the 'New Water Colour Society', or Society of Painters in Water-Colours, whose creation in 1832 is one sign of that shift in patronage towards the middle classes on which Palgrave had commented. Hopkins's verdict was, 'Nothing that I could see at the Junior Water Colours worth seeing, excepting Jopling's "Fluffy"'—described by *Blackwood's* as 'a little doll of a dog which a lady is in the act of holding up to the gaze of doating affection'[25]—and a view in the East by Telbin which Hopkins considered 'the most intense effect of colour I ever saw in water colours' (20 July 1864, *LIII* 212). He had, however, noticed more than this entry reveals; in the essay, 'On the Origin of Beauty' (May 1865) he has his fictional 'Professor' comment on Frederick Smallfield's painting titled only by the first two stanzas of Shelley's poem,

> Music when sweet voices die,
> Vibrates in the memory—
> Odours when sweet violets sicken,
> Live within the sense they quicken.
>
> Rose leaves, when the rose is dead,
> Are heaped for the belovèd's bed;
> And so thy thoughts, when thou art gone,
> Love itself shall slumber on.

Of the painting the Professor says, 'It was an exquisite thing. It is seldom one sees a picture shewing so much imagination of the painter's own which yet in no way draws aside the expression of the sentiment of its text. It was full of what one calls *poetry* in painting and other arts: it is not in fact that the quality belongs to poetry and is borrowed by the other arts, but that it is in larger proportion to the whole amount there than anywhere else, and that, for reasons which would take some time to enquire into, the accessories without it collapse more completely and obviously than in the other arts' (*J* 110–11). Hopkins's comment to Baillie of the year before suggests that he considered that Millais had not quite achieved this fidelity with *The Eve of St Agnes*.

Hopkins's stamina for exhibitions must have been considerable. The show of Old Masters held in the British Institution, which he saw on the same day as the Water-colours, prompted a characteristically bubbling response from him. Describing the pictures to Baillie as 'charming', he wrote:

I had a silent gush before a Gainsborough; ἀπ' ὀμμάτων 'έσταξα πηγὰς [I shed welling tears] of admiration. There was a portrait of a handsome young gentleman by Leonardo (it is most knowing of all to write it Lionardo), a Baptism of Our Lord by Luini, exquisite grace refined almost into effeminacy. There were numbers of Gainsboroughs, Sir Joshuas and Romneys. Romney is like them. Five Velasquezes, a Murillo, a Zurbaran, many Canalettos, which I have now unbared; you cannot deceive yourself when you see 'the Rotunda, Ranelagh' or 'Westminster Bridge' whatever you may do in Venetian pictures. But I have *invented* a Canaletto with genius. His name is Guardi. If you see any of his things do not pass them by. The colouring is no warmer than Canaletto's, but the difference is vasty. There were also Carlo Dolces, a Sasso Ferrato, Correggios, Rembrandt's Mill, Vandycks, Wouvermans, Tenierses, Hobbimas, a charming Cuyp, Holbeins, and a fine early landscape painter we have, Crome of Norwich. There was a landscape by Sir Joshua Reynolds, curiously. Also Sir Thomas Lawrences, Sir Peter Lelys, and Sir A. W. Calcotts. (*LIII* 211–12)

Though the style is 'gush', Hopkins makes several astute observations. He was before his time in appreciating Guardi, whose work attracted no comment by the reviewers for *The Times* or the *Art Journal*, and although 'vasty' is not helpful, in conjunction with the comment on the similarity of palette, he is right in that one would not often mistake a Guardi with its sense of movement and mood for a Canaletto with its greater attention to buildings. It may have been that depiction of a Venetian world brought to life with boatmen bending to their oars, the clouds or water played upon by storms that caught Hopkins's eye; nature in his poems is seldom without movement. It is also a good test, as he says of Canaletto, to examine pictures in which the attention to technical excellence is not swayed by the exotic nature of the subject.

The critic from *The Times*, Tom Taylor, remarked, 'Of the few Italian pictures here only one is of great interest—a portrait by Leonardo da Vince of a young man belonging to the Archinta family of Milan, with the date 1404 ... it has all the characteristics which mark the few genuine easel pictures of the master—delicate but vigorous modelling, exquisiteness of drawing, and smoothness of surface wrought over a brown underpainting. ... The picture ... is one likely to have more interest, perhaps, for students than for the general public; but, as a

characteristic example of the rarest of all the Italian masters, it has a full right to its place of honour in the centre of the north wall of the large room.'[26] Leonardo was 'lionized' by art critics of the day, described by the reviewer of three books on medieval Italian sculpture as 'that universal genius who rivalled or surpassed all his contemporaries in sculpture as in painting, science, music, horsemanship, and arms'.[27] Herman Grimm, in his *Life of Michael Angelo*, which Hopkins included in a list of books to read in the first week of April 1865 (*J* 60), describes Leonardo as 'this great master ... let us step before Leonardo's finest works, and see if the dreams of ideal existence do not appear natural and significant!'[28] 'Leonardo is not a man whom we could pass by at will, but a power which enchains us, and from the charms of which no one withdraws who has once been touched by it. He who has seen the Mona Lisa smile, is followed for ever by this smile, just as he is followed by Lear's fury, Macbeth's ambition, Hamlet's melancholy, and Iphigenia's touching purity' (i. 43). Leonardo lionized indeed.

Tom Taylor continued his account of the Old Masters Exhibition by commenting that, 'A "Baptism of our Saviour," ascribed to Luini ... is, perhaps, after the Leonardo, the most noteworthy Italian picture here. The composition is the conventional one of the Lombard school, with the angels in attendance as bearers of the Saviour's vestments. The forms have the regularity bordering on tameness, and the sweetness verging on insipidity, which are to be found in most of Luini's easel pictures' (*The Times*), an observation which Hopkins caught in his description, 'exquisite grace refined almost into effeminacy'.

The portraits by Velasquez were two of Philip IV (one mounted, the other on foot), 'his first queen—the fair and good Isabella—and his great but mischievous Minister, Olivarez, and a sketch or reproduction of his painting "Las Meninas" ' (*The Times*). It was perhaps these Hopkins had in mind when he later commented on the 'ugliness' in Velasquez when defending Millais to Robert Bridges. The first picture the visitor sees, remarked the critic from the *Art Journal*, is Velasquez's Philip IV but 'before the visitor can reach it, he is arrested by Rembrandt's famous "Mill", from the Lansdowne Collection, which hung for the first time on these walls' when the British Institution was founded in 1806 (*The Times*) 'creating such a sensation among the artists of the time, that many wished to copy it';[29] The 'Mill' sits 'on one of the bastions of Utrecht, overlooking the town-fosse, a finely-imagined landscape, its homely materials lifted into mystery and grandeur by the magic of sunset light which touches on the sails of the mill, and, lower down, struggles

with the deepening shadows under the bastion, and in the trees on the border of the fosse, and still partially irradiates the evening sky' (*The Times*). It is a picture of a mill in keeping with the growing casualness of the seventeenth-century portrait; individual, seeking something behind the formal public face. Hopkins later commented that Alma-Tadema's *Vintage Festival* 'impressed the thought one would gather also from Rembrandt in some measure and from many great painters less than Rembrandt/of a master of scaping rather than of inscape. For vigorous rhetorical but realistic and unaffected scaping holds everything but no arch-inscape is thought of' (23 May 1874, *J* 245). He was making the assessment from an engraving by A. Blanchard of the first painting that Alma-Tadema completed after his move to England in 1869. The painting, which is not the *Autumn Vintage Festival* pictured in *AMES*, shows a procession led by a woman holding a flaming torch. The participants are grouped into three flute players followed by two women playing tambourines after which come two men holding urns of wine and a woman carrying a basket of grapes. The groups are separated into units so as not to be hidden by a number of objects in the foreground: a large urn, an altar and further vintner's equipment. Clearly Alma-Tadema wanted to display his ability to paint the furniture of pictures. The composition has a casualness that today's amateur photographer is accustomed to in that there are extraneous objects at the edge of the picture and the final figure is not quite complete. It is thus more like a snapshot of an ancient festival than a composed narrative. Hopkins's concern with realism was always balanced by an insistence on artistic composition and he criticized Everard for being insufficiently attentive to it in his drawing of *Addressing the Free and Independent Electors*: 'You did not, I believe, realise that so large a design can by no means be treated as differing from one a half, a quarter, or an eighth the size in its size only. As difficulties of perspective increase greatly with the scale so do those of composition. The composition will not come right of itself, it must be calculated. I see no signs of such calculation. I find it scattered and without unity, it does not look to me like a scene and one dramatic moment, the action of the persons is independent and not mutual, the groups do not seem aware of one another.'[30] That greater organicism and formal composition was here, I think, the distinction Hopkins was making between 'scaping' and 'inscaping'. Taylor made criticisms of this sort about picture after picture in exhibitions that Hopkins saw in the 1860s. In an essay on 'The Probably Future of Metaphysics' written during Hilary Term (January–March) 1867 Hopkins comments

that there are 'some pictures we may long look at and never grasp or
hold together, while the composition of others strikes the mind with a
conception of unity which is never dislodged ... the forms have in some
sense or other an absolute existence' (*J* 120).

Hopkins's list shows him responding to a wide range of styles and
subjects: of the Vandyke's he listed 'three portraits on one canvas
of Charles I., one front face and two profiles,—given by Charles
to Lord Strafford'.[31] The Murillos were ' "Santa Rosa" in monastic
habit ... embracing the child Jesus' and an early work, *Spanish Girls*
which consisted of 'a couple of girls at a window, the elder one half
hiding her laughing face in her white veil, while her younger and more
brazen companion gazes down, unabashed, and exchanges glance and
gibe with some companion or chance passer-by. Though the painting
is harder and dryer than in the later and more masterly works of
the painter, he has never painted momentary expression and common
Spanish character more truthfully than in this picture.'[32] Hopkins's
reference to Teniers was to what the *Times*'s critic called 'a fine kitchen
scene ... a first-rate example of the master'. Having commented that
'great force' had been given to 'landscapes in preference to personal, or
what is called historical, narrative' in the show, he said, 'the landscapes
in this room (the north) are of the highest order: they are by Hobbema,
Van der Neer, Ruysdael, Cuyp ... and Salvator Rosa'.

The South Room housed the British masters, a 'Landscape' by
Reynolds, 'four by Crome, one especially fine' (*Art Journal*). There were
also several by Romney. Among the Gainsboroughs was one of 'George
IV. when Prince of Wales'. *The Times* described 'the full-length of a child
in a white frock' as 'the most charming of the Gainsboroughs ... The
full-length of Charlotte, Lady Sheffield, is, however, a very charming
example of this fascinating painter's colour, and of the somewhat
mannered grace which he imparted to his fine ladies, though he kept it
for them. There is also an excellent full-length by him of Lord Mulgrave.'
A. W. Callcott, Hopkins's final listed name, had two pictures, placed
opposite to each other in the centre of the room. These were his 'best
figure picture, "Raeffaelle and the Fornarina," and one of his grand
classic landscapes' (*Art Journal*).

Tom Taylor used the Velasquez to comment in *The Times* on the
effects of Pre-Raphaelitism:

In these days of minute elaboration, evenly distributed finish, and almost
exaggerated emphasis, the corrective influence of such painting as that of

Velasquez is invaluable. All work need not be of this kind ... such a picture as this [*Las Meninas*] shows us to what, in the way of intentional breadth, the most exact study of nature and the most absolute respect for her may be turned. Now there is a way to pictorial truth altogether distinct from that of exact transcription by which most of our cleverest young painters are now travelling. We do not mean to say this is the only right road. But it is certainly that which the greatest masters of the past have followed. The path of minute transcription has, in all arts hitherto, been exclusively that of the *learner* and the *student*.

Hopkins evidently also saw the Royal Academy Exhibition of 1864. It included a number of pictures by Millais, now 'RA Elect', including *My Second Sermon*, where the little girl's slumber during the sermon would not have pleased Hopkins.[33] There were paintings by his relatives, R. B. Beechey and W. H. Hopkins, three by Arthur Hughes,[34] Frederick Sandys's *Morgan-le-fay* and two lithographs by R. J. Lane from photographs of Charles Fechter and Charles Dickens. The market for modern pictures was thriving, with demand easily outstripping production.[35]

At about this time Hopkins made acquaintance with an artist who was in the Pre-Raphaelite circle: Frederic William Burton. He might have met him at the Gurneys' party in July 1864, though he could also have met him at the Lanes's since Burton had been friendly with the Lanes from the time when Richard James Lane had made a lithograph of his portrait of Helen Faucit (1857). There are just two references to him in Hopkins's journals late in July 1864, and a remark in 1866 that his study exhibited in the Painters in Water-colours that year was 'not very interesting'. It is not much but the nature of the entries makes them more important than their brevity might otherwise indicate. Here was an active artist friendly with the Pre-Raphaelites, and Hopkins, who was probably at the peak of his hopes of becoming an artist himself, had an avalanche of questions to ask: 'Mem. To ask Mr Burton about picture-frames, price of models, whether the pictures by W. S. Burton in the Academy are his, about the Preraphaelite Brotherhood, the French Preraphaelites, the Düsseldorf school etc.' (after 22 July, *J* 31). What Hopkins remembered of his answers to the last two questions he seems to have jotted down a few pages later:

Frau's Anatomie.
F. Madox Brown. ...
Cornelius, Overbeck and some one else (Rechel?) founders of German medieval-ism. Cornelius used to draw his smallest figures in charcoal.

Rethel a man of real genius would have been the master of the school but died young.

Düsseldorf School, a poor affair. Now split into sects. Chiefly imitates the French.

Belgian School. Has one great medievalist Henri Leys. His followers feeble.

Sort of French Preraphaelitism, but very little medievalism *in feeling* though medieval subjects. (*J* 32–3)

It may have been at the party that the following entry was made: 'On this page is a capital of a column and line of roof in perspective, by Burton the painter, to illustrate the absurdity of the architects' perspective, in which if a section of a column were made, the column would have, not a horizontal, but a vertical or oblique, ellipse, so that the column must be elliptical, not round, in shape; which occasions the odd look of architects' drawings. July 25. 1864' (*J* 33). It would appear that the two were getting on well. F. W. Burton was born in 1816 into a wealthy Irish family in County Clare. His father was an amateur landscape painter. Burton was handsome, very sociable and a lifelong bachelor who adopted his brother's orphans. His right arm had been seriously injured when he was a baby in a fall from his nurse's arms so that he painted with his left. He also avoided using oils, apparently because he disliked the smell, and worked in watercolours and pastels. He was trained in Dublin by the Brocas brothers and initially became primarily a portrait painter. By the 1840s he was considered the foremost Irish painter, elected to the Royal Hibernian Academy in 1839. He spent 1844 in Munich, where he was employed by Ludwig I to make copies of paintings and repair some in the Royal Collection. Burton also had an interest in Irish antiquities and was one of the founding members of the Archaeological Society of Ireland and a close friend of George Petrie, with whom he visited numerous archaeological sites. He was later to supply Petrie with traditional Irish melodies for his book on folk songs (1868). Between 1851 and 1858 Burton lived in Munich, where for five years from 1851 he was Curator of the Royal Art Collection. He became friendly with George Eliot and George Lewes when they were in Munich in 1858, a friendship that was continued in London. Burton was one of the couple's inner circle, travelling with them in Italy at their invitation for parts of May and June 1864 and drawing George Eliot in 1864 and 1865, one of few artists she permitted to do so. The latter chalk drawing is now in the National Portrait Gallery and is probably the best-known likeness of her. Burton had exhibited *The Aran Fisherman's Drowned Child* at the Royal Academy in 1842 and a portrait of Helen Faucit as Antigone

in 1849. He was elected an Associate Exhibitor of the British Society of Painters in Water Colour in June 1854 on the strength of a single painting and was made a full member the following year. He settled in London in the early 1860s. Burton was fluent in German and Italian and his knowledge of art history was exceptional. He became Director of the National Gallery in London in 1874 and held the post for twenty years. Considered one of the great directors of the Gallery, he added 450 foreign pictures and 100 British ones to the collection, including Leonardo da Vinci's *Madonna of the Rocks* and Velasquez's full length portrait of *Philip IV*. He was a greater champion of British art than Eastlake or Boxall, his two predecessors, and purchased Rossetti's *Ecce Ancilla Domini*, and Fred Walker's *Vagrants*. Walker's *Harbour of Refuge* was given to the Gallery in the last year that Burton was Director. He was also important in the foundation of the National Gallery of Ireland. Burton was knighted in 1884 and died in 1900, outliving Hopkins by eleven years.

Burton was also friendly with the Rossettis and from the 1850s with another of that circle, George Boyce, a number of whose pictures were praised by Hopkins. Burton's painting, *Hellelil and Hildebrand: the meeting on the turret stair*, which George Eliot greatly admired, is Pre-Raphaelite in manner, in its detail and restrained handling of an emotionally charged moment, though subtler in its rich colouring. A drawing of a closely observed tree stump by Burton made in the 1850s in the Tyrol would have pleased Ruskin.

Burton and Hopkins had a striking number of ideas in common with regard to admirable qualities in art. Whether Burton communicated any of these to Hopkins or not can only be guessed at. Both men would seem to have possessed a highly sensuous response to colour. Burton's private vocabulary in notes on drawings for himself shows that same imported sense of touch that can be seen in Hopkins as early as 1 September 1865 in 'Daphne': 'He shall be warm with miniver | Lined all with silk of juicy red.' Burton on a sketch of tree trunks meeting the ground notes 'the shadows wonderfully warm—juicy and broken'.[36]

In a lecture to the Royal Geological Society of Ireland in 1844 on the subject of 'Art and Zoology' Burton set down his belief in the necessity of drawing animals from life: 'one glance at the moving, breathing creature, with an eye & judgment previously prepared, will teach more than all the metaphors of poetry—all the accuracy of scientific description—or months of toilsome study over dried bones and lifeless muscles.'[37] Hopkins was to admire such grasp of animals in Briton Rivière's *Apollo*

of 1874. Such fusion of appearance and action in the identity of an animal is caught by Hopkins in lines 9–10 of 'The Windhover': 'Brute beauty and valour and act, oh air, pride, plume here | Buckle', come together. Burton's notion of the role of the artist, while common in the period, is also worth noting: 'there is in the separate individuals of each species a continual tendency towards a great specific type—which type would, if ever actually produced, concentrate in itself the perfections displayed singly in these separate individuals. ... the Greek artist ... found ... that each group or species had its own peculiar character of beauty, which distinguished it from all other species ... It is for the artist to seize upon the collective idea—to fuse the separated elements in his reason—& from the mould of the imagination to draw forth those forms which are the triumph of the mental powers—exhibiting to the senses in vivid reality the permanent typal forms, which, not to be found in mere individual nature, have their existence in the human mind—Visioning to the beholder in the horses of the Parthenaic marbles the very ideals of swiftness—courage—fire & agile strength—Reflecting from the pure form of the Venus of Melos the dignity—the sweetness—the innate love, that the sculptor conceived as the attributes of woman—& the ineffable external grace ... It is thus in art that man becomes truly a creator—& seeks to realize to his senses the unceasing aspirations after the perfect & the godlike which are the truest circumstantial evidence of his ultra-sensuous and immortal nature' (fos. 31, 47–8). There is here what Burton acknowledges as a misunderstanding of the theory of the Ideal but one which has much in common with Hopkins's early uses of 'inscape', though the idealizing Burton envisages is in keeping with Academic aims of the period, an emphasis which would later be diminished by the influence of the Pre-Raphaelites and the popularity of genre pictures. There are also clear similarities with the metaphorical, analogical nature of all in the world to which Hopkins was later so attuned by his religious training, for example in the octave of 'As kingfishers catch fire', though Burton does not suggest the active relationship between God and the world that Hopkins envisions in his notes towards giving instruction on 'The Principle or Foundation': ' "The heavens declare the glory of God." ... The thunder speaks of his terror, the lion is like his strength, the sea is like his greatness' etc.[38]

~

We tend to think of the Pre-Raphaelites as a phenomenon of the 1850s and see the 1860s as witnessing the inception of aestheticism

but the distinction was much less clear in contemporary criticism. When Hopkins refers to the Pre-Raphaelites as the modern school in the mid-1860s, he is reflecting comments of the day;[39] Elizabeth Prettejohn suggests that in 1867, when Pater was writing his essay on Winckelmann, he may still have considered the Pre-Raphaelites 'the pre-eminent modern movement in British art'.[40] William Michael Rossetti, brother of Dante Gabriel Rossetti, worked for the Inland Revenue assessing the value of art collections. He brought together two of the areas of contention in an article in *Fraser's Magazine* in July 1864 on 'The Royal Academy Exhibition', a show that Hopkins saw: 'We observe that the British School has gradually become tinctured with a very appreciable infusion of the foreign, and especially the French, artistic tendencies.' The characteristic that he associates with this 'is to carry their works up to a certain point where the several qualities of expression, grouping, colour, *couleur-locale*, surface-handling, and so on, have reached, and will preserve a balance highly satisfactory to the exhibition-goer, and by no means to be underrated by the artistic sense. In short, these painters have attained the quality of good "keeping," one of the primary requisites, though far from the summit, of good style. In this characteristic respect more especially, as well as in the particular quality of broad surfaces of unforced and mostly agreeable half-tone, they exhibit the distinct foreign influence.' The artists of whom this was true he lists as Calderon, Yeames, Hodgson, Marks, and, 'in a somewhat diverse yet distinct phase, Prinsep'. He contrasts this subtlety and unity with what he calls 'insistency', which he finds in Holman Hunt, Inchbold, Rankley, Fisk, and Cope. He does not define what he means by the term but it may well be colouring that is 'too bright', outline that is too sharp, a certain 'crudity' of tone and handling.

Rossetti's second point was that though 'Patriotism might be inclined to suppress the fact; but a fact it is that, setting Sir Edwin Landseer, and possibly Mr Lewis aside, the three best exhibitors are either simply foreigners, or not absolutely British: we mean M. Legros, Mr Whistler, and Mr Millais'. Finally he comments on the absence of a landscape painter among the full Academicians. Sharing Palgrave's hesitations, he remarks that 'the decrease of landscape-painting may be ascribed partly to a change of tendency in the school...partly to the development of photography, so destructive to any level of landscape art save the highest...The result, however, is one very contrary to what appeared to be impending some few years after the first advent of prae-Raphaelitism: a movement which, initiated by figure-painters, and

mainly in the interests of the higher order of figure-subjects, produced a rapid crop of pictures—or more properly scraps and studies in most instances—of landscapes, and seemed to the timid as if it were likely to stagnate into that form of work more decidedly than any other. In this respect, prae-Raphaelitism has, in the long run, been true to its first impulse. It has changed the face of our schools, and has itself undergone considerable modification: but it has not deserted the man for the stone, the living and emotional for the merely vegetative, the expression of thought and character for the copyism of detail' (p. 57). Rossetti's remarks on the prevalence of foreign painters affirms the importance of the Pre-Raphaelites' contribution to English art, and his efforts to disassociate the Pre-Raphaelites from charges of paying too much attention to background detail draw attention to the higher genres in which they worked.

That there was still a need to defend 'Pre-Raphaelitism' is evident from the criticism of J. B. Atkinson, who as the art critic of *Blackwood's*, set out to condemn the 'school' in every review. He wrote of Burne-Jones's paintings in 1864 for example, 'In the name of nightmare, convulsions, delirium, and apoplexy, we would demand to what order of created beings do these monstrosities belong? ... [I]t is, however, just possible that in the remote depths of the darkest of medieval centuries, innocent of anatomy, perspective, and other carnal knowledge, something like these non-natural figures might be found. And so, after all, Mr Jones may turn out not quite as original as he would at first sight seem, by these forms so studiously grotesque, by his contempt for beauty, and his persistent pursuit of unmitigated ugliness. Yet on the whole, as witness the "Knight and the Kissing Crucifix", also "The Annunciation," we incline to the judgment that Mr Jones has surpassed all that ever went before him. ... With this egregious exception, and with the addition of a few solitary examples scattered through other galleries, the much-vaunted Preraphaelite school of figure and landscape painting may be said to be extinct. ... [T]he opinion we have long entertained of the impracticabilities of this thankless school—a school which makes of its disciples slaves, and reduces art to drudgery. These penalties, attaching to the carrying out of certain plausible but essentially false principles, seem to have disgusted the leaders of a schism which at one time threatened in its consequences to grow serious, if not fatal. However, as we have said, this eccentric school is now all but extinct.'[41] Pre-Raphaelitism was even seen as a critical commonplace in the reviewing of music. Wagner's writing of *Lohengrin* was compared in the *Saturday*

Review[42] to a Pre-Raphaelite picture: 'He systematically writes operas, as the Pre-Raffaellites paint pictures, in a multitude of carefully designed and highly wrought mosaics, and wonders that the heart of the age remains cold and unmoved to passion by the elaborate whole. The Pre-Raffaellite artists forget that the human eye is not formed to see all the separate portions of a scene with an equal distinctness of outline, and that the operation of this physical peculiarity is practically increased by the depth of the emotions with which the spectator regards the principal actors in any event of absorbing interest. In like manner, the musical school of Wagner forgets that the human mind cannot move so to say, beyond a certain pace in the melodious expression of its emotions, requiring a distinctly defined prolongation of each musical idea in order that it may be musically felt at all.' In May 1882 Hopkins remarked to Baillie, 'Ah! *you will have heard* the Nibelungs' Ring. You must tell me your impressions' (*LIII* 250). The cross-fertilization of criticism of art and music extended to the adoption of musical terms in titles and in criticism of painting, where the relation of colours was analysed in terms of 'keys' and, by Hopkins, 'scales'.

Hopkins made his own private contribution to the contemporary debate in an essay 'On the Origin of Beauty', probably written though characteristically equally probably not made public, for Hexameron in May 1865.[43] In this platonic dialogue set in the gardens of New College, Hopkins develops the ideas he had initiated in 'Health and Decay in the Arts'. Through the dialogue between his Ruskinian professor, Hanbury, a 'scholar of the college', and Middleton, an artist associated with the painting of the murals in the smoking room of the Oxford Union, he establishes several principles: (i) complex beauty is a mixture of regularity and irregularity, 'regularity' being defined as 'consistency or agreement or likeness, either of a thing to itself or of several things to each other' (*J* 90). The beauty of oaks, chestnut-fans and the sky is 'a mixture of likeness and difference or agreement and disagreement or consistency and variety or symmetry and change' (*J* 90). (ii) The beauty of composition of a picture lies in the relation between the masses, relation being defined as 'things which are near enough to have something in common, but not near enough to be one and the same' apprehended through comparison (*J* 95). This idea he had sketched in an essay on 'The Origin of our Moral Ideas' written shortly before for Walter Pater, where he had stated that 'in art we strive to realise not only unity, permanence of law, likeness, but also, with it, difference, variety,

contrast: it is rhyme we like, not echo, and not unison but harmony'
(*J* 83). In 'On the Origin of Beauty' he develops this into further
consideration of the organic relation of the parts to the whole. (iii) Much
of the later part of the dialogue concerns poetry rather than painting,
examining ideas of parallelism, antithesis, and proportion in ideas and
construction. In this he criticizes the Prayer Book as pompous because its
repetitions are equal rather than more artistically proportional (*J* 113).

Hopkins may have seen Dante Gabriel Rossetti's black-and-white
illustrations before he saw any of his paintings. We can be sure that
he knew Dante Gabriel's etching for the frontispiece of Christina
Rossetti's *Goblin Market and other Poems* (1862), since he remarked on
it through the voice of Middleton, in 'On the Origin of Beauty' (1865,
J 103). Rossetti had made a pattern of three dots in triangles on the
dress of one of the sisters in his illustration to 'Goblin Market' and
Hopkins had Middleton comment that the three dots were prettier than
triangles would have been because of the combination of continuity
and discontinuity (p. 103). Hopkins must have studied the drawing
carefully to note the pattern on the dress. What is far more arresting in
the illustration is the mature, voluptuous beauty of the maiden—she
was evidently modelled by Fanny Cornforth and is recognizably akin
to *Woman combing her hair* of 1864. Even more remarkable are the
'goblins', interpreted by Rossetti as an owl, a parrot, a purring cat, and
several rodents; all with the hands of men. Their expressions are full
of deceit and cunning. The dark-haired sister pictured in the upper left
corner is clearly leaving the scene as rapidly as she can while looking
back apprehensively at her sister. Hopkins may well also have seen
Rossetti's five striking etchings for the Moxon edition of Tennyson's
Poems (1849), and even possibly his well-known illustration to the *Maids
of Elfenmere* for William Allingham's *The Music Master*. There is in
Rossetti's etchings a strong sense of pattern that tends to increase the
emphasis on the aesthetic and allegorical rather than realistic impression.
The abstract patterning is something that is also often true of Hopkins's
landscapes, which may have been pushed in this direction through
Rossetti's stylistic influence.

On 2 July 1866 Hopkins noted in his journal, 'Was at the
Water-Colours. Burne Jones' Cupid conveying Psyche and *Le Chant
d'Amour.*—"je sais un chant d'amour triste ou gai tour à tour". The
best of Smallfield's things was girl with raspberries in a garden. Burton
had one study not very interesting. E. K. Johnson a name I did not know
before had some genre pieces, chiefly with near landscape, the best being

called A study of Yew trees—an *oeil de boeuf* in a garden formed by yews, a bed of irises chiefly in the midst with a [] tree, and a lady in a peach-coloured grey silk part lit part shadowed by sunset light. At that particular pitch no further correctness could be wished in the growth of the yews etc and the folds of the dress. Boyce's things as good as usual. Rosenberg's are good too: he had some things from Goderich castle etc showing the green mossy mould which covers some facets of the sandstone, but he has definitely given himself to a mannered tree touch although the departure from simplicity is slight' (*J* 142). Hopkins seems to have been experimenting with his private 'critic's article in brief'. The italicized foreign words, the clause, 'no further correctness could be wished' being very much in the condescending tone of the time. The picture by Burton that Hopkins did not consider very interesting was titled *A Study*. The *Art Journal* disagreed, saying instead, 'Mr Burton, who is always deliberate, measured, and thoughtful, sends "A Study", which, though small, is of choicest quality. A girl in white head-dress, that comes as a foil to the warm hue of the Italian features, rests at a well under the cool green shade. The treatment is simple and broad, and the drawing firm of purpose'.[44] The last sentence may give a clue to Hopkins's lack of interest: 'broad' treatment did not satisfy him. Smallfield's *The Girl with Raspberries* was praised as 'rare in beauty and remarkable for delicacy. The softly diffused light and dappled hues thrown especially on the background, bring grateful repose to the eye. Needful force and contrast are obtained through sparing but well-timed use of black and purple. Here and there some accidental blemish on leaf and flower gives emphasis. The execution, though detailed, is kept broad and free. This picture in strongest contrast hangs as a pendant to Mr Walker's work to which we shall next refer.' If Hopkins yet noticed Walker's painting—he would certainly have known his illustrations for *Once a Week*—he made no notes on it. In keeping with much of the criticism of Walker's oils, his picture, *The Bouquet*, was described as showing 'powers misapplied' (pp. 173–4). Of Boyce the *Art Journal*'s critic said, 'Mr Boyce only a few seasons ago entered this gallery as an anomaly. He ... loves to plant his sketching stool just where there is no subject. Yet does he manage to make out of the most unpromising of materials a picture which for the most part is clever and satisfactory ... [I]n the artist's special department of landscape we have two drawings pitched in directly opposite keys: "Pangbourne" is grey, green, silver, and black; and "Wotton House" is glowing as cloth of gold. The style of Mr Boyce

will be eccentric in variety so long as it remains unmannered' (pp. 174–5). E. K. Johnson was one of the most recent of the Associates of the Society. The *Art Journal* commented on his eighteenth-century manner. What followed, however, is to today's readers, a surprise though it is in keeping with the response generally meted out to Burne Jones during the 1860s. For the pictures which first caught Hopkins's eye, the critic said, 'But those who seek for an antidote [to Johnson's eighteenth-century polish] behold what the good gods have provided for you in the works of Mr Burne Jones! Gracious heavens! What profundity of thought, what noble teaching, what mystery of loveliness are here brought forth for the delight and edification of the elect! "Zephyrus bearing Psyche asleep to the Palace of Love" is nothing less than a pictorial miracle ... In a sphere so expressly non-natural, the articulations of anatomy, together with the laws of gravity, are of course suspended. But for the worshippers of the supernatural, food still more sustaining to the soul is provided in that marvellous and mysterious conception, "Le Chant d'Amour" (p. 174). What a blessing that Cupid is blind; for with the exception of the armour-clad and Giorgione-intoned knight, what is there here to delight his beauty-loving eye? This mythology in the midst of mediaevalism would take the jolly little god by surprise! Sentiment may be something very fine, yet common sense, even in the world of Art, is a useful commodity not wholly to be despised.' Etc. etc. Hopkins may be forgiven for confusing Cupid with Zephyrus; the rather androgynous god is simply young and tender in his carrying of Psyche. Judging from the oil into which Burne Jones developed the subject, the criticism was overly harsh. The painting shows a central maiden kneeling at a mechanically simple but ornately decorated organ, whose bellows are powered by blind Love, an androgynous youth clothed in rich burnt umber. Beside and slightly behind her is a love-lorn knight in armour with a scarf on his arm slightly redder in colour than Love's robe. The figures, who are convincingly depicted as listening dreamily, are set on a board or a wall (which puzzled Henry James) in the midst of a sunset scene with medieval buildings in the background and flowers in the foreground, tulips signifying ardent love and wallflowers the bitterness of love. It is a colourfully harmonious, poetic piece.[45] Robyn Asleson in an article on the aesthetic development of Albert Moore points out that any tidy division made today between naturalism and Aestheticism overlooks the fact that most of the artists who became part of the latter movement went through a phase of discipleship to Ruskin or Pre-Raphaelite naturalism.[46] Burne-Jones further exemplifies such a

difficulty of classing artists since his career does not follow a progression from one to the other; some of his paintings exemplify Pre-Raphaelite naturalism, others are Aesthetic. *Le Chant d'Amour* is an example of a picture by Burne-Jones in which the balance between narrative, and the concentration on mood and a beautiful arrangement of line and colour has tipped to the latter, aesthetic mode. The title, *Le Chant d'Amour*, comes from an old Breton song and the design's inception dates from 1864.[47] Although some of what the *Spectator*'s critic was complaining about is a lack of naturalism, he was also pointing to technical inadequacies and Burne-Jones never fully mastered figure drawing. Bridges, with his doctor's eye, complained that he had 'never seen such badly drawn feet any where, his angels in the [Days of] Creation have both gout and rickets, which is discouraging to the hopeful mortal who dreams of some day getting rid of deformities in heaven' and, in 1886, Hopkins lamented to Dixon the 'bad, unmasterly' drawing that marred Burne-Jones's gifts of 'spirituality and invention'.[48] But his appreciation shows that by 1866 Hopkins's pictorial criteria were clearly not confined to realism.

Hopkins noted in his Journal that he had been 'at the Academy too lately. Prinsep shews breadth. He had a portrait of Gordon in costume of mandarin of the yellow jacket and "La Festa di Lido" in the Venice public gardens in October. A. Hughes illustrated "my heart is like a singing bird". There was an atmosphere study of midsummer midnight by a certain Raven who might turn out something. Brett had a landscape of Capri. Leighton's Syracusan bride. The *new* realist school scarcely appears at the Academy' (2 July 1866, *J* 142–3). The critic of *The Times* said of John Samuel Raven's *Midsummer Moonlight*, 'The picture startles from its unlikeness to conventional painting of moonlight, but it is true, and represents as we do not remember to have seen it represented the dew-haze that in summer nights blurs and veils the landscape, and produces an effect as unlike as possible to the clear, sparkling, chilly aspect of bright moonlight, but one far more impressive to the imagination.'[49] There were four pictures classified by the critic as Idylls, three small ones, by Mason and Watt's and Mawley, and Leighton's 'fifteen-foot frieze, from the Love Charm of Theocritus' (p. 10e), who had been one of Hopkins's favourite poets early on in his time at Oxford. Val Prinsep's pictures caught the attention of Hopkins, and Tom Taylor, who said, 'Mr. V Prinsep's large picture of the "Festa di Lido" shows a delicate perception of beauty in the female heads, a fine and original sentiment of colour, a courage of hand, and a largeness of execution, all remarkable in the work of so young a man. But Mr. Prinsep, as is to

be expected in an immature painter, shows the defects complementary of his qualities in a very striking way. His strong sense of beauty in female faces renders him careless of beauty in all beside; his feeling for colour has made him indifferent about form; his scorn for conventional rules of picture-making seems to have left him without respect for due considerations of composition, and his power has been allowed to degenerate sometimes into slovenliness, sometimes into coarseness. In short, his work is full of imperfection, some of it apparently wilful, but it has merits which are not common in our school, and if faults are not passed over too indulgently, the power should develop into something very far above the average. In this picture, which has a fine luminous quality in its colour, as a whole, and a sober richness in the parts, which it would be difficult to surpass, Mr. Prinsep seems to have committed the mistake of treating on a large scale a subject only fitted for cabinet size.'[50] The criticisms of scale and composition were ones that Hopkins, perhaps learning such concerns as well as the tone from Tom Taylor, levelled at his brothers' work.

Arthur Hughes's pictures were compared by Taylor with F. Wyburd's *Lady Jane Grey*, which he called 'a conspicuous example of that prettiness in general colouring and in the features and form of the principal figure which establishes an irresistible claim to popular favour, but is little valued by graver or more cultivated taste'. By contrast, 'appeal to a far more delicate and refined sense of beauty is made by Mr A. Hughes's' three pictures. Of these Hopkins selected what he called 'My heart is like a singing bird', probably the *Guarded Bower* (no. 457), described in *The Times* as showing 'a lover who flings his armed hand over his lady's head, to guard her against the world'. Taylor, whose comments show a greater sensitivity to sexual stereotypes than to moral questions, asserted that it 'would be far more satisfactory if the guardian were cast in a manlier mould of face and figure'. While Hopkins would undoubtedly have agreed in preferring a 'more manly figure', the typecasting of the behaviour would, as his letters to Patmore showed, have met with his approval. Interestingly, Hopkins does not seem to have been attracted by Maclise's heroic *Death of Nelson* or O'Neil's *Last Moments of Raphael* with its Catholic resonances of chalice, candle, and monstrance on the side-table and the painter's unfinished picture, *The Transfiguration* resting on its easel. The biblical paintings of Armitage with their realistic detail also failed to catch his attention.

In July 1866 Hopkins visited the French and Flemish Exhibition formerly held by Gambart but now managed by Wallis at The Gallery,

120 Pall Mall, opposite the Opera colonnade. He remarked, 'interesting to remember Daubigny's suggestive and sombre landscape (a view of Villerville and a river-scene [*Near Antwerp*]) not unlike Crome' (9 July, *J* 144). Crome was indeed an artist whose work Daubigny was to admire when he fled to Britain in 1871. Of Tissot's *Spring* Hopkins remarked on the similarity with Millais's painting *Apple blossoms—Spring*. Both show young women lying languidly on the ground beneath flowering apple trees. Hopkins saw them as 'curiously like in motive'. Millais's young women are ethereal. The one on the far right faces the viewer. Dressed in gorgeous yellow satin she lies in front of a scythe which points down towards her heart. The painting would seem to carry a moral of memento mori. Under the shadow of the Fall even these innocent girls in the spring of their life and beauty are destined to die. Perhaps the picture came back to his mind to be combined with Isaiah 40 when in 'The Wreck of the Deutschland' he wrote, 'Flesh falls within sight of us, we, though our flower the same, | Wave with the meadow, forget that there must | The sour scythe cringe'. In Tissot's picture, the two principal young women are of marriageable age and maturity in an apple orchard on a sunny afternoon. They are far more fleshly than those in Millais's picture. One lies on her stomach, the other sits leaning on her hand. Both are expensively dressed. They are evidently chatting while waiting for a nibble at their simple fishing rods which rest into a stream in the foreground. Although there are again the inevitable associations of mortality brought about here by the proximity of women and apples, Tissot's picture lays more stress on the secular cycle of women's lives—these ample creatures, dressed in the fashion of the day are waiting to hook their men. Their idleness, however, raises questions about the utility of their lives, questions that they seem to feel in the ennui on their faces and which the Christian symbolism heightens. One might compare the picture to Hopkins's poem, 'Miss Storey's character', with its supercilious analysis of the young woman: '… thinking that she thinks, has never thought; | Married, will make a sweet and matchless wife, | But single, lead a misdirected life'.

Hopkins made a note to compare Baron Leys and Lagye, his pupil, with our medievalists. 'All their colouring "sleepy"' (9 July 1866, *J* 144). Lagye, whom Hopkins referred to as Leys's pupil, followed Leys's historical subjects from Faust. Leys's characterization was praised in an article in a series on contemporary Belgium artists by James Dafforne in the *Art Journal* as 'calm, benign, vigorous, and honest', revealing

'the inner life of our ancestors better than do ten chapters of Barante, of Meyer, of Oudegherst or any other of our chroniclers'.[51] The continental artists of the Medievalist school were subject to the same sort of polemicized criticism as the Pre-Raphaelites. For example, the *Fortnightly Review*'s Sidney Colvin (who was shortly to praise the Aesthetic artists)[52] remarked of Baron Leys's paintings in the French and Flemish Exhibition, 'There is one painter ... whose reverence for Van Eyck and the quaint barbarism of art has utterly obliterated every trace of individuality. He has been likened to our Pre-Raphaelites, a school which attained notoriety for a brief season; yet the comparison is not fair to the latter. It is true that in their blind zeal they equally rejected what was good or bad in the ancient faith, and set up an idol whose rigid ugliness was as false an embodiment of nature as was the insipid prettiness of its predecessor. But in spite of the conventional affectation and offensive mannerism which pervaded the works of that school, its followers at least endeavoured to imitate nature—it may be said, too closely—but Leys imitates art alone. He has a large number of pictures in the Exhibition, but it is impossible to look at them with any degree of patience. To think that a man who evidently had the power to excel, provided he kept in a proper path, and trusted to his own perception of nature, should forfeit his individuality and content himself with producing too faithful imitations of by-gone barbarisms, is utterly deplorable. The eye is soon wearied by looking at representations of human nature which awaken no responsive echo in the heart, and we turn away at last indifferent and even disgusted, lamenting that so much ability should be wasted on the resuscitation of a manner which was simply the result of inexperience; for what was the simplicity of childhood in Van Eyck is downright affectation in Leys.'[53] The long quotation shows clearly the grounds of the objections to 'modern medievalism'—the simplified, unidealized figure drawing, especially when applied to religious figures; the photographic detail which was seen as enslaving. But it also shows how the art establishment, the Royal Academy, and even the advocates of aestheticism had been altered by the Pre-Raphaelite movement. Reynolds had advocated painting in a tradition of past painters. Here this is a ground for complaint. Look at nature and paint what you see—so had Ruskin said in support of Turner and the Pre-Raphaelites.

Hopkins's attention to pictures affected his way of viewing scenery, leading him to compare what he saw on visits to France and Switzerland

with paintings. A visit to France in July 1867 brought the following observation:

Flames of mist rose from the French brooks and meadows, and sheets of mist at a distance led me to think I saw the sea: at sunrise it was fog. Morning star and peach-coloured dawn. The scales of colour in the landscape were more appreciable before than after sunrise: all was 'frank'.[54] The trees were irregular, scarcely expressing form, and the aspens blotty, with several concentric outlines, and as in French pictures. In the facing sunlight there was very little colour but bright grey shine and glister, with trees interposing in their stems and leafage poles and strokes of bluish shadow. The day was fine, everything bright: even the iron rings in the walls of the Seine wharfs dropped long slant pointed shadows like birds do. (10 July 1867, *J* 147)

Most of this description, with its concentration on the play of light and the indefinite expression of form, is the vision of Turner and the French Impressionists, though the last observation recalls Ruskin's comments in *The Elements of Drawing* on the ring on the chimney wall. That Hopkins had looked attentively at Turner is suggested by his comment in August 1867 on a visit to Urquhart at Bovey Tracey when he commented on 'elms ... slimmer and falling towards one another, as in Turner's rows of trees' (*J* 153). A year later Hopkins was in the Ticino and comparing there the scenery and appearance of women with painters' perceptions: 'Ashes here are often pollarded and look different from ours and they give off their sprays at the outline in marked parallels justifying the Italian painters' (11 July 1868, *J* 172) and 'Some women we met were dressed in Italian fashion with red borders to their gowns, that curious red and green diaper border one sees in Italian pictures, and black steeple hats. Their features in the same canton are of Italian cast—straight eyebrows across and thick noses as in modern English art [Jane Morris?], with a modest expression of face' (12 July 1868, *J* 173).

The Exposition Universelle in Paris in 1867 became another controversial item in the development of nineteenth-century English art. Although many of the nations allowed their principal artists considerable space to show all their recent works, the British committee in charge of selection decided to allow each British artist only three. There was no British sculpture on show because the cost of insurance was levied against those lending their work. The result was that the British selection fared ill in continental criticism of the Exhibition. Hopkins, who visited it with his Aunt Kate, one of his mother's artistic sisters, mentions in his journal seeing the Flemish and Bavarian displays. Among the Flemish he cited Baron Leys, Alfred Stevens, and F. Willems, who

exhibited between twelve and eighteen paintings each. The Exhibition was the triumph of Stevens's career. Stevens, who had begun his career with political paintings about the hardships of the poor, had in the 1860s turned to aesthetic subjects from contemporary high life, later influencing his friend Tissot, who produced modern 'aesthetic' pictures with slight narrative. Stevens sometimes used several different titles for his pictures, though Peter Mitchell notes that 'Stevens' subjects (and their titles) were simply an excuse to paint...If the titles were really unimportant, their novelty and chic, like the subject-matter, were appealing. Perhaps his most original gift as a painter was a sense of colour which touched upon unusual and intriguing subtleties.'[55] He was one of the early enthusiasts of oriental accessories and during the 1860s painted Impressionist seascapes and inside scenes with a dazzling technical proficiency. It was his fashionable ladies that he exhibited in the Exposition. Hopkins's third choice, Willems, was another of the subjects in James Dafforne's series on Modern Painters of Belgium and was known for his ladylike models and for the 'truth and perfection of the draperies', often of elaborate, patterned material.

Eleven days later Hopkins visited the 'Foreign Paintings', again with Aunt Kate. Tom Taylor said of it in *The Times*, 'The comparatively small number of the pictures (212), the cabinet size of most of them, and the low or subdued scale of colour characteristic of foreign schools, unite to make the general effect of the room agreeable. The subjects are, as a rule, simple, the treatment generally modest, reserved, and conscientious. One comes away with an impression that the work of these painters, on the whole, is guided by a sounder knowledge of their craft and better taste than that of the contemporary English painters with whom they most suggest comparison.' However, he noted that the exhibition was a commercial one designed to provide what 'comes most home to the tastes and falls in with the house arrangements of English picture buyers'.[56] Hopkins noted Alma-Tadema's ' "Tibullus' visit to Delia" and honeymoon *temp.* Augustus'. They were the first two pictures in the exhibition. Alma-Tadema was a pupil of Leys. He had, with the assistance of a fellow student, Victor Lagye, enticed Gambart to visit his studio (*c.*1864), where Gambart, liking what he saw, had commissioned twenty-four pictures from him. He later commissioned a further forty-eight.[57] Tom Taylor thought the honeymoon ugly but remarked on Alma-Tadema's remarkably 'forceful' colours 'obtained at the expense of a disagreeable forcing and some blackness'; he seems to have 'mastered all the details of Roman dress and house furniture with great industry.

If we must have revivals, we do not see why we may not as well go back to Imperial Rome as to medieval Flanders. Thanks to Herculaneum and Pompeii we have almost as much material and authority for the one as the other.' Hopkins included in his list of works L. Bonnat's *St Vincent of Paul and the galley-slave.* Although Hopkins seems to have kept his religious affiliations independent of his artistic judgement, Bonnat's striking *St Vincent de Paul taking the place of a convict* might well have had an appeal to one who had just decided to join the Roman Catholic Church; Hopkins was later to serve as chaplain to the Society of St Vincent de Paul in Liverpool.[58] Characteristically of Bonnat, the painting is more a 'biographical' portrait of the Catholic cleric than a religious painting, although the example of Christ taking on suffering for man's sins is an evident model for St Vincent's actions. It was Christ's suffering for man that gripped Hopkins's religious emotions as he had explained in a letter to his father in 1866.[59] There is considerable subtlety in the depiction of the personality of St Vincent de Paul's gentleness and resolution while the ball and chain is transferred to his ankle and the compassion with which he steadies and comforts the man he has freed, who does not know how to thank him. There is too a similarity in method with Pre-Raphaelite work in the combination of a realistic scene with Christian symbolism. The ball and chain are easily representative of the world that Christ saved through his acceptance of undeserved punishment. Hopkins might also have admired the muscular torsos of the shirtless prisoners. He repeatedly praises muscular men whose bodies have been shaped by their physical work—such as the sailor in 'The Loss of the Eurydice', 'Harry Ploughman', Hamo Thornycroft's statue of *The Sower*, among others.

Hopkins commented on a picture by Devriendt of 'Guillebert de Lannoy recounting his adventures at the Crusades to Isabella of Portugal'—'style of Baron Leys; by the latter the Proposal, a garden scene, by his pupil Lagye Faust and Marguerite'. Taylor remarked, 'it is interesting to compare the historical art of Belgium, in such small examples as we have here, with that of France; to see the confirmed bent towards mediaevalism, which the influence of Baron Leys has given to this school, and the revival in his work and that of his scholars, along with Flemish incidents and costume of the 15th and 16th century, of Flemish downright ugliness. Leys is himself represented by a group of young *arquebusier* making love to one of the plainest maidens ever suggested by imitation of Cranach and his school, and by pictures of even clumsier youths and more forbidding maidens from the hands of Lagye (112), and

the De Vriendts (53 and 54). But Leys has a closer follower, strangely
enough, in the Frenchman James Tissot, whose well-known subjects
from Faust have given him a position of his own. There is only one
picture of his this year, "Holy Prayer" (178).' On this Hopkins did
not comment. He did praise the 'good genre pictures by De Jonghe,
Ruiperes, and especially Vibert, also by Escosura, Gripps, Hamman,
Stevens, Toumouche, and a tiny thing, ' "the Smoker", by Meissonier'
(J 149). Charles Joseph Grips painted nineteenth-century versions of
Dutch interiors with considerable mastery of still-life techniques in
the many jars and pieces of household equipment which he arranged
in rooms that otherwise might have been mistaken for seventeenth-
century settings. Hopkins noted Vibert, who 'had a pastoral, Chloe
and Daphnis, he teaching her to play the pan-pipes, the motive being
exactly that of Leighton's this-year pastoral'. Taylor commented, 'A
very vigorous young French painter, who promises to make a position
for himself, and in that effort grasps, though not as yet firmly, a wide
range of subject, though he seems more particularly at home in Spain,
is J. G. Vibert. He has no less than eight pictures here, from a life-size
idyllic group—"Daphnis and Chloe" (198) (the boy well drawn and
coloured, the girl neither)—to a remarkably clever cabinet picture of
the studio of a French engraver in the time of the Revolution (191)'. All
three Bonheurs exhibited but Hopkins noted a landscape by Auguste,
Rosa's brother, described in *The Times* as 'a bold Welsh landscape (910),
with cattle, Moel-Siabod in the distance'. The 'landscapes by Lambinet'
noted by Hopkins were described in *The Times* as 'A "Stormy Day
on the Coast of Brittany" (103), merely a tumble-down hovel, a low
range of clay cliff, and a broken gray sky … an uncommon example of
Lambinet, a painter whom we usually associate with luxuriant meadow
flats, reedy river sides, and sunny orchards. "The Spring in the Country
Lane" (102) is a bright, pleasant specimen of his more familiar style of
subject.' Hopkins praised 'a country lane, with a woman leading a cow,
by Weber (Otto) which for several reasons was very good, especially
the way in which a tree a little way off against the light has its boughs
broken into antler-like sprays by the globes of the sunbeams or daylight'.
The Times said of it, 'in the way of animal painting we may notice a
clever picture of Otto Weber's (204), an old woman tending her cow in
a green lane, worth noticing as an example of how a simple subject of
this class may be made interesting by treatment'. What Hopkins found
in the picture were things that he noticed in nature and described in
poems, the sunlight through trees of 'Binsey Poplars' and the ashes,

their bare boughs like talons sweeping, tabouring against the sky in the late sonnet, 'Ashboughs'. Hopkins grouped Ruipérez, Stevens, De Jonghe, and Alfred Stevens as showing 'good *genre* pictures'. *The Times* remarked that 'of the costume and boudoir subjects, of which so many both of the French and Flemish cabinet painters are such consummate masters, there is no want'. Gérôme's picture of Louis XIV reproving his courtiers for their slighting of Molière caught the eye of *The Times*'s critic while Hopkins, perhaps partly because of his uncle Edward Lane's Eastern interests, noted his 'Gate of the Mosque El Assaneyn Cairo, where were exposed the heads of the Beys sacrificed by Salek-Kachef'. The latter was available from Goupil as a gruesome *carte de visite* until 1904. It also forms part of the list of those, generally Catholics, of course, martyred for their religious beliefs that Hopkins accumulated in his poems, journals, and letters from St Dorothea, St Thecla, St Laurence, Margaret Clitheroe, to St Francis Xavier, and perhaps the tall nun. Landelle's fellah woman in her colourful costume was described in *The Times* as 'clever ... though the texture of the flesh is disagreeably waxy'. Of the paintings of children by Edouard Frère, drooled over by *The Times*, Hopkins made no mention.

The National Portraits Exhibition, which Hopkins visited in August, was the second show devoted to British portraiture and it concentrated on portraits of the eighteenth century. Inevitably this meant comparisons between Reynolds and Hopkins's relative, Gainsborough. A 'Conversation—The Portraits at South Kensington' in *Fraser's Magazine* for July 1867 concluded, 'If it is not heresy to say so, I must confess that without calling in aid his landscapes, I prefer Gainsborough to Reynolds ... And if he had been as popular as Reynolds in his day, and had painted as many pictures ... I am sure that his general reputation would equal, if it did not exceed, that of his great rival. In this collection Reynolds' pictures (about 150) are as three to one of Gainsborough's (about 50), but this gives an excessive representation to Gainsborough, according to the total number of their respective works.'[60] In considering the qualities of portraiture the critic quoted from Tennyson's 'Idylls of the King' lines that express much of what Hopkins too sought in portraits:

> As when a painter poring on a face,
> Divinely, thro' all hindrance, finds the man
> Behind it, and so paints him that his face,
> The shape and colour of a mind and life,
> Lives for his children, ever at its best
> And fullest[.][61]

In August Hopkins also visited the South Kensington Museum twice, first on 17 August, the same day as the National Portrait Exhibition, and secondly, two days later when he went with his brother Lionel and spent time looking at portfolios of 'photographs of metal-work from some of the loan exhibitions'. He evidently also looked at the musical instruments and Oriental pottery since he noted in his journal 'names of medieval etc musical instruments.—Celadon green' (19 Aug. 1867, *J* 151).

On 9 February 1868 he made notes on the history of Greek philosophy in which he distinguished between two kinds of mental energy: a transitional kind, 'when one thought or sensation follows another, which is to reason, whether actively as in deliberation, criticism, or passively, so to call it, as in reading etc.' and a second kind, which he called contemplation, consisting of being absorbed or enjoying a single thought. Art, he noted, required both sorts; even music required that 'the synthesis of the succession should give, unlock, the contemplative enjoyment of the unity of the whole. It is however, true that in the successive arts with their greater complexity and length the whole's unity retires, is less important, serves rather for the framework of that of the parts' (*J* 125–6). Elaborating on this, he continued, 'The more intellectual, less physical, the spell of contemplation the more complex must be the object, the more close and elaborate must be the comparison the mind has to keep making between the whole and the parts, the parts and the whole. For this reference or comparison is what the sense of unity means; mere sense that such a thing is one and not two has no interest or value except accidentally ... The further in anything, as a work of art, the organisation is carried out, the deeper the form penetrates, the prepossession flushes the matter, the more effort will be required in apprehension, the more power of comparison the more capacity for receiving that synthesis of (either successive or spatially distinct) impressions which gives us the unity with the prepossession conveyed by it.' Explaining his more elliptical comments on the inferior nature of suggestive art made in his essay on the 'Health and Decay of Art', he concluded that this last sort of unity leads to 'saner contemplation' because it is contemplation of something 'which really is expressed in the object. /But some minds prefer that the prepossession they are to receive should be conveyed by the least organic, expressive, by the most suggestive, way. By this means the prepossession and the definition, uttering, are distinguished and unwound, which is the less sane attitude' (*J* 126).

On 16 April 1868 Hopkins attended the Hampstead Conversazione Society, a local group who generally held loan exhibitions of contemporary art. Hopkins noted '*Pied Piper* by Pinwell; Praeraph. pictures by E. Dalziel'. House and Storey explain that Pinwell exhibited illustrations to Browning's *Pied Piper* the following year at the Water-Colour Exhibition and that it was probably either *Children* or *Rats* that Hopkins saw. What Dalziel exhibited is more difficult to establish: as well as his wood-engravings he painted in oil and watercolour (*J* 164, 382–3). Nine days later, on 25 April 1868, Hopkins went to see the French and Flemish Exhibition in the Pall Mall Galleries. It had opened on 10 April and was greeted by Tom Taylor as showing 'as usual ... the superiority of foreign art-training'.[62] He praised religious pictures by Bouguereau, landscapes by the Bonheurs, Gerome's cruelly realistic *Bullring*, Meissonier's *Le Rixe* and *The Stirrup Cup*, Alma-Tadema's *Dancers* and *A Roman Poet*, landscapes by Daubigny and Lambinet, and a *Breton Wedding* by Otto Weber. Hopkins's impression was rather different. He noted that 'Bischoff's [Bisschop] things most interesting' (*J* 164). Of these Taylor made no mention.

On 29 May 1868 Hopkins took his degree. He recorded that he 'Saw Swinburne. Met Mr. Solomon' (*J* 166). Solomon, who was prominent in early accounts of Aestheticism (1867),[63] has been credited with confirming, if not initiating, Pater's interest in paintings associated with the movement and the phrase 'art for art's sake';[64] Pater first published the phrase later that year in reviewing Morris's poems in the *Westminster Review*.[65] Free of his studies, Hopkins expanded the number of things that he did, going to the horse show at Islington on 3 June, and the Architectural Exhibition on the 12th. There he noticed the 'Furniture and glass by Burges', Lameire's *Catholicon* and 'Suggestions by Moore worked out by an architect for the Queen's Theatre'. Five days later he had lunch with Pater followed by visiting Solomon's studio and seeing the Royal Academy's Centenary Exhibition. Presumably it was Pater who introduced Hopkins to Solomon and one wonders about the nature of the conversation that led Pater to make the introduction. It is more likely to have been about art than homosexuality, but how would Pater have defined Solomon's art to Hopkins and interested him in it? Solomon was a friend of Swinburne's and Fred Walker's. He had exhibited three watercolour paintings in the Dudley Gallery earlier in the spring and they may well have been back in his studio by June: *Heliogabalus, High Priest of the Sun and Emperor of Rome, Patriarch of the Eastern church pronouncing the Benediction of Peace*, and *Bacchus*

wandering by the seashore. Solomon had been praised for 'his uncommon power of representation. No one has given more attention than Mr. Solomon to the study of metallic lustre, and he can paint a golden utensil or an embroidered robe better than any water-colourist now living.' He was also commended for his 'profound philosophical intention'; Pater described Solomon's depiction of Bacchus as 'modern', partly because his vision of him brought out a sense 'of things too sweet ... a certain darker side of the double god of nature' latent in Greek notions of Dionysus.[66]

Hopkins listed in his Journal many of the pictures mentioned by reviewers of the Royal Academy Exhibition. Mason's *Evening Hymn*, which Hopkins lists first, is discussed in Chapter 6.[67] Hopkins noticed all the paintings by Millais and by Leighton. Some of the listed titles are underlined, presumably indicating those paintings that he preferred. Among those of Leighton (*Ariadne, Actaea, Jonathan's token to David, Acme and Septimius*) he underlined *Actaea* and *Jonathan's token to David*. *Actaea* is a full frontal nude, though the body is more that of a piece of sculpture than a woman's. She is supposed to be a nymph reclining on the seashore 'with the usual Leighton face, fair, delicate, and with a certain disdainfulness on lip and brow ... with a beauty belonging rather to our Northern race than to any Greek ideal'. The background was deep blue with dolphins playing in the middle ground, 'and in the sky a cumulus and a rain-cloud.'[68] It was Leighton's second nude to be exhibited at the RA. Trained in Germany and in touch with continental trends, he was representative of a resurgence of classicism, but with characteristics that are more sensual than the classicism of the earlier part of the century. Linked with Moore and Poynter, Leighton's brand of classicism has been seen as 'a natural development towards Aesthetic abstraction under the influence of his European contemporaries'.[69] *Jonathan's token to David* was, according to *The Times*, 'knowingly drawn, and painted in a manly style' (p. 11d). *The Times* praised Watt's *Meeting of Jacob and Esau* as 'a heroic composition, fit to serve as a pendant to Mr. Leighton's "Jonathan," for which, we understand, it is painted'. The critic preferred his 'Wife of Pygmalion', which he ticketed as 'the statue called to life', referring to its origin as a depiction of 'a beautiful head discovered by Mr. Charles Newton among the Arundelian marbles at Oxford, which Mr. Watts has here verified with colour. Such work as his is eminently welcome and wholesome in our exhibitions, when the large and noble style has to struggle at such a disadvantage with the pretty, the attractive,

and the dramatic, that only the most ingrained love of the former can resist the influence which is always drawing away in the direction of the latter, till the great in art threatens to disappear altogether from the walls of the Academy.'[70] Hopkins underlined it in his list, evidently liking it more than *The Meeting of Jacob and Esau*. He also underlined Walker's *Vagrants*. The latter met with conflicting responses from the critics. For the *Saturday Review*, 'Mr Walker's "Vagrants" [was] not a pleasant picture, but it is a fair specimen of the artist's workmanship—of his now strongly developed mannerism.' He praised Walker's characterization, but lamented that 'the picture leaves rather an unpleasant impression, due to a painful air of stifled suffering and indignation in the face of one of the women, which haunts us afterwards. The landscape, though simple, is mysterious, and there is a feat of technical skill in the management of the smoke from the burning sticks, and the appearance of objects seen through it.'[71] Hopkins noted Sandys's 'a study of a head, long hair fully detailed; she bites one lock'—which Sandys had done as 'Proud Maisie', an illustration of Scott's poem, 'The Pride of Youth' (*J* 388–9). It was inexplicably praised as 'one of the most admirably finished works ever executed by an English painter'. Holman Hunt's *Pot of Basil* drew no comment from Hopkins though he listed Poynter's *Catapult*. Leys's 'historical picture', part of his work for Antwerp town hall on which his pupil Alma-Tadema was assisting, occurred second in Hopkins's list. It was described as 'a singularly dry picture; not merely grave and seriously mediaeval, but positively dry. The subject is the Talaviani family of Genoa claiming the rights of citizenship at Antwerp in 1542, and the work has a general look of a collection of quaint old portraits, grouped simply for portraiture, and not with reference to any common action. Though there is a great deal of character in the faces, nobody seems to be living, or is it a case of animation suddenly suspended by enchantment, every one remaining motionless in his place till the spell is removed, which in this case it will not be for the next five hundred years.'[72] Tom Taylor, on the other hand, said of it that it had 'all the gravity, unstagy earnestness of character, and absorption by the business in hand, with all the attention to mediaeval usage, costume, and accessories, which are characteristics of its eminent painter', though he did also comment on the uniform ugliness of the physiognomy of the men and women he presented. The qualities praised tease out ones that Hopkins looked for in literature—an earnestness, taking seriously the subject and conveying it with appropriate keepings. These were things that he cautioned Bridges to remember in his writing of plays

(17 May 1885, *LI* 216–18). Taylor also liked Legros's work, saying, 'The inspiration of a grave purpose, and the power of a disciplined and self-restrained skill never fail M. Legros, who stands almost alone, like Mr. Armitage, in the Exhibition, but as the example of a different class of results of foreign training. His "Refectory" [which Hopkins underlined] is a large picture of three monks, at their sparely spread convent table, one reading, as convent usage is, some pious grace of holy legend to sanctify the meal, the others listening. The picture is broad, simple, and noble in light and in colour, the heads earnest and dignified, and the whole work has an impress of almost ascetic sobriety, in marked contrast with the aim at being lively, startling, or attractive, written on the face of almost every canvass here. Altogether this picture is one of the very few examples of really large work in the exhibition.'[73] Legros had been persuaded to move to England by Whistler, who approved of his subdued palate.[74] Hopkins also underlined Albert Moore's *Azaleas*. Moore, who had been close to Mason and Fred Walker and like them was heavily influenced by Greek art, especially the Elgin marbles, was at this time drifting into affinity with Whistler. His painting has become important in the history of English Aestheticism through the remarks made of it by Swinburne, who suggested that, like the poetry of Théophile Gautier, *Azaleas* was 'one more beautiful thing ... one more delight ... born into the world; and its meaning is beauty; and its reason for being is to be'.[75] The critic for the *Building News* considered it and its frame, 'the only decorative painting' in the exhibition and suggested that it 'ought to have been hung with the architectural drawings.'[76] Hopkins summed up his overall response to the show by recording that 'Walker's and Mason's things most interesting' (17 June 1868, *J* 167). It is a comment that suggests a wish to combine aesthetic design and colour and a classical idealizing of the human figure with contemporary, rather than antique subjects.

Ten days later he evidently went to the National Gallery, noting 'that Madonna by Beltraffio', 'Mantegna's draperies' and wondering whether Giotto had 'the instress of loveliness' (*J* 168). The Beltraffio Madonna had been bought in 1863 and shows the child lying 'in His Mother's lap, with a deep red sash round His waist, having just turned away from the breast: behind is a green-and-gold curtain, with landscape showing on either side' (*J* 390). There was no Giotto in the Gallery but House and Storey record that 'no. 276, the fragment of the head and shoulders of two Apostles, from a fresco in S. Maria del Carmine, Florence, now attributed to Spinello Aretino (?1333–1410), had been

bought in the Samuel Rogers sale, 1856, as by Giotto' (*J* 390–1). The only Mantegna was no. 274 *Virgin and Child with St John Baptist and Magdalen*; purchased 1855. 'The Virgin, seated under scarlet canopy, with rose and ash-blue drapery; both saints elaborately draped' (*J* 429).

For most of July Hopkins was in Switzerland with Edward Bond. On their trip they visited the Museum in Basle, where Hopkins commented on a 'noble dead Christ by the younger Holbein, but the other Holbeins were unimpressive' and a crucifixion by a German master 'in which the types of the two thieves, especially the good thief—a young man with a moustache and modern air—were in the wholeness and general scape of the anatomy original and interesting'. He analysed the German paintings of Holbein's period, concluding that they were characterized by a 'peculiar square-scaped drapery'. He also sketched part of the spiralling drapery from an angel in a drawing by Dürer (7 July 1868, *J* 170). J. D. C. Masheck points out that Hopkins must have made the drawing from memory since he reversed the twist in the drapery from clock-wise to counter-clockwise.[77]

On 21 August, Hopkins went with Baillie to see the National Portrait Exhibition. The third and last of the national shows, it was in two main parts: one devoted to important figures of the nineteenth century and a supplementary section of paintings that would more properly have fitted into the two previous shows. Hopkins singled out the portraits of Keats and Shelley, and the Holbeins in the supplementary collection, among which he mentioned one of Lord Delaware, a small portrait 'called Surrey and the Fair Geraldine, beautifully and delicately painted heads, in a most elaborate landscape'. Taylor added, 'we know of no such minute background work from the painter's hand'.[78] He mentions the portrait of William West, the first Lord Delaware, 'in a black cloak and doublet slashed with crimson, face and dress alike masterly'. Hopkins describes 'a portrait of a gentleman with some beautiful conventionalised leafage behind—palmate leaves disposed along an equally-waved stem'. The painting would seem to have been of 'Sir Henry Guildeford, controller of the household of Henry VIII, whose portrait in Windsor Castle (exhibited in 1866) is one of the painter's best and best-known pictures'. Hopkins lamented that he was turned out before he had had a chance to see all the portraits (*J* 186).

Tom Taylor, opening his remarks on the Centenary Exhibition of the Royal Academy, contrasted the importance of portraiture in 1768 with that in 1868 by saying that 'in 1768 English art had hardly any

recognized status except as portraiture, while in 1868 portrait-painting is the branch in which English art is weakest'.[79] He elaborated on the current faults, blaming 'prettiness, smoothness, or attractiveness which are the ruin of the popular portrait-painter's work and the secret of his success. This palpable aim at pleasing is the besetting sin of our portrait-painting when followed as an exclusive occupation. Till English portrait-painters are bold enough to paint truthfully, even their cleverest work will be bad. But besides the conscious untruth of painters who could do better if they had the courage, there is the deep-rooted incapacity of painters who have no adequate idea of making the best of a subject pictorially, and the unconscious vulgarity of painters who cannot be refined or noble, let them be never so honest. Conscious dishonesty, defective art-education, and unconscious vulgarity, are the three rocks ahead of English portraiture at this time and for long past, and in their wide operation we have the main secrets, so far as we can discover, of the continuous decline of this great branch of the art from the days of Reynolds and Gainsborough till now.' Hopkins's awareness of such condemnation and his sympathy with it may in part lie behind the severity with which he criticized such drawings by Arthur as his *The Paddling Season* and *Type of Beauty no. xviii* (see Chapter 5, pp. 197–9, 205–9).

In January 1873 Hopkins went to Burlington House to see the third loan exhibition of Old Masters' paintings. He made no notes but the richness of the show make it worth describing a little of what was there. The *Saturday Review* devoted four articles to the Exhibition. Holbein's *The Ambassadors* it proclaimed as 'the finest Holbein yet seen in Burlington House', although curiously if it was written by J. B. Atkinson, who was specially learned about Italian paintings in various continental galleries, the skull in the foreground of Holbein's painting was identified as 'apparently the bone of a large fish'.[80] Botticelli's *The Assumption of Our Lady* was praised as the 'most important picture of the Prae-Raffaellite period we have met with for many a day'. The critic made a number of comments about the handling of drapery 'the broken up and angular draperies are not Tuscan, but Lombardic'.[81] It displayed Titian's *Cornaro Family*, Carracci's *Holy Family*, and *Charity*. Raphael's *The Agony in the Garden*, described as 'true, simple, and devout' was preferred to Domenichino's *St Sebastian*, and Guercino's *San Luigi di Gonzaga received into the Society of Jesus*.[82] There were portraits by Velasquez of the first and second wives of Philip IV, Rembrandt's *Lady opening the Casement* from the Royal Collection, Poussin's *Worship of the Golden Calf*, and Claude Lorrain's *Passage of the Red Sea*. There were no

less than eighteen portraits by Vandyke and twenty-three by Reynolds, eight by Gainsborough, and a number by Romney. In addition there were representative paintings by Wilson, Constable, Turner, Crome, and Cotman, and 'a roomful of water-colour drawings from the easels of Varley, Robson, Girtin, Cozens, De Wint, Copley Fielding, David Cox, Turner etc.'.[83] The critic suggested that, 'Young artists will do well to analyse the different manipulations now to be seen in Burlington House. They might pass with advantage from this largely treated head by Rembrandt to the miniature "Geographer" by Dow; then to the naturalistic "Woman making an Omelette" by Velasquez; thence to the severe "Ambassadors" by Holbein; afterwards to the stately "Cornaro Family" by Titian; and, lastly they might end with the highly wrought "Agony in the Garden" by Raffaelle. Thus within the short range of three rooms is found an answer to the question, how representative masters and leading schools set down their facts and gave expression to their thoughts; how they arranged their palettes and handled their brushes; how execution was with them never an accident, but always the outward sign of an underlying law; how each touch was in a manner, part of the artist himself.'[84]

In September Hopkins visited the Kensington Museum, taking time not only to look as on earlier occasions at the musical instruments, but to examine the standard portfolios of Indian architecture and Michelangelo's paintings at the Vatican and the contemporary British painting that was housed there at the time. He commented on 'the might' of Michelangelo's figures, with which he 'was more deeply struck than ever before, though this was in the dark side courts and I could not see well'. It derived, he decided, 'not merely from the simplifying and then amplifying or emphasising of parts but from a masterly realism in the simplification ... there is the simplifying and strong emphasising of anatomy in Rubens, the emphasising and great simplifying in Raphael for instance, and on the other hand the realism in Velasquez, but here force came together from both sides' (18 Sept. 1873, *J* 237). Of the contemporary English paintings he remarked, 'thought more highly of Mulready than ever before—Watts: Two sisters and a couple of Italian peasants with a yoke of oxen—instress of expression in the faces, as in other characteristic English work, Burne Jones', Mason's, Walker's etc' (*J* 237). In Mulready's work Hopkins would have seen colouring and handling of trees reminiscent of Dutch paintings and Crome, and treatment of villagers as in some of the illustrated newspapers he had pored over as a child.

When Hopkins went home to Hampstead for Christmas 1873, he and Arthur visited the Winter Exhibition of the Society of Water-Colour Painters. Tom Taylor in *The Times* commented on the changes to the winter show. Once devoted to 'sketches and studies', it was now indistinguishable from the Spring Exhibition. He attributed the change to the increase in the market for watercolours; the widespread practice of painting in watercolour among the middle classes led to 'a more animated and interested body of visitors to these galleries, and a more intelligent criticism of their contents than can be found in any other art exhibition in London. As might naturally be expected of a form of art thus widely popular, we find in these exhibitions a combination of remarkably high average technical skill, with a preponderance of work addressed to average appreciation. There is little either of eccentric method or startling achievement, and as little as in all other exhibitions of imaginative or creative power in its highest forms.'[85] Like Hopkins, Taylor spent most space on Fred Walker's *Harbour of Refuge*, which is discussed in Chapter 6.[86]

Hopkins visited the National Gallery with Father Goldie on 16 February 1874, remarking on two new Michelangelos he had not seen previously. Of *The Entombment* (purchased 1868), an incomplete painting, he noted, 'touches of hammer-realism … (also a touch of imperfection or archaism)', which House and Storey suggest convincingly as 'partial recognition that it is a very early work (c.1495), derived from a print by Mantegna' (*J* 429). Of the other (*Virgin and Child with S John and Angels*, purchased 1870), Hopkins wrote, 'masterly inscape of drapery', though he thought it inferior to that of Mantegna's in the grisaille 'Triumph of Scipio' and the 'Madonna with saints by a scarlet canopy' (*Virgin and Child with St John Baptist and Magdalen*, purchased 1855). The drapery in this he considered 'unequalled, it goes so deep' (*J* 241).

On 12 June 1874 Hopkins went with Brother Bampton to the Royal Academy, housed since 1869 in Burlington House, and then to Agnews to see Holman Hunt's *Shadow of Death*. They spent two days 'sightseeing'. The pair occupied a good part of the first day in the Royal Academy, to which they returned for a shorter visit the second day before revisiting All Saints', Margaret Street, and Agnews. Reviewing the Exhibition, Atkinson summarized the characteristics of contemporary art with which he felt at odds. These were largely attributable to the emphasis on realism of Ruskin and the Pre-Raphaelites and the fact that many of the leading artists had spent time illustrating contemporary novels. For Atkinson,

'the least satisfactory works' were, 'as usual, the most ambitious'. 'Our English school', he lamented, 'scarcely cares to be historic, if it could; it seldom takes a retrospective view of past ages, but prefers instead to realize present times. And this realistic spirit of our art naturally determines the character of the pictures devoted to historic personages. The few painters who now deal with past times do not allow themselves as heretofore to rely on imagination for their facts; on the contrary, they go to the National Museum or South Kensington for archaeological accessories and chronological costumes. This mode of study comes as an all but inevitable sequence to the more searching inquiries of historians, and to the more accurate investigations of men of science. In short, the whole of our modern art, as exemplified within the Academy and elsewhere, bears the sign of being in accord with the time in which we live. From historic acts to domestic incidents, from genre to landscape, we everywhere see facts in place of fancy, realism as a substitute for romance; thus historic compositions become archaeological records, and landscape studies might serve to show geological strata. These tendencies determine at once the strength and the shortcomings of the present Exhibition in common with its immediate predecessors.'[87] It is the fruition of the trends that Palgrave had forseen in 1862.

Hopkins's notes on the pictures that he saw in 1874 are more extensive than for any other exhibition. The pictures that first caught the eye of Tom Taylor in *The Times* did not receive comment from Hopkins but they did share appreciation of some of the landscapes. Taylor began as in previous years in lamenting the unfair neglect of landscape by the Academy in its selection of Members and in the pictures chosen for prime spots, a subject to which he would return. Selecting three different approaches to landscape, he began with two large paintings by Millais, *Scotch Firs* (68) and *Winter Fuel* (75) each 'some 8 ft. by 6 ft. or 7 ft.': 'The scenes of both pictures lie in the beautiful wooded region traversed by the Tay between Perth and Dunkeld. Birnam Hill appears in both.'[88] Of *Scotch Firs* he said, 'this is no carefully composed and generalized picture of woodland scenery, but the translation into most subtle and potent painting of the truths of so many square yards ... of actual wood, as it stood to the artist, to be painted with infinite pains and pleasure for a certain number of autumnal weeks of still weather. With a skill which enables him to distinguish between what is passing and what is permanent in appearances and effect, Millais combines practice of a hand and eye of the rarest natural aptitudes, in the detecting and recording of appearances, such as has seldom been possessed by

any painter. These gifts have never been more strikingly shown than
in this picture and its companion, less interesting because here the
principal objects are cut, not growing trees, the subject being a cartload
of "The Birks of Aberfeldy" ... already bound into faggots for winter
fuel, and their boles, in sober splendour of silver gray slashed with
russet and purple, piled on the rusty-red cart for haulage home. One of
the woodcutter's children, in her red hood and white pinafore over her
buff and lilac frock, sits on the trunks, with her head turned away to
the wooded hills of Birnam in the background, where the silver stems
of the still growing birks sparkle upon hazy heights and slaty terraces.
The child's figure we cannot but feel a blot; she ought to be brought
up nearer to the level of the marvellously-painted birch stems, or she
should be taken out altogether. For subtlety and exactness of drawing and
colour combined, nothing we have ever seen in painting can go beyond
these birches ... The difference between all the marvellous detail in this
picture and in the painter's earlier subjects ... is that here the parts are
subordinated to the artistic effect and intentions of the whole, and that
there they were not. In the earlier work the painter was painfully trying
to paint the infinite details of nature as they were, that he might learn, in
this the later work of the master, to paint the effect of the same details on
the eye, to translate them into what they look like by tones and touches
in themselves utterly unlike the thing they are to help in representing.
We can suggest no more useful lesson to the young painter than to look
close into the execution of this carpet of heather, moss, and grasses, in
the fir-wood, and then, retiring to the distance required to take in the
picture as a whole, to mark the gradual change from what the close eye
saw to what the eye, at successive distances, has told the brain it was
seeing. ... Rightly judging these pictures, not as idealizations, but as
realizations, on a scale rarely attempted, and which lifts the work of the
realist into a new region altogether, we doubt if anything more masterly
of its kind has ever been seen in an English Exhibition.' The *Saturday
Review* called the two paintings 'bold and unflinching yet conscientious
studies from nature [with] little of the slightness and incompleteness of
former and more experimental efforts. On the whole, these companion
landscapes are the most remarkable products of the year.'[89] Hopkins
was more critical. Of *Scotch Firs*, subtitled 'The silence that is in the
lonely woods', he retorted, 'No such thing, instress absent, firtrunks
ungrouped, four or so pairing but not markedly; true bold realism but
quite a casual install of woodland with casual heathertufts, broom with
black beanpods and so on, but the master shewn in the slouch and

toss-up of the firtree-head in near background, in the tufts of fir-needles, and in everything. So too *Winter Fuel: "Bare ruined choirs"* etc.—almost no sorrow of autumn; a rawness (though I felt this less the second time), unvelvety papery colouring, especially in raw silver and purple birchstems, crude rusty cartwheels, aimless mess or minglemangle of cut underwood in under-your-nose foreground; aimless posed truthful child on shaft or cart; but then most masterly Turner-like outline of craggy hill, silver-streaked with birchtrees, which fielded in an equally masterly rust-coloured young oak, with strong curl and seizure in the dead leaves. There were two scales of colour in this picture—browns running to scarlet (in the Red-Riding-Hood girl) and greys to blue (little girl's bow or something) and purple in the smoke on the hill, heather, birchwoods, and in foreground the deep mouldy purple of the stems; then for a gobetween a soft green meadow. There was a beautiful spray-off of the dead oak-scrolls against dark trees behind with flowing blue smoke above. Toss or dance of twig and light-wood hereabouts' (*J* 244–5). Hopkins's analysis is here more technical, although expressed with his own terms, than that of Taylor.

In his third notice of the Academy Taylor reverted to the problem of landscape paintings in the annual exhibitions; 'Academicians ask you seriously to name a landscape painter clearly entitled to election, and so many names occur to one, but so few which stand out saliently from the rest, that the advocate of the landscape painters' claims is apt to feel for the moment perplexed and puzzled. More brains and heart both are undoubtedly wanting to our landscape painting, more selection of subjects which have taken a strong hold on the painter's feeling, more treatment of subjects showing that the work has passed through a process of absorption and re-creation in the painter's mind; or, short of this, more of that strong grip of outward truth which makes Mr. Brett's work stand out so clear and strong, though that painter, we presume, would deny that any special imaginative process is needed, or indeed possible, for the landscape painter, whose function, he would probably maintain, is confined to the exactest possible representation of what he sees, having regard to the means he has at command.'[90] He had described Brett's *Summer Noon in the Scilly Isles* as 'pitiless sunlight reflected in the vivid blue and purple wavelets of the Scilly sea, and the intensely realized surface of the lichened granite pines embedded in the mossy shore vegetation, scarred with russet tufts of withering sea-pink. This striking picture is the highest expression of a third conception of landscape art, as different from that of Millais's on the one hand as from that of A. Hunt',

20. John Everett Millais, *Winter Fuel (Manchester Art Gallery)*

on whose Welsh sunset Hopkins did not comment, 'on the other, agreeing with them only in the determination to be faithful to the truths which the artists respectively feel or value most in nature. It would be difficult to conceive exactness of representation carried further than it is here, whether we take the drawing or colouring of rocks, sky, or vegetation. To some minds this work will have the highest charm that landscape can give. To others it will be as uninteresting as art can be, even while they admit its perfection of representation, as accurate as the closest study continued on the spot from day to day can give. All depends on the painter's power to control the accidents of changing light by his predetermined purpose. No doubt opinions will vary as to how far Mr. Brett has succeeded in doing this. But no one will contest his right to stand as the champion of his own theory of landscape in the English school.' Hopkins, rather similarly to Taylor's judgement, more concisely recorded of it, 'Emerald and lazuli sea; true drawing of clouds; sooty-mossed boulders in foreground a little scratchy and overdry—not quite satisfying picture but scarcely to be surpassed for realism in landscape' (*J* 246–7).

Of *Let the hills be joyful together* (533), by J. Raven, Taylor protested, it 'is one of the conspicuous examples of hard landscape-hanging of which we have complained. Here a most subtle and delicate study of autumnal tints on the hills embosoming one of the English lakes is placed where its beauty can only be guessed at.'[91] The unflattering hanging did not stop Hopkins, who commented, 'Like what I have seen of his before—grace of line and colour: the colour gathers in rosy or in purple tufts and blooms; trees, clouds, and mountaintops "seized" or "shrugged", as in Turner' (*J* 247). That the record in the journal was written up after he had left the Exhibition from briefer notes made as he was going round is revealed by his remarks on A. S. Wortley's *In Wharncliffe Chace*: 'Much sense of growth in bare oaks and much cast (so I have written: I hardly understand it) in the boulders' (*J* 247). Devising a new technical language could have its drawbacks. Taylor commented, 'Winter in Wharncliffe Chase (987), by Mr. A. Wortley, is a grim composition of red-rusted winter bracken, out of which rise great gray mountain limestone boulders, with a range of leafless oaks, standing along the edge of a plateau, which overlooks a wide stretch of more level distance. The work of a young painter, this is one of the landscapes here leaving the most distinct impression on the memory, perhaps from the simplicity of its materials, but certainly in some degree also from the vigour with which it has been conceived and rendered. There is a largeness and manliness of style about it from which the best results may be augured.'[92]

The last of the landscapes Hopkins remarked upon were by H. Moore. In his *Rough Weather in the Mediterranean* he praised the 'fine wave-drawing; waves glass-blue and transparent with underlights', which Taylor described as 'a pleasant variation in green from his usual sea studies in gray, and showing as true a feeling for open sea as he has so often shown for inshore surf on our own coasts.'[93] Of Moore's second piece of a shipwreck, *Rough Water on the Cumberland Coast*, Taylor thought more highly than Hopkins, describing it as 'likely to draw off attention from all the sea painting in its neighbourhood, so full is it of dreary truth ...'. Hopkins made no comment about the wreck; his attention was all on the truthfulness of the drawing of the water: 'a coast-scene with wave breaking, but there the moustache of foam running before the wave or falling back to it seemed a little missed or muddled' (*J* 247). Similarly of W. L. Wyllie's *Goodwins* (1330), described by Taylor as 'a very impressive study of the fatal sands, spanned by a rainbow, with the sea birds playing in the white light that tells of recent storm, about a lately stranded hull, while the timbers of others, in various stages of digestion by the hungry sand, protrude in the foreground',[94] Hopkins wrote only, 'Fiery truthful rainbow-end; green slimy races of piers; all clean, atmospheric, truthful, and scapish' (*J* 247). Unmoved by the wreck, he gives his most frequently used terms of approval for the landscape: 'clean', i.e. not scribbled, 'atmospheric' (or poetic), 'truthful', and 'scapish' (i.e. showing aesthetic rhythm or pattern, a lower quality than 'inscape', where the pattern is significant).

Beside his landscapes, Millais had three portraits and his *North-West Passage* on display. Hopkins commented on all four. His analysis of *The North-West Passage* shows his accumulated knowledge of Millais's style: 'Characteristic *ruffling*—in grandfather's coat, girl's skirts and *rouches*, in chart and the creased flag. This picture more unsatisfying than the others, want of arch-inscape even to scattering; besides old sea-captain seemed crumpled together somehow' (*J* 245). Taylor, by contrast, had a lot of nationalist and sexually stereotypical praise to make of this 'triumph in the way of subject painting,' the 'old man, his rough vigour all the more felt by contrast with the womanliness of the gentle girl at his feet. ... We need hardly direct attention to the wonderful truth of the in and out door light, the perfection of representation in the bunting of the flag, the flowers and the jug that holds them—even the tumbler of grog. Nothing is forced, but nothing is scamped; and at the distance at which the whole can be taken in by the eye the effect of every part and object is perfectly expressed.'[95] The first of the portraits was of

Young Nathaniel de Rothschild, where Hopkins wrote enthusiastically, 'Must be the very life—hair (just bridled with a gilded curl or two), lips, eyes (Bidding in the hair, eyebrows and lips) crimson scarf, stride, embroidered bright-leather shoes carried to a knifeblade edge and a little rising; but then scapeless aimless background of tapestry, a cannon, and so on, just like him. Should be remarked how he makes his figures out into pieces—scarlet turning of the coat collar, white waistcoat, red tie, face, hair, scarf, breeches etc. So also in the *Picture of Health* the head, curls on either side, green-blue butterfly of scarf, velvet coat, muff.' Hopkins was more harsh on a lack of dramatic unity or design in his brothers' drawings, the comments he makes here of Millais balance between criticism and objective analysis of characteristics; 'want of arch-inscape even to scattering', 'scapeless aimless background', and 'should be remarked how he makes his figures out into pieces' referring to the way in which the figures can be seen to comprise units rather than flowing into one, which may have been the effect of the bright colours. 'Bidding' he defined for Bridges as 'the art or virtue of saying everything right *to* or *at* the hearer, interesting him, holding him in the attitude of correspondent or addressed or at least concerned, making it everywhere an act of intercourse' (to R.B., 4 Nov. 1882, *LI* 160). Like his description of 'Nathaniel de Rothschild', Hopkins's poem, 'Morning, Midday, and Evening Sacrifice' catches qualities he admired in young people:

> The dappled die-away
> Cheek and the wimpled lip,
> The gold-wisp, the airy-grey
> Eye, all in fellowship—
> This, all this beauty blooming,
> This, all this freshness fuming,
> Give God while worth consuming.

Taylor's less incisive comments on the same portraits were: 'Millais' "Picture of Health," a halflength of a bright little girl, glowing from her winter's walk, which should be compared with his full-length of a young Rothschild (95) for the well-understood contrast of treatment and effect'.[96] On Millais's last picture Taylor, who may have been short of time and space, rounded off his account of the paintings with an airy flourish: ' "A Day Dream" (1432), a pensive girl in plain white with a blue scarf, seated by a garden basin, by Millais, brings the contents of the last room to a pleasant close, and leaves us a very delightful impression wherewith to pass to the sculpture.'[97] By contrast, Hopkins's attendance

at the Portraits Exhibitions is reflected in his account of the final of Millais's pictures, of which he wrote: '*Daydream*—a Millais-Gainsborough most striking crossbreed: colouring raw, blue handkerchief not any stuff in particular but Reynolds' emphatic *drapery*, background (bushes and tank) either unfinished or mere mud. Intense expression of face, expression of character, not mood, true inscape—I think it could hardly be exceeded. Features long, keeling, and Basque. The fall away of the cheek (it is a 3/4 face) masterly. Great art in the slighted details of the hat on the lap, blue of the bracelet, lace of scarf; fingers resting on or against one another very true and original (see on Holman Hunt's *Shadow of Death* much the same thing)' (*J* 245). Hopkins's reference to his notes on Hunt's *Shadow of Death* would seem to be to his remarks on the figure of Christ: 'the feet not inscaped but with a scapeless look they sometimes no doubt have (I cannot remember and do not put it down for reverence: see above on Millais' *Daydream*) and veined too, which further breaks their scaping' (*J* 248). The anxious phrase, 'do not put it down for reverence', seems to suggest a judgement on the balance between truthfulness and ugliness. Hunt paints Christ's feet as ugly but in a convincing way and offends both Hopkins's sense of beauty and his conviction that Christ must have been beautiful. The quality of including details without drawing too much attention to them would seem to be caught in Hopkins's phrase, 'slighted details'. It was this sort of effect that W. M. Rossetti praised in foreign painters in his article of 1864 and which he lamented as absent in what he called the 'insistence' of contemporary British artists.

The contrasting approach to the change from academic to more intensively realistic painting is evident in the responses of Taylor and Atkinson to Richmond's *Prometheus*. Taylor asked, 'How is the critic to deal with Mr. W. B. Richmond's colossal "Prometheus" (687)? How do justice to the courage and ambition which have prompted the young painter to such an effort, and yet not do more than justice to an aspiration which is only justified by a measure of achievement which we do not feel has been reached in this instance? The Titan is represented chained to a rocky pinnacle, which runs clear up into the blue till it affords just space for the gigantic prisoner to be fettered to it. Around him swoop the seagulls, far below lies the gray-blue sea, around him the gray-blue sky. All is lurid and weird in the heavens above and on the waters beneath, and the Titan's head is gray, whether with weight of years or agony. We ought to be reminded of Michael Angelo, but we cannot help thinking of Fuseli. That is the truth, though it may seem a hard truth to

Mr. Richmond. But in such a case there is not kindness but sincerity. If we are right Mr. Richmond had better fly at lesser game. If we are wrong he may defy all the blindness of all the critics.'[98] Atkinson predictably commented that the picture 'carries us back to the forsaken region of high art, to the time when colossal scale, deep tones, and dark shades were deemed essential to grandeur. ... The conception is imposing, though necessarily not very novel; indeed in the figure we seem to see under disguise the torso of Hercules in the Vatican ... [W]e ... recognize in this noble effort a mind which holds converse with historic master-works, and composes from like points of view'[99] (p. 593). Hopkins remarked, 'Fine; academic in attitude and colouring, as dark tinsel-blue sea, big moon, brown clouds; fine anatomy' (*J* 247). It is a pithy and objective analysis.

When Frederic Burton became Director of the National Gallery in 1874 he ceased to paint. His last contribution to the Royal Academy was described in *The Times* as an 'exquisite life-size half-length of "Mrs. George Smith" (869)—a striking example of the delightful effect with which water colours may be used for portraiture even of the size of life'.[100] The *Saturday Review* said, 'Amongst the "water-colour drawings" the most noteworthy is the portrait of "Mrs George Smith" (869), by Mr. Frederick Burton, the new Director of the National Gallery.'[101] Hopkins made no notes on it.

Taylor gave considerable space to Tissot's three paintings: ' "London Visitors" (116) ... is another illustration of the thorough appropriation of English types and subjects by this clever French painter. A young country gentleman and his young wife are standing under the portico of the National Gallery. He consults his guide-book or catalogue; she, looking rather bored, points towards Whitehall. A bluecoat boy, descending the steps, turns to look at the country visitors, and behind are some other figures, and the portico of St. Martin's Church. The painting is very clean and clear, executed with a firm hand that perfectly carries out the painter's intentions. The predominant tone is gray, of various shades, in architecture and dresses; the atmospheric effect is hard and dry, and here is the weak point of the picture. The courage of M. Tissot in grappling with the ugliness and awkwardness of the bluecoat boy is worthy of note.' On 26 May the critic noted: 'M. Tissot represents a pleasant "Waiting" (387) under the golden chestnut shade, in the nook of the river, by this pretty sternwoman, who sits looking out for her "oars," yoke-linen in hand. Once more we are struck with the thoroughliness with which the French painter has made himself at home among us and

our types' (p. 6b). 'J. Tissot's "Ball on Shipboard" (690) is another of
those illustrations of modern society in which this accomplished French
painter delights to face the artistic problems raised by modern costume
and the familiar conditions of every-day life. Here he has set himself
the difficult task of representing the scene on board a man-of-war at
Spithead, converted into a ball-room by an awning lined and fringed
with flags. The light is filtered through canvas and bunting till the
whole picture is lowered to a soothing half-tone, in which the brilliant
summer toilettes of the ladies look cooler than the normal coolness of
even muslin and tarlatan and the lightest linen. There is more pictorial
skill in the way this is managed than the unlearned public is ever likely
to appreciate; and the grace of the girls, the taste of their toilettes, and
the capital characterization of the gentlemen, old and young, yachtsmen,
and man-of-war officers, cannot be praised too highly. Above all, there is
one group in pale sea-green, near the gangway just beyond the awning,
which is a delicious little picture in itself. But we take leave to doubt
the possibility of successful pictorial treatment of a subject in which the
light is diffused throughout, and strong light and shadow is nowhere
resorted to. Besides, we get rather tired of the repetition of the same
type of feminine face in all M. Tissot's pictures. A painter has no more
right to impose on us the same man's. Every one would resent this in
the masculine case. It is a mistake to suppose character so separable
from charm that variety can be dispensed with in painting women.'[102]
It was the atmosphere of Tissot's work that Hopkins responded to. He
noted that there were 'Several Tissots—Atmosphere; green and yellow
chestnut leaves; atmospheric women in clouds of drapery with mooning-
up eyes and mooning-up nostrils of oddly curved noses: his interesting
management of modern costumes (as in the *Ball on Shipboard*) is very
clever but he should not have tried to paint Bluecoatboys' yellow legs'
(*J* 247). Tissot's work is often a coloured equivalent of Du Maurier's
black and white illustrations; Tissot's first work in England after his
escape from the Paris Commune was cartoon portraits for *Vanity Fair*.[103]
His technically superb etchings and paintings of the stylish *demi-monde*
soon enabled him to set himself up comfortably in London.

The Times critic remarked, 'The delicate beauty of both figures and
landscape in A. Hughes's "Convent Boat" (584), a novice being ferried
back to the convent after parting with her family, is seriously impaired in
effect by the hanging of the picture. With some weakness, the picture is
full of beautiful passages, and inspired with the most refined feeling both
in its figures and landscapes of still river, and quiet conventual buildings

shrouded in autumn woods, with no suggestion of sound beyond the faint ripple as the boat is pushed across the stream.'[104] Hopkins only comments on the foliage: 'piecing and parting of the ivy, poplars, and other trees attempted but not quite mastered' (*J* 247).

Tom Taylor described Alma-Tadema's *Picture Gallery* (150) as 'the interior of a Roman painter's studio, with the artist—or is it a famous connoisseur and collector?—expatiating to a group of critical visitors, including a graceful lady in peach-coloured *pallium*, on the merits of a picture still on the easel. Other visitors scan the pictures on the walls. The light falls through windows high up, all but one of them shaded by blinds, which subdue the sunshine and account for the broad, cool, diffused light which irradiates the richly-coloured room, the yellow covering of the couch in the foreground, the blue satin of the cushion under the lady's pretty foot. No picture here shows such mastery of all the technical resources of composition, colour, light, and air as this. In these points it is indeed a standard which most of the work about it is quite unable to bear.' Atkinson commented, 'We find yet another phase of what we have designated retrospective art in that remarkable resuscitation of Roman times ... Yet it is a startling anomaly that, instead of a company of old Romans, we meet the familiar faces of a quondam London picture-dealer and his family. ... Yet the artist might have found among the descendants of the old Romans in the Trastevere, who still live on the borders of the Tiber, a physique more strictly historic, though scarcely an eye so professional for a picture ... Mr. Tadema's picture is at once a curiosity and a stroke of genius; no picture in the Exhibition is so provocative of criticism.'[105] Taylor commented: 'The exactness with which Egyptian costume and accessories are reproduced should secure attention to Mr. Alma Tadema's small picture of "Joseph" (300), black-wigged and white-linen-robed, seated in his chair of office, staff of authority in hand, while a scribe beside him notes the quantities of various grain purchased for the Royal granaries, samples of which are spread on a cloth in the foreground. The locust painted on the step of Joseph's chair is typical of his victory over famine. The only defect is, as in so much of this painter's delightful work, that the figures, in complexion and pose, are too statuesque.'[106] Hopkins's response to Alma-Tadema's *Joseph overseer of Pharaoh's granaries* was that it was 'merely antiquarian but excellent in that way'. He found *The Picture Gallery* 'less antiquarian; lighting just a little studio-fashioned; two Romans with check or patterned tunics like a snake's slough, the arm of one resting on the other's shoulder very faithful drawing; little colour;

happy use of openings [there are a number of sources of light], accidental installs,[107] people's feet, hands etc seen through'. Hopkins seems to have invented the word 'install' as an equivalent for patterns made by lines to chiascuro for the patterning of light and dark areas in paintings. He seems to be referring to the patterns made by the juxtapositioning of the figures' hands and feet with the background seen around/between them. He commented on the 'use of square scaping', something he had associated with German painting of Holbein's time. He also remarked on the engraving of Tadema's *Vintage Festival*, mentioned earlier.[108] His conclusion that 'vigorous rhetorical but realistic and unaffected scaping holds everything but no arch-inscape is thought of' would seem to apply to all three pictures.

Hopkins noted, '*Queen of the Tournament*—P. H. Calderon—*Clear*; composition in the pieces, the figures singly, not in the picture or piece in the old-fashioned sense of piece; clever frank treatment of bright armour. His name is Spanish: I think there is something Spanish about him' (*J* 244). Taylor described it as Calderon's 'very ornamental and delightful "Queen of the Tournament" (335), a beautiful lady, in white satin, gold embroidered, and one of the high head-dresses of Charles VII.'s time, about to place the chaplet of victory on the brow of a happy knight, who kneels at her feet, and wears her colours on his arm. In the foreground the knight's page bears his lance and shield.'[109] 'A fat and homely old humorist among the spectators robs the picture of the insipidity of unrelieved good looks. It recalls former scenes by the master from the same stately world of chivalry ... but this is a more purely festive and ornamental subject than any of these, while it is painted with the same charm of finished and agreeable workmanship.'[110] Taylor was less flattering about Briton Rivière's *Apollo* (260), calling it an unsuccessful 'new chapter in his "beast epic"', which represents Apollo charming the beasts in the pine woods of Othrys, while doing service as a herd in the household of Admetus. The most striking point of the picture is the lionesses' lambent eyes glaring in the shadow of the pines. Indeed, the feline actors in the *tableau*—lions, lionesses, lynx, and leopards—are, strange to say, the best. The goats are not made the most of, and the stags are stiff and lifeless, and there are as much too many of them as of the pine-boles between which they thrust their listening heads and necks, stark with wonder, as the god strikes his lyre with a not very well-drawn arm, his bare back uncomfortably leaning against a rugged pine-stem.'[111] Hopkins admired the painting. Recalling Leighton's *Idyll* of 1866 based on Theocrites, he commented, 'Like a roughened boldened Leighton,

very fine. Leopards shewing the flow and slow spraying of the streams of spots down from the backbone and making this flow word-in and inscape the whole animal and even the group of them; lion and lioness's paws outlined and threaded round by a touch of fur or what not, as one sees it in cats—very true broad realism; herd of stags between firtrees all giving one inscape in the moulding of their flanks and bodies and hollow shell of the horns' (*J* 244). An appreciation of the clear link between surface appearance and structure was one of the things that Hopkins admired in William Butterfield's buildings.[112] It is that unity of appearance and physical structure expressing identity that he seems to allude to here with 'word-in' and 'inscape'.

Taylor announced, 'Mr. F. Leighton has painted a court in a house of the Jews' quarter of old Damascus, with graceful figures—a woman beating down the lemons which a girl catches in her rose-coloured robe, while in the foreground a graceful green-robed young woman is shifting pots of pinks. All these combinations of tenderly coloured robes, green foliage, and golden fruit, with the softly coloured rose and creamy white of the marbles, and the soft blue and blue green of the tiles used in the architectural decorations of arch, pavement, and column, make up a delightful and subdued harmony, which this year the painter seems to have especially sought in three out of his four pictures.'[113] Of Leighton's *Moorish Garden* he said, 'a lovely little maiden drags along a brace of peacocks, one of the familiar green and gold and azure, the other of spotless white. In the background are the cypress and orange gardens, and a glimpse of the fretted masonry of the Alhambra. The charm of the picture is in the tender and dreamy sentiment, well described by the title. The materialist's or realist's criticism is likely to be a question—Why introduce peacocks to take all the colour out of them; and, indeed, why introduce us to a Moorish garden under an Andulasian sky to dim all its green and golden glories down to these subdued and sober harmonies viewed through the haze of dreamland?'[114] On 26 May the critic wrote, 'Mr. Leighton's pictures are the solitary representatives here of a kind of work to which alone, as some critics contend, all who truly deserve the name of artist should dedicate themselves. From such a conception to any notion of art and art's work practically carried out in this country is the distance between us and the Antipodes. Such is the distance, in the conception of the same judges, between the point at which England stands aesthetically and the starting-point of her renaissance.'[115] Hopkins's taste led him to a similar preference. Leighton's *Old Damascus: Jews' Quarter* he

described as the 'gem of the exhibition'. His detailed comments on it are in Chapter 3 (pp. 106–7) because of the relation of what he liked to Butterfield's architectural style. Of Leighton's *Moorish Garden: a dream of Granada*, which he liked less, Hopkins wrote, 'Whimsical little girl, blown together of Andalusian afternoon air, leading a white and a coloured peacock (its train brown in the light exhibited); brown and green cypresses parcelled into flakes, which were truthfully slanted, trellised alley, rushing stream down a marble channel, blue inlaid dome in distance; no central inscape either architecturally or in the figure grouping—little girl should have transomed the trailing sweep of the peacocks' trains, as indeed their necks did but not markedly enough; however beautiful chord of blue and green × browns and reds' (*J* 245–6). The use of 'Andalusian' suggests that Hopkins might well have read Taylor's article, answering his criticism of the painting's dim colouring by attributing it to the gallery lighting. Hopkins would seem to have been right, the painting does not have a subdued palette.

Taylor described 'Mr. F. Leighton's high, classical Clytemnestra, with rigid face, and statuesquely stiffened form, her draperies gleaming ghostly white under the moon, waiting on the battlements of Argos for the signal fires which are to announce the fall of Troy and the return of her doomed lord to his home and his death. The classical inspiration which prompts such work is so rare that we can but hope Mr. Leighton's picture will find fit appreciators, as we fear it can hope to find but few. Fully admitting the severely noble intention of the design, we must question Mr. Leighton's treatment of Clytemnestra's drapery, both in the great main lines and the disposition of the lesser folds. Would any linen take such convolutions? And, supposing them non-natural, is there any grace or grandeur to justify the invention? We cannot but feel them small, and what the French call "tormented"' (5c).[116] Atkinson referred to 'Mr Leighton's massive and majestic figure … the pose is immobile and statuesque … the light within the picture is spectral; indeed the figure is so cold that we might almost imagine flesh had been changed into stone'.[117] Hopkins's response was an analysis of how well Leighton had conveyed the drapery, light, and expression and, like Taylor, he had some reservations. He wrote: '*Clytaemnestra watching the beaconfires*—very smooth and waxen; addled cream-drapery, rhetorical, not recognised; scaping in it', by which he seems to have been suggesting that there was patterning but not a convincing understanding of how such drapery would fall about the figure. Of the lighting he was more approving: 'moonlight clear and white, without any exaggeration or

sillybillying in blue and bottleglass, delicately browning her arms'. His moral conscience would seem to have stifled any possible emotional reaction: 'face fine, scornful voluptuous curl and all that (as it was really there must say so); behind tall-up battlements, not massive' (*J* 246).

Hopkins noted that 'Bright Japanese pictures are the rage. The best was *Five O'clock Tea* by Mrs. Jopling' (*J* 247). Tom Taylor came to the same conclusion: 'Alfred Thompson's "Embroidery" (999), and "A Japanese Cleopatra" (1001), with F. Moscheles's treatment of the same subject (654), and "On the banks of the Kanagawa" (1006), and Mrs Romer-Jopling's "Five o'clock Tea" (1047), are all products of that Japanese inspiration now so active among English artists. It must be owned, gallantry apart, that the lady has turned this inspiration to best account. Not only have her Japanese beauties more of the national character than either Mr. Thompson's or Mr. Moscheles's, but she has not pushed the supremacy of merely material splendour so far in their costume, while giving quite as full play to its artistic qualities of colour and quaintness of character. Mrs. Jopling's ladies look actually like a party of Yokohama or Nagasaki belles as a visitor might drop in upon them at their "5 o'clock tea." Mr. Thompson's and Mr. Moschelle's more gorgeously attired maidens are evidently posed for the sake of showing off their fine clothes and the other Japanese properties with which the Regent-street Japanese *bric-à-brac* warehouse might have supplied the painter *ad libitum*.'[118]

Taylor described C. Green's "May it Please Your Majesty" (1022)— as 'a Corporation which has come forth to meet its Sovereign, and bends in loyal homage, from the Mayor downwards, bearing key on cushion, through all the worshipful officer-bearers at his back'. He remarked, 'Mr. C. Green has reached a point, both in scale of work, conception of his subject in general and particulars, and execution, in all respects so far beyond anything yet attained by him, that he takes new rank altogether.'[119] Running out of time Hopkins jotted down, '(a royal entry, burghers, carpets etc)—Tone; projection; colour studio-muffled' (*J* 247). Similar brevity was accorded H. Bource's *Ruined* (719) described in *The Times* as 'a clever Dutch picture of a subject à la Israel—two Scheveningen women, sitting woeful among the sandhills the day after storm and wreck'.[120] Hopkins merely listed it under the title 'Day after the Tempest'. W. Maclaren's *Huckle Bones* (948) shows us, said Taylor, 'a graceful group of Capri girls playing with the "*tali*" which amused their ancestresses in the days of Horace and Virgil'.[121] Hopkins noted 'Maclaren (Uncle Edward's friend at Capri)—*Girls playing at knuckle-bones*—Much tone; colouring

quite (Italian) classical—black, two siennas, green, blue (both Raphael-like), rosepink flowers, bamboo-yellow fence, grey ground; figures a little weak though and flattened' (*J* 247).

Luke Fildes's *Casuals* and F. Holl's *Deserted* were both displayed this year. Hopkins made no comment on either but Taylor protested in terms Matthew Arnold had used for poetry: Fildes' 'picture is one of unrelieved squalor and hopeless misery, without even such a gleam as the sickly light of the gas-lamp to help the spectator in his struggle with its gloom. It is late to argue that such a subject is not within the limits of art as now recognized; but we doubt the justification of inflicting such pain through painting, unless there be some suggestion, in subject or treatment, of hope, remedy, or repentance. Here we fail to find any of the three. ... Mr Fildes has unconsciously betrayed the unsoundness of his ground by choosing for so many of his models the professional beggars of the streets—those who never, or very rarely, seek the shelter of the casual ward, but prefer the warmth and squalid luxury of the thieves' kitchen or cheap lodginghouse, and are seldom without the price of it in their ragged pockets. There is a certain hollowness in any appeal to compassion on behalf of these, and it cannot be got rid of by spicing the unsavoury dish with such ingredients as the young mother and her children. Still, whatever we may think of the groundwork of the picture, there is no contesting the effectiveness of its working out, which shows in the painter a power hitherto unsuspected, such as is often revealed by the transition from conventional themes to those which have some breath of real life in them, even though it be life so shiftless and sordid, and only in the very slightest degree truly pathetic, as is this which Mr. Fildes has here so strikingly depicted.'[122]

There was also a painting by Madam Courtauld-Arendrup, who established a religious house at Wimbledon and had called a number of times at Roehampton while Hopkins was a novice there, donating pictures to the novitiate, and who had exhibited at the Royal Academy before. Taylor commented that he had seen from her 'a picture very like (671) "An Eastern Twilight," expressive of the awful pause of nature which followed the Crucifixion. But this does not prevent our feeling the impressiveness of her work, which is ill-hung, but, from its breadth and simplicity of effect, suffers less than most pictures as hardly treated by the hangers.'[123] Hopkins later remarked to Bridges of her gifts to Roehampton that, 'we have also three remarkable pictures of great size by a lady, a sort of "new departure"' (15 May 1882, *LI* 145).

21. William Holman Hunt, *The Shadow of Death (Manchester Art Gallery)*

Hopkins walked down from the Royal Academy to Agnews in Bond Street where he observed of Holman Hunt's *Shadow of Death*: 'First impression on entering—great glare and lightsomeness (so that, strange to say, I could not help knowing what a woman behind me meant by saying that, well it reminded her of those pictures they hang up in national schools); true sunset effect—that is/the sunset light lodged as the natural light and only detected by its heightening the existing reds, especially in the golden-bronze skin he has given to our Lord's figure, and by contrast in the blue shadows on white drapery and puce-purple ones on pink silk. Also thin unmuscular but most realistic anatomy of arm and leg. Also type of figure not very pleasing—seems smaller from the waist down, head overlarge, and the feet not inscaped but with a scapeless look they sometimes no doubt have (I can remember and do not put it down for reverence: see above on Millais' *Daydream*) and veined too, which further breaks their scaping. On the whole colour somewhat overglaring. The pale weathered brick (?) interior throws up the glare of our Lord's figure. Face beautiful, sweet and human but not quite pleasing. Red and white embroidery of broad flat belt giving a graceful inscape and telling in the picture. Clever addled folds of the white cloth. Shavings and all the texture too tufty and woolly—and you get the thought of this from the sea-shot blue-and-green woollen gown our Lady wears. The saws and other tools seemed over-blue. No inscape of composition whatever—not known and if it had been known it could scarcely bear up against such realism' (*J* 248). Hopkins's impression was closer than in the past to that of Atkinson, who gave it over two columns in the *Saturday Review*. He began by proclaiming: 'We may safely prophesy that no picture will in the coming season excite so much interest or provoke such warm debate as this startling apparition of Christ in the carpenter's shop ... It comes as the mature fruit of an earnest and laborious life; it is the latest expression of an unfaltering faith; the creed of "prae-Raffaellitism," in which the artist was reared, and of which he now remains perhaps the only unswerving disciple, has never found so thoroughgoing an exponent. ... Nothing is the creation of imagination; historic truth is reached through selection of still existing facts, a process which is all the more trustworthy from the known permanence of Oriental forms. This carpenter's shop was indeed in part painted "in a carpenter's shop," and the figure and head of Christ were studied from living models in Palestine. ... It was not till the arts became secularized that we find the carpenter's shop freely admitted within the pale of pictorial narrative. ... One of the inferences we thus

arrive at is that we are here thrown not so much within the domain of high art as of *genre*. This interior, with its accessories, pertains more to the literalness of Dutch art than to the high generalization of Italian schools ... But the painter has endeavoured, and not wholly in vain, to elevate his subject by means of symbolism. Such art reminds us of the mysticism and symbolism which coloured our sacred poetry in bygone centuries ... by way of apology, we are told that this is the only picture which has ventured to show "Christ in full manhood enduring the burden of common toil." ... It may be objected that ... this ... has more of the accent of mundane legends and of apocryphal books than of the tone of inspired writings. ... The attempt ... is to elevate materialism by mysticism, and to make even the accessories of an inanimate realism instinct with spiritual symbolism ... The head of the Saviour and the figure, the greater part of which is undraped, have evidently, in common with every other part of the picture, received anxious thought. And the result is an independence of treatment which will throw the world into controversy ... Though the idea of the existence of any trustworthy portrait of Christ has long been abandoned, yet there is, as we all know, a type which for centuries obtains acceptance. Mr. Hunt, throwing aside the traditional form, goes to nature and makes for himself a new type. To this there can be no objection, provided only he realizes the fundamental idea of the character, which is the divine residing in the human. We believe that two or more models have been employed, a practice for obvious reasons habitual with both painters and sculptors. The defects of one model are thus rectified by the others. In the present instance the torso and limbs have been studied from a man in Syria better known for his physique than for his moral attributes. The artist has articulated the form firmly; the anatomy has nerve and sinew; the modelling is sharp and even severe; the style and manipulation are somewhat between the early Italian and the early German; the colour is warm to crudity. The physical frame is that of a man well proportioned, strongly and compactly knit in bone and muscle, fitted by nature for skilled manual labour; and so far the artist gains what he aims at. Yet, judged by the highest standards, more might be desired. Winckelmann describes the steps by which the ancient sculptors ascended from heroines to gods; and Leonardo in the "Last Supper" ... endeavoured, in the words of Winckelmann, to realize "the prophetic declaration which announced the Saviour as the most beautiful of the children of men." ... Mr. Hunt, it is understood, met with an actual head which, with modifications, served him for a model, just as Leonardo is said to have used the study from the life now in the

Brera, Milan, for his consummated wall picture. ... Mr. Holman Hunt
has adhered more closely to individual nature; hence his type has more
of the actual and less of the ideal. The head is crowned with auburn hair,
which falls in disordered curls upon the shoulders; the beard is short, the
mouth open showing teeth white as ivory; the eyes, liquid and lustrous
as gems, are turned upwards. It is often written "And Christ looked up
to heaven"; the artist has seized on such a moment, and in his upraised
face we read not only the weariness of the flesh through labour, but the
anguish of the spirit, and the prayer for divine aid. The conception is
truly Christian ... The work is the earnest labour of five years, the canvas
shines under the sun of Palestine, the picture comes from the land in
which the Saviour lived and taught; it is the unburdening of a mind that
has long dwelt on the noblest theme that can tax or inspire a painter's
genius.[124] Hopkins was well aware of traditional depictions of Christ.
He told his parishioners at Bedford Leigh in 1879 (16 November):

There met in Jesus Christ all things that can make man lovely and loveable.
In his body he was most beautiful. This is known first by the tradition in
the Church that it was so and by holy writers agreeing to suit those words to
him / Thou art beautiful in mould above the sons of men [Ps. 44: 3]: we have
even accounts of him written in early times. They tell us that he was moderately
tall, well built and slender in frame, his features straight and beautiful, his hair
inclining to auburn, parted in the midst, curling and clustering about the ears
and neck as the leaves of a filbert, so they speak, upon the nut. He wore also
a forked beard and this as well as the locks upon his head were never touched
by razor or shears; neither, his health being perfect, could a hair ever fall to
the ground. The account I have been quoting (it is from memory, for I cannot
now lay my hand upon it) we do not indeed for certain know to be correct, but
it has been current in the Church and many generations have drawn our Lord
accordingly either in their own minds or in his images. (S 35)[125]

On 25 August 1874 Hopkins visited Westminster Abbey and then
the National Gallery, where he made notes that unfortunately have not
survived. In his Journal he simply remarked, 'as I hurried from picture to
picture at first these words came to my mind—"Studious to eat but not to
taste"' (J 257). We know that he also saw the Royal Academy Exhibition
of 1878 since he jotted down a list of 'paintings seen at the Royal
Academy Exhibition after 6 July 1878'. Among these were a number by
artists with whose work he was already familiar: Leighton's *Nausicaa*
and *Skein*; Millais's *Mrs Langtry*; Yeames's *Royalist* ['And when did
you last see your father?']; Watts's *Britomart*, Rivière's *Sympathy* and
Victims; Brett's *Lions*; and Herkomer's *Workhouse* ['Eventide—a scene

in the Westminster Union']. He noted several whose subject caught his eye, though he made no note of their artist: *Prince's Choice* [Lamont], *Haunted House* [Ellis] and two landscapes, where he noted the title of one 'Skirt[s] of a Wood' [Benham], and the artist of another 'May'.[126] He also alluded to a show in the Grosvenor in 1880 at which he had seen a 'queer landscape of the Beloved in the Canticles' by Spencer Stanhope. He may have been referring to 'I charge ye, O daughters of Jerusalem, that ye wake not my beloved', described as a 'complicated allegory from the Song of Solomon' portrayed as a 'curiously domestic scene in a palisaded front garden' (*LI* 130 Liverpool, 15 May 1881).[127]

During the years that Hopkins was attending art exhibitions, Dante Gabriel Rossetti did not exhibit. However, from the 1870s Hollyer sold photographs of his paintings[128] and there were very detailed descriptions of them in various articles, such as one by F. G. Stephens in which he tried to generate as much interest in Rossetti's work as he could. The article was in a series about the collection of contemporary art made by George Rae, a Liverpool banker, and was printed in 1875 in the *Athenaeum*,[129] a journal that Hopkins was reading that year. For example, in his long description of *The Beloved*, which he considered the most important of Rae's Rossettis, Stephens wrote of the Beloved, 'She is clad in an apple-green robe, which is as lustrous as silk, and as splendid as gold and variously-tinted embroideries of flowers and leaves can make it. ... Besides her splendid robe, the bride wears about her head and throat a veil of tissue differing in its green from the robe, and above her forehead rises an aigrette of scarlet enamel and gold, that resembles in some respects the peculiar headdress of ancient Egyptian royalty; this is set like a coronet on her pale golden hair. While advancing towards the bridegroom with an action at once most graceful and most natural, she half-thoughtfully, half in the conscious pride of supreme loveliness, has moved the tissue from before her face and throat.' And so on.

Hopkins came close to seeing some of Rossetti's paintings in 1879 when Robert Bridges tried to persuade Philip Rathbone, with whom he had become friendly while in Italy, to invite Hopkins to see his collection. Rathbone was one of the rich middle-class patrons vital to the success of metropolitan galleries outside London, in this case, Liverpool, where he organized autumn exhibitions and he ultimately left the gallery a number of fine paintings. But he did not issue an invitation to Hopkins to see them.

In 1881 Hopkins took the initiative and, writing to another local collector, the banker George Rae, he asked to see his collection. Some

time between 30 April and 7 May he was taken round the house by Mrs Rae, who spent hours showing him 'everything', gave him lunch and asked him to come again. Hopkins described her to Bridges as 'simple and homely and at the same time lively, with a real enthusiasm for art and understanding of it ... She was very kind, I liked her very much' (*LI* 130). 'The pictures', he added, 'were beautiful of course'. He said that he 'might run on all about these pictures' but made no further detailed comment. So, what did he see? Archives in the Walker Gallery, Liverpool, show that by this time the Raes possessed a fabulous collection of Rossetti's work, much of which was bought by the Tate in 1916, although a few pictures also entered the Lady Lever Gallery in Liverpool. They included: *The Beloved, Monna Vanna, Sibylla Palmifera, Fazio's Mistress, Venus Verticordia, The Wedding of St George, The Tune of the Seven Towers, The Blue Closet*, among others—a total of eighteen paintings in oil or watercolour and two drawings. Hopkins alluded to imagery in *The Sibylla Palmifera* later in 1881, showing that he had looked carefully at the painting (26 Sept. *LII* 61). In addition, while he was in Liverpool, Hopkins saw Rossetti's largest picture, his *Dante's Dream* (216 cm × 312 cm), which had been bought by the City of Liverpool. Two years later Hopkins received in the post Hall Caine's pamphlet about the picture in which Noel Paton was quoted, as Hopkins put it, 'with goodnatured gush saying that it may be ranked with the Madonna di San Sisto'. Hopkins told Bridges that, 'Now you know it may *not*, and I am considering whether I shall tell Hall Caine so' (*LI* 169–70). He evidently did write to Caine, who agreed that Paton's praise could not be defended. Hopkins concluded that 'there is a great deal of nonsense about that set, often it sickens one (though Rossetti himself I think had little of it); but still I disapprove of damfooling people. I think it is wrong, narrows the mind, and like a "parvifying glass" makes us see things smaller than the natural size' (*LI* 172).

That he was still interested in Rossetti is evident in a letter he wrote to Baillie in January 1883 urging him to, 'Tell me about the Rossetti exhibition; but you need not enlarge on Dante's Dream or on Mr. Rae's pictures, for these I have seen' (*LIII* 253). The exhibition he was referring to was the comprehensive show customarily held after an artist's death, celebrating his achievement and sometimes also with the practical aim of selling off his unsold paintings to generate money for his dependants.

Reflecting on the life and importance of Dante Gabriel Rossetti, Hopkins wrote in 1886:

It may be remarked that some men exercise a deep influence on their own age in virtue of certain powers at that time original, new, and stimulating, which afterwards ceasing to stimulate[,] their fame declines; because it was not supported by an execution, an achievement equal to the power. For nothing but fine execution survives long. This was something of Rossetti's case perhaps. (*LII* 134)

Hopkins had come to see Dante Gabriel Rossetti rather than Millais as the leader of the Pre-Raphaelites and therefore as the innovative centre of the movement, though he evidently considered Millais technically superior. He clearly saw more of Millais's paintings than were exhibited at the shows we know he attended. Defending Millais in 1881 against criticism that Bridges had evidently made, he wrote, 'he has, I have always seen, no feeling for beauty in abstract design and he never designs; but he has a deep feeling, it is plain, for concrete beauty, wild or natural beauty, much as Keats had. The element of ugliness in him is like the element of ugliness in nature and there is that plainly enough. In Millais I allow there is too much of it, too little of the contrary. But still, as above. And how much ugliness there is in Velasquez! Do you mean to say the Order for Release [1853] is not a noble work? And the Proscribed Royalist [1853]? The Huguenot [1852] has some splendid "concrete beauty" in the vegetation and so on. But the Brunswicker [1860] I do think bad and ugly' (16 June 1881, *LI* 132). Perhaps Bridges had seen Millais's *Souvenir of Velasquez*, which was his Academy diploma picture, a portrait of a blond girl clothed in black and red silk, inviting comparison with Velasquez. Hopkins saw the painting in the Royal Academy of 1868, underlining the title, along with *Stella*, which was admired in the press for 'a great deal of fine colour' and *Sisters*, Millais's three daughters 'painted with splendid power and directness',[130] and *Pilgrims to St. Paul's (Nelson's tomb)* which he seems similarly to have liked and which was praised for 'very much of the kind of technical power which used to astonish people in Mr. Millais ... two old pensioners visiting the tomb of Nelson. There is a lantern close to the inscription, and the painting of both lantern and inscription is wonderfully intelligent and comprehensive. In a still more essential point, the expression of the faces, the artist also recalls former successes.'[131] He listed but without stressing *Rosalind and Celia*, which Millais also exhibited that year but which was criticized for 'an eternal conflict of glaring colours which leave no comfort to the wearied eyes ... further, the trunk of the beech is not well painted, it lacks texture, it is not well modelled', though Tom Taylor suggested that Millais was

directing attention to the figures by using a broader technique for the tree. The stress Hopkins placed on the beauty of nature suggests one very strong reason for his affinity with Millais. His poems are full of that close observation and love of 'wild or natural beauty'. For Hopkins it had come to have spiritual significance as a channel of communication with God. While he does not seem to have sought such symbolism in Millais's work, a conventional moral position would seem here to be playing some role in his aesthetic judgements. *The Order of Release* shows the loyalty and long-suffering of a woman who is poor and who has in some way not specified managed to win an Order for the release of her soldier husband. She has travelled a long distance carrying their child and accompanied by his collie dog, who licks his master's hand. Her bare feet in comparison with his shoes and her simple, plain cloak in comparison with his good uniform suggest a lack of vanity, and her subsidiary importance in comparison with her husband. Her restrained self-disciplined expression (before the turnkey to whom she hands the signed Order) suggests that public decorum approved of in the period. There is also an element of simply doing her duty without gloating or self-congratulation. One wonders whether Hopkins considered how the woman might have obtained the Order and whether it required a loss of 'virtue'? If not, then the woman exemplifies characteristics that he celebrated time and again in his poems, as for example, in the sailors and captain of the *Eurydice*, and the widows at the poem's end. The reuniting of the basic family unit, complete with pet or, if the man is a shepherd, the working animal companion—the implied happy ending; he aware of her goodness and loyalty; she the centre of the family but subordinate in authority. She nurturing the child, holding her husband's hand in moral support. Hopkins may even have remembered the Margaret section from Wordsworth's 'Excursion', depicting the decline of a poor country woman whose husband fails to return from war. It is a text that displays the same values and relative hierarchy of the woman and her husband as the painting.

 The Proscribed Royalist would have had Catholic implications and the secrecy and danger of being Catholic was something that Hopkins had almost revelled in as a novice. He told his mother that 'To be persecuted in a tolerant age is a high distinction' (7 Feb. 1869, *LI* 106). He also included in his description of his first vows the fact that they had had to be made in secrecy. *The Huguenot* is based on the St Bartholomew's Day Massacre. Millais's picture shows a Catholic girl trying to persuade her Huguenot beloved to tie on his arm the white armband to signal

Catholic belief. He gently resists her attempts. Millais, a keen opera fan, had based the picture on the key scene from *Les Huguenots*. The scene as performed at her debut in 1849 by Giula Grisi, the most famous Valentine of the century, was described in the *Manchester Guardian*:

One of the most densely packed audiences we ever saw within the walls of a theatre witnessed Grisi as Valentine, and it was a decided triumph. She gave a new reading to the great scene in the third act. Instead of expressing her distress at Raoul's probable fate by frantic gestures, Grisi embodied an expression of great mental suffering and anxiety in a single look more eloquent than the most elaborate acting. The manner in which she depicted feelings of deepest emotion brought down a perfect hurricane of applause at the conclusion of the scene. Never did Grisi declare a greater triumph.[132]

It was a similar understated, repressed emotion that most people praised in Millais's depiction of the key moment. The intense feeling in the faces of the two lovers, Valentine's desperate attempt to save Raoul and his self-command in knowing the full price of his integrity. Hopkins's mother gave him a print of the picture which he lamented losing in 1864. In 1881 Hopkins chose to praise the vegetation, which although good, is clearly subsidiary to the picture's main concerns. Had the two characters been of the opposite religious conviction one suspects that Hopkins's response would have been critical of the woman. One wonders how much Raoul embodied for him that conscious choice of forsaking worldly values for religious. He was certainly aware of paying a price for his vocation; compare, for instance, 'To Seem the Stranger' and perhaps the assertion to Dixon that 'when one mixes with the world and meets … its … solicitations [to fame], to live by faith is … very hard' (1 Dec. 1881, *LII*, 93).

The Black Brunswicker shows a soldier of the Prussian Cavalry attempting to leave the Duchess of Richmond's ball in Brussels on the eve of the Battle of Waterloo. His English sweetheart tries to prevent him leaving, signalled by her attempt to close the door he is trying to open. Hopkins's reaction is similar to that he gave to a number of Bridges's poems in which after making various technical suggestions, he would comment, 'the meaning is bad', using 'bad' in its moral sense. Here I would suggest that 'bad' and 'ugly' are both really moral terms. The protagonists are both handsome but the woman is attempting to dissuade the man from his patriotic duty. Hopkins made very clear to Coventry Patmore his thoughts on the relation of men and women when commenting on part of *The Angel in the House*, where he said that Christian marriage was a

comedy if the woman did not consent to obeying her husband as her lord (24 Sept. 1883, *LIII* 310).

The last show at the Royal Academy that we know that he attended was that of 1886, but his reactions to it are discussed in Chapter 6.

So, Hopkins's experience of art exhibitions occurred during a very complex time in British art when classicism (Leighton, Alma-Tadema), Pre-Raphaelitism (Holman Hunt, Millais), aestheticism (Whistler, Burne-Jones, Rossetti, Albert Moore), social realism (Fildes, Frank Holl), were all on display and what was thought of as Academic and what as avant-garde was shifting. So too were notions of art criticism. When we compare what Hopkins saw, read, and wrote with some of the most widely read criticism of the day by Tom Taylor of *The Times* and J. B. Atkinson of the *Saturday Review*, we can see that he was far more knowledgeable and his criticism far more complex and 'professional' than has been thought.

5

Gerard, Arthur, and the Illustrated Press

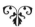

The latter part of the nineteenth century saw the heyday of publications illustrated with engravings. To this there were several contributing economic factors. In the second half of the nineteenth century, particularly in the final quarter, wages rose sharply and at the same time the prices of many staples plummeted so that the 'average' family's disposable income grew by over 60 per cent.[1] A number of changes affected the cost of books and newspapers, including technological improvements such as the invention of electrotyping in 1839, the use of power platen and cylinder presses, and the introduction of photography to transfer drawings onto wooden blocks for cutting. All of these speeded up the process and reduced the cost of printing. About 1860 the cost of making paper dropped when the African grass esparto was introduced as a cheap substitute for rags. Contemporaneously the size of the market for reading matter increased as educational standards improved. In the 1860s sweeping changes were made to the curriculum in a number of the public schools as the result of a government inquiry into the poor educational standards in the nation and a system of Payment by Results was set up in grant-maintained schools by which each pupil who failed one of the prescribed examinations cost the school 2s. 8d. in grant. The result was a system of teaching by rote that the children hated but which did have the effect of increasing the number of those with basic reading, writing, and arithmetic. The rapid expansion of the railway network meant that publications could be swiftly distributed to this larger audience.

Legislation also assisted: on 1 July 1855 newspaper stamp duty was removed as, in 1861, was paper duty. In 1852 the Booksellers' Association which had, through a price agreement, kept the price of books high, was

dissolved at the decree of a committee under Lord Campbell. The result was that book buyers could routinely expect a discount of between 15 and 25 per cent on the cover price. Publishers found it paid to reissue successful novels with illustrations and that illustrations helped to sell journals. The decrease in costs meant that some publishers could afford to employ top artists to do the illustrations and many of the best-known British artists of the period did at least some illustrative work: artists like George Du Maurier turned to illustration as a serious career and others such as Frederic Leighton, John Everett Millais, D. G. Rossetti, Arthur Hughes, Edward Poynter, and Albert Moore spent considerable time and effort on graphic illustration. These factors all contributed to making the 1860s in particular the heyday of the illustrated journal and book. There were a number of famous illustrated magazines founded at the time: *Once a Week* in 1859, the *Cornhill* and *Good Words* in 1860, and *London Society* in 1862, for example.

Once a Week's title page proclaimed that it was 'an Illustrated Miscellany of Literature, Art, Science & Popular Information'. The first volume was illustrated by Leech, C. Keene, Phiz (Hablot K. Browne, the illustrator of Dickens's novels), Tenniel, and Millais. Many of them were already working for *Punch*, another of Bradbury and Evans's publications. *Once a Week* contains a striking range of style in its drawings from caricatures by Phiz and reproductions of Japanese prints to the melodramatic poses and expression of Tenniel, Keene, and Leech and the genre pictures of Millais, Du Maurier, and Frederick Walker. Most of the engraving was done by Swain, one of the two best known and admired of the engraving workshops of the period. The editor chosen was Samuel Lucas, who had been a reviewer for *The Times*. In fiction he looked for a convincing portrayal of life and, admiring George Eliot, Thackeray, and Meredith, demanded that drawings illustrate a text in fact and style, as, for instance, in Millais's drawing for Tennyson's 'Grandmother's Apology' (vol. I). And, as described in Chapter 1, from childhood, Arthur and Gerard had daily access to all this black-and-white illustration by some of the best artists of the day.

As well as developing the artistic taste of the family, *Once a Week* seems to have influenced Gerard in an indirect way. While his father kept notebooks and journals that were specialized: some for travel, others for transcribing things that he found interesting in his reading, and his sister Kate had a number of these classified notebooks, Gerard's journals and diaries reflect the range displayed by journals such as *Once a Week*: creative poems and short stories, literary and linguistic

analysis, descriptions of places, buildings, drawings. They were intended to be private, produced only for himself but the resemblance to *Once a Week* suggests that Gerard was very much the ideal middle-class reader at whom such a publication was aimed and that it fostered such diversity of interests. There is, thus, in Gerard's work a connection between the genre of 'journal' as serial publication and 'journal' as private notebook. We know from allusions in his letters and notes in his journals that Hopkins also read *The Times*, the *Illustrated London News*, the *Graphic*, the *Cornhill Magazine*, *Macmillan's*, the *Quarterly*, the *Edinburgh Review*, *Blackwood's*, the *Spectator*, the *Academy*, the *Athenaeum*, the *Saturday Review*, the *Englishman's Review*, the *National Review*, *St James's Gazette*, the *Nineteenth Century*, the *Christian Remembrancer*, the *Church Times*, *Essays and Reviews*, the *North British Review*, the *Pall Mall Gazette*, and the *Union Review*.

The idea of journal as publication has implicit in it the question of the relation of work to its time. Journalism as serial publication usually focuses on topics of the day in order to feed and develop its market and, taking subjects of potential interest, it deliberately increases interest in them. One of the early and highly influential newspapers, the *Illustrated London News* (*ILN*) came into being in 1842. It was a phenomenon of the period and was to prove significant for both Arthur and Gerard. Its founder was Herbert Ingram, a printer and newsagent who had made his money (though not yet a fortune) by selling a patent medicine, which, as a printer, he was able to advertise. The medicine was 'Old Parr's Life Pills'. Old Parr was a Shropshire countryman celebrated for allegedly living to the age of 152 years, a feat attributed to the remarkable qualities of Old Parr's Life Pills, which also, so it was claimed, cured both diarrhoea and constipation, 'gave fresh vigour to the whole body', and 'increased the beauty of women'. The pills sold in boxes costing 1s. $1\frac{1}{2}d.$, 2s. 9d., or 11s. for a 'family box' and they sold so well in Ingram's home town of Nottingham that—so the story goes—he went to London to see if he could have them advertised in the larger marketplace.

Once in London, the ingenious Mr Ingram was able to develop his long-held ambition of owning his own newspaper. As a newsagent he had noted that illustrations of news items, especially sensational ones, enormously increased the sale of newspapers, and he planned to start up an illustrated weekly magazine. He chose as his partner the wood engraver Henry Vizetelly. Ingram set up an office, recruited artists and journalists and an editor, Frederick Bayley, and on 14 May 1842 the first issue of the *Illustrated London News* appeared. Its sixteen pages contained

thirty-two engravings on the war in Afghanistan, a train crash in France, a fire in Germany, a fatal steam-boat explosion in Chesapeake Bay, a fancy-dress ball at Buckingham Palace, and a survey of the candidates for the American presidency. It also had a dash of gossip in a charge of libel made by the owner of a matrimonial agency against Alderman Sir Peter Laurie, lengthy crime reports, shorter theatre and book reviews, notes on gardening and fashion, a description of the sculpture exhibition at the Royal Academy, a list of births, marriages, and deaths, and the winners at the Newmarket Second Spring Meeting. There were three pages of advertisements for such useful commodities as Godfrey's extract of elderflowers for ladies' complexions and Madame Bernard's 'treatment of the human hair' which removed 'the causes of baldness however inveterate or of long standing'. The paper cost 6d. and rapidly became a success. The first issue sold 26,000 copies, and was reprinted twice in the first week; circulation soon achieved a regular 40,000 and reached 60,000 by the end of the year. The increasing circulation was also attributable to the use made of new technology in the ever more rapid production of the paper. For instance, the paper possessed an early example of Applegarth's vertical printing machine, which was on show in the Great Exhibition in 1851, and could produce 10,000 printed sheets per hour. In 1851, when the paper managed to publish Joseph Paxton's designs for the Crystal Palace before, so it was rumoured, Prince Albert had seen them, sales reached 130,000; the special issue on the death of the Duke of Wellington brought 150,000 sales, and in 1855, when the newspaper tax was abolished and the paper published Roger Fenton's photographs of the Crimean War, the *ILN*'s weekly circulation was 200,000 rising to over 300,000 by 1863. It has been calculated that the real readership of a nineteenth-century journal was about five times the number of copies sold. If so, the *ILN* was probably reaching some 1.5 million people, many of them the upwardly mobile and expanding middle class. The paper described itself as 'a Pictorial Family Newspaper, containing Essays on Public Affairs; Literature; Fine Arts; Music; the Drama; Sporting Intelligence; science; and a complete record of all the events of the week, at home, and abroad, or in the colonies; the whole illustrated in a high style of art by wood-engravers of the first eminence'. It is noticeable that the claim with regard to the news items was of their completeness, not their truthfulness and that the illustrations were praised for 'their high style' rather than their veracity though the inclusion of pictures of the illustrators on the scene were doubtless intended to give an aura of photographic accuracy. It was standard practice for readers at the press

office to scan unillustrated papers for the key events of the week and for
a picture to be compiled if the paper had no illustrator at the site; when,
for instance, there was a fire at Hamburg just as the first issue of the
paper was going to press, the editor sent to the British Museum for a
print of the city and the artist-engravers were set to work to produce a
doctored version with smoke, flames, and onlookers. That provided the
front-page picture.[2]

One of the paper's illustrators was Arthur Hopkins, younger brother
by three years to Gerard. He had gone to Lancing College (1860–5).
On leaving school, he joined Cyril in their father's firm but he longed to
be an artist, and in 1872 he left the firm to study at the Royal Academy
and Heatherley's. Group portraits in the National Portrait Gallery in
London associate Arthur with the Primrose Hill School along with
Sir Ernest Albert Waterlow, Walter Dendy Sadler, Maurice William
Greiffenhagen, and Sydney Prior Hall (1893); and the St John's Wood
Arts Club, along with Sir Lawrence Alma-Tadema, Arthur Hacker,
John Collier, Charles Francis Annesley Voysey, Edward Onslow Ford,
John Bagnold Burgess, and Walter Dendy Sadler (1895).[3]

The *Illustrated London News* contained many drawings of objects and
buildings celebrating England's technological and industrial advances.
It also had fine engraved portraits of famous people of the day, the new
Cabinet, for example, and the soprano Madam Adelina Patti (18 July
1874). It carried illustrations of situations at home, of vessels in the news
and of events abroad and a regular supply of reproductions of paintings
exhibited at the Royal Academy, the Paris Salon, or other exhibitions.
It even printed engravings of art photographs by Goupil and Co. The
papers of 1871 had numerous illustrations of the deteriorating situation
in Paris, the Bois de Boulogne with many of its trees chopped down, the
worsening conditions suggested by what meat was for sale so there were
consecutively drawings of the horse market and the dog and cat market.
The captions assert that the drawings had been brought by pigeon from
'our special artist'. Illustrators specialized just as television reporters do
today. Drawings of royalty and war drawings from Afghanistan were
often done by Nash; social aristocratic occasions were usually covered
by Alfred Hunt, a Yorkshireman who worked regularly for the *ILN*
from 1865. Like Arthur he sometimes signed his work AH and the list
of drawings in *Further Letters* attributed to Arthur are all Hunt's work,
pre-dating Arthur's association with the paper: *Derby Day* (27 May
1871), *Evening at the Volunteer Camp, Wimbledon* (15 July 1871); *The
Picnic* (26 Aug. 1871); *A Forest Fire in America* (28 Oct. 1871); *Archery*

(24 Aug. 1872), *LIII* 119. Hunt's work can often be identified by the hook he gives noses on almost all his women and many of his men. His drawings usually incorporate a range of styles so that while some areas of them are realistically representative, others verge on caricature. Arthur and Alfred were good friends and their families went on holiday together to Whitby, a Yorkshire coastal village also frequented by the *Punch* illustrators.

One of Arthur's first drawings for the *ILN* was a brilliant skit called *Patience and Determination*.[4] It shows an old working-class woman waiting to see the Queen on her way to the service of thanksgiving for the recovery of the Prince of Wales in March 1872. The old lady clearly feels a fellowship with the Queen, though, perhaps with compassion for the working class, Arthur makes her very thin in contrast with the robust monarch. One can see why Arthur later drew for *Punch*. Like Du Maurier, he has here captured something beyond the merely superficial suggestion of the caption—the old lady knows what it is to fear for one's children and her expression contains not only kinship but a sense of sadder experience too. It would have been typical of the period if she had not always had occasion for thanksgiving.

For some thirty years from 1872 Arthur worked as an illustrator in black and white for the *Illustrated London News* (1872–98), the *Graphic* (1874–86), *Punch* (1893–1902), and *Belgravia*. Looking back at the experience in an interview with J. A. Reid in the *Art Journal* in 1899, he said,

I daresay it is not generally realised what a terrible strain that is. One receives a note or telegram suddenly, with instructions to go somewhere, in town or country, at a moment's notice—perhaps a Royal wedding, or a Drawing Room, a State ball, or goodness knows what, take it all in, make up your mind how you would treat it, sketch or commit to memory all sorts of details, and finally make a page or double-page drawing in a day or two. And one always had to remember that, however difficult, the drawing must be delivered sharp to time without fail. It was fearful work, and, after slaving all day long, one generally had to sit up half the night, and on more than one occasion the whole night. And I never once failed to hand to the messenger who called the drawing finished.[5]

That strain often shows in his drawings; there is impatience in the scribbled peripheral vegetation, a resentment that sometimes betrays itself in a lack of sympathy for the comfortable characters drawn. Gerard criticized the effect in an early attempt, *The Short Cut* (p. 472), which showed a well-to-do lady and her son being helped to cross a muddy field. It was published opposite *The Fishmarket at Berlin*, a scene of evident poverty.

Gerard commented to their mother, 'In the *Short Cut* it is perhaps the engraving that is bad: the ground is a great mess, not of mud and water, as it should be, but of ink and blotting and the splashes on the hero's legs look like I don't know what—stars or sparks. Then the fence and hedge is not intelligible even: no doubt such accessories may well be sketchy, they should not be scribble; they shd. stand to the finished parts as handwriting perhaps to print but not as an illegible word in a letter which you can only make out from the context stands to the rest I hope he will not get to draw carelessly.'[6] This falling short is very much in contrast with Arthur's pencil sketches made on holidays, busman's holidays. A note that this or that would make a 'good subject', occurs on a number of the pages in the sketchbooks. Faced with genuine people rather than his studio and jottings and the pressure of the expected messenger, he shows himself highly sympathetic to the poor and the elderly and appreciative of the beauty of children and young men and women. This adds immensely to the power of the drawings. There is too a sense of humour that gently observes, evident, for example, in a sketch of three fishermen caught in a group pose reminiscent of the three graces, the title he gave the sketch. One is never tempted to laugh outright at his drawings in *Punch*; they provoke only recognition of the relationship of drawing and caption. Arthur was contributing in much the same vein as Du Maurier, who was on the *Punch* staff. Charles Keene was, in Du Maurier's day, to provide comic drawings about the masses, Tenniel was to carry out political squibs, and Du Maurier 'was particularly told not to try to be broadly funny ... but to warble in black and white such melodies as [he] could evolve from [his] contemplations of the gentler aspect of English life'.[7] Du Maurier's drawings had a depth which Arthur absorbed. Leonée Ormond remarks that 'below the surface of this fashionable world [in Du Maurier's drawings] with its brightly lit and airless rooms, its whiskered gentlemen and bustled ladies, and its air of complacent success, Du Maurier analysed the emotions which gave it life—the social jockeying, the carefully delivered snub, the misery experienced by the nervous and the misfits, the gaffes committed by the parvenu, the status which birth conferred and to which all paid court, the advantage enjoyed by wit and beauty, the callousness and superficiality which are the result of a rigidly organised and conventional society' (p. 329).

Flipping through the illustrated papers of the day one is not always aware of the care that went into the illustrations. Arthur's sketchbooks

show that beside being on the lookout for subjects, he also made careful studies of effects of light. For instance, he has a note on 'A figure in open Sunlight':

A man's shirt (or any white dress, white Cow &c) standing against grass in sun tells thus. The greater part of the white generally is in flat shade with strong edges or tops. These latter of course tell much lighter than the grass which is a moderately strong tone. The parts in shade tell as but a degree or so darker than the grass.

A sunburnt hand & arm are 2 or 3 degrees when in shade darker than the grass & their upper edges quite bright against it.

These notes will be useful for drawings on wood, but as strong sunlight had better be avoided in painting (at least noonday sunlight) I will add notes of the same objects when the *Sun is obscured by cloud.*

The flat gray of the white object then disappears almost entirely the lighter edge on top being less obvious though discoverable. Hence the whole object becomes light while the grass becomes darker, and the result is that the White Object tells as an obvious White spot. Faces, under shade of a hat or Sunbonnet, are flats of semi transparent clear tone with but little darks under eyebrows. &c—In fact the forms or drawing of the face are almost lost in the semi-shade & translucent light to which they are subjected, while the eyes, eyebrows, lashes, lips &c, are distinct.

Gerard too was interested in capturing the effects of sunlight, both in his poems and in his early journals, where he makes notes that seem initially intended for a painting:

The chalky light was striking up, and in the strawberry-tree the leaves were yellow-green below and in the sky-light above blue. One tree—a beech, I think—I saw on which the ground cast up white reflection like glass or water and so far as I could see this could only come from the spots of sunlight amidst the shade. (1 Sept. 1867, *J* 154)

Later his observations were fed into poems such as 'the furl of fresh-leaved dogrose' (discussed in Chapter 6) and 'That Nature is a Heraclitean Fire':

> Down roughcast, down dazzling whitewash, wherever an elm arches,
> Shivelights and shadowtackle in long lashes lace, lance, and pair.

(ll. 3–4)

Comparison of Arthur's drawings with engravings of his work suggests that much of the subtlety of his drawing was destroyed in transferring it to woodblock. Leonée Ormond suggests that there was 'a general decline in the quality of illustration during the 1870s and 1880s. The reasons why the achievement of the 1860s was not sustained are various and

complex. New technical developments, and the failure of the succeeding generation of illustrators, were certainly prominent causes. Older artists, like Millais, Leighton and Poynter, no longer needed to supplement their incomes, and began to concentrate solely on painting. Even Frederick Walker and Frederick Sandys were turning to water-colours, pastels and oils, though their black-and-white work, when they produced it, showed no signs of weakening inspiration and skill ... It was not until the 1890s, with the exception of a few isolated and original illustrators, that artists like Beardsley and Shannon revived and rediverted black-and-white art' (p. 184). Arthur's control of tone in pencil is exceptional, as is his ability to convey personality and situation. There is also a political difference between his illustrations and his sketches. In the latter his favourite subjects are the poor at work. At Whitby he drew the barefooted children, the women cleaning fish, the men hauling nets. He noted groups of friends meeting, men standing while women worked, the elderly with faces seamed by toil and weather. Like Gerard, he was also fascinated by ships and shipwrecks and made many painstaking drawings of both a range of boats and their shipwrecked remains washed ashore.

In 1888 he had a two-man show at Dowderswells and Dowderswells in London with C. Robertson, which was titled 'Our Country and Our Country Folk'. Gerard's poems on 'Tom's Garland' (the garland(s) can be found on his hobnailed boots) and 'Harry Ploughman', both written in 1887, also belong to this artistic movement that flourished during the last two decades of the century with its concern for the rural poor and those who made a precarious living from the sea, shown by such talented exponents as Herkomer, the Newlyn school, and Hamo Thornycroft.

Gerard wrote comments to his mother on one of Arthur's drawings for the *Illustrated London News* of 3 August 1872, while he was still a student. The drawing was *The Paddling Season*. 'This is perhaps the best yet and I heard people admiring it: still the boy's face is poor in expression and if Arthur can refer to one of Keene's drawings in a late *Punch*, perhaps of the same week or the one before, ('Give your mistress my compliments and tell her I'm going to the seaside myself') and look at the boy on the steps, who is in all respects a parallel to his boy and like enough to what Everard is or was, he will see the difference in that matter. In the girls he has again evaded difficulties by powerful black hair. But if he can keep up illustrating in this way a little time longer I suppose his monetary success is assured, for the drawing is so good and on such a bold scale that people will easily see they have a first-rate article which commands its own price and is not to be got elsewhere

22. Arthur Hopkins, *The Paddling Season, Illustrated London News*, 3 August 1872 (*University Library, Cambridge*)

except in the recognised first hands, Du Maurier etc. I hope however he sticks to his metatarsals and studies from the nude, without which his work will not be thorough' (30 Aug. 1872, *LIII* 119–20).

Arthur used sketches he had made at Whitby for the drawing and, rather than a desire to evade difficulty, it is this source in reality that dictated that the girls should have their backs to the viewer. That their faces should not be seen also fits with the emphasis that Arthur would seem to have wanted on the boy's face. The title, *The Paddling Season*, is inadequate for the drawing's full subject. Keene's boy stands idly by, watching the tramp laconically without any worry about his own situation. He simply observes. Arthur's boy, by way of contrast, is part of a larger theme, more representative of all young boys. His imaginative world of heroic sea adventure in which his toy yacht is a vessel he commands, like the real sailing vessels on the horizon, has been disrupted by the invasion of the pert girls, unwelcome potential challenges, only too ready to mock his dreams and demand attention for their priorities set by ambitious mamas preparing them for the marriage market they will face in ten years or so. Their fashionable dress, the care they take of it in keeping it out of the waves while still decorously covering their knees, and the elaborate styling of their hair suggest that the grooming for their future challenge is already well under way. The boy's face expresses surprise, resentment, dislike grounded in distrust. Gerard's comments, while ahead of his time in appreciating Keene's talent,[8] fail to go beyond the caption to the more profound meaning in Arthur's drawing.

However, his advice that the way to succeed was through careful drawing from life was sound. It was the secret that Frederick Sandys passed on to George Du Maurier in 1861. Du Maurier reported to his mother, 'I have plenty of work just now, but am taking such pains that I do not get through it quickly. Have recourse to nature for everything, and spend 4 or 5 days over a drawing which a year ago I should have done in 8 or 10 hours. Indeed I seem to be in a great vein of progress, and hope soon to get a place in front of the first rank; you can have no idea of the passion and anxiety with which I work and the labour I bestow; and now I am settling down into an ardent plodding and patient drawing machine so that I must soon become first rate. In so doing I follow the advice of Sandys who told me never to let a block go out of my hands unless I was well satisfied that all that patience, time and model could do for it had been done. It does not pay one so well at first as quick drawing from chic but in the end one can command any amount of work and any price one likes.'[9] Du Maurier had an illustration to Fred H. Whymper's poem

'From My Window' rejected by *Once a Week* 'on the grounds that he had not accurately represented a muslin dress. Du Maurier was furious, and quarrelled with the editor about the rejection, but Lucas was adamant, and commissioned another artist, Frederick Sandys, to do the work. Sandys's drawings, much influenced by German artists [such as Rethel and Menzel], were among the finest of the period, and Du Maurier generously acknowledged the superb technique of his illustration to 'From My Window': 'Wasn't Fred Sandys's drawing exquisite? That was the poem that I illustrated, and which they refused.'[10] Generally Arthur's drawing is less convincing than Du Maurier's but he adopted his hasty scribbled details that are peripheral to the main interest and the choice of dramatic night scenes. Arthur may have met Du Maurier in the 1860s and from the 1870s he lived near him in Hampstead. His work is noticeably influenced by the older artist, as he himself acknowledged, and by Pinwell, from whom he learnt much about drawing men's clothing. Du Maurier's son-in-law, C. C. Hoyer Millar, comments that 'except after private view days and visits to the studios of his particular friends, there was [in the Du Maurier home] very little talk about pictures unless [the Revd Alfred] Ainger [who supplied Du Maurier with quips for his *Punch* drawings] or artists like Briton Rivière and Arthur Hopkins, who were close neighbours near the Swiss Cottage, happened to drop in.'[11]

Arthur worked for another illustrated paper, the *Graphic*, from 1874 to 1886. It treated its middle-class readers to gory pictures of war in various parts of the globe, to upper-class social occasions, and to royal weddings and tours. Each issue typically contained a poem and an episode from a novel, reviews of art exhibitions, an explanation of a simple scientific experiment, and brief accounts of spectacular news. Arthur's work for the *Graphic* was an occasional full-page or double-page spread, generally a picture of a pleasant social occasion enjoyed by the middle classes. For example, on 8 March 1879, when the paper was publishing illustrations of the Zulu War and the Afghan War, Arthur was employed to produce *A Fancy Ball on the Ice* with beautiful young adults dressed in seventeenth-century garb skating through a dance on ice holding paper lanterns, a variety of which also dangle from the trees (p. 233). The paper was also carrying a serialized novel, ' "Under One Roof: An Episode in a Family History" by James Payne, Author of "Lost Sir Massingberd", "By Proxy", etc', the last of which Arthur had illustrated.

In 1878 and 1879 Arthur was, in addition, the only illustrator for *Belgravia*, doing a drawing for each of the two serials for each issue.

The drawings inevitably vary in quality but the best are fine. One of the novels the *Belgravia* carried in 1878 was Thomas Hardy's *The Return of the Native*. Arthur did one drawing for each of the twelve episodes. For the first he chose the line, 'Didst ever know a man than no woman would marry?' depicting the villagers chatting while watching a roaring fire. The swirling heat above the fire is well caught and the varying distribution of light on the figures around the fire. The second episode was almost entirely devoted to Eustacia and he pictured her on the heath about to lift the telescope to her eye. This was a less successful effort. Her singularity is not evident, Arthur not having been warned off by the description of her face as 'though side-shadows from the features of Marie Antoinette and Lord Byron had converged upwards from the tomb to form an image like neither but suggesting both'.[12] The most successful of his pictures for the book all involve a single source of light in a night scene, such as 'Tie a rope round him; it is dangerous' for Book 3, chapter 1; 'My Mind to me a kingdom is' and 'The reddleman re-reads an old love letter', which appeared on the cover of the journal. Responses to his illustrations for the novel have been mixed: he has been praised for possessing 'both dramatic flair and predilection for depicting scenes from country life that the illustrations for Hardy's novel would require'. He has also been criticized for not capturing the 'superbly poetic quality' of the novel (*J* 304). In some respects it is perhaps a novel that is more powerful if not illustrated because of that very poetic quality so evident, for example, in the suggestive but ultimately unvisual description of Eustacia. There are letters from Thomas Hardy to Arthur Hopkins about the illustrations, which 'reveal that the artist was not familiar with the entire text of *The Return of the Native*, but was having to work with one instalment at a time. Hardy thus felt it necessary to explain to [him] the main threads of the plot and the relationships between the principal characters, and to provide sketches of a mummer's clothing and staff.'[13] (Arthur was also providing drawings for Wilkie Collins's *The Haunted Hotel* at the same time.) *Belgravia* carried advertisements for the *Gentleman's Magazine*, in which Arthur was the again the only illustrator, drawing for Lynn Lynton's *Under Which Lord?* and then G. J. Whyte-Melville's *Roy's Wife*. The Piccadilly Novels series included Arthur in its list of illustrators, and second and third editions of novels such as Justin McCarthy's *Miss Misanthrope* and James Payne's *By Proxy* were advertised 'with Twelve Illustrations by ARTHUR HOPKINS'.

Arthur was also involved in the practice of compiled pictures. For the issue of the *Graphic* of 8 February 1879 he produced *Life in Southern*

India: the Early Morning Ride (p. 133) in which three young women, all drawn from his wife, Rebecca Bockett, appear, two on horseback and one descending apparently without overly much pleasure to a waiting man holding her mount. In the foreground is a fluffy dog resembling the Hopkinses' family's pet, Rover. The paragraph on the picture in the regular column on 'Our Illustrations' starts, 'The most persistent sluggard manages to rise early in India, for if he lies in bed till after the sun is up he may bid good bye to all chance of active exercise for the day Hence the exercise which the Britisher craves as an antidote to the relaxing climate must be taken early in the morning, as soon as the first rosy streaks appear in the eastern sky' (p. 126).

There was another intermediate degree of such compiled pictures in which the papers made use of the 500–600 illustrators and engravers living in greater London at the time but had them elaborate into drawings sketches done overseas by artists on the spot. Arthur did this for an incident from South Africa: 'Everybody has heard of Table Mountain ... It is a favourite resort for picnics, but ... if a south-easter should blow, the top of the mountain becomes enveloped in a dense white cloud, commonly called the Table-cloth, and many people have lost their lives from being unable in the thick mist to find a descending path, of which there are not many ... Our sketch represents a young man and two ladies endeavouring to find their way among the rocks.'[14] Arthur's interest in the drawing was in capturing the apprehension of the three people whose lives were in danger. The background scene could have been on any mountainside.

Iced Tea, Arthur's contribution to the *Graphic Christmas Number* 1875, evidently made use of Everard as a model, as well as his wife. Gerard wrote to his mother that, 'he [Everard] appeared unmistakeably in *Iced Tea*' (*LIII* 136). Critics have not been certain whether *Iced Tea* was a play in which Everard was performing or even whether, in fact, the first word of the title was 'Iced'. The picture is a sort of charade with serious-looking people carrying out ridiculous actions. In the centre an elegantly dressed lady (with familiar features) well wrapped up on a sledge holds a cup and saucer and stares longingly out of the picture while behind her an elderly, bewhiskered 'gallant knight' in the role of butler skates a bit uncertainly holding a steaming silver teapot; another, younger man skims towards him with two more cups, and a youth as page skates towards the lady with a tray for her empty cup. The 15-year-old Everard might have been the model for the younger man. Gerard's

23. Arthur Hopkins, *Iced Tea*, *Graphic*, Christmas Number, 25 December 1875 (*University Library, Cambridge*)

compliment is not, of course, directed at Everard but counterbalances criticism he had made to Arthur of his failure in capturing their brother's features in an earlier illustration. The caption of *Iced Tea* reads:

> Though it looks extremely nice
> To be drawn along the ice
> While seated in a sledge at your ease;
> Yet your fingers and your toes,
> To say nothing of your nose,
> Are apt, for want of exercise, to freeze
>
> So you bless that gallant knight
> Who is heedful of your plight,
> And who, poising himself deftly on his skates,
> Provides, to cheer your heart,
> And to warm each vital part,
> 'The cup that cheers, and not inebriates'

Arthur's *Swimming à la mode* is similarly fanciful. Again it depicts his wife, here in eight different poses, draped in good thick cloth that suggests her figure but leaves it fairly discreet. The explanation reads: 'A good many of our fair readers, who have first of all to take a long journey to the seaside in order to bathe at all, and then have to sit for hours on the steps of the bathing machines patiently awaiting their turn, will feel rather envious of the nymphs in our picture, since they appear to have got hold of a delightfully sequestered pool or river all to themselves, with apparently no apprehension of prying eyes, and no duenna to raise objections on the score of propriety. In fact, we are transferred, in imagination, to the Golden Age, and as, while we write, the thermometer is close upon 80 deg., we too wish we belonged to the company of these Naiades.'[15] The explanation suggests that the picture is purely fancy. The clear use of the same model for all the figures, common in paintings by Pre-Raphaelites, has the effect of removing the painting from reality—what is seen is clearly not photographic but illustrative of an idea. There is a striking similarity in the psychology of the two brothers: Arthur drawing swimmers as a fanciful escape in a heatwave and Gerard writing in his 'Epithalamion' for Everard's wedding a description of bathing as an escape from the drudgery of setting, invigilating, and marking university examination papers in the middle of winter. Gerard's boys from the nearby town who enjoy the river also have no individuality; they are even further removed from it in a description of them as a 'bevy' who 'with dare and

with downdolfinry and bellbright bodies huddling out, | Are earthworld, airworld, waterworld thorough hurled, all by turn and turn about' ('Epithalamion', ll. 17–18). The subject of bathing would in 1888 have had for Gerard family associations, through both Arthur's *Swimming à la mode* and a watercolour he made in 1878 of boys bathing naked entitled *The Boys' Paradise*, and because the shared subject suggests that such bathing was a family boyhood pleasure.

Many of Arthur's pictures betray his ambition to be recognized as an artist rather than a draughtsman. He had exhibited his first painting, *The Mowers*, at The Royal Academy in 1875; there followed *The Call to Supper* (1876), *The Quay*, and *The Plough* (1877). He was made an Associate Member of the Royal Society of Painters in Water-Colour in 1877 and a full Member in 1896, serving the Society as its treasurer for thirty years. His double-page spreads in the *Graphic* are in an intermediate category between the illustrations of contemporary social events and genre paintings of the day. They are of representative rather than of identified people and have a whimsical element of fantasy in them. He provided for the paper a series of 'studies of faces of the people'. One of these, a *Type of Beauty* was the no. XVIII referred to by Gerard in his long and detailed critique of November 1888. What Gerard was criticizing has not previously been known.[16] The drawing was a huge A2 black-and-white engraving, showing once again Arthur's wife and designed to be removed from a supplement to the journal. It was 'by Arthur Hopkins R[oyal]. W[atercolour]. S[ociety]. From the picture exhibited at "The Graphic" Gallery' and 'presented with "the Graphic", November 24, 1888'. Gerard wrote:

The resident students hung it in their reading-room and I have studied it and heard it discussed. It is admired, and it is a sweet and pretty face; but now I am sorry to say, that is all that I can write in its favour. I have to remonstrate with you about it.

In the first place it has to me the look of a sketch enlarged. A picture of that size whether engraved from drawing or painting ought to be a picture, not a sketch. The enlargement of a sketch will not make a picture. This was Doré's weakness: he was a sketcher only; his large drawings and the engravings after his paintings (for the paintings themselves I have never seen) are the works of a sketcher sketching on a great scale; the limbs, the draperies, the buildings have the outlines, contours, folds, shading, everything of a sketch; the suggestion of things, not their representation. Or to speak more precisely, this head looks as if it had been first a picture proper then a sketch on a small scale made from that, and then this sketch enlarged to the original size, the execution proper to

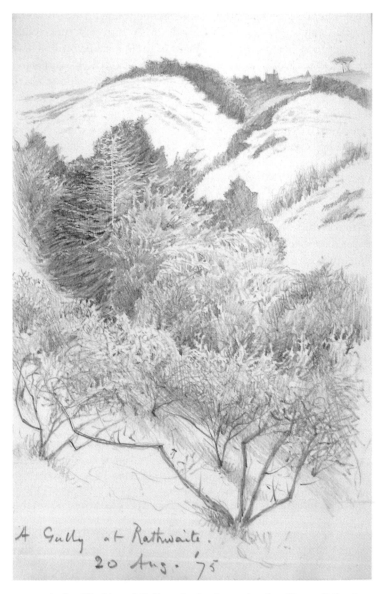

24. Arthur Hopkins, *A Gully at Rathwaite 20 Aug. '75 (Boston College)*

25. Arthur Hopkins, *Type of Beauty*, no. XVIII, *Graphic*, 24 November 1888
(*University Library, Cambridge*)

a picture being in the meantime lost. This appears in the hair, but flagrantly in the drapery of the breast: there is no searchingness in the drawing of these things. Then the line of the nose, which in a sketch might be well enough, is not subtle enough for the size. There the engraver however may have injured you.

You came very near producing a very beautiful thing: the face has a Madonna-like pensiveness and sweetness; but there is also a certain foolishness in the expression and the updrawn upper lip is too much of an upper lip, it is not successful.

Fr. Mallac also makes the following criticisms. He says you are not strong in your perspective and that the off-side of the face is out of drawing and has the distortion given by some lenses to photographs. Also he says the back of the head is suppressed. I do not feel sure of this but about the side of the face I think he is right, though it is difficult to point out where the fault is. But his greatest complaint on the score of drawing is about the dwarfing of the breasts, which are altogether much too high up and probably too flat. It is generally agreed that a finely proportioned figure is divided in half exactly at the groin and into quarters at the nipples and lowest point of the kneecap respectively. These proportions will not suit your girl at all.

He criticized the intense shadow between the lips, which makes the upper lip stand up from the paper and complained that the intense shadow also comes from carrying the method of sketching into a finished picture, for in a sketch exaggeration of shadow to indicate certain things is necessary and suppression of it for others.

In conception this is a beautiful head and grows on one, as people have said of it to me; and the beauty is regular. Now the number of really and regularly beautiful faces (on a considerable scale and not the simple repetition of a type, as in allegorical figures) is quite small in art; for ancient works, which are perfectly regular, are mostly much wanting in grace, so much so that those Venuses of Cnidus and Milo and what not can scarcely be said to be beautiful in face at all; while modern ones, which have plenty of charms, are often irregular: I think Leonardo's La Gioconda [the Mona Lisa] even, perhaps the greatest achievement of modern art in the ideal treatment of the human face, is not quite regular in the conformation of the cheeks. If I were you then I would keep this type by me, correct its drawing, carefully compose *in life* and then from life draw the draperies, and work at it till I had made the most perfect thing of it I could. That scrawl of folds on the breast "must come out, Bishop" as Mrs. Proudie said; and the breasts must go down lower vertically and come up horizontally. The hair and ear and all must be thoroughly done I am afraid this ballyragging will make you gloomy; I hope not angry. (26 Nov. 1888, *LIII* 187–9)

The incident provides an insight into the life of the community at St Stephen's Green with the engraved drawing 'pinned up' in the

students' reading room, the serious and detailed analysis of its strengths and weaknesses. Did Gerard think that the drawing of a beautiful face would bring its artist fame? Perhaps the interest of the students and the contemporary adulation of Leonardo led him to think that. Grimm's biography, which as an undergraduate he had listed as a book to read, described *La Gioconda* as Leonardo's 'highest triumph ... a creation which surpasses everything that art had produced in that direction. Francis I. purchased it for France, where it is still to be seen in the Louvre. All description of it would be vain. As the countenance of the Sistine Madonna represents the purest maidenliness so we see here the most beautiful woman,—worldly, earthly, without sublimity, without enthusiasm,—but with a calm restful placidity, with a look, a smile, a mild pride about her, which makes us stand before her with endless delight.'[17] Gerard's comparison with a painting may have been prompted by the fact that the picture was presented in the same format as the *Graphic* used for the reproductions of paintings from the Royal Academy exhibitions. Most of his criticisms of it are just. He may also have had in mind accusations of careless drawing made against Arthur by Robert Bridges, to which he had replied somewhat anxiously in 1878, 'My brother's pictures, as you say, are careless and do not aim high, but I don't think it would be much different if he were a bachelor. But, strange to say—and I shd. never even have suspected it if he had not quite simply told me—he has somehow in painting his pictures, though nothing that the pictures express, a high and quite religious aim; however, I cannot be more explanatory' (*LI* 51). In 1899 Arthur said: 'so long as the artist sticks to truth, and learns from Nature to be faithful and modest, he will always have his reward.'[18]

It is within the context of contemporary journalism that I want to turn to Gerard's work. We know that he wrote his first major poem, 'The Wreck of the Deutschland' for journal publication—not in the *Illustrated London News* and its ilk, but for an audience that had had its tastes formed by such papers. He was also drawing on the *ILN* and *The Times* for his material: details of the construction of the ship, the issues behind the presence of the nuns aboard it, the narrative of the fateful voyage, and some of the accounts of the experience given by survivors.[19] My interest is in why he chose to incorporate this sort of information and in the questions it raises about the perceived relation of different types of truth—factual reality and the psychological reaction to that factual reality. It seems to me that Gerard was aiming his 'Wreck of the Deutschland' far more closely at contemporary expectations

cultivated by journals of the day than has been recognized. The details of 'The Wreck' select memorable features of a sort publicized in the papers—railway deaths, the construction of the ship, the headless sailor swayed back and forth by the waves—though he leaves out of the account the accusations of corpse-robbing by local sailors and neglect of duty by the lifeboat crews. He constructs a poem in which industrial, technical detail combines with emphasis on human reactions to the tragedy. Like T. S. Eliot some seventy years later, he tries to communicate a Christian message by embedding it in material of secular interest. Eliot used philosophical paradoxes, Gerard contemporary journalism. For example, the *Illustrated London News* reported that 'The Deutschland was a screw steam-ship belonging to the North German Lloyd's Company, and employed on the line from Bremen to New York, touching at Southampton The result of the inquiry [into the disaster] is not final, but it gives so far the following figures:—Passengers saved, 48 men and 21 women and children; crew saved, including the captain and three pilots, 86, total saved, 155. Drowned—passenger, about 44; crew about 20; total (approximate), 64.' Hopkins condenses this to:

> On Saturday sailed from Bremen,
> American-outward-bound,
> Take settler and seamen, tell men with women,
> Two hundred souls in the round—
>
> (st. 12)

The *ILN* recorded that 'the sea was very rough, blowing hard from the east-north-east, thick with snow' (18 Dec. 1876). Hopkins writes:

> Into the snows she sweeps,
> Hurling the Haven behind,
> The Deutschland, on Sunday; and so the sky keeps,
> For the infinite air is unkind,
> And the sea flint-flake, black-backed in the regular blow,
> Sitting Eastnortheast, in cursed quarter, the wind;
> Wiry and white-fiery and whirlwind-swivellèd snow
> Spins to the widow-making unchilding unfathering deeps.
>
> (st. 13)

His observation of the sea on his various crossings near the British coast and his experience of being out in the elements in the burning cold of a snowstorm bring the description to life. The *ILN* reported, 'As the wind was blowing strongly from the east-north-east, it is probable that

the numerous shoals of the Dutch coast were sought to be avoided by a westerly course, with the result that the ship approached too close to the Thames shoals. The Kentish Knock is distant from Harwich ... about twenty-three miles ... the steamer struck on Monday morning at five o'clock. The lead was cast every half hour. They found twenty-four fathoms and then seventeen fathoms. Immediately afterwards the ship struck while going dead slow. The engines were turned full speed astern, and the propeller was immediately broken. The ship was then driven further up ... During the Monday efforts were made by throwing cargo overboard from the forehold to keep the ship's stern to the sea; and passengers were sheltered as far as possible in the deck-houses.' Hopkins turns this into:

> She drove in the dark to leeward,
> She struck—not a reef or a rock
> But the combs of a smother of sand: night drew her
> Dead to the Kentish Knock;
> And she beat the bank down with her bows and the ride of her keel;
> The breakers rolled on her beam with ruinous shock;
> And canvass and compass, the whorl and the wheel
> Idle for ever to waft her or wind her with, these she endured.

(st. 14)

The Times, with more narrative drive to its account, reported, 'At 2 a.m. Captain Brickenstein, knowing that with the rising tide the ship would be waterlogged, ordered all the passengers to come on deck After 3 a.m. on Tuesday morning a scene of horror was witnessed. Some passengers clustered for safety within or upon the wheelhouse, and on the top of other slight structures on deck. Most of the crew and many of the emigrants went into the rigging, where they were safe enough as long as they could maintain their hold. But the intense cold and long exposure told a tale. The purser of the ship, though a strong man, relaxed his grasp, and fell into the sea. Women and children and men were one by one swept away from their shelters on the deck The shrieks and sobbing of women and children are described by the survivors as agonising.'

> Hope was twelve hours gone;
> And frightful a nightfall folded rueful a day
> Nor rescue, only rocket and lightship, shone,
> And lives at last were washing away:
> To the shrouds they took,—they shook in the hurling and horrible airs.

(st. 15)

> They fought with God's cold—
> And they could not and fell to the deck
> (Crushed them) or water (and drowned them) or rolled
> With the sea-romp over the wreck.
> Night roared, with the heart-break hearing a heart-broke rabble,
> The woman's wailing, the crying of child without check—
>
> (st. 17)

The Times recorded that 'One brave sailor, who was safe in the rigging, went down to try and save a child or woman who was drowning on deck. He was secured by a rope to the rigging, but a wave dashed him against the bulwarks, and when daylight dawned his headless body, detained by the rope, was seen swaying to and fro with the waves' (11 Dec. 1875).

> One stirred from the rigging to save
> The wild woman-kind below,
> With a rope's end round the man, handy and brave—
> He was pitched to his death at a blow,
> For all his dreadnought breast and braids of thew:
> They could tell him for hours, dandled the to and fro
> Through the cobbled foam-fleece. What could he do
> With the burl of the fountains of air, buck and the flood of the wave?
>
> (st. 16)

There is in this stanza a sense of Hopkins's command of his new technique, a satisfaction in its flexibility, allowing him a deft narrative control and mimetic rhythms. He quipped to Bridges, 'I may add for your greater interest and edification that what refers to myself in the poem is all strictly and literally true and did all occur; nothing is added for poetical padding' (25 Feb. [1878], *LI* 47). When Bridges refused to read the poem more than once, Hopkins replied, 'I must tell you I am sorry you never read the Deutschland again. | Granted that it needs study and is obscure, for indeed I was not over-desirous that the meaning of all should be quite clear, at least unmistakeable, you might, without the effort that to make it all out would seem to have required, have nevertheless read it so that lines and stanzas should be left in the memory and superficial impressions deepened, and have liked some without exhausting all' (21 May 1878, *LI* 50).

Hopkins's poem and his art criticism both show the interrelation of types of truth. Gerard's response to his brother's portrait uses criteria that combine faithfulness to physical reality—the position of the bosom, the flow of the drapery and hair—with an idealism or typological symbolism

that reaches beyond physical reality. One might see a similar move in the religious symbolism in 'The Wreck of the Deutschland'—the fact that there had been five nuns connecting to five as the cipher of Christ, the significance of the nuns being Franciscans linking to St Francis's vision of Christ crucified and the tall nun's vision, the connection between Luther and Gertrude through the town of Eisleben, the loss of a ship of the same name as a country evicting its Catholic clergy and thereby losing its spiritual protectors.

> She was first of a five and came
> Of a coifèd sisterhood.
> (O Deutschland, double a desperate name!
> O world wide of its good!
> But Gertrude, lily, and Luther, are two of a town,
> Christ's lily and beast of the waste wood:
> From life's dawn it is drawn down,
> Abel is Cain's brother and breasts they have sucked the same.)

$$(st. 20)^{20}$$

This constant moving from the physical to something beyond, the turning of physical fact into symbol was characteristic of Pre-Raphaelite paintings that Hopkins admired and is also evident in his explanation as an undergraduate to his friend Alexander William Mowbray Baillie of Tennyson's poem, 'St Simeon Stylites'. Gerard, like Arthur, was working at a time when the perception of fact through art was very fluid: the journals, as I have been suggesting, included drawings made on the spot of news items, engravings of photographs of subjects that could as easily have been oil paintings, and pictures that were in the same sort of category as the fictional stories and narrative poems they published. Photography, through which newspapers now convey what we take as truthful representations of events, had not yet a secure niche: photographic exhibitions of the 1870s included touched up landscapes, reproductions of paintings that had been shown at the Royal Academy's annual exhibition, as well as portraits, and photographs made by the military barracks of pieces of military hardware. The shows were similarly reviewed with very mixed criteria from aesthetic comments similar to those made of Royal Academy exhibitions to highly technical observations on the various methods of developing and printing.

One of the celebrated photographers of the day was Julia Margaret Cameron and her work shows in an extreme form this sort of mixing of genres. For instance her *Vivien and Merlin* was both a portrait

of her husband with a visitor, and a representation of a scene from Tennyson's *Idylls of the King*. (Mrs Cameron's husband delayed the process considerably by fits of laughter.) This type of still photography confuses categories of presentation that we now generally keep separate, but the nineteenth century was of course the age of charades and *tableaux vivants* as evening entertainment. Cameron's photograph of Alice Liddell as Aletheria, an earth goddess, was influenced by C. F. Watt's painting of the actress Ellen Terry. It was both a portrait of Alice Liddell, recognized by us as the Alice from *Alice in Wonderland*, and the representation of an idea, an example with her youthful firm figure and flowing hair of earth's bountifulness. Sylvia Wolf, in her book on Julia Margaret Cameron, comments that, 'for the most part, religious images did not figure prominently in British art of the 1860s and 1870s. Instead, moral messages were conveyed through myth, literary allusion, or domestic narratives.'[21] Cameron photographed a servant and relative as the angel at the tomb and the Virgin Mary, emphasizing certain of her qualities of motherly love. These were little known women but caught in art to convey religious ideas. One might think of Gerard's 'tall nun' from 'The Wreck of the Deutschland' as similarly both a portrait and symbol.

> Joy fall to thee, father Francis,
> Drawn to the Life that died;
> With the gnarls of the nails in thee, niche of the lance, his
> Lovescape crucified
> And seal of his seraph-arrival! and these thy daughters
> And five-livèd and leavèd favour and pride,
> Are sisterly sealed in wild waters,
> To bathe in his fall-gold mercies, to breathe in his all-fire glances.
>
> (st. 23)

> Jesu, maid's son,
> What was the feast followed the night
> Thou hadst glory of this nun? —
> Feast of the one woman without stain.
> For so conceivèd, so to conceive thee is done;
> But here was heart-throe, birth of a brain,
> Word, that heard and kept thee and uttered thee outright.
>
> (st. 30)

When, in 1878 Hopkins's muse was stirred into action by another shipwreck and he wrote 'The Loss of the Eurydice', he adhered even more closely to news reports. Those in *The Times* were his principal

source, though the main articles make no mention of the manly corpse that C. C. Abbott speculated was the starting point of the poem. Hopkins may, however, have been responding to another aspect of the press, one of a number of letters to *The Times* on the sinking. This one concerned one of the lost men, and was probably written to assist the fund-raising for the families of those drowned, about whose welfare there was great concern:

A poor widow in this village, who lost her husband in the prime of life several years ago, now mourns the loss of her eldest son. A few months ago I saw the fine open-faced stalwart boy of 19 in his mother's house, her pride and hope, to whom he could say, 'Mother, rough as we are, we never "turn in" without giving ourselves into the hands of God.' Of splendid make and countenance, and in stature bidding fair to equal his almost Herculean father, he was a boy from our village Band of Hope—a staunch abstainer, of faultless character and manners. (*The Times*, 27 Mar. 1878 p. 10d)

Though probably not the only source, this might have influenced Hopkins's description of the drowned sailor:

> They say who saw one sea-corpse cold
> He was all of lovely manly mould,
> Every inch a tar,
> Of the best we boast our sailors are.
>
> Look, foot to forelock, how all things suit! he
> Is strung by duty, is strained to beauty,
> And brown-as-dawning-skinned
> With brine and shine and whirling wind.
>
> O his nimble finger, his gnarled grip!
> Leagues, leagues of seamanship
> Slumber in these forsaken
> Bones, this sinew, and will not waken.

Such a description was a political statement in line with the attitude of *The Times'* editorial when it reported that the Royal Navy was replacing sailing vessels with 'turret ships and other mastless vessels, where the specific duties of seamen are reduced to a "minimum"'. Such training as the sailors aboard the *Eurydice* were receiving was considered more of a 'necessity' than at any time previously: 'The huge iron monsters of our modern fleet give our sailors few opportunities of learning by experience the physical and mental agility which have been so characteristic and so remarkable in the naval history of this country ... If then our young sailors are to acquire any skill in the old

seamanship which is acknowledged to be indispensable for the efficient working even of the newest ships, they must be trained and practised in sailing vessels of the old type.'[22] The whole incident was juxtaposed with accounts of 'The Eastern Question' asserting that it was imperative that Britain maintain the standard of its armed forces. Hopkins imported not only such details as the number thought drowned ('three hundred souls') and the depth at which the sunken vessel rested ('eleven fathoms fallen'), and the length of time Sydney Fletcher was in the water before being rescued ('an hour'), but he also caught the sentiment with which the accounts were imbued. *The Times* commented:

The loss to the country of so many gallant men is severe, and at this juncture especially it will be keenly felt; but our sympathies are first of all due to the friends and relatives of those who in the very moment of buoyant hopes and confident expectations of a happy return to their homes have thus been suddenly swept to their doom. (*The Times*, 25 Mar. 1878, p. 9d)

Hopkins writes, 'Precious passing measure, | Lads and men her lade and treasure' (ll. 12–13) and turns to the grieving relatives in some rather awkward stanzas at the poem's end in which their sorrow is uneasily moderated by ideas expressed in *The Times* as follows:

Every Englishman who loves his country and is grateful to those who defend it will feel a personal grief at the loss of the Eurydice, and will acknowledge that those who went down with her died at their posts, and were serving their country as if they had been actually fighting in the cause. After all, there is no nobler end for a brave man than to die in the service of his country, and the friends of those who are gone will be consoled, even at this bitter moment of their grief, by the conviction that the country shares their sorrow, and is not unmindful of the sacrifices which those who serve her either in person or through their kith and kin are daily called upon to make in her behalf (25 Mar. 1878, p. 9d)

Hopkins seems to be caught by these ideas as well as the religious significance of the fact that the majority of the men would not have been Catholic and none could have been given the last rites. The role of God in the disaster is more muted than in 'The Wreck of the Deutschland' except at the end:

> O well wept, mother have lost son;
> Wept, wife; wept, sweetheart would be one:
> Though grief yield them no good
> Yet shed what tears sad truelove should.
>
> But to Christ lord of thunder
> Crouch; lay knee by earth low under:

> 'Holiest, loveliest, bravest,
> Save my hero, O Hero savest.

He tried too to capture in the rhythm the movement of the ship just before it went down, described by the survivor, Sydney Fletcher, as 'a lurch forward'. When Bridges objected, Hopkins replied, 'I don't see the difficulty about the "lurch forward"? Is it in the scanning? which is imitative as usual—an anapaest, followed by a trochee, a dactyl, and a syllable, so that the rhythm is anacrustic or, as I should call it, "encountering"' (30 May 1878, *LI* 52–3). The description of Fletcher's experience in the water, which follows that in the press,[23] is among the most dramatic stanzas in the poem:

> Now her afterdraught gullies him too down;
> Now he wrings for breath with the deathgush brown;
> Till a lifebelt and God's will
> Lend him a lift from the sea-swill.
>
> Now he shoots short up to the round air;
> Now he gasps, now he gazes everywhere;
> But his eye no cliff, no coast or
> Mark makes in the rivelling snowstorm.
>
> Him, after an hour of wintry waves,
> A schooner sights, with another, and saves,
> And he boards her in Oh! such joy
> He has lost count what came next, poor boy.–

Fletcher had just turned 19 and Hopkins's description is infused with the pity in *The Times* when it lamented that 'the men were nearly all young, scarcely more than boys'. He caught the tone of the descriptions of the captain's care for his men in the crisis; his ordering men down from the rigging when the squall blew up; telling them to cut free what sails they could not release and his final orders of every man for himself and attempts to get the forecutter free, reported at the tribunal where there were also a number of mentions of last sightings of the captain as he prepared to go down with his ship.[24] Hopkins's stanza runs:

> Marcus Hare, high her captain,
> Kept to her—care-drowned and wrapped in
> Cheer's death, would follow
> His charge through the champ-white water-in-a-wallow.

There was controversy over whether the captain had been negligent in not lowering the sails sooner, as a number of the ships in the vicinity

had done, and in leaving open for ventilation portholes only five or six feet above the waterline. These allowed in the weight of water that sank the ship, drowning those below who were on the mess deck, preparing for the imminent change of watch. The Royal Naval vessel was carrying even her topsails (the royals) until, too late, the captain saw the danger and sent his men to cut free whatever they could not lower. To watchers on the cliff, the vessel was seen sailing proudly, was hidden by the sudden snowstorm and then when the cloud passed, only the tops of her masts remained visible above the waves. Hopkins catches both the drama of the event and these criticisms in the stanzas:[25]

> Too proud, too proud, what a press she bore!
> Royal, and all her royals wore.
> > Sharp with her, shorten sail!
> Too late; lost; gone with the gale.
>
> This was that fell capsize.
> As half she had righted and hoped to rise
> > Death teeming in by her portholes
> Raced down decks, round messes of mortals.

The conclusion was that the position of the ship meant that the cloud responsible for the squall was hidden by the cliffs, cliffs along which Hopkins had walked with his family and from which he had made drawings with Arthur in 1863. The concision and density of the factual information is evident in the inclusion of the phrase, 'high her captain', referring to the fact Hare had been 'specially chosen' for his previous experience and skill in training seamen and, perhaps for the 'four medals' he had received for his services.[26]

The poem was, thus, not just an account using the facts but also caught the emotion and attitudes expressed towards the catastrophe in the press. Of course, in literature moral messages have always been embedded in narratives but 'The Wreck of the Deutschland' and 'The Loss of the Eurydice' can, I would argue, be much more precisely placed within the journalism and photography of the latter part of the nineteenth century. Both Arthur and Gerard were in their own ways combining aesthetic and spiritual concerns with news items within a context that saw the connection between those things in a far more amorphous way than we do today.

6
Hopkins, the Countryman and the New Sculpture

In June 1886 Hopkins attended the Summer Exhibition of the Royal Academy for the first time in twelve years. He wrote to Canon Dixon, 'I saw the Academy. There was one thing, not a picture, which I much preferred to everything else there—Hamo Thornycroft's statue of the *Sower*, a truly noble work and to me a new light. It was like Frederick Walker's pictures put into stone and indeed was no doubt partly due to his influence' (30 June 1886, *LII* 132–3). The comment, as will be evident later, is astute in its grasp of the interrelation of two contemporary movements in art: the Idealists and the New Sculpture.

But how far back in his artistic development did Hopkins's interest in sculpture go; what did he know of it and why should this particular piece have created such enthusiasm? We have very few of his childhood drawings but two of the half dozen or so extant are of sculpture: the *Warrior [from the British Museum]* and the *Fountain with Birds*, both watercolours dated 1857 and probably, though perhaps at one remove, of bronze objects. The *Fountain with Birds* might be seen as attempting to convey movement through picturing a number of the characteristic views one has of a bird as it alights on a birdbath, then looks round, drinks and preens itself. The *Fountain with Birds* can be understood as an attempt in 2-D to bring still-life or landscape to life, suffusing it with movement much as he tried to do in early poems through personification and superimposition of images, subjects discussed in more detail in Chapter 2. These concerns with conveying movement and the fleeting effects of changes in light were ones shared by the Impressionists though Hopkins never explicitly mentions their work.[1]

In the 1860s, when Hopkins frequently went to the Royal Academy's summer exhibitions—the start of the summer Season—there was sculpture exhibited in a room of its own, though the sculptors complained that the room was too small and badly lit. Hopkins evidently sometimes looked at it and occasionally commented; he praised, for example, G. F. Watts's unfinished marble bust of *Clytie* in 1868, now owned by the City of London. Watts subsequently had the bust cast in bronze, which Hopkins might have liked rather less. Clytie is a muscular young woman with substantial shoulders and neck, the figure caught just as she disappears into the petals of the sunflower into which she was turned. Clytie, the daughter of Oceanus, loved Apollo but was abandoned by him and, pining away, she turned into a sunflower, following the path of his chariot in its daily traverse across the sky. The bust is seen as a forerunner of the New Sculpture, and would seem to have been influential on one of Hamo Thornycroft's early works, *Lot's Wife*, in which she turns her head in a very similar way, captured at the moment at which she turns into a pillar of salt. But in 1868 *Clytie* was exceptional. What was there that might have appealed to Hopkins? Allusion to classical literature was an invitation to a shared male culture, a product of the education of the middle and upper classes. Then, the bust combines strongly realistic physical presence with symbolic meaning, just as much of Hopkins's imagery does, from the ranging back and forth between physical and symbolic meaning in the opening stanza of 'The Wreck of the Deutschland' to the interplay between the many significances of Mary in 'The Blessed Virgin Compared to the Air we Breathe'. However, looking through the Royal Academy catalogues for the 1860s, what one becomes very much aware of is the close connection between sculpture and the art market. The vast majority of pieces are commemorative busts or statues, or designs for medals. Tennyson's *Idylls* and classical literature are the inspiration for most of the rest. In the 1850s and 1860s there simply was not the sort of work that Hamo Thornycroft and other 'New Sculptors' produced in the 1880s, nor the more realistic images of peasants produced by French sculptors in the 1870s.

When Hopkins went up to Oxford in 1863 the University had a display of casts of classical statues on display on the ground floor of its Ashmolean Museum, a building completed in 1845. These included casts of the *Laocoon*, the *Apollo Belvedere*, the *Venus di Medici*, and Phidias's *Athena*, many of them made from moulds originally manufactured in Rome for Napoleon Bonaparte.[2]

In 1865 Hopkins wrote for Robert Scott, Master of Balliol at the time, an essay 'On the true idea and excellence of sculpture'.[3] It was one of the weekly 'Master's essays' that, when he had first gone up to Oxford, Jowett had advised him would be more important for his success than anything else (22 Apr. 1863, *LIII* 73). Characteristically for these pieces, 'On the true idea and excellence of sculpture' takes a proposition and constructs an argument from analysis of the conditions that would be necessary for it. Here Hopkins starts with ideas that he develops from Lessing's *Laokoon*[4] and works towards identifying the possibilities for expression that are characteristic to sculpture. He also builds in part on the thought in several of his previous essays on the relation of art to ideas of truth and beauty. Excellence, he says, can only come from understanding the natural constraints of the material and from working with these rather than attempting to accomplish a subject that it is not suited to. He proceeds to criticize a recent Italian stone sculpture called *The Sleep of Sorrow and the Dream of Joy* because it purports to show a floating figure surrounded by 'a crowd of flowers'. His objection is that stone is 'heavy, massive, but without toughness and able to bear but little suspension'. It is, thus, suitable for 'repose, a sense of natural balance, action none or little or else at least not scattered,—and centrifugal'. Those admiring the sculpture, he contends, were admiring the sculptor's 'ingenuity' not in using but 'resisting' his material, and therefore, not so much his 'experienced skill as his ignorance'. The statue was the work of Raffaelle Monti and was an allegory of the foundation of the new kingdom of Italy floating free of the domination of Austria. It had been exhibited to great applause in the International Exhibition of 1862, which is where Hopkins may have seen it.[5] Hopkins asserts that an observer may well not have such criteria consciously in mind but will intuitively be affected by them in his judgement. He contrasts stone sculpture with bronze, asserting that in the latter 'more action is given, the details are sharper, the draperies have more narrow, ridgy folds, wh. all befit the tough and ductile material. Therefore equestrian statues are most commonly in bronze not simply because it is easier to give the suspension thus than in stone, but—wh. follows fr. this—because the knowledge that it is metal wh. he sees pleases the beholder with a better sense of reality and security in the free action.' Such freedom, he contends, is required by the material—to use it timidly without action, is to misuse it. Such sensitivity to the engineering elements of sculpture, the conveying of movement and supporting of weight, might be seen as related to Hopkins's acute sense of the timing between stresses in his

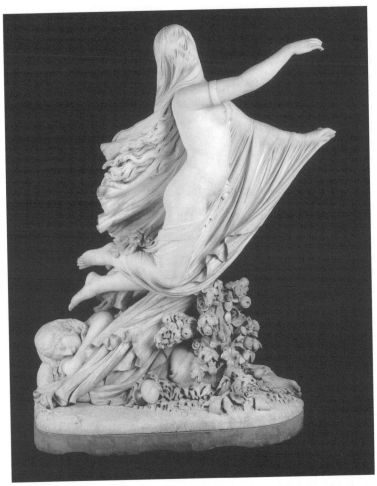

26. Raffaelle Monti, *The Sleep of Sorrow and the Dream of Joy: An Allegory of the Italian Risorgimento*, carved marble, 1861 *(Victoria and Albert Museum)*

use of rhythm; the arches carrying sound between the pillars of stress, something that will be of particular relevance to the analysis of 'Harry Ploughman' at the end of the chapter.[6]

The final phase of Hopkins's essay concerns the sculpture of figures. He concludes that the fact that sculpture is difficult and lasting and is capable of limited realism has led to the closest study of nature by artists. He refers to a comment by Sir Joshua Reynolds on a statue by Agasias

the Ephesian in the Vatican that it showed a knowledge of anatomy which would take a lifetime to acquire. Perhaps only in sculpture, Hopkins deduces, would artists be pushed, as Michelangelo and others were, to attend or carry out dissection in order to absorb the anatomical knowledge of another discipline, that of surgery. In fact, 'the study of anatomy for wh marble offers so great a field has become so peculiarly the pursuit of sculpture that it sometimes has by a convention, banished drapery, representing as naked what shd. be, or shd. more naturally be, clothed'. Hopkins's point is not an explanation for the nude, which appears in similarly unconvincing situations in paintings in order to flaunt the artist's accomplishment, but an expression of the way in which in sculpture the artist's knowledge of anatomy can be tested as one walks round the figure, able to examine its adherence to the human form far more than in a painting. Just as the amount of realism is limited in sculpture by convention and problems of engineering, so 'the idealism aimed at, that is the modification of nature or truth so as to attain the beautiful ... also is limited, [and this] shd. task the imagination for high and concentrated effort'. Ignoring Lessing's comment on the disproportionately long legs of the *Belvedere Apollo*, Hopkins states that the statue is still the standard against which beauty of the human figure can be tested. Observing that 'the expression of a single, generally simple, passion' is one of sculpture's strengths, Hopkins concludes that 'in the unprogressive arts' such as sculpture or painting Lessing's advice to portray a moment before an emotional climax is reached is sound because it leaves the imagination free and avoids the dangers of satiation. His own poetry, which is exceptionally emotional, suggests that he believed, or came to believe, that in such 'progressive arts' the work would take the audience with it through to the height or depth of the experience; see, for example, the ecstasy of 'Hurrahing in Harvest' and despair of 'No worst'.

Hopkins speculates that although the statues of Michelangelo, who had found the *Laocoon* liberating in its expression of extreme emotion, exceed ancient Greek work in imagination and 'wider sympathies', and though sculpture of the Middle Ages may show greater tenderness and bolder fusion of elements and religious depth, nevertheless, the Greeks remain the supreme masters in the medium because their mentality was ideally suited to the conditions that produce sculpture: 'it is here unity is most strongly marked; perfection, fr. the fewness of the elements, is most directly attainable here; and sculpture expresses most of the arts that quality of a noble civilisation, distinction, the union namely

of genius of a refined sort with high culture, wh. the finest of Greek poetry and other art seem naturally and beyond other nations to have assimilated to themselves.'[7] He evidently came to think of Thornycroft as an individual rather than a representative of English sculpture since, in 1887, he was still viewing sculpture as a characteristically Greek achievement, writing to Robert Bridges, 'Every age in art has its secret and its success, where even second rate men are masters. ... second rate men were masters of sculpture in Phidias' time' (6 Nov. 1887, LI 267). Their own age he considered to be one of excellence in 'wordpainting'.

In his essay Hopkins remarked that sculpture was miscalled 'the plastic art' since it was least affected by contemporary trends, being slow both to degenerate and to learn from current ideas. The criteria by which he is asserting 'degeneracy' would seem from other comments that he makes at this period to be a Ruskinian testing of a work's physical verisimilitude and freshness of vision. It is a very apposite remark for 1865 given the opposition between the conventional idealism espoused by the Academy and the 'new realism' associated with Ruskin, the Pre-Raphaelites, and the avant-garde French artists. The dispute is apparent, for example, in a lecture at the Royal Institution in 1872 by Edward Poynter, later to become President of the Royal Academy. (It was attended by Hamo Thornycroft's parents, who were also sculptors.) Poynter 'made it his object to defend the Academy tradition against Mr Ruskin on the one hand and the French realistic school on the other'; Millet may be a representative figure of what he had in mind among French artists.[8] He advocated Reynolds's views 'that an artist must try to enter into the spirit of the ancients and seek an abstract ideal of human form. The grand aim, he said, must be to catch the spirit of the old masters and to create works of art which would inspire noble ideas in the mind of the beholder: "to create a new world and not to imitate the world we know"', by which he seems to have been countering the contemporary popularity of genre pictures. Known as 'one of the last upholders of the Classical academic tradition in England',[9] Poynter favoured historical subjects for his paintings, often including nudes. His oil, *The Catapult*, which Hopkins noted in the Royal Academy Exhibition of 1868 (17 June, J 167) is in many ways typical of his work. In it the main figure is a nude study of the body at work. The play of muscle under stress was one of the admired characteristics in Greek sculpture and something that Hopkins approves in his description of the drowned sailor in 'The Loss of the Eurydice' although there, beyond the sense of loss of a human being,

the sorrow stems from Hopkins's fears that the man's soul is lost and that, furthermore, he is but one representative of 'My people and born own nation' similarly beyond spiritual redemption.

It is difficult in these days to appreciate fully the sheer gymnastic strength and agility required by sailors of sailing ships. There is a film shown in the museum within the *Cutty Sark* showing barefooted sailors setting sails from the yardarms, clinging high up on the wooden yardarms with their bare feet and toes while manoeuvring the heavy sails. Hopkins's praise of the dead man's body is informed by his admiration for learnt skill and hard work, as well as for that virile strength, as with other working men, so far beyond his own. These were criteria that Pater brought more sensually to bear in his selection for praise of the youths from the Panathenaic frieze: 'that line of youths on horseback, with their level glances, their proud, patient lips, their chastened reins, their whole bodies in exquisite service. This colourless, unclassified purity of life, with its blending and interpenetration of intellectual, spiritual, and physical elements, still folded together.'[10] In choosing a historical subject for his painting and including a prominent nude Poynter was producing a classical piece of the two highest pictorial genres. However, in placing the Roman general away from the central focus and making his principal figure instead an ordinary soldier, he showed affinity with such later nineteenth-century artists as Walker and Thornycroft. The extreme accuracy with which the catapult was drawn prompted comparisons with educational illustrations but also aroused antiquarian interest, sharper in an age when classics formed a major element in education.[11]

It was Poynter's predecessor as President of the Royal Academy, Frederic Leighton, who was to influence Hamo Thornycroft, the sculptor of *The Sower* that Hopkins admired in 1886. Hamo had spent nine years from 1854 living with his uncle and aunt on their farm in Cheshire. There he developed his sympathy with farm workers and learnt to mow. His father hoped that he would become an engineer but Hamo's interest was in sculpture and he spent his spare time in London copying the Greek sculpture in the British Museum, as filled by admiration of the 'majestic beauty' of the Elgin Marbles as his father had been. In the Museum he was spotted by Burne-Jones, who invited him to his studio, where he was attracted by the examples of Morris's decorative work. Hamo subsequently entered the Academy schools where Leighton taught. He later recalled that Leighton 'did much to help on the School of Sculpture and also the special study of drapery on the living model.

His great knowledge of drapery and his admirable method of making studies in this department of art were a new element in the training in the schools and soon had a visible effect on the work done by the students after that date' (Manning, 53). Leighton urged his students to consider that, 'there is as much principle in drapery as in anatomy; work logically … Work the lines round the form so as to represent the form more completely' (Manning, 60). One of the things on which Hopkins commented on several occasions was the skill with which drapery had been caught. In February 1874, for example, he visited the National Gallery, noting Michelangelo's 'masterly inscape of drapery' in the unfinished *Virgin and Child with S. John and Angels*, a painting in which the handling of the drapery and the composition are considered to have much in common with Michelangelo's early sculpture. Hopkins also remarked on Mantegna's 'inscaping of drapery' in the *Triumph of Scipio* and the *Madonna with Saints*, which he said was 'unequalled, it goes so deep' (16 Feb. *J* 241). The *Triumph of Scipio* is interesting because it is a grisaille painting of a sculptural frieze. Hopkins's artistic friend of 1864, Frederic William Burton, had written an article on the qualities of *The Triumph of Scipio* for the *Portfolio* of 1874 (vol. 5, pp. 4–7) when it was acquired by the National Gallery. In it he comments on qualities in Mantegna that are very similar to those Hopkins was to find in Purcell: 'it is the ethos of Mantegna that … is apparent in every work that proceeded from his hands … which interests us irresistibly in the man himself. Nor is our interest diminished by the fact that no thought of pleasing us seems to have guided his creative pencil. … As in the scenes of the Passion, and those which follow it, his deep tones of melancholy are given out for the disburthening of his own overladen sense of supernatural agony and human suffering; so, in themes from profane history, his notes of solemn exultation record for himself alone his sympathy with humanity in its heroic moments' (p. 4).

> Not mood in him nor meaning, proud fire or sacred fear,
> Or love, or pity, or all that sweet notes not his might nursle:
> It is the forgèd feature finds me; it is the rehearsal
> Of own, of abrupt self there so thrusts on, so throngs the ear.
>
> ('Henry Purcell', ll. 5–8)

Leighton recommended that 'the more every line you make expresses form, the more rapidly you are able to work. Your object is not so much to make a good drawing as to impress what you see upon your memory' (Manning, 52). In 1857 Ruskin advocated the same thing

in his *Elements of Drawing*, advice that is accepted as part of the inspiration for Hopkins's term, 'inscape'. That Leighton (and Burton) were making similar recommendations suggests that the ideas were more in the air at the time than is sometimes thought and that the influences on Hopkins's famous term should be seen as more widespread and less directly the result of Ruskin's writing. Leighton praised the Elgin Marbles as the supreme example of precise sculpture, the essential lines all caught and without exaggeration, a comment which helps to explain why Greek sculpture was a touchstone of the time against which to measure figure drawing. It also influenced those artists that Hopkins particularly admired. One of the most explicit examples is probably Frederick Walker's *The Bathers*, painted in 1866, an early forerunner of the more naturalistic *plein air* nudes of the 1880s by artists such as Henry Scott Tuke. Walker had left school at the age of 16 and, like Thornycroft, had devoted many hours to the study of the Elgin Marbles. The influence of Greek sculpture on his work was permanent. In *The Bathers* he deliberately tried to give his figures of town lads bathing qualities of beauty of the antique marble, though Roman as well as Greek. On 13 February 1866 he wrote to his family describing his progress on the picture, 'I have put in one boy that will *do it, I think*—the classic fellow standing up and throwing off his shirt—[it] will require fetching up bit by bit, though he's *all there* now. Then I've got one chap in the left corner in front, who is rushing in bellowing, and tearing off his coat; besides the back view of two fellows who are running towards the water, one of them throwing up his arms. These are on the other side of the picture; and I've put in a boy in his shirt only, who is helping another out of the water, and another leaning on his arms with only his hat on, à la Mercury.'[12] In the painting Walker, to whom it was important to capture realities of the world around him, had taken one of few contemporary subjects that naturalized nudes. G. F. Watts commented to Hamo that he remembered when the painting was first seen on the Members' Varnishing Day—'it made a sensation' among the artists present, though not all admired Walker's command of oil painting. Hamo later said that he wished he might see another picture 'as good and national' as *The Bathers*, adding that it seemed strange that no one had taken up the torch that Walker [had] held so firmly while he lived (Manning, 101). He later did a bronze statue of the central lad from Walker's picture. The painting was not complete when it was exhibited and the public response to it was mixed. The critic from *The Times*, Tom

Taylor, snorted that it was 'only a study of vulgar little boys bathing on the flat bank of say the River Lea not far from Tottenham' (13 May 1867), a comment that serves to reinforce Hamo's judgement as to the 'national' quality of the subject. This was, of course, to be the sort of material that Hopkins included in his 'Epithalamion' in his celebration of 'boys from the town | Bathing'. It is not clear that Hopkins saw *The Bathers*, though he may have heard of Tom Taylor's snide remark from R. W. Macbeth. Robert Bernard Martin suggests that Hopkins saw it at the Royal Academy Exhibition of 1868, but Walker exhibited *In the Glen, Rathfarnam Park*, now known as *The Vagrants*, there.

When he went to the Royal Academy Exhibition of 1868 Hopkins made a list in his journal of pictures that caught his eye, many of which were mentioned by reviewers of the Exhibition. The first of these was by George Mason, who was considered as being in the same 'school' as Walker. Mason's *Evening Hymn* was called 'one of the most perfectly successful pictures in the present Exhibition' by the *Saturday Review* in July.[13] The painting is now lost and the only thing extant is an early preparatory version of it. *The Evening Hymn* was described as 'Five or six girls ... coming home from school in the evening, and singing. There is a yellow sky, after sunset, with red near the horizon; the landscape is rather extensive, and includes the church and a distant river, seen between near trees. Two young shepherds and a dog are stopping to see the girls pass. These girls are dressed in the simplest prints, and one cannot say that the shepherds are anything but ordinary English shepherds, yet so great is the art with which the attitudes are chosen and the group arranged, that the picture awes us by a very strong impression of grandeur and nobleness.' There are in this description several things that also recur in art criticism by Hopkins or in his poems: a sensitivity to the grouping of figures which he criticized Everard for not considering sufficiently, a preference for rural working people, and appreciation of rural English landscape. The stereotypical comments on class made by the reviewer can also be found in Hopkins, in his poem 'Tom's Garland' with its distinctions between the physical hardships of the labourers and the mental stress of the upper classes. In this Norman White comments that Hopkins's 'social thinking had not undergone much change since he had seen the painting "Work" in 1865, and had copied into his commonplace-book Ford Madox Brown's accompanying sonnet: "Work! Which beads the brow and tans the flesh | Of lusty manhood ... " '.[14] Tom Taylor liked Mason's *Evening Hymn*, praising it as 'rivalling the best that France can show'. He added that 'One cannot

say what it is in these girls ... which lifts them into a region of art as high and pure as any ever peopled by the Grecian power of form or the mediaeval spirit of faith'.[15]

Taylor pointed to another picture selected by Hopkins, Walker's *Vagrants*, praising it for 'the same power and charm' as in *The Evening Hymn*. The scene was, he said, 'of a tired family of vagrants, at the end of a wet and weary day's tramp, huddling round a handful of damp sticks, which give out more smoke than heat, in a marshy bottom, under a sky which promises more rain'. He commented on the technique of the picture: 'the manner of the painting is peculiar, and the touch rough, and what practised oil painters may call unskilful, [but] the relative power and quality of tone and colour, and light and shade, is well conveyed, and the picture, at a right distance, tells admirably.'[16] Hopkins also admired 'a pretty medieval ploughing-scene by Pinwell' which Taylor liked rather less. Pinwell was another member of the group centring on Walker and which in the 1890s came to be known as the Idealists. The qualities identified by the term were the union of figures with their physical surroundings, and the influence of Greek sculpture on the figures, traits that came to influence Thornycroft in his sculpture. The Idealists were primarily watercolourists who had done much of their formative work as illustrators during the heyday of the pictorial press in the 1860s. This tended to make them pattern all areas of their paintings and in Walker and John William North led to their continuing to choose subjects from contemporary life, such as they had accomplished during their time as illustrators.

Writing in 1885 J. Comyns Carr asserted that while 'in watching closely the simple duties of rustic labour' Walker and those who followed him gave to modern painting new resources, 'graceful and energetic expression ... and in following more closely than others had done the actual facts of the life before them, they proved once again how high and noble, in a spiritual sense, that art may be which seems to concern itself most attentively with physical truth'.[17] This accuracy was a quality that Hopkins appreciated in Walker. Comparing him to Burne-Jones he commented, 'Now no one admires more keenly than I do the gifts that go into Burne Jones's works, the fine genius, the spirituality, the invention; but they leave me deeply dissatisfied as well, where Walker's works more than satisfy. It is their technical imperfection I cannot get over, the bad, the unmasterly drawing—as it appears to me to be. They are not masterly. Now this is the artist's most essential quality, masterly execution: it is a kind of male gift and especially marks

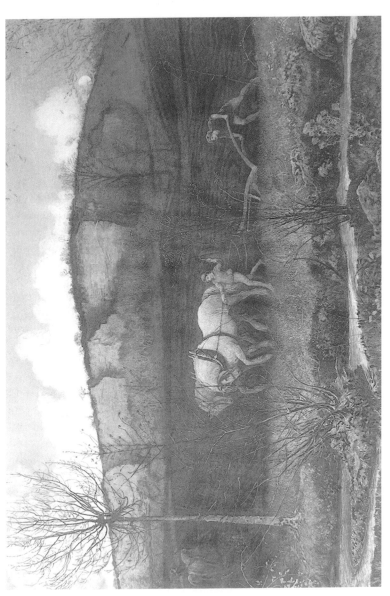

27. Robert Walker Macbeth, etching of Fred Walker's *The Plough* (*Agnews*)

off men from women, the begetting one's thought on paper, on verse, on whatever the matter is; the life must be conveyed into the work and be displayed there, not suggested as having been in the artist's mind: otherwise the product is one of those hen's-eggs that are good to eat and look just like live ones but never hatch (I think they are called wind eggs: I believe most eggs for breakfast *are* wind eggs and none the worse for it)' (30 June 1886, *LII* 133). Writing of him after visiting the studio of an artist and engraver, Robert Walker Macbeth, Hopkins told Dixon, 'My brother Arthur, who is a painter too, took me to Macbeth's studio when I was last in town. There happened to be little of Macbeth's own there then, but he was employed on an etching of Walker's *Fisherman's Shop* for Messrs. Agnew and the original was of course with him. It is not a work that I care for very much except so far as I revere everything that Walker did (I remember the news of his death gave me a shock as if it had been a near friend's), though artists greatly admire the technic of it; but there were other etchings by Macbeth and other reproductions of Walker's pieces and most of them new to me, the *Ferry* I think it is called (an upper-Thames riverside scene), the *Plough* [RA 1870] (a divine work), the *Mushroom Gatherers* [unfinished at the time of his death], and others. If you have not yet studied Walker's work you have a new world of beauty to open and go in' (30 June 1886, *LII* 134).

Carr admired *The Plough* for the integration of the figures and the landscape they inhabit.

Hopkins's praise of *The Plough* as 'a divine work' resembles his admiration for Wordsworth's 'Intimations of Immortality', which he described, also to Dixon, as being penned with the intercession of St. George and St. Thomas of Canterbury (23–4 Oct. 1886, *LII* 148). What the two works have in common is their capturing of characteristic movement: Walker catches the way in which the ploughman must constantly adjust his balance to keep control of the plough, and Wordsworth, in the stanza that Hopkins praised most, fuses in the rhythm and imagery the sudden elation, 'the magical change' of the shorter lines:

> O joy! that in our embers
> Is something that doth live[.]

Macbeth, who was four years younger than Hopkins and who, like Arthur, had worked for the *Graphic*, had begun to exhibit etchings of Walker's work at the Royal Academy in 1885 when he had shown *The Harbour of Refuge* and *Marlow Ferry*. In 1886 he had followed this with *The mushroom-gatherers*. When Hopkins visited him he evidently had

some of the work he was to show in 1887 complete or in hand: *The fishmonger's shop* and *The Plough*. It is not clear whether he had yet begun work on *A rainy day*, also exhibited in 1887, or *The Bathers*, which he exhibited in 1888, nor whether he had the original paintings of these in his workshop. Macbeth's final two etchings of Walker's work for the Royal Academy were *Autumn* and *Spring*, both shown in 1890. As well as reproducing Walker's paintings, Macbeth also made etchings for the Royal Academy Exhibitions of George Mason's work, including *The harvest Moon* of 1883. In 1886 he presented *The end of the day* and *A Pastoral Symphony*. Perhaps he was already working on *Return from milking*, *The cast shoe* (purchased for the Chantrey bequest in 1890), and *The May of life*, which he exhibited in 1887.[18]

Carr remarked on the way in which increased understanding of nature in modern art was leading to 'a return to the beauty of antique sculpture'. He traced a similar process in Renaissance painters: 'So soon as the study of nature among the Italian painters became so serious that the body and its capabilities of expression overpowered the devotion to religious sentiment the value and beauty of the antique were freshly and clearly perceived. And this same process is repeated within narrow limits in the art of men like Millet and Walker.' At times he recognized that this was quite deliberate: 'in several of Walker's pictures the suggestions of the grace of antique sculpture are consciously imported into the design.'[19] The case is indeed easier to make for Walker than for Millet whose forms often seem to have more in common with the distorted, monumental shapes of Henry Moore. Comparing the portrayal of rustic youths in William Holman Hunt's work with that in Walker's, Carr comments that although Hunt was 'in his time a sincere and accurate observer of peasant life ... yet there is not in his peasant figures half the knowledge of reality that we find in a peasant figure drawn by the hand of Millet or Walker. ... If we compare one of Hunt's boys with the lad who guides the horses in Walker's picture of "Ploughing" we shall realize the distance between the two ideals.' In place of Hunt's 'series of happy pictures crowded with rosy portraits', the knowledge of the countryside possessed by Mason, and still more Walker and Millet, results in 'the kind of beauty that is most closely dependent upon physical form and movement'. The result is that he 'faithfully records the energetic movements of peasant life, and seizes the grace that attaches to all the expressive attitudes of toil. He is no longer in need of finding or inventing pathetic incidents of domestic existence, for he has found out that the most serious thing in the life of a labourer is his

labour, and that the forms of rustic people, as they are imaged against the landscape, contain in themselves the highest kind of truth possible to art.'[20] This is a description that also fits 'Harry Ploughman'.

Hopkins's poem, 'Harry Ploughman' has been compared to Walker's figure in *The Plough* and this I will return to, but I want to broaden the context of the comparison. For instance, Hopkins's earlier poem, 'The furl of fresh-leaved dogrose' (1879) could be seen as having far more in common with William Holman Hunt's pictures:

> The furl of fresh-leaved dogrose down
> His cheeks the forth-and-flaunting sun
> Had swarthed about with lion-brown
> Before the Spring was done.
>
> His locks like all a ravel-rope's-end,
> With hempen strands in spray—
> Fallow, foam-fallow, hanks—fall'n off their ranks,
> Swung down at a disarray.
>
> Or like a juicy and jostling shock
> Of bluebells sheaved in May
> Or wind-long fleeces on the flock
> A day off shearing day.
>
> Then over his turnèd temples—here—
> Was a rose, or, failing that,
> Rough-Robin or five-lipped campion clear
> For a beauty-bow to his hat,
> And the sunlight sidled, like dewdrops, like dandled diamonds
> Through the sieve of the straw of the plait.

This is like a preparatory attempt at a portrait such as he was to make in 'Harry Ploughman', though there is a significant difference. Here we have but a picture of a country lad—no indication of his personality beyond his unkempt hair and liking for red flowers—all those mentioned are red; Hopkins seems to have seen him enough times to notice his floral preferences. There is no direct indication of the young man's work, though the comparison with sheep fleeces 'a day off shearing day' may suggest he is a shepherd. Above all there is no evocation of movement, an important difference between this poem and 'Harry Ploughman'. The sensuous appreciation of this handsome young man, suggested by comparison of his hair to 'a juicy and jostling shock of bluebells' in spring, a loaded image for Hopkins since he connected such bluebells with a knowledge of Christ, is held at a distance by the

sustained observation that concentrates on the effects of light on the face only, by the lack of communication, the omission of mention of eyes or mouth. One can see Hopkins observing him with a certain amount of wry amusement as well as admiration.

Hopkins's knowledge of farming stemmed largely from the fact that most of the Jesuit houses contributed through their own labour to feeding their communities. He notes in his Journal for 8 September 1873, for example, 'I talked to Br. Duffy ploughing: he told me the names of the cross, side-plate, muzzle, regulator, and short chain. He talked of something *spraying* out, meaning splaying out and of *combing* the ground' (*J* 237). If we take the use of the present participle literally we are presented with a picture of Hopkins making his way over the uneven ground beside Brother Duffy, who presumably is manhandling the plough while tossing out phrasal explanations of the parts of the equipment. The alternative, in which we interpret 'ploughing' as one of Hopkins's abbreviations, here expandable into 'while he was resting during a day of ploughing' we get a much less vibrant picture of Hopkins watching what he was later to try to capture in 'Harry Ploughman', the ploughman in the act of ploughing.

In the same year, 1873, Hopkins commented on the 'blue twelvemonth service of plates or platters' with stanniferous glaze by Luca della Robbia in the South Kensington Museum (18 September, *J* 237). The plates, actually roundels, dated 1450–6 were originally inserted in the vaulted ceiling of Piero de' Medici's study in the Palazzo Medici in Florence. Each shows a figure engaged in the rural occupation associated with that month in the year. The sketched figures are simple but vigorous and the tasks they display combine elements of contemporary agricultural practice, including viticulture, with classical descriptions. Some of the techniques and equipment pictured are specialized and send the viewer to the museum's explanations. Hopkins's interest in the equipment of physical labour is clear in 'Pied Beauty' (1877). The poem contrasts socially with 'The Windhover', which was written shortly before. In comparison with the overtones of French chivalry and royalty of the dauphin, 'king | (dom) of daylight' in the octave and first tercet, 'Pied Beauty' picks up the mundane references of the sestet and celebrates 'all trades, their gear and tackle and trim'. Hopkins's mind moves from his appreciation of a landscape that is man-made, 'plotted and pieced' into meadow ('fold'), fallow and ploughed field through manual labour to an admiration of other forms of manual work implied by 'all trades'

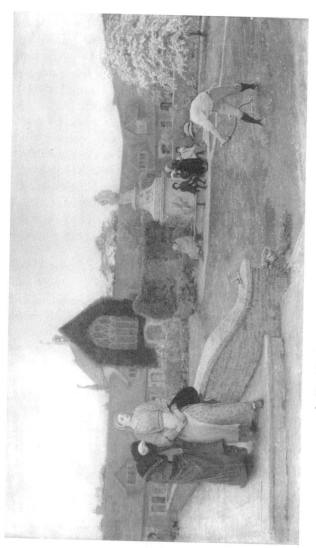

28. Fred Walker, *The Harbour of Refuge* (*Tate Gallery*)

requiring 'gear and tackle and trim'. The last perhaps with a reference to fishing boats.

At the end of 1873 Hopkins went with Arthur to the winter exhibition of the Society of Painters in Water Colour. He commented on Walker's *Harbour of Refuge*, a 'smaller watercolour reproduction of the oilpainting in the Academy for '72: that sold for £1500, this for £1000. Execution rough, the daisies and may brought out by scratching and even rudely, but perhaps this is more lasting than chinese white. The sunset sky and boughs of tree against it most rude, yet true and effective enough—at a distance, though this seemed inconsistent, for the details of the faces needed to be looked at close' (*J* 240). These are practical comments—about expense relative to return and techniques that last and the need to consider the ideal viewing distance and maintain it consistently—and would be natural in someone who, having once considered art as a career, imaginatively thinks his way into the situation of others such as Walker, or his brother Arthur. He continued, 'When I wrote these notes my memory was a little duller. The young man mowing was a great stroke, a figure quite made up of dew and grace and strong fire: the sweep of the scythe and swing and sway of the whole body even to the rising of the one foot on tiptoe while the other was flung forward was as if such a thing had never been painted before, so fresh and so very strong.' Again it is the capturing of physical movement, especially in activities where we think that Hopkins acknowledged his limitations, that attracts his admiration. He continued his observation, praising the 'enforced languor' of 'the young girl with the old woman on her arm', repressing her youthful exuberance in order to walk sufficiently slowly for the old woman, her face 'very pensive and delicate and sweet' with 'a pretty clever halo of a cap'. She exhibits a little of that self-repressive behaviour that Hopkins also frequently advocated ('Margaret Clitheroe', 'St Alphonsus Rodriquez', 'Brothers', 'To what serves Mortal Beauty?') and which he described in its ultimate form to E. H. Coleridge as Christ's 'incredible condescension' in his Incarnation: 'our Lord submitted not only to the pains of life, the fasting, scourging, crucifixion etc. or the insults, as the mocking, blindfolding, spitting etc. but also to the mean and trivial accidents of humanity' (22 Jan. 1866, *LIII* 19).

According to Edmund Gosse, the 'New Sculpture' began in 1875 with Hamo Thornycroft's response to the set theme, *Warrior carrying a Wounded Youth from the Battlefield*, which won the gold medal at the Summer Exhibition of the Royal Academy. Thornycroft's closest rival for the medal was Alfred Gilbert with a Celtic youth 'flung across a

hairy pony', a sculpture showing some of the same qualities of greater realism and the exploiting of the qualities of bronze rather than marble.[21] These were evident in Leighton's *Athlete with Python* exhibited at the Summer Exhibition of 1877. The movement was later to have more social implications in the choice of working-class subjects. By the end of the First World War, it had disappeared. In 1884 Thornycroft exhibited *The Mower* at the Royal Academy. John Addington Symonds wrote, 'The "Mower" seems in my opinion, to open for the English a new and very fateful path in sculpture. In painting, Mason and Walker have given us something of the same sort. I welcome with the most intense enthusiasm the dawning of a democratic ideal art in England.[22] Michael Hatt suggests that Symonds had in mind a homosocial utopia that transcended class barriers but Thornycroft in fact chose a heterosexual union and believed human beings had fundamental differences in their abilities.[23] Offering a retrospective opinion in 1932, Herbert Maryon, a former Art Master at Reading University, called Thornycroft 'the pioneer in the use of labour as a subject for sculpture. He anticipated even Meunier and Dalou in his figures of labourers. Of course J. F. Millet had painted them from 1848 onwards but Sir Hamo was the first to realise their possibilities in sculpture. ... Spielmann is right in calling him a "Neo-Greek of the front rank". But he is more than that, he was the pioneer in this country of the modern way of looking at nature, which is exemplified in "The Navvy", "The Mower", "The Sower", "The Bather", "By the Sea". In him the Greek and the modern French traditions met and they produced the pioneer of our modern sculpture' (Manning, 94).

Among the French sculptors important in the development of New Sculpture was Jules Dalou, who, implicated in the French Commune in 1871, escaped to London and exhibited and later taught at English art schools until 1880. Thornycroft, Maryon claimed, 'was the first who by his example and teaching led us away from the pseudo–classic work of Gibson, Calder Marshall, and the mid-Victorian group' (Manning, 94). One might contrast Gibson's *Pandora* of 1856 with Jules Dalou's terracotta *Peasant woman nursing a baby* of 1873.

In 1884 at the private view of the Royal Academy exhibition Hamo noted, ' "The Mower" has lots of admirers but none more enthusiastic than Mr. Stanford, the composer, of Cambridge [Stanford, one of the main contributors to the renaissance of English music at the time, used folk tunes in his music] ... Although he did not know me personally until introduced today, he almost hugged me, simply because the "Mower"

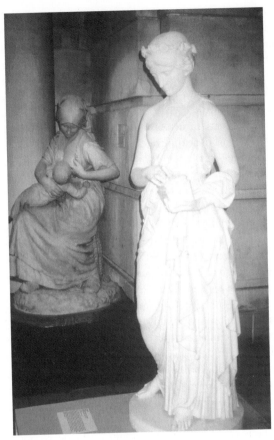

29. John Gibson, *Pandora*, marble, 1851, and Jules Dalou, *Peasant woman nursing her baby*, terracotta, 1873 *(Victoria and Albert Museum)*

had given him such pleasure. It is very wonderful and kind of people to see so much in my work. This I can't understand. ... During the last two years my political opinions have undergone a change and I am become a radical and feel infinitely happier for the change. Every workman's face I meet in the street interests me, and I feel sympathy with the hard-handed toilers and not with the lazy do-nothing selfish "upper ten". I feel that I am of the generation in which I live and am not living apart from it, as I fancy I see many doing' (Manning, 93). The winter of 1885–6 was one of the worst on record. The condition of the poor was aggravated by high levels of unemployment and socialist

agitators were active among them; in 1886 and 1887 there were a number of riots, most particularly in February 1886 and November 1887. Hopkins wrote to Baillie asking for some 'on-the-spot account of the late riots, as witnessed by yourself or friends and informants' (11 Feb. 1886, *LIII* 257).[24] In August 1871 Hopkins had sent to his friend Robert Bridges what is called his 'Red' letter in which he expressed his feeling that 'it is a dreadful thing for the greatest and most necessary part of a very rich nation to live a hard life without dignity, knowledge, comforts, delight, or hopes in the midst of plenty—which plenty they make. They profess that they do not care what they wreck and burn, the old civilisation and order must be destroyed. This is a dreadful look out but what has the old civilisation done for them?' (2 Aug. 1871, *LI* 27–8). Hopkins's attitude does not seem to have been one of communist equality but closer to the 'corporative view of society' of Pope Leo XIII[25] which says, 'as the perfect state of body consists in the composition and joining of the different limbs together, which differ in form and in use, nevertheless when joined together and each put in its proper place make a whole beautiful in appearance, firm in strength, fit for action, so also in the republic of men there is likewise an almost infinite dissimilitude of parts, which, if they are tested as if they were the same, and each allowed to follow its own judgment, no state would be found more deformed; whereas if they, with the distinct grades of dignity, profession, and pursuits, they properly harmonise together for the common good, they then fitly represent a well constituted state, harmonious with nature.[26]

In an excellent, extended study of attitudes to the poor among the leading Catholic churchmen that is the historical background to these poems, Sjaak Zonnefeld points out that this model of the state would seem to lie behind Hopkins's poems, 'Harry Ploughman' and, most explicitly, 'Tom's Garland', both written in 1887.

In 1886 Hamo drew up a 'Chart of Sculpture' showing the various influences which had worked on the sculptors of his time. In it he indicates that he had had two masters only: Nature and the Elgin Marbles, though it is difficult to believe that he was unaware of French sculptors such as Dalou. Elfrida Manning asserts that 'The Mower was the first life-size statue ever made—at least in Europe—of a man in working clothes. That it is thoroughly convincing is no doubt partly due to [Thornycroft's] early experience of life on the farm' (p. 95). The direct inspiration for the statue had been a glimpse he had had from a boat of a mower standing resting at Marlow on the Thames. The

finished statue was praised as being dignified without the sentimentality which hampered so many of the contemporary pieces adhering to William Morris's creed of 'the "dignity of labour"' (Manning, 95). In the Exhibition the statue's title was accompanied in the catalogue by three lines from Matthew Arnold's poem *Thyrsis*, his classical elegy for Clough:

> who, as the tiny swell
> Of our boat passing heaved the river-grass,
> Stood with suspended scythe to see us pass.

Benedict Read points to the importance to the poem of a 'classical title. Yet within this frame the poem is a rich vehicle of natural description', a combination that he sees Thornycroft deliberately achieving in a parallel way.[27] It has been suggested that the painting style closest to Thornycroft's is George Clausen's in his scenes of country labour. This does not seem to me quite right but looking at the other end of the spectrum, as shown in the paintings of Birkett Foster, suggests that *The Mower* is best placed between these two, along with Mason's and Walker's paintings. It is clear that in *The Sower*, Thornycroft took another step forward towards realism in presenting the sower carrying out sowing. And this is of relevance to 'Harry Ploughman', which Hopkins wrote in September 1887. In sending it to Bridges, Hopkins said that it was 'a direct picture of a ploughman, without afterthought', though in the following weeks he revised it and there are several versions with some helpful revisions. Hopkins remarked that he wanted the ploughman 'to be a vivid figure before the mind's eye; if he is not that the sonnet fails' (6 Nov. 1887, *LI* 265). If we look for artistic precedents and pedigree then I think that it is not just Walker's painting *The Plough* that is relevant, but equally Thornycroft's sculpture of *The Sower*. The form of Hopkins's poem is a sonnet but with the interpolation of five 'burden' lines (partial lines that rephrase, and sometimes simplify key phrases). The first three lines of 'Harry Ploughman' give us a description that is almost of a nude man though the last line of that 'quatrain' (l. 5) brings in a wider range of reference ('By a grey eye's heed steered well, one crew, fall to'). Here we have the naval image familiar from 'The Loss of the Eurydice' of a ship's captain and trained, coordinated crew. Also relevant, though not so obvious, are two Greek associations—from the Phaedrus of the chariot driver representing man's intelligent management of the horses that represent his emotional drives and, secondly, grey eyes that not only fit the blond Irishman pictured but also recall Athena, the grey-eyed

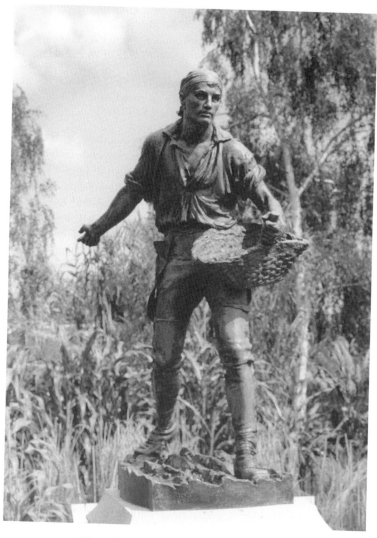

30. Hamo Thornycroft, *The Sower (Conway Library, Courtauld Institute of Art)*

goddess of wisdom. Lines 6, 8, 9, emphasize discipline, again reminiscent of 'The Loss of the Eurydice':

> Each limb's barrowy brawn, his thew
>
> Though as a beechbole firm, finds his, as at a rollcall, rank
> And features, in flesh, what deed he each must do—
> His sinew-service where do.

Behind the description of disciplined physical action, most especially in the clause, 'what deed he each must do—' referring immediately only to the coordination of the limbs, lie the assumptions of poems like 'As kingfishers catch fire' with its assertion of the all-pervasive presence of Christ and the fundamental need of dedicating all that men do to God, and 'How all is one way wrought' (the poem that Bridges titled 'On a piece of Music'). Here Hopkins sets out the relationship between worldly accomplishment and the necessity of choosing a moral master:

> What makes the man and what
> The man within that makes:
> Ask whom he serves or not
> Serves and what side he takes.
>
> For good grows wild and wide,
> Has shades, is nowhere none;
> But right must seek a side
> And choose for chieftain one.

Hopkins emphasizes with Harry the connection between landscape and worker praised as a feature of Walker's work by using images from the landscape for the ploughman: his arms are 'hard as hurdle', those tough young branches supple enough to be intertwined to make a fence—and his legs 'firm as beechbole'; beeches were cut for use as masts because they were straight and strong. Harry is a young man with scooped flanks and the churlsgrace that is a quality of working men's strength. He wears the creased hide boots so evident in paintings of working people by Clausen and Herkomer. The sestet suggests that unselfconscious unity of personality and action that Hopkins praised in 'Henry Purcell' and which he sought to convey there through comparison with the movements of a large sea-bird launching itself into the air. He admires the flexibility of the young man and notices his fair skin which crimsons with exertion and the tangled locks (as in the young man of 'The furl of fresh-leaved dogrose').

Beyond the visual picture, Hopkins tries to capture the actions of the ploughman as he responds to the erratic movements of the plough, taking the opportunity of movement provided by verse to the edge of which Thornycroft had gone in showing the sower in the act of sowing. The final four lines describe how the ploughman lifts his foot ('hangs' it) to counterbalance the tipping plough as it catches on a tough clod (a movement that Walker captures in *The Plough*), or 'hurls' his foot forward in an extra-long stride to catch up with the rapid spurt of the plough as it cuts through softer soil. Harry's shoes race both 'with' and 'along' the fountain of upturning clods that curve up on either side of the plough, gleaming with the moisture of spring soil ('a-fountain's shining-shot furls'). Hopkins dictated with a series of marks how the poem was to be read aloud, directions that, if followed, convey the ploughman's movement in following the erratic path of the plough. The burden lines that help grammatically to clarify the poem's meaning have a second function in unsettling the sound units. The effect balances precariously between meaning and a flow of sound conveying movement. The marks, which he wrote out on the sheet after the poem when he sent it to Bridges (MS A), are:

(1)	^	strong stress; which does not differ much from
(2)	⌒	pause or dwell on a syllable, which need not however have the metrical stress;
(3)	′	the metrical stress, marked in doubtful cases only;
(4)	~	quiver or circumflexion, making one syllable nearly two, most used with diphthongs and liquids;
(5)	⌢	between syllables slurs them into one;
(6)	⌢	over three or more syllables gives them the time of one half foot
(7)	‿	the outride; under one or more syllables makes them extrametrical: a slight pause follows as if the voice were silently making its way back to the highroad of the verse.[28]
	∥	heavy stress
	● ○	black ball indicates the heard stress, the white ball indicates a dumb or metrical stress

Hard as hurdle arms, with a broth of goldish flue
Breathed round; the rack of ribs; the scooped flank; lank
Rope-over thigh; knee-nave; and barrelled shank—
 Head and foot, shoulder and shank—
By a grey eye's heed steered well, one crew, fall to;

Stand at stress. Each limb's barrowy brawn, his thew
That onewhere curded, onewhere sucked or sank—
 Soared ór sánk—,
Though as a beechbole firm, finds his, as at a rollcall, rank
And features, ín flesh, whát deed he each must dó—
 His sinew-service where do.
He leans to it, Harry bends, look. Back, elbow, and liquid waist
In him, all quail to the wallowing o' the plough. 'S cheek crimsons; curls
Wag or crossbridle, in a wind lifted, windlaced—
 Wind-lilylocks-laced;
Churlsgrace too, Child of Amansstrength,, how it hangs or hurls
Them—broad ín bluff híde his frówning féet lashed! ráced
With, along them, cragiron under and cold furls—
 With-a-fountain's shining-shot furls.

Where in the spectrum of attitudes to rural people does Harry Ploughman fit? He has the slender, muscular figure of a Greek statue but with fair hair on the arms and tangled locks of an English/Irish countryman. He has the tough, worn boots always very evident in the pictures of country people by such realist painters as Herkomer. But it was Herkomer who said of Walker, 'in Frederick Walker we have the creator of the English [nineteenth-century] Renaissance, for it was he who saw the possibility of combining the grace of the antique with the realism of our everyday life in England. His navvies are Greek gods, and yet not a bit less true to nature (1893)'. The statement could stand too for Thornycroft's rural statues and for 'Harry Ploughman'. Hopkins goes further towards the unity that Pater encapsulates in his statement of all the arts aspiring to the condition of music, in trying to capture the inscape of a generic ploughman ploughing, just as earlier, in the only other extended poetic precedent that comes to mind, he had conveyed something of the movement of a kestrel in flight.

7

Theories of Vision

In his Journal for 23 December 1869 Hopkins recorded two recent dreams. In the second of these 'being very tired', he closed his eyes while listening to the Rector giving instructions for the evening meditation and 'without ceasing to hear him', began to dream. 'The dream-images seemed to rise and overlie those which belonged to what he [the Rector] was saying and I saw one of the Apostles—he was talking about the Apostles—as if pressed against by a piece of wood about half a yard long and a few inches across, like a long box with two of the long sides cut off' (*J* 193). The box was remembered from the water closets where it contained cinders that kept the pipes from freezing. Hopkins, who had had the job of cleaning the water closets, had seen the box and been puzzled as to its use. He concluded that 'it is just the things which produce dead impressions, which the mind, either because you cannot make them out or because they were perceived across other more engrossing thoughts, has made nothing of and brought into no scaping, that force themselves up in this way afterwards' (*J* 194). Instead of 'scaping' Hopkins had originally written 'inscaping' and then crossed out the 'in'. I think that by 'no scaping' here he means lacking a relation to other things, or meaningful context. He continued:

The dream-images also appear to have little or no projection, to be flat like pictures, and often one seems to be holding one's eyes close to them—I mean even while dreaming. This probably due to a difference still felt between images brought by ordinary use of function of sight and those seen as these are 'between our eyelids and our eyes'—though this is not all, for we also see the colours, brothy motes and figures, and at all events the positive darkness, made by the shut eyelids by the ordinary use of the function of sight, but these images are brought upon that dark field, as I imagine, by a reverse action of the visual nerves (the same will hold of the sounds, sensations of touch, etc of dreams)—or by

other nerves, but it seems reasonable to suppose impressions of sight belong to the organ of sight—and once lodged there are stalled by the mind like other images: only you cannot make them at will when awake, for the very effort and advertence would be destructive to them, since the eye in its sane waking office kens only impressions brought from without, that is to say either from beyond the body or from the body itself produced upon the dark field of the eyelids. Nevertheless I have seen in favourable moments the images brought from within lying there like others: if I am not mistaken they are coarser and simpler and something like the spectra made by bright things looked hard at. (*J* 194)

The phrase in brackets, 'between our eyelids and our eyes' may be in quotation marks as a partially remembered quotation from his father's poem, 'Association', to which Manley Hopkins appended a note: 'As to the association of unconnected ideas, see "Abercrombie on the Mental Powers." '

> 'Betwixt the eye-lid and the eye,'
> Where the filmy dreams do lie,
> Quaint processions rise and move;
> Things we love and things we hate,
> Fancies guessed at, things above,
> Friends remembered—now too late;
> Wild inconsequential throng
> Hand in hand, they dance along
> In a tangled, endless maze,
> Though our eyes on blackness gaze.
> Or by day, when open-eyed
> We see the rush of human tide
> Pass in cities, glistening shows
> Which crystal-windowed shops disclose;
> Or watch the brook which dimpling flows.
> Vanishes the living stream
> The real melts in pictured dream.
> Fancy's incoherent chain
> Cheats the sight and holds the brain.
> Mab is queen, the actual dies,
> Betwixt the eye-lids and the eyes.
> All things mingle, blend, confuse,
> And th'impressive soul amuse.[1]

The book to which Manley Hopkins was referring was most probably John Abercrombie's popular collection of *Inquiries concerning the Intellectual Powers and the Investigation of Truth*.[2] This combined medical knowledge (Abercrombie was a doctor) with anecdotes of a range

of visual illusions and speculations on such topics as the sources of dreams. Among his sections was one on the way in which the mind absorbs information that is not central to the attention at the point at which it is taken in, such as Gerard described, but where the source of the information can be rediscovered in a dream (pp. 268–9). He also discussed a range of 'False Perceptions' from *muscae volitantes* (floaters) (p. 60) to 'impressions of visible objects remaining for some time after the eye is shut, or has been withdrawn from them; generally accompanied by some remarkable change in the colour of the objects' (p. 61). Most people observe things of this sort, but Gerard was clearly particularly interested in them and he incorporated a range of such subjects in his poems, speculated about them in his journals and later in letters to *Nature*, and even tried experiments such as that of the duck he persuaded to walk along a chalk line (27 Apr. 1871, *J* 207). Gerard Hopkins's interest in the nature of visual phenomena can, thus, be found throughout his work. There are, for example, the early poems, 'It was a hard thing' and 'When eyes that cast'. The first of these, which belongs to mid-August 1864, shows him working out the balance between internal and external contribution in perceiving a rainbow. It runs:

> It was a hard thing to undo this knot.
> The rainbow shines, but only in the thought
> Of him that looks. Yet not in that alone,
> For who makes rainbows by invention?
> And many standing round a waterfall
> See one bow each, yet not the same to all,
> But each a hand's breadth further than the next.
> The sun on falling waters writes the text
> Which yet is in the eye or in the thought.
> It was a hard thing to undo this knot.

There are explorations of optical illusion in his Journals too, such as, 'What you look hard at seems to look hard at you, hence the true and the false instress of nature' (Mar. 1871, *J* 204). Here Hopkins seems to be distinguishing between the actuality of looking at nature and the fabricated impression that it is looking back at the observer. Some of Hopkins's observations incorporate scientific facts that he may have read in journals or learnt in his training. For example, in the following passage he includes a note of the length of time an image persists. This is more the sort of information found in books like Alfred Smee's *Vision in Health and Disease*,[3] though overall Hopkins's grasp is not

thoroughly scientific and much of his analysis is couched in his own
terminology: 'firework ... its seeming to pass the crest of Pendle is
curious. It may be because the eye taking up the well-marked motion
and forestalling it carries the bright scape of the present and past motion
(which lasts ⅛ of a second, they say) on to a part of the field where
the motion itself has not or will not come' (25 June 1873, *J* 232); 'the
sun sitting at one end of the branch in a pash of soap–sud–coloured
gummy bim–beams rowing over the leaves but sometimes flaring out
so as to let a blue crust or platter from quite the quick of the orb sail
in the eye' (18 July 1873, *J* 233); 'Flashes lacing two clouds above or
the cloud and the earth started upon the eyes in live veins of rincing
or riddling liquid white, inched and jagged as if it were the shivering
of a bright rib and string which had once been kept bound round a
blade and danced back into its pleatings. Several strong thrills of light
followed the flash but a grey smother of darkness blotted the eyes if
they had seen the fork, also dull furry thickened scapes of it were left in
them' (22 July 1873, *J* 233–4). Although these were visual phenomena
of sorts considered by Abercrombie, I do not think that we need turn
to him as a source of Hopkins's observations. In his poems he explores
various reasons for illusions he evidently experienced. For instance,
'When eyes that cast', which was written in February 1865, deals with
sensory misconceptions:

> When eyes that cast about the heights of heaven
> To canvass the retirement of the lark
> (Because the music from his bill forth-driven
> So takes the sister sense) can find no mark,
> But many a silver visionary spark
> Springs in the floating air and the skies swim,—
> Then often the ears in a new fashion hark,
> Beside them, about the hedges, hearing him:
> At last the bird is found a flickering shape and slim.
>
> At once the senses give the music back,
>
> { The proper sweet re-attributing above.
> { That sweetness re-attributing above.—

'A Vision of the Mermaids', a poem of 1862/3, seems to contain a
reference to an optical illusion in the lines:

> Plum-purple was the west; but spikes of light
> Spear'd open lustrous gashes, crimson-white;

(Where the eye fix'd, fled the encrimsoning spot,/
And gathering, floated where the gaze was not;)

(ll. 7–10)

Such illusions Hopkins was to report on more officially in the course
of a letter to *Nature* about the sunset effects caused by the eruption of
Krakatoa. Commenting on descriptions others had reported of the sun
appearing green or blue, he said:

It is, however, right and important to distinguish phenomena really new from
old ones first observed under new circumstances which make people unusually
observant. A sun seen as green or blue for hours together is a phenomenon only
witnessed after the late Krakatoa eruptions (barring some rare reports of like
appearances after like outbreaks, and under other exceptional conditions); but a
sun which turns green or blue just at setting is, I believe, an old and, we may
say, ordinary one, little remarked till lately. I have a note of witnessing it, with
other persons of a company, in North Wales on June 23, 1877, the sunset being
very clear and bright. It is, possibly, an optical effect only, due to a reaction
(from the red or yellow sunset light, to its complementary colour) taking place
in the overstrained eye at the moment when the light is suddenly cut off, either
by the sun's disappearance or by his entering a much thicker belt of vapour,
which, foreshortened as the vapour is close to the horizon, may happen almost
instantaneously. And this is confirmed by a kindred phenomenon of sunset. If
a very clear, unclouded sun is then gazed at, it often appears not convex, but
hollow; swimming—like looking down into a boiling pot or a swinging pail,
or into a bowl of quicksilver shaken; and of a lustrous but indistinct blue. The
sky about it appears to swell up all round into a lip or brim, and this brim
is coloured pink. The colour of the light will at that time be (though the eye
becomes deadened to it) between red and yellow. Now it may be noticed that
when a candle-flame is looked at through coloured glass, though everything else
behind the glass is strongly stained with the colour, the flame is often nearly
white: I suppose the light direct from the sun's disk not only to master the red
and yellow of the vapour medium, but even, to the eye, to take on something of
the complementary blue.

Even since writing the above I have witnessed, though slightly, the phe-
nomenon of a blue setting. The sunset was bright this evening, the sun of a ruddy
gold, which colour it kept till nothing was left of it but a star-like spot; then this
spot turned, for the twinkling of an eye, a leaden or watery blue, and vanished.'[4]

Tom Zaniello points out that at the time Hopkins wrote this letter
scientists were happy to use comparisons drawn from fine art and artists
with scientific interests made paintings of the sunsets that were included
in the report on the effects of the volcano.[5] Hopkins had no hesitation

in refuting the theory of the Astronomer Royal for Scotland, Professor Piazzi-Smyth, that the unusual colours round the sun and in it at sunset were the result of a halo round the sun itself: 'Now Prof. Piazzi-Smyth says that sunlight, as tested by the spectroscope, is weaker, not stronger, since the phenomena of last winter began. To set down variations in light and heat to changes in the sun when they may be explained by changes in our atmosphere, is like preferring the Ptolemaic to the Copernican system.' Not many people would pick that as the voice of Hopkins. In his descriptions of the sunset Hopkins drew on his knowledge of art, showing how carefully he had observed Rembrandt's style:

A bright sunset lines the clouds so that their brims look like gold, brass, bronze, or steel. It fetches out those dazzling flecks and spangles which people call fish-scales. It gives to a mackerel or dappled cloudrack the appearance of quilted crimson silk, or a ploughed field glazed with crimson ice. These effects may have been seen in the late sunsets, but they are not the specific after-glow; that is, without gloss or lustre.

 The two things together, that is intensity of light and want of lustre, give to objects on the earth the peculiar illumination which may be seen in studios and other well-like rooms, and which itself affects the practice of painters and may be seen in their works, notably Rembrandt's, disguising or feebly showing the outlines and distinctions of things, but fetching out white surfaces and coloured stuffs with a rich and inward and seemingly self-luminous glow.[6]

Hopkins's acquaintance with optical theories went back at least to his days at Oxford. For example, in an essay on 'The Origin of our Moral Ideas' he compared different moral systems, commenting that utilitarianism where 'moral action with its specific elements having become more and more definite and "*accidented*" in our minds by its perpetual occurrence' is no stranger than 'that the difference between green and purple should turn on the different speed of vibrations of light in striking our retinas' (1865?, *J* 81–2).

 He also played with the juxtaposition and superimposition of images, in ways that go beyond the normal flow of imagery in poetry. His early poem, 'A fragment of anything you like', for example, plays in three short stanzas with the superimposition of a picture of a damsel in distress and the moon almost as a visual pun:

> Fair, but of fairness as a vision dream'd;
> Dry were her sad eyes that would fain have stream'd;
> She stood before a light not hers, and seem'd
>
> The lorn Moon, pale with piteous dismay,

> Who rising late had miss'd her painful way
> In wandering until broad light of day;
>
> Then was discover'd in the pathless sky
> White-faced, as one in sad assay to fly
> Who asks not life but only place to die.

The poem is weak not just because it is clichéd but also because of its deliberate ignorance of astronomy; if it had not pre-dated 'Floris in Italy' by nearly twenty months it would be tempting to fit it into that. Similar but more serious superimposition appears in 'Hurrahing in Harvest' where the images resemble the 'silk-sack clouds' that like 'wilful-wavier | Meal-drift' mould and melt in rapid succession. Here the picture of the clouds is turned into a background against which the features of Christ's face appear, a bit as they are pictured in such places as the dome of Santa Sophia or the similarly thirteenth-century Peterborough Cathedral, another building where the picture of Christ (head and shoulders) breaks the picture plane as he apparently holds out his hand in blessing. The sestet gives us the distant view of hills, a fleeting classical one of Hercules with world-wielding shoulders pivoting into the sexually charged simile of the stallion. As in 'The Windhover', in which the image of the kestrel is combined with that of riding a steed, the comparison combines regal associations, power, and virile masculinity.

> And the azurous hung hills are his world-wielding shoulder
> Majestic—as a stallion stalwart, very-violet-sweet!—

The experience suggested is an ecstatic devotion, similar to that of Bernini's famous St Teresa, captured through the evocation of Christ's presence as a lover within a specific scene; a feeling of his presence, expressed through visual terms that are to be read as symbolic, not actual, so that what is implied is not a 'vision' but a passionate spiritual experience. In conveying this, Hopkins merges the picture of Christ and the landscape. There is in general a certain cross-over of descriptive words between his vocabulary in describing scenery or architecture and theological topics that makes this easier (see 'The Wreck of the Deutschland' l. 95 'bay of thy blessing', for example). 'Shoulder', the relevant shared word here, is found pervasively in the descriptions of ranges of hills in his Lancashire journals. Here the rapid movement from one scale to another, characteristic of much of his imagery throughout his life, is at its extreme as he flits from the field 'barbarous' as a stubbly face to the hills as a gigantic shoulder to a stallion's shiny flank to the earth as a globe hurled through space.[7]

However, Hopkins was not averse to drawing his imagery from classical and religious as well as contemporary scientific stores. There seem, for instance, to be four important classical and religious theories of vision to consider: Plato's version of extramission, Aristotle's intromission, Euclid's inception of what becomes perspectiva, and Augustine's 'eye of the mind'. Hopkins uses modified versions of Plato but the later thought is most easily understood as adjustments to his theory.

There are comments about vision in a number of Plato's dialogues and in the *Republic* but the most compact description of extramission as it had developed by Plato's time is sketched in the *Timeaus*:

Whenever there is daylight round about, the visual current issues forth, like to like, and coalesces with it [i.e. the daylight] and is formed into a single homogeneous body in a direct line with the eyes, in whatever quarter the stream issuing from within strikes upon any object it encounters outside. So the whole, because of its homogeneity, is similarly affected and passes on the motions of anything it comes in contact with or that comes into contact with it, throughout the whole body, to the soul, and thus causes the sensation we call seeing. (trans. Francis Cornford)

What Plato achieves in this model is a mechanical means by which the presence of an exterior object is transmitted into the perceiving body. He makes a distinction between visual fire and ordinary flame: the visual fire is finer and does not burn things but gives off a gentle light. The eye is constructed with fine apertures that let through it only this gentle type of fire. All objects give off streams of particles that enter the visual ray compounded of the fire from the eye and the surrounding light. The theory becomes more complicated than seems relevant to Hopkins's poems but the attractiveness of this much for him would, I think, be its reciprocal movement, the tactile bonding of perceiver and object perceived and the volitional element of perception.

Aristotle in his treatises *De sensu* and *De anima*, though not in the *Meterologica* if indeed that was by Aristotle, disagreed with extramission, the idea that a ray is emitted from the perceiver. We can see to the stars and that, he thought, ruled out the possibility of a ray issuing from the eye as necessary for perception. Instead, he suggested that between the observer and object seen is a medium which he calls the transparent. It allows one to see something coloured through it. Light is a particular state into which the transparent can turn, darkness is another and opposite state. When fire is introduced, the transparent changes instantly. It is then affected by the colour of objects in contact with it. The eyes are,

in this theory, composed mainly of water so perception occurs when the object's colour affects the transparent so that it is communicated into the perceiver's eye. It is therefore a theory of intromission and maintains the direct contact between the object perceived and the observer, though, unlike the extramission theory, it changes the state of a medium that is already in place rather than creating a new chain of connection between observer and object.

Euclid's contribution of relevance seems to be the first three postulates from his *Optica*. They assume an extramissive model and state:

1. That the rectilinear rays proceeding from the eye diverge indefinitely;

2. That the figure contained by a set of visual rays is a cone of which the vertex is at the eye and the base at the surface of the objects seen;

3. That those things are seen upon which visual rays fall and those things are not seen upon which visual rays do not fall.

The remaining four of his seven postulates show that the model is strictly geometrical. Things seen under a larger angle appear larger, those under a smaller angle appear smaller; things seen by higher visual rays appear higher, and things seen by lower visual rays appear lower; things seen by rays further to the right appear further to the right, and things seen by rays further to the left appear further to the left; things seen under more angles are seen more clearly. Things that fall between the rays because they are sufficiently far from the eye to miss the diverging rays, are not seen.

Unlike Euclid, of course, Augustine did not write a treatise on optics. However, his ideas about our perception of God are expressed through images of physical vision: as, for example, in a sermon where he stated that 'our whole business in this life is to restore to health the eye of the heart whereby God may be seen'. The ideas are explored in his *De trinitate*, and in his *Confessions*. Hopkins alludes to St Augustine, or St Austin, as he usually calls him, on several occasions: to Bridges, explaining a passage from St Paul (Phil. 2: 5 ff.) on Christ's suppression of his divine power while on earth—something that he says 'it is this holding of himself back, and not snatching at the truest and highest good, the good that was his right, nay his possession from a past eternity in his other nature, his own being and self, which seems to me the root of all his holiness and the imitation of this the root of all moral good

in other men'—he refers to St Austin's interpretation of the passage, which he says he was following (3 Feb. 1883, *LI* 175–7). Hopkins says that he 'got the sense of ἁρπαγμόν [a crucial word in the passage] from Jowett or some modern critic: it in reality adds force to St. Austin's interpretation, which otherwise I was following'. Hopkins had had to be prepared to answer on two of Paul's Epistles for the Divinity Paper in Greats. It was a subject that Liddon was also lecturing on when Hopkins first went up to Oxford and he annotated his New Testament with Liddon's comments.

Hopkins evidently also knew something of Austin's *Confessions*, a book that was a popular choice among the novices for their elective spiritual reading. He wrote to Bridges in August 1884 that he was 'hoping myself to publish a new and critical edition of St. Patrick's "Confession", a work worthy to rank (except for length) with Austin's Confessions and the Imitation [*Imitatis Christi* by Thomas à Kempis]' (*LI* 195). To Dixon he referred to St Austin's *De musica* in an overly complex analysis of the proportions of the quatrains and sestets in sonnet form (*LII* 71–2). We know that St Austin's *City of God* was a subject for the Essay Society to discuss at St Beuno's in January 1876[8] and that a section from the *Confessions* was read at dinner on 23 December 1869, during Hopkins's novitiate.[9] Manley Hopkins used a 1620 edition of St Augustine's *City of God*, listing it under a number of headings in his commonplace book devoted to noting places in books in which information could be found.[10]

It may be as well to start with what Augustine seems to have meant by the soul. It is, according to Margaret Miles, 'a partially centred energy, initially barely distinguishable from its cosmic, physical, and spiritual environment, which comes to be cumulatively distinguished and defined by the objects of its attention and affection'.[11] The soul projects a visual ray that attaches to the object and is united with it momentarily before absorbing the image back into itself, imprinting it on itself. The model is extramissive. The soul comes to be characterized by the habitual dwelling on particular images by which it forms its self-identity. God gives the individual the possibility of glimpsing the divine but the individual has to have faith and be clean of heart. It is the soul's affection that energizes the activity of seeing. The eye of the mind and the eye of the body therefore work together in sight. Augustine extends the idea by saying that individuals need to train their vision by loving the physical world and its creatures not for their appearance but for the love and good that is God in them. He cautions people against allowing their

minds to be overwhelmed by a plethora of sense impressions that in their eclectic nature confuse the soul, puzzling it as to its identity. Augustine distinguishes between the possibility of glimpsing God while we are on earth and the gazing on him that will be possible to the risen. It is necessary to train the soul to long for God. 'What you long for as yet you do not see ... By withholding of the vision, God extends the longing; 'through longing he extends the soul, by extending it he enlarges it'.[12] The longing of the soul for God is its visual ray. The Holy Spirit inflames the human soul with a love of God and for God in his neighbour: 'For human beings do not have whence to love God except from God.'[13]

Hopkins remarked to Bridges shortly after he sent him the poem 'That Nature is a Heraclitean Fire and of the Comfort of the Resurrection': 'lately I sent you a sonnet, on the Heraclitean Fire, in which a great deal of early Greek philosophical thought was distilled; but the liquor of distillation did not taste very Greek, did it?' (25 Sept. 1888, *LI* 291). If we look at 'The Lantern out of Doors' it may be that just as with 'That Nature is a Heraclitean Fire' where the descriptions of nature actually incorporated the philosophy of Heraclitus and others, so here too there may be snippets of the theories of vision roughly sketched out above.

> Sometimes a lantern moves along the night.
> That interests our eyes. And who goes there?
> I think; where from and bound, I wonder, where,
> With, all down darkness wide, his wading light?
>
> Men go by me, whom either beauty bright
> In mould or mind or what not else makes rare:
> They rain against our much-thick and marsh air
> Rich beams, till death or distance buys them quite.
>
> Death or distance soon consumes them: wind,
> What most I may eye after, be in at the end
> I cannot, and out of sight is out of mind.
>
> Christ minds: Christ's interest, what to avow or amend
> There, eyes them, heart wants, care haunts, foot follows kind,
> Their ransom, their rescue, and first, fast, last friend.

It may be that the poem's second line is weightier than it initially seems:

> Sometimes a lantern moves along the night.
> That interests our eyes.

Why put it in that way? Singling out the eye as the gateway of the experience would seem to foreground theories of vision; 'interests our

eyes' suggests impressions made upon the eyes, leading to a mental act of being interested, but also gives 'eyes' a degree of agency. Is this extramission, or does the sestet imply God-guided extramission in an Augustinian manner? If it is the latter, then the poem is not just a meditation upon the image of a lantern accidentally seen from a window one night. The Augustinian model of vision, if it is called upon here, implies that the beauties, physical and mental and other of the men who pass through the community and enrich the speaker's life are seen by him through God's gift and his own faith. The image of light beams for the effect of these men fits neatly with Augustine's method of explaining God's availability with visual metaphors. The 'much-thick and marsh air' has the effect of providing a medium upon which the rich beams impress themselves, a medium that stretches to the speaker, as in Aristotle's intromissive theory. 'Rain' at first seems a strange verb for the light, even if the lantern is passing higher up the hillside than the observer—we think of rain as falling downwards from above—but it carries connotations of growth, of providing the moisture necessary for life that pervade Hopkins's work—'O thou lord of life, send my roots rain' ['Justus tu es, Domine'] for example, and links the impression of driving rain with the conventional lines of dashes to indicate radiating light in medieval religious pictures.

The first tercet might be seen as following a Platonic or Augustinian pattern of extramission, the speaker longing for the contacts in a metaphor of a visual ray leaving the soul and following its desired object but the limit of human sight is sealed by the limit we all know on our vision and the tercet collapses in the common saying: out of sight is out of mind—its very mundanity and lack of originality emphasizing human limitation.

The image of the first tercet provoked an exchange between Hopkins and Bridges, in which Bridges evidently criticized Hopkins for his physical description. Bridges was by 1879 a fully qualified doctor working very hard in three London hospitals. He constantly faced patients whose illnesses stemmed from superstitious misunderstanding of their bodies. It was also a period in which scientific methods were replacing orthodoxies based upon reverence for the past and there was quite a lot of friction between doctors of different generations trained under different systems. His poem 'Wintry Delights' of 1903 displays his low opinion of any 'physiology' without man's 'one scientific intelligent hope'. He evidently rebuked Hopkins for what he detected as an outmoded physiological model in the course of criticizing him more

generally for his poetic eccentricity. Hopkins's defence is interesting. He stresses that what he has sent is art.

No doubt my poetry errs on the side of oddness. I hope in time to have a more balanced and Miltonic style. But as air, melody, is what strikes me most of all in music and design in painting, so design, pattern or what I am in the habit of calling 'inscape' is what I above all aim at in poetry. Now it is the virtue of design, pattern, or inscape to be distinctive and it is the vice of distinctiveness to become queer. This vice I cannot have escaped. However 'winding the eyes' is queer only if looked at from the wrong point of view: looked at as a motion in and of the eyeballs it is what you say, but I mean that the eye winds/only in the sense that its focus or point of sight winds and that coincides with a point of the object and winds with that. For the object, a lantern passing further and further away and bearing now east, now west of one right line, is truly and properly described as winding. That is how it should be taken then. (15 Feb. 1879, *LI* 66–7)

The models I have been suggesting do not involve any 'winding of the eyeballs' and Hopkins's use of 'eye' as a verb gives greater emphasis to the connection between the object and the observer than can be explained by his paraphrase. Bridges seems to me to have been right in his suspicion that there was more going on than someone watching a lantern.

The first quatrain of the Lantern's companion poem, 'The Candle Indoors' also has a dense visual allusion:

> Some candle clear burns somewhere I come by.
> I muse at how its being puts blissful back
> With yellowy moisture mild night's blear-all black
> Or to-fro tender trambeams truckle at the eye.

Other variants read: 'truckling to-fro trambeams finger the eye', revised to 'dally at the eye'. The tactility of this strongly suggests the conveying medium of extramissive theories even if the final version suggests a rotating movement rather than one between the candle and the eye of the observer. 'Truckle' and 'trambeams' give the rays of light a greater physical presence than in modern theories and again 'moisture' is a positive value, fighting against the dark into which all must vanish. The poem exists on that borderline between literal and figurative/symbolic language where so much of Hopkins's work is poised. He remarks on how his lack of knowledge of the inhabitants ('just for lack of answer') makes him more eager that they be believers, perhaps because he does not know any reason why they may not worship God. I think that if

we simply take it as the priest not knowing about the trades Jessy and Jack follow we can make little sense of the fuss in the final tercet, the accusations not quite directed at them—the faults he evidently worries over but does not elaborate to us. Ultimately it is, I think, a poem about the lack of the right sort of light. As I read it the priest's longing to reach out to bring people to God is imaged by his extramissive relationship with the candle that is all that he knows of the couple. The priest, aware that an uninvited appeal to them may be resented, tries to be tolerant, focusing instead on his own diminishing resources.

'To what serves Mortal Beauty?' would seem to follow an Augustinian pattern with its distinction between a gaze and a glance. Mortal beauty, says the speaker, 'keeps warm | Men's wit to the things that are; to what good means—where a glance | Master more may than gaze, gaze out of countenance.' Like Plotinus, Augustine remarks 'So in the flash of a trembling glance it attained to that which is. At that moment I saw your "invisible nature understood through the things which are made" (Rom. 1: 20) But I did not possess the strength to keep my vision fixed. My weakness reasserted itself, and I returned to my customary condition' (*Confessions* xvi (22)). Hopkins is not, I think, saying that we can absorb more of human beauty by a covert glance that leaves the person viewed unselfconscious but, following Augustinian ideas, that what we need to look for in humans is God's beauty and good and that this is perceptible in glances. 'Heaven's sweet gift', then, is not just the enriching of our worldly lives with the perception of mortal beauty but the gift of the availability of connection with God on earth. The poem is filled with a thinking through of Augustine's awareness of the value of mortal beauty coupled with his cautions about being distracted by it from the greater beauty of God. In his *Confessions*, Augustine remarks, 'I said to all ... things in my external environment: "Tell me of my God who you are not, tell me something about him." And with a great voice they cried out: "He made us" (Ps. 99: 3). My question was the attention I gave to them, and their response was their beauty' (Bk X. vi (9)).[14]

Another poem that seems to have Augustinian overtones is 'Hurrahing in Harvest' in its emphasis on the necessity of the beholder in the act of glimpsing God, which probably means not so much seeing God as in a picture as grasping God's love within the world. The tactility of Augustine's description of vision is captured in Hopkins's account. Lines 5–8

I walk, I lift up, I lift up heart, eyes,
Down all that glory in the heavens to glean our Saviour;
And, eyes, heart, what looks, what lips yet gave you a
Rapturous love's greeting of realer, of rounder replies?

Here the harvesting image—glean, a gathering up—is applied to Christ who is identified with love within the landscape of the world. In the final tercet, the violence of the reaction when the beholder glimpses and is drawn through his longing towards God seems Augustinian.

'The Blessed Virgin compared to the Air we Breathe' combines contemporary reference and understanding with images that could have been drawn from Augustine. For example, ll. 108–12 in which Mary is praised for filtering the brilliance of God's appearance—'whose glory bare would blind | Or less would win man's mind'—so that man may see him: 'through her we may see him | Made sweeter, not made dim, | And her hand leaves his light | Sifted to suit our sight'. Robert Grosseteste gives a summary of this in his *De veritate*: 'Therefore it is true, as Augustine attests, that no truth is perceived except in the light of the supreme truth. But just as infirm corporeal eyes do not see coloured bodies unless they are illuminated by the light of the sun (however, they cannot gaze on the light of the sun itself, but only as radiated onto coloured bodies), so the infirm eyes of the mind do not perceive truths themselves except in the light of the supreme truth; however, they cannot gaze on the supreme truth itself, but only in conjunction with and irradiation upon true things.'[15]

Finally, if the sestet of 'The Windhover' were taken as referring to an Augustinian model of vision, then 'buckle' could be seen as the fastening of the visual ray, and therefore the movement of the soul that it images, on the element of God perceivable in the kestrel. The resultant 'fire' would be the 'glimpse' of God allowed the faithful and cleansed heart. In his *Confessions* (xxvii (38)) Augustine writes, 'Late have I loved you, beauty so old and so new ... you were within and I was in the external world and sought you there, and in my unlovely state I plunged into those lovely created things which you made. You were with me, and I was not with you. The lovely things kept me far from you, though if they did not have their existence in you, they had no existence at all. You called and cried out loud and shattered my deafness. You were fragrant, and I drew in my breath and now pant after you. I tasted you, and I feel but hunger and thirst for you. You touched me, and I am set on fire to attain the peace which is yours.'[16] This is a very important passage

containing ideas that seem to surface in 'The Wreck' ('flash from the fire to the fire', 'over again I feel thy finger and find thee'), in 'Hurrahing in Harvest' ('these things were here and but the beholder wanting') and in the transition from seeing a beautiful and dangerous creature in the world to perception of Christ in 'The Windhover'. The remaining tercet of this last poem could then be understood to comment on matter very similar to that in 'The Blessed Virgin compared to the Air we Breathe': the accessibility through reduced glare/light of a vision of God. Such a reading gives added significance to the poem's opening: 'I caught', for the thing caught would be not just an ordinary sight of a bird, but the imprinting on the soul/heart of a glimpse of God's presence.

As with 'That Nature is a Heraclitean Fire', Hopkins's prose descriptions in his journals give no indication that his mental picture of the physical organization of the world could be explained by theories culminating in Heraclitus's thought, especially in the fragmentary form in which it has come down to us. Hopkins was clearly interested in optical phenomena and learnt about contemporary theories. However, he was probably struck, as I suspect anyone who reads Greek philosophy is, by how far ancient understanding penetrated. The Atomist theory with its grasp of something underlying all matter but capable of taking different external form comes amazingly close to molecular theory at the beginning of the twentieth century. It also has relevance to the theories of vision I have been mentioning both in its transmutation and in the transfer of energy through chain motion. What attracted Hopkins to the Heraclitean model for that poem may have been the integration of various parts of nature, the binding together of everything. If we look at Hopkins's descriptions of nature we find time and again the meeting of elements particularly of earth and sky more closely than we generally, I think, tend to consider them. For example, in 'Spring' he has the lines, 'the glassy peartree leaves and blooms, they brush | The descending blue'. 'Ashboughs' says of the trees' branches that 'they touch heaven, tabour on it; how their talons sweep | the smouldering enormous winter welkin'. We can take these descriptions as painterly, two-dimensional, the trees and sky meeting as the artist covers the page but that explanation leaves out of account an emotional charge that is contained in Hopkins's words; he desperately wants that connection between parts of nature and most between the earthbound and a sky that has resonances of heaven as the source from which all the rest flows. I think that we can get closer to the poems if we refer to theories of vision that are highly tactile, as the extramissive and intromissive theories are,

and which, furthermore, as in Augustine, infuse the process of seeing with Christianity.

The converse of the suggestion of the connection between heaven and the world is a tentativeness that enters Hopkins's writing when he is describing religious visions, for example, in the stanzas about the tall nun in 'The Wreck of the Deutschland'. Both Elisabeth Schneider and Alison Sulloway think that the nun is described as having a vision of Christ.[17] But Hopkins makes the situation more complex by insisting on an extra layer of interpretation between what the nun experienced and the reader. The speaker requires an inspiration, granted by Fancy, in order to describe the nun's experience and by calling attention to the fact that the account of it is the product of a writer guided by a literary muse, Hopkins does what he was later to do in 'Spelt from Sibyl's Leaves', attests to religious truth while reducing the claim to significant religious vision. Hopkins was in no position to assert what had provoked the nun's cry but he did not want to rule out possibilities that might extend to readers the resurgence of religious faith that he believed she had brought to her fellow passengers. In stanza 29 the nun is praised for 'Wording it how but by him that present and past, | Heaven and earth are word of, worded by'. Rumour of an actual vision that might be interpreted as pointing to the imminence of the Day of Judgement just might bring converts, hence, perhaps, the ambiguity. A more cautious reading would suggest that the nun's experience was closer to that of the speaker in stanza 5 of 'The Wreck', feeling God's presence and responding to it as to a greeting:

> I kiss my hand
> To the stars, lovely-asunder
> Starlight, wafting him out of it; and
> Glow, glory in thunder;
> Kiss my hand to the dappled-with-damson west:
> Since, though he is under the world's splendour and wonder,
> His mystery must be instressed, stressed;
> For I greet him the days I meet him, and bless when I understand.

Such a strongly emotional moment need not involve a vision and poems such as 'The Windhover' and 'Hurrahing in Harvest' would seem to suggest that Hopkins had a number of such experiences. The plea for the assistance of Fancy casts the speaker in the role of Platonic poet as a vessel through which messages are carried. It may be that something similar occurs in 'Spelt from Sibyl's Leaves' where the vision is derived

from the Sibyl rather than from David. Although much of the original research in Hopkins's time on sibylline literature was being done by French and German scholars, the results of their work were percolating into English books and journals; there was, for example, an excellent review article of some thirty pages on the subject in the *Edinburgh Review* of July 1877.[18] Much of the nineteenth-century scholarship lay in the rediscovery and reassembling of scattered pieces belonging to individual prophecies. Among works in English dealing with them were the Revd Charles Warren's study of the *Dies Irae*, Moses Stuart's *Commentary on the Apocalypse*, and Richard Chevenix Trench in his *Sacred Latin Poetry*.[19] Trench's note on 'David cum sibylla' raises the possibility that Hopkins's choice of title may also have had significance for the status he was claiming for his 'vision'. Trench commented that 'in those uncritical ages [of early and medieval theology] the Sibylline verses were not seen to be that transparent forgery which indeed they are; but were continually appealed to as only second to the sacred Scriptures in prophetic authority; thus on this very matter of the destruction of the world, by Lactantius. It is not too much to say that these Sibylline oracles, with other heathen testimonies of the same kind, were not so much subordinated to more legitimate prophecy, as co-ordinated with it, the two being regarded as parallel lines of prophecy, the Church's and the world's, bearing consenting witness to the same truths' (p. 297). To emphasize the sibyl, therefore, is to steer clear of any claim to having had a religious vision while attesting to the religious truth of the Day of Judgement.

A very short walk away from St Stephen's Green is the National Gallery of Ireland. Opened in 1864 it had purchased in 1871 Francis Danby's colossal painting, *An Attempt to Illustrate the Opening of the Sixth Seal* (73″ × 101″, 1854 cm × 2580 cm). When it had first been exhibited at the Royal Academy in 1828 it had been so popular that officials had had to move it to a distant gallery because of the crowds it attracted. The painting sets out the scene from Apocalypse book 6, verses 12–17, where St John says, 'Then, in my vision, he [the Lamb] broke the sixth seal; and with that there was a great earthquake, and the sun grew dark as sackcloth, and the whole moon blood-red; the stars of heaven fell to earth, like unripe fruit shaken from a fig-tree, when a high wind rocks it; the sky folded up like a scroll, and disappeared; no mountain no island, but was removed from its place.'[20] It is a passage in which the text from the Bible and that from the sibylline literature are particularly close and, as it seems more than likely that Hopkins would have given the Gallery

at least one visit and could hardly have missed the painting, that sight too may have influenced his response to the evening described in the poem. It is possible, that as with his attempt to capture inscapes of a kestrel in flight and a ploughman in the act of ploughing, here he sought to express the witness of someone at the start of the Day of Judgement both as a record to himself of the chasm in importance between the natural world with all its beauty and the moral realities to which he schooled his personality, and as a statement like those he made to Bridges that, 'As I am criticising you, so does Christ, only more correctly and more affectionately, both as a poet and as a man; and he is a judge qui potest et animam et corpus perdere in gehennam'[21] (22 Feb. 1879, *LI* 73).

Critics, such as Norman White, have seen a conflict in Hopkins's verse between his recording of a full and free response to natural beauty and a castigating of that response into religious didacticism. There are certainly places where this is true and the moral censor is active. But there are times too when the integration may be more thorough than is suspected, for example, in a poem like 'Spring', where Hopkins's response to spring flowers would seem to have been so often linked to Mary and Christ that a description of a natural scene had religious associations for him, even before he drew out specific significance. His response may, perhaps, be compared to that to religious music which, beautiful in itself, has additional though not necessarily explicit value to a believer. Certainly Hopkins was concerned about the balance between a physical enjoyment of natural beauty and one that he permitted himself within the constraints of living chastely. Certainly too those responses were not simply pure but shaped by social attitudes of his time and the changes that occurred in the visual environment within which he lived. He was someone who, especially as an undergraduate, but to a surprising degree throughout his life, was in tune with and sometimes ahead of contemporary artistic trends. This book has been about the people who shaped his early responses, about the vision that grew out of his innate gifts as they were shaped and as he learnt to express them artistically and about how what he learnt can be seen to have influenced the poetry and prose on which his reputation is based.

NOTES

PREFACE

1. Jacques Lacan, *The Four Fundamental Concepts of Psycho-analysis*, ed. Jacques Alain Miller, trans. Alan Sheridan (New York and London: W. W. Norton, 1978), sections 6–9 in Norman Bryson, 'The Gaze in the Expanded Field' in Hal Foster (ed.), *Vision and Visuality*. (Seattle: Bay Press, 1988), 91–2.
2. See Jerome Bump, 'Hopkins's Drawings' in *AMES*, 69–87, 71.
3. Peter Gallwey's Exhortations to Novices, Farm Street.
4. See *J* 190 (24 Jan. 1869), for example, in which Hopkins notes, 'The elms have long been in red bloom and yesterday (the 11th) I saw small leaves on the brushwood at their roots. Some primroses out. But a penance which I was doing from Jan. 25 to July 25 prevented my seeing much that half-year.' See too Norman White, *Hopkins: A Literary Biography* (Oxford: Clarendon Press, 1992), 407.
5. Ruskin deplored the influence of Michelangelo on modern art, saying that his 'dark carnality' had 'fostered insolent science, and fleshly imagination' (*The Eagle's Nest*) while Poynter saw the life class as essential training, and even set one up with partially draped figures for women. See Caroline Arscott, 'Poynter and the Arty', in Elizabeth Prettejohn (ed.), *After the Pre-Raphaelites* (Manchester: Manchester University Press, 1999), 115–34, especially 140–3.
6. The Custom Book of the Scholastic Novices of the English Province. Farm Street.
7. The burgeoning of medical information just before the field was divided into specialisms led Robert Bridges to abandon a career in hospitals in the early 1880s; he simply could not remember enough. On Whistler v. Ruskin a great deal has been written. See, for example, Linda Dowling, *The Vulgarization of Art: The Victorians and Aesthetic Democracy* (Charlottesville and London: University Press of Virginia, 1996), 46 in particular; Robin Spencer, 'Whistler, Swinburne and Art for Art's Sake', Prettejohn, in *After the Pre-Raphaelites*, 60–1; Anne Koval, 'The "Artists" Have Come out and the "British" Remain: The Whistler Faction at the Society of British Artists', ibid. 99; Linda Merrill, *A Pot of Paint: Aesthetics on Trial in Whistler v. Ruskin* (Washington and London: Smithsonian Institution Press, 1992).

8. Stonyhurst was one of the centres of the Society of Jesus at the time and the college had an observatory and weather station.

9. See, for example, Michael Lynch, 'Recovering Hopkins, Recovering Ourselves', *Hopkins Quarterly* 6 (1979), 107–17; Linda Dowling, 'Ruskin's Pied Beauty and the Constitution of a "Homosexual" Code', *Victorian Newsletter* 75 (1989), 1–8; Richard Dellamora, *Masculine Desire: The Sexual Politics of Victorian Aestheticism* (Chapel Hill: University of North Carolina Press, 1990); and Joseph Bristow, '"Churlsgrace": Gerard Manley Hopkins and the Working-Class Male Body', *ELH* 59 (1992), 693–711. Richard Cronin suggests that 'it is traditional to note in Hopkins a conflict between sensuality and spirituality, but it seems truer to say that he found his sensuality and vocation together', that he could 'turn with delight to the "ruck and reel" of the visible world only in the confidence that such a world is mortal and subordinate' (*Colour and Experience in Nineteenth-Century Poetry* (Basingstoke: Macmillan, 1988), 173). This seems to me an excellent description of those times in Hopkins's life when the relation of body and mind was harmonious and such harmony can be seen in his art criticism.

10. Julia Saville, *A Queer Chivalry: The Homoerotic Asceticism of Gerard Manley Hopkins* (Charlottesville: University Press of Virginia, 2000). Subsequent page references in text.

1. EARLY INFLUENCES

1. William Gell, *Pompeiana: The Topography, Edifices and Ornaments of Pompeii, the Result of Excavations since 1819*, 2 vols. (London: Jennings and Chaplin, 1832), vol. ii, opp. p. 70.

2. *The Thousand and One Nights*, commonly called, in England, The Arabian Nights' Entertainments. A new translation from the Arabic, with copious notes by Edward William Lane, illustrated by many hundred engravings on wood from original designs by William Harvey, 3 vols. (London: Charles Knight and Co., 1839), i. 174.

3. *Once a Week*, 18 Aug. 1860, p. 217.

4. William E. Buckler, '*Once a Week* under Samuel Lucas, 1859–65', *Proceedings of the Modern Language Association of America* 67/7 (Dec. 1952), 924–41, 926 n. 9.

5. Ibid. 934 n. 32.

6. Leonée Ormond, *George Du Maurier* (London: Routledge and Kegan Paul, 1969), 111.

7. *Old England: A Pictorial Museum of Regal, Ecclesiastical, Baronial, Municipal, and Popular Antiquities* (London: Charles Knight and Co., 1845).

8. *Spicilegium Poeticum: A Gathering of Verses by Manley Hopkins* (London: The Leadenhall Press, n.d.). Subsequent page references in text.

9. See N. H. MacKenzie, *OET*, opp. pp. 414–15; *A Reader's Guide to Gerard Manley Hopkins* (London: Thames and Hudson, 1981), 129 ff.; W. H. Gardner, *Gerard Manley Hopkins, 1844–89: A Study in Poetic Idiosyncracy in Relation to Poetic Tradition*, 2 vols., rev. edn. (London: Oxford University Press, 1966), i. 185 ff. Alan Heuser, *The Shaping Vision of Gerard Manley Hopkins* (London: Oxford University Press, 1968), 77, 114; Elisabeth Schneider, *The Dragon in the Gate* (Berkeley: University of California Press, 1968), 178 ff.; P. Mariani, '"Andromeda" and the New Aestheticism', *Victorian Poetry* 11/1 (Spring 1973), 39–54; R. Langbaum, *PMLA* 81 (Dec. 1966), 578 ff.; Michael Moore, *Hopkins Quarterly* 6/3 (1979), 131 ff.

10. *J* 332, note to p. 59.

11. Alice M. Johnson, 'Edward and Frances Hopkins of Montreal', *Beaver* (Autumn 1971), 4–19, p. 5. Hereafter cited in text as Johnson.

12. Janet E. Clark, *Frances Anne Hopkins 1838–1919: Canadian Scenery*, exhibition catalogue (Thunder Bay: Thunder Bay Art Gallery, 1990), 15 and 17. Hereafter cited in text as Clark.

13. The problems with using Frances's picture of the Red River Expedition as evidence will be dealt with later.

14. Richard Hamblyn, *The Invention of Clouds: How an Amateur Meteorologist Forged the Language of the Skies* (London: Picador, 2001), 201.

15. National Art Library, Victoria and Albert Museum, 200 B 187 no. 52.

16. Ibid. 200 B 142

17. Ibid. 200 B 420 no. 146.

18. Algernon Graves, *The Royal Academy of Arts: A Complete Dictionary of Contributors and their Work from its Foundation in 1769 to 1904* (London, 1906), in Johnson, 18.

19. 'Photographs and Photographers in the Witness Box', *British Journal of Photography* (22 Dec. 1871), 601.

20. 'The Photographic Exhibition [Second Notice]', *British Journal of Photography* (Nov. 1871), 553. Subsequent page references in text.

21. 'The Photographic Exhibition [Fifth Notice]', *British Journal of Photography* (15 Dec. 1871), 588.

22. 'The Photographic Exhibition [Third Notice]', *British Journal of Photography* (1 Dec. 1871), 564.

23. 'The Photographic Exhibition [Fourth Notice]', *British Journal of Photography* (8 Dec. 1871), 578.

24. 'The Photographic Exhibition [Sixth Notice]', *British Journal of Photography* (22 Dec. 1871), 601.

25. Humphry House, typescript, 'Early Life of Gerard Manley Hopkins', fos. 23–8, Farm Street.

26. Anthony Hamber, 'The Photography of Art and the South Kensington Museum', leaflet for an exhibition, Victoria and Albert Museum, 1996.

27. Diary of a holiday in France 1875 by Manley Hopkins, Box 5 no. 1, John of Burns Library, Boston College, unpaginated.

28. I. Giberne Sieveking, *Memoir and Letters of Francis W. Newman* (London: Kegan Paul, Trench, Trübner and Co., 1909), 22–3.

29. To Arthur, after a 'ballyragging' of a drawing by Arthur, 30 Nov. 1888, *LIII*, 189.

30. Manley Hopkins, *Hawaii: The Past, Present, and Future of its Island-Kingdom* (London: Longman, Green, and Roberts, 1862).

31. Lane appended the following note: in the second edition of 'Notes on some of the principal Pictures in the Royal Academy', occurs this passage: 'Hereafter, it will be known that when I have thought fit to attack a picture, the worst policy that the friends of the artist can adopt, is to *defend* it.'

32. 'Notes on so much of the Catalogue of the Present Exhibition of the Royal Academy As Related to the Works of the Members With a Report of the Private View and the Dinner 1855' [not published] by R. J. Lane, sent to John Prith Harley Esq. 15 Dec. 1855, National Art Library, 145F 33B, pp. vii–viii.

33. 'Richard James Lane' in *DNB*.

2. HOPKINS'S DRAWINGS

1. See J. D. C. Masheck, 'Art by a Poet: Notes on Published Drawings by Gerard Manley Hopkins' in *Hermathena* 108 (Spring 1969), 24–35, p. 25. John Ruskin, *The Elements of Drawing. In Three Letters to Beginners*, 2nd edn. (London: Smith, Elder, and Co., 1857). *The Elements of Drawing* was advertised as 'nearly ready' in the endpapers to Manley Hopkins's *Handbook of Average* (London: Smith, Elder and Co., 1857). Subsequent references to *Elements* in text.

2. *The Works of John Ruskin*, ed. E. T. Cook and Alexander Wedderburn, vol. xxxv: *Praeterita II* (London: George Allen, 1908), 314.

3. *AMES*; see the illustrations on pp. 59, 60, 61, 63, and 65.

4. *Walter Pater: Three Major Texts (The Renaissance, Appreciations, and Imaginary Portraits)*, ed. with an introduction by William E. Buckler (London: New York University Press, 1986), 5

5. *OET* 398–9.

6. Printed in *Nature*, 3 Jan. 1884, p. 223, and reprinted in Patricia Ball, Appendix 'An Uncollected Letter from Hopkins to *Nature*, 30 October 1884', in *Science of Aspects: The Changing Role of Fact in the Work of Coleridge, Ruskin and Hopkins* (London: Athlone Press, 1971), 148–50.

7. For studies of Hopkins's inscape see W. A. M. Peters, SJ, *Gerard Manley Hopkins: A Critical Essay towards the Understanding of his Poetry* (London: Oxford University Press, 1948), 1; Robert C. Wilson, 'Hopkins and the Art of Painting', *Thought* (June 1976); *LI* no. 201, 153–4.

8. Richard Hamblyn, *The Invention of Clouds: How an Amateur Meteorologist Forged the Language of the Skies* (London: Picador, 2001), 120. Subsequent page references in the text.

9. *Nature*, 8 Sept. 1870, pp. 382–5, p. 385.

10. The second half-line originally read: 'have swan-wing-whiter', an association also seen in the prose description of 1871.

11. Ruskin, *Modern Painters*, in *The Works of John Ruskin*, ed. E. T. Cook and Alexander Wedderburn, 39 vols. (London: G. Allen, 1903–12) vol. i, part ii, sect. 368.

12. Ball, *Science of Aspects*, 89. Subsequent page references in the text.

13. *The Diaries of John Ruskin*, selected and ed. Joan Evans and John Howard Whitehouse 1835-1847 (Oxford: Clarendon Press, 1956).

14. Tom Zaniello, *Hopkins in the Age of Darwin* (Iowa City: University of Iowa Press, 1988), 73.

15. Ruskin, *Elements*, 138, 141. Subsequent references in the text.

16. J. D. C. Masheck points to similarities with Grandville's *Scènes de la vie privée et publique des animaux* (Paris, 1842), vol. i, pl. before p. 235 in 'Art by a poet', p. 25.

17. That title is on the stub of a page that was removed from the book.

18. *Gerard Manley Hopkins: Selected Poetry*, with an introduction and notes by Catherine Phillips, World's Classics Series (Oxford: Oxford University Press, 1998), 32.

19. Jerome Bump, 'Hopkins' Drawings', in *AMES* 73.

20. Cf. Hopkins's poetic fragment, 'What being in rank-old nature'.

21. Notes made 26 July [1875] in sketchbook in the Burns Library, Boston College, box 11, folder 1.

22. See Norman White, 'The Context of Hopkins' Drawings', in *AMES* 53–67, 64.

23. Ball, *Science of Aspects*, 119.

3. 'DAPPLE': HOPKINS AND ARCHITECTURE

1. 'In 1851 Gustave Le Gray introduced an important improvement [to Calotype]. He found that by waxing the paper *before* sensitizing, the keeping properties of the negative paper were greatly improved. Calotype paper had to be exposed soon after sensitizing, preferably while still moist; waxed negative paper could be kept for days or weeks before exposure without loss of quality. The waxed paper negative was also capable of recording very fine detail, although it was much less sensitive than the Calotype paper.' Brian Coe, *The Birth of Photography* (London: Spring Books, 1976, 1989), 28–9.

2. 'Leaves from my Note Book', in *The British Journal Photographic Almanac* (1872), 76.

3. 'Ackland's Collodio-Albumen Process', in *The British Journal Photographic Almanac* (1967), 78.

4. John Henry Parker, *An Introduction to the Study of Gothic Architecture* (Oxford and London: John Henry Parker, 1849), 162–3. Subsequent page references in text.

5. See Norman White's excellent section on this in his *Hopkins: A Literary Biography* (Oxford: Clarendon Press, 1992), 21–2.

6. John Henry and James Parker, *A Hand-book for Visitors to Oxford* (Oxford: James Parker and Co., 1858), 197. Subsequent page references in text.

7. *A Hand-book for Visitors to Oxford* (Oxford: James Parker and Co., 1875), 286–7. Subsequent page references in text.

8. A. J. B. Beresford Hope, *The English Cathedral of the Nineteenth Century … with illustrations* (London: John Murray, 1861).

9. *A New Pictorial and Descriptive Guide to Oxford and District* (London: Ward, Lock and Co. Ltd, n.d. [*c.*1924]), 62.

10. Charles Eastlake, *A History of the Gothic Revival*, ed. Mordaunt Crook (Leicester: Leicester University Press, 1970), 287.

11. Paul Thompson, *William Butterfield* (London: Routledge and Kegan Paul, 1971), 323–4. Hereafter cited in text as Thompson.

12. Bodl. MSS. Engl. Letters, e. 28, f. 112, undated.

13. George E. Street, *Notes of a Tour in Northern Italy* (London: Waterstone and Co., 1986; reprint of 1855 edn. published by John Murray), 457–8.

14. David Beevers, the Revd David Hutt and Dr Christopher Rawll, *All Saints, Margaret Street* (London: Pitkin Pictorials, 1990), 4. Subsequent page references in text.

15. Ibid. 16.

16. See n. 8. Subsequent page references in text.

17. Letter from Beresford-Hope to Henry Tritton, 6 Aug. 1850, Tritton Collection, quoted by Thompson, 163.

18. Ruskin, *The Stones of Venice*, ii. 144–5.

19. http://myweb.tiscali.co.uk/terryleaman/Tiscali/churches%202/All-Saints-Babbacombe.htm.

20. Eastlake, *History of the Gothic Revival*, 259.

21. Ibid. 253–4.

22. *Gerard Manley Hopkins: Selected Letters*, ed. Catherine Phillips (Oxford: Oxford University Press, 1990), 89.

23. George Street, *Notes of a Tour*, pp. xv–xvi.

24. Paul Johnson, *Cathedrals of England, Scotland and Wales* (London: Weidenfeld and Nicolson, 1990), 60.

4. ART CRITICISM

1. 15 Sept. 1867 to Baillie, *LIII* 229: 'I have just through impatience destroyed a photograph of one of Ghiberti's bronze gate panels from the Florence *duomo* while trying to unmount it: Taylor [Aubrey] gave it me and I am vexed at the loss: the panel was the creation of Eve: have you any idea whether and where I cd. get another of it?' 23 Jan. 1864 to his mother, 'I am afraid now I have really lost the *Huguenots* photograph you gave me', *LIII* 88.

2. 15 Sept. 1867 to Baillie, *LIII* 229. In the *Elements of Drawing* Ruskin repeatedly implies this 'truism'. See e.g. p. 131 n. 1: 'I do not mean that you can approach Turner or Durer in their strength, that is to say, in their imagination or power of design. But you may approach them, by perseverance, in truth of manner.'

3. The exceptions are his notes on Leighton's *Clytemnestra* and Hunt's *Shadow of Death*, discussed below.

4. 'The Exhibition of 1862.—Its Work and Features', *The International Exhibition of 1862; The Illustrated Catalogue of the Industrial Department*; British Division, vol. i, printed for Her Majesty's Commissioners (London: Clay, Son, and Taylor *et al.*, n.d.), 131. Subsequent page references in text.

5. See Elizabeth Prettejohn, 'Aesthetic Value and the Professionalization of Victorian Art Criticism 1837–78', *Journal of Victorian Culture* (Spring 1997), 71–94.

6. See Linda Dowling's fine discussion in *The Vulgarization of Art* (Charlottesville and London: University of Virginia Press, 1996), esp. ch. 2; and

Caroline Arscott, 'Poynter and the Arty', in Elizabeth Prettejohn (ed.), *After the Pre-Raphaelites* (Manchester: Manchester University Press, 1995), ch. 6.

7. Francis Turner Palgrave, *Descriptive Handbook to the Fine Art Collections in the International Exhibition of 1862*, 2nd edn. revised and complete (London: Macmillan and Co., 1862), 1–2. Subsequent page references in text.

8. 'the greatly increased industry of our *young* painters, their heightened standard of finish and force, the enhanced strenuousness of their study of nature, [which] are every year tending to raise the level of their work, so far as this is affected by general influences. What is wanted to engender better fruit of this careful culture is a higher conception of the purposes and aims of the art, a higher standard of education and thought among our painters, and a demand among patrons and purchasers for the products of minds thus enlarged and elevated. ... The influence of some form of public employment is needed to counterbalance the exclusive tendencies of the English market to cabinet work of the attractive kind' (2 May 1863, p. 11b).

9. Ibid.

10. Norman White, *Hopkins: A Literary Biography* (Oxford: Clarendon Press, 1992), 82.

11. By the 1880s Hopkins had carefully observed a number of Millais's paintings. See below, pp. 185–7.

12. Ruskin, *Works*, iii. 617; *Modern Painters*, vol. ii, part III, sect. 216. See Linda Dowling, *The Vulgarization of Art*, 28.

13. Richard Ford, *Hand-book for Travellers in Spain* (London: John Murray, 1845).

14. Humphry House places the Hopkins's collection of photographs within the context of the Victorians' penchant for such celebrity in his unpublished manuscript, 'The Youth of Gerard Manley Hopkins', Farm Street Archives.

15. *LIII* 88, 23 Jan. 1864; Revd R. Cattermole, *The Book of the Cartoons* (London: Joseph Rickerby, Sherbourn Lane, 1837), 17.

16. Everything was auctioned when the firm Overend, Gurney and Co. went into liquidation (*The Times*, 15 Nov. 1866, p. 10a; and 15 Mar. 1867, p. 10b).

17. He later called 'intervallary' beauty 'diachronic'. See 'On the Origin of Beauty', *J* 104–6.

18. For an interpretation of the essay tracing its relation to Kant's thought see Daniel Brown, *Hopkins' Idealism* (Oxford: Clarendon Press, 1997), 82–4. Hilary Fraser (*Beauty and Belief: Aesthetics and Religion in Victorian Literature* (Cambridge: Cambridge University Press, 1986), 82) suggests that the ideas reached Hopkins through his reading of Ruskin.

19. One of the sources of Hopkins's remark about Goethe may have been a review in August 1863 of an edition of Goethe's letters to the Grand Duke Karl August of Weimar, Goethe's patron and friend (*Saturday Review*, 29 Aug. 1863, pp. 292–4), in which Goethe's recorded conversation and letters were praised as all showing 'that serene self-command and self-knowledge of which he never lost sight and which formed a chief element of that perfection of humanity to which it was the object of his life to attain' (pp. 292–3).

20. W. S. Burton had two paintings on subjects from the *Idylls* in the Royal Academy Exhibition, the first of which depicted a meeting between Guinevere and Lancelot in the early stages of their relationship. Hopkins made a note in his journal, 'Mem. To ask Mr Burton [Frederic William Burton] … whether the pictures by W. S. Burton in the Academy are his' (*J* 31). They were not. William Shakespeare Burton's paintings were no. 192, *Guinevere*, accompanied by the quotation 'All in an oriel on the summer side, | Vine-clad, of Arthur's palace toward the stream they met', and no. 351, *Elaine*, with the lines: 'When she heard his horse upon the stones, | Unclasping flung the casement back, and look'd | Down on his helm, from which her sleeve had gone; | And Lancelot knew the little clinking sound; | And she by tact of love was well aware | That Lancelot knew that she was looking at him.'

21. *Letters of Dante Gabriel Rossetti*, ed. Oswald Doughty and John Robert Wahl (Oxford: Clarendon Press, 1965), vol. i: *1835–1860*, 252.

22. Campion Hall MS DIX from Hilary Term 1867; Lesley Higgins, 'A New Catalogue of the Hopkins Collection at Campion Hall, Oxford', *HQ* 18/1–2 (Apr.–July 1991), 18.

23. For a discussion of the relationship of the two poems, see Catherine Phillips, ' "Our evening is over us": The Influence of the Sibylline Oracles and Book of the Apocalypse on the Poetry of Gerard Manley Hopkins', *Manuscript* 5 (2000), 39–54; and Mariaconcetta Costantini, 'A Poem "for four hands" and Many Voices: The Myth of St. Dorothy in Christina Rossetti and G. M. Hopkins', in Rama Kundu (ed., with six associate eds.), *Widening Horizons: Essays in Honour of Professor Mohit K.Ray* (New Delhi: Sarup and Sons, 2005), 73–89. Francis L. Fennell's article, 'Hopkins and Rossetti:

Reforming a Poetics', in Michael E. Allsopp and David Anthony Downes (eds.), *Saving Beauty* (London: Garland, 1994), 1–22, suggests the influence of a number of Rossetti's poems on those of Hopkins.

24. One of the poems that disturbed Bridges most in this way was 'Hurrahing in Harvest'. Rossetti's *Blessed Damozel*, especially in its revised form both in the painting and poem show sexual lovers in heaven. Buchanan's article appeared under the pseudonym Thomas Maitland, in the *Contemporary Review*, 18 (Oct. 1871), available at the Rossetti Archive site at the University of Virginia.

25. *Blackwood's* (July 1864), 96.

26. *The Times*, 6 June 1864, pp. 5a–c. Subsequent references in the text are to this article.

27. *Edinburgh Review* (Apr. 1865), 542.

28. Herman Grimm, *Life of Michael Angelo*, trans. Fanny Elizabeth Bunnett, 2 vols. (London: Smith, Elder and Co., 1865), i. 212.

29. *Art Journal* (July 1864), 215.

30. 5 Nov. 1885, *Selected Letters of Gerard Manley Hopkins*, ed. Catherine Phillips, Oxford Selected Letters series (Oxford: Oxford University Press, 1991), 216–17.

31. *Art Journal* (July 1864), 215.

32. *The Times*, 6 June 1864.

33. Millais's other paintings were: '*Charlie is my darling*'—*Jacobite Song* (118), *Leisure Hours* (289), *Harold, son of the Dowager Countess of Winchelsea* (135), and *Lilly, daughter of J. Noble, Esq.* (570).

34. R. B. Beechey's no. 416, *The Eddystone Lighthouse, with H.M.S. 'Prince Consort', iron-clad, a sailing frigate, Trinity Board cutter, trawlers. &c, in the distance*, W. H. Hopkins's no. 399, 'The low-backed car. Rustic figures by E. Havell | 'When first I saw sweet Peggy, | 'Twas on a market day.' A. Hughes's paintings were *A Music Party* with a quotation from Keats's 'Ode to a Grecian Urn' (62), 'Then by a sunbeam I will climb to thee'—George Herbert, with the lines by Henry Vaughan: 'An age of mysteries! which he | Must live twice that would God's face see' (384), and *Silver and Gold* (486).

35. Jeremy Maas, *Gambart: Prince of the Victorian Art World* (London: Barrie and Jenkins, 1975), 169.

36. British Library, print room, cat. no. 1901–11-13-2.

37. National Gallery of Ireland, archives, cat. no. 51 fo. 39.

38. *Sermons and Devotional Writings of Gerard Manley Hopkins*, ed. Christopher Devlin (London: Oxford University Press, 1959), 239.

39. See 2 July 1866, *J* 142–3.

40. Elizabeth Prettejohn, 'Walter Pater and Aesthetic Painting', in Prettejohn, *After the Pre-Raphaelites.*

41. See n. 25.

42. *Saturday Review*, 5 Sept. 1863, pp. 333–4.

43. See Chapter 2, pp. 61–2.

44. *Art Journal*, 1 May 1866, p. 173. Subsequent page references in text.

45. Russell Ash, *Victorian Masters and their Art* (London: Pavilion, 1999), 136–7.

46. 'Nature and Abstraction in the Aesthetic Development of Albert Moore', in Prettejohn, *After the Pre-Raphaelites*, 115.

47. Christopher Wood, *Burne-Jones: The Life and Works of Sir Edward Burne-Jones (1833–1898)* (London: Weidenfeld and Nicolson, 1998), 81.

48. Bridges to Lionel Muirhead, 10 Feb. 1893, Bridges Papers no. 98, Bodleian Library, quoted in Catherine Phillips, *Robert Bridges: A Biography* (Oxford: Oxford University Press, 1992), 153; Hopkins to Dixon, 30 June 1886, *LII* 133.

49. *The Times*, 5 May 1866, p. 10d. Subsequent page reference in text.

50. *The Times*, 22 May 1866, p. 12c.

51. *Art Journal*, June 1866, p. 197.

52. Elizabeth Prettejohn notes that in 1867 Colvin praised nine artists at the RA for concentrating on beauty, which he considered the 'true end' of art. The artists were Leighton, Albert Moore, Whistler, D. G. Rossetti. Burne-Jones, Simeon Solomon, Watts, Arthur Hughes, and George Heming Mason. Introduction to *After the Pre-Raphaelites*, 3.

53. Sidney Colvin, 'English Painters and Painting in 1867', *Fortnightly Review* NS 2 (Oct. 1867), 473–5.

54. 'frank' is a term. Hopkins uses for Calderon's *Queen of the Tournament* in the Royal Academy Exhibition of 1874: 'clever, frank treatment of bright armour' (*J* 244) where it may mean 'straightforward', 'undisguised'.

55. Peter Mitchell, *Alfred Emile Léopold Stevens 1823–1906* (London: John Mitchell and Sons, 1973), 12.

56. *The Times*, 1 Apr. 1867, p. 126.

57. Jeremy Maas, *Gambart: Prince of the Victorian Art World* (London: Barrie and Jenkins, 1975), 171–2, 215.

58. See Sjaak Zonneveld, 'Gerard Manley Hopkins and the Society of St. Vincent de Paul in Liverpool', *HQ* 9/3 (Fall 1982), 109–19.

59. 16 Oct. 1866, *LIII* 95.

60. *Fraser's Magazine* (July 1867), 98.

61. Ibid., p. 95.

62. *The Times*, 10 Apr. 1868, p. 46.

63. Sidney Colvin's article, 'English Painters and Painting in 1867' (see n. 53), listed Leighton, Moore, Whistler, Rossetti, Burne-Jones, Solomon, Watts, Hughes, and Mason as Aesthetic painters; Elizabeth Prettejohn, 'Walter Pater and Aesthetic Painting', in Prettejohn, *After the Pre-Raphaelites*, 55.

64. Ibid. 39.

65. *Westminster Review* NS 34 (Oct. 1868), 312.

66. Prettejohn, 'Walter Pater and Aesthetic Painting', 39.

67. *The Times*, 2 May 1868, p. 11c. Chapter 6, pp. 228–9.

68. *Saturday Review*, 11 July 1868, p. 55.

69. Richard Ormond, 'Leighton and his Contemporaries', in Stephen Jones, Christopher Newall, *et al.* (eds.), *Frederic Leighton 1830–1896* (New York: Harry N. Abrams, Inc., 1996), 27.

70. *The Times*, 2 May 1868, pp. 1c–d.

71. *Saturday Review*, 18 July 1868, p. 91.

72. *Saturday Review*, 30 May 1868, p. 719.

73. *The Times*, 21 May 1868, p. 11a.

74. Prettejohn, 'Walter Pater and Aesthetic Painting', 40.

75. William Michael Rossetti and Algernon C. Swinburne, *Notes on the Royal Academy Exhibition, 1868* (London: John Camden Hotten, 1868), 32, cited by Robyn Asleson in 'Nature and Abstraction in the Aesthetic Development of Albert Moore', in Prettejohn, *After the Pre-Raphaelites*, 126. Further page references in text.

76. *Building News*, 1 May 1868, p. 188; Asleson, 'Nature and Abstraction', 124.

77. J. D. C. Masheck, 'Art by a Poet', *Hermathena* 108 (Spring 1969), 24–35, p. 27.

78. *The Times*, 17 Apr. 1868, p. 10c.

79. *The Times*, 2 May 1868, p. 11b.

80. *Saturday Review*, 1 Feb. 1873, p. 148.

81. *Saturday Review*, 4 Jan. 1873, p. 19.

82. Ibid.

83. *Saturday Review*, 8 Feb. 1873, p. 184.

84. *Saturday Review*, 1 Feb. 1873, p. 149.

85. *The Times*, 18 Dec. 1873, pp. 3c–e.

86. See Chapter 6, p. 236.

87. *Saturday Review*, 9 May 1874, p. 592.

88. *The Times*, 2 May 1874, p. 12b.

89. *Saturday Review*, 2 May 1874.

90. *The Times*, 1 July 1874, p. 12a.

91. *The Times*, 26 May 1874, p. 6c.

92. *The Times*, 1 July 1874, p. 5c.

93. Ibid., p. 5d.

94. Ibid.

95. Ibid., p. 12e.

96. *The Times*, 2 May 1874, p. 12d.

97. *The Times*, 1 July 1874, p. 5d.

98. Ibid., p. 5b.

99. *Saturday Review*, 9 May 1874, p. 593.

100. *The Times*, 1 July 1874, p. 5b.

101. *Saturday Review*, 2 May 1874, p. 562.

102. *The Times*, 1 July 1874, p. 5b

103. Christopher Wood, *Tissot* (London: Phoenix Illustrated, 1986), 53.

104. *The Times*, 26 May 1874, p. 6d.

105. *Saturday Review*, 9 May 1874, p. 593.

106. *The Times*, 1 July 1874, p. 12e.

107. Install: *J* 207 clouds: 'these are not ribs; they are a "wracking" install made of these two realities—the frets, which are scarves of rotten cloud ... and the whiter field of sky shewing between' (1871); *J* 225 waves: 'I looked down ... on the rocks at high-water ... first, say, it is an install of green marble knotted with ragged white' (1872); *J* 244: 'true bold realism but quite a casual install of woodland with casual heathertufts, broom with black beanpods and so on' (1874).

108. See p. 133.

109. *The Times*, 1 July 1874, p. 12e.

110. *The Times*, 26 May 1874, p. 6a.

111. *The Times*, 1 July 1874, p. 12e.

112. See Chapter 3, pp. 104–6. Ruskin commented in his *Elements of Drawing*, 'The greatest masters are always fond of drawing patterns; and the greater they are, the more pains they take to do it truly ... when you [the pupil reader] can draw the spots which follow the folds of a printed stuff [fabric], you will have some chance of following the spots which fall into the folds of the skin of a leopard as he leaps' (p. 65).

113. *The Times*, 1 July 1874, p. 12e.

114. Ibid. 12c.

115. *The Times*, 26 May 1874, p. 6a.

116. *The Times*, 1 July 1874, p. 5c.

117. *Saturday Review*, 9 May 1874, p. 593.

118. *The Times*, 1 July 1874, p. 5c.

119. Ibid., p. 5d.

120. Ibid., p. 5b.

121. Ibid., p. 5c.

122. *The Times*, 26 May 1874, p. 6c.

123. *The Times*, 1 July 1874, p. 12a.

124. *Saturday Review*, 6 Dec. 1873, pp. 727–8.

125. C. Devlin (*Sermons*) says that Hopkins's account is based 'on that traditionally ascribed to Publius Lentulus, a friend of Pilate. It is probably not earlier than the beginning of the 4th century.' For other passages describing the personal appearance of Christ see Tertullian (trans. Dodgson, Oxford Library of the Fathers (1842)), i. 253 ff.

126. Norman White, *AMES* 96; N. H. MacKenzie, *The Later Poetic Manuscripts of Gerard Manley Hopkins in Facsimile* (London: Garland Publishing, 1991), 152.

127. David Lavender and John Woodwark, *Works by John Rodham Spencer Stanhope at Cragside* © 2000–2005.

128. Information supplied by Rachel Sloane, a Ph.D. student at the Courtauld working on Dante Gabriel Rossetti.

129. *Athenaeum*, 2 Oct. 1874, pp. 443–5.

130. *Saturday Review*, 30 May 1874, p. 6a.

131. *Saturday Review*, 30 May 1868, p. 719.

132. G. H. Fleming, *John Everett Millais: A Biography* (London: Constable, 1998), 82–3.

5. GERARD, ARTHUR, AND THE ILLUSTRATED PRESS

1. The figures come from Peter Mathias, *The First Industrial Nation: An Economic History of Britain 1700–1914*, 2nd edn. (London: Routledge, 1969, 1983), 343. See Paul Goldman, *Victorian Illustrated Books 1850–1870: The Heyday of Wood-engraving* (London: British Museum Press, 1994), 40. He is quoting Richard Altick, *The English Common Reader* (Chicago: University of Chicago Press, 1957), 306.

2. James Bishop, 'The Story of the ILN', *The Illustrated London News*, 280. 7106 (May 1992), 29–34, 30; quoted in Peter W. Sinnema, *Dynamics of the pictured page: representing the nation in the Illustrated London News* (Aldershot: Ashgate, 1998), 70.

3. http://www.npg.org.uk nos. NPG4404 and 4405. NPG4404 was by Sydney Prior Hall in chalk and wash; NPG4405 was by an unknown artist in chalk.

4. *ILN*, 9 Mar. 1872, p. 233.

5. J. A. Reid, 'Arthur Hopkins, R.W.S.', *Art Journal* (July 1899), 193–6, p. 194.

6. *The Short Cut* appeared in *ILN*, 14 Nov. 1874, p. 472. Letter to his mother, 18 Dec. 1874, *LIII* 129.

7. George Du Maurier, 'Social Pictorial Satire' (1898), quoted in Leonée Ormond, *George Du Maurier* (London: Routledge and Kegan Paul, 1969), 167; subsequent references in text.

8. 'Most of the public were [incapable]… of appreciating the genius of Charles Keene, which has only become recognized in the present century', in Ormond, *George Du Maurier*, 312.

9. October 1861, Daphne Du Maurier (ed.), *The Young George Du Maurier: A Selection of his Letters, 1860–67* (London: Peter Davies, 1951), 86.

10. Ormond, *George Du Maurier*, 126.

11. Hoyer married Trixie Du Maurier in 1884. C. C. Hoyer Millar, *George Du Maurier and Others* (London: Cassell, 1937), 29.

12. *Belgravia* (Feb. 1878), 493.

13. 8 and 20 Feb. 1878; see *The Collected Letters of Thomas Hardy*, ed. Richard Little Purdy and Michael Millgate (Oxford: Clarendon Press, 1978), i. 52–5.

14. *Graphic*, 20 Oct. 1883, p. 386.

15. *Graphic*, 4 Sept. 1880, p. 226.

16. Abbott's note to the letter reads: 'Despite many efforts (too considerable to summarize here) this picture remains untraced. It seems probable that "No. 18" refers to an engraved reproduction of a picture on exhibition at the time, perhaps in a "one-man" show. But the journals, art and other, of the day, do not seem to contain a notice of such an exhibition. It is possible, also, that "No. 18" may refer to that issue of a paper to which AH contributed, especially as reproductions were obviously easily available' (*LIII* 187).

17. Herman Friedrich Grimm, *Life of Michael Angelo*, trans. Fanny Elizabeth Bunnett, 2 vols. (London: Smith, Elder, 1865), i. 214.

18. J. A. Reid, 'Arthur Hopkins R. W. S.', *Art Journal* NS 175 (July 1899), 193–6, p. 195.

19. See *LIII*, Note F, Additional Notes for excerpts from the *ILN* and *Times*, which C. C. Abbott compares with stanzas from 'The Wreck'. There has been a great deal of criticism of the poem. See Peter Milward, *Commentary on G. M. Hopkins '"The Wreck of the Deutschland"* (Tokyo: Hokuseido Press, 1968), and with R. V. Schoder, SJ (eds.), *Readings of 'The Wreck': Essays in Commemoration of the Centenary of G M Hopkins' 'The Wreck of the Deutschland'* (Chicago: Loyola University Press, 1976), R. Boyle, SJ, 'The Thought Structure of *The Wreck of the Deutschland*', in N. Weyand, SJ, and R. V. Schoder, SJ (eds.), *Immortal Diamond* (London: Sheed and Ward, 1949); J. E. Keating, SJ, *'The Wreck of the Deutschland': An Essay and Commentary* (Kent, Oh.: Kent State University, 1963); N. H. MacKenzie, *A Reader's Guide to Hopkins* (London: Thames and Hudson, 1981); Norman White, *Gerard Manley Hopkins in Wales* (Bridgend: Border Lines, 1998), 92−109.

20. There is in the Victoria and Albert Museum (the South Kensington Museum as Hopkins knew and visited it) a cast of a pulpit by Pisano (acquired in 1864) in which one of the supporting pillars is a statue of a woman suckling two babes; this would traditionally be taken to represent Charity, but might have contributed to Hopkins's imagery of Abel and Cain in this stanza.

21. Sylvia Wolf, *Julia Margaret Cameron's Women* (New Haven: Yale University Press, 1998), 60.

22. *The Times*, Editorial, 25 Mar. 1878, p. 9d. Most of the accounts are reprinted in an appendix to Weyand and Schoder, *Immortal Diamond*, 375−92.

23. *The Times*, 26 Mar. 1878, p. 10a; 27 Mar., pp. 10b, c.

24. *The Times*, 27 Mar. pp. 10b−d, for example.

25. *The Times*, 27 Mar. pp. 7a, 10c; 28, Mar., p. 10c, for example.

26. *The Times*, 25 Mar. 1878, p. 9a; 26 Mar. 1878, pp. 6a, 10b−c.

6. HOPKINS, THE COUNTRYMAN AND THE NEW SCULPTURE

1. See Murray Roston, 'Hopkins as Poetic Innovator', in *Victorian Contexts, Literature and the Visual Arts* (Basingstoke: Macmillan, 1996), 130−59.

2. Arthur MacGregor, *The Ashmolean Museum* (London: The Ashmolean Museum in conjunction with Jonathorne Publications, 2001), 51−2.

3. D.V. in Lesley Higgins's 'New Catalogue of the Hopkins Collection at Campion Hall, Oxford', in *HQ* 18/1 and 2 (Apr.−July 1991), 9−44, p. 17. The essay was published in *Gerard Manley Hopkins: Journals and Papers*, ed. Giuseppe G. Castorina (Bari: Adriatica Editrice, 1975), 174−80.

4. Daniel Brown, *Hopkins's Idealism* (Oxford: Clarendon Press, 1997), 316 n, identifies the edition that Hopkins was using as the translation by E. C. Beasley of 1853. Hereafter cited in text as Brown, *Idealism*.

5. I recently identified the statue when visiting the Victoria and Albert Museum. It is reproduced in Paul Williamson (ed.), *European Sculpture at the Victoria and Albert Museum* (London: Victoria and Albert Museum, 1996), 175. One of the most remarkable technical achievements of the statue is the effect of a thin cloth that drapes the face and part of the figure, apparently only partially hiding the features beneath it.

6. Daniel Brown (*Idealism*, 317 n) sees a parallel between Hopkins's approach to sculpture here, which seeks for its 'true nature', and his favouring of sprung rhythm in the later essay on 'Poetic Diction' of 1865.

7. 'On the True Idea and Excellence of Sculpture', in *Gerard Manley Hopkins: Journals and Papers*, 180.

8. Elfrida Manning, *Marble and Bronze: The Art and Life of Hamo Thornycroft* (London: Trefoil Books, 1982), 41. Hereafter cited in text as Manning.

9. Harold Oxborne (ed.), *The Oxford Companion to Art* (Oxford: Oxford University Press, 1970), 907.

10. 'Winkelmann', in Adam Phillips (ed.), *The Renaissance: Studies in Art and Poetry*. (Oxford: Oxford University Press, 1986), 140.

11. Poynter's *Catapult* was praised as 'an uncommonly interesting illustration of Roman warfare' followed by a description of how the catapult worked and concluding, 'all this is set forth visibly by Mr. Poynter with infinite spirit and skill, so that after seeing his picture we have the feeling of having been actually present at a Roman siege. This is historical painting of a rational and valuable kind. Such pictures as this ought to be reproduced on a large scale by photography, and distributed amongst schools.' *Saturday Review*, 30 May 1868, p. 719.

12. John George Marks, *The Life and Letters of Frederick Walker* (London: Macmillan and Co., Ltd, 1896), 71. Hereafter cited in text as Marks.

13. *Saturday Review*, 11 July 1868, p. 56.

14. Norman White, *Hopkins: A Literary Biography* (Oxford: Clarendon Press, 1992), 432.

15. *The Times*, 2 May 1868, p. 11c. Chapter 6, pp. 228–9.

16. Ibid.

17. J. Comyns Carr, *Frederick Walker* (London: Chiswick Press, 1885) Originally printed among Carr's *Essays on Art* (London: Smith, Elder and Co.), 6. Subsequent page references in text.

18. Algernon Graves, *The Royal Academy Exhibitors, 1769–1904* (London, 1906), 126–7.

19. Carr, *Frederick Walker*, 9–10.

20. Ibid. 8–9.

21. Edmund Gosse, *Art Journal* (1894), 141, in Susan Beattie, *The New Sculpture* (London: Yale University Press, 1983), 32.

22. Letter to Thornycroft, 24 Oct. 1884, in Manning, 94.

23. Michael Hatt, 'Near and Far: Homoeroticism, Labour and Hamo Thornycroft's Mower', *Art History* 26/1 (Feb. 2003), 26–55.

24. Sjaak Zonnefeld, *The Random Grim Forge: A Study of Social Ideas in the Work of Gerard Manley Hopkins* (Assen: Van Gorcum, 1992), 31.

25. Pope Leo XIII, encyclical *Humanum Genus*, 20 Apr. 1884.

26. Zonnefeld, *Random Grim Forge*, 7.

27. Benedict Read, Introduction to Manning, 18.

28. Norman H. MacKenzie, *The Later Poetic Manuscripts* (New York: Garland, 1991), 311, 313; text from MS B, p. 313.

7. THEORIES OF VISION

1. Manley Hopkins, *Spicilegium Poeticum: A Gathering of Verses* (London: Leadenhall Press, n.d.), 44. The phrase occurs in 'Abdallah Ben Nafi and the King's son of Cashghar', *Takes from the Arabic*, Breslau Text, vol. xi, p. 400.

2. London: John Murray, many editions, 9th 1838. Subsequent page references in text.

3. Alfred Smee, *Vision in Health and Disease* (London: Horne, Thornthwaite, and Wood, Opticians, 1847), 18.

4. *Nature*, 30 Oct. 1884, p. 633, reprinted in Patricia Ball, Appendix, 'An Uncollected Letter from Hopkins to *Nature*, 30 October 1884', in Ball, *Science of Aspects* (London: Athlone Press, 1971), 148–50. The precision of Hopkins's reference (23 June 1877) confirms that there must have been more of his remarkable journals, unfortunately no longer extant.

5. Tom Zaniello, *Hopkins in the Age of Darwin* (Iowa City: University of Iowa Press, 1988), 120–3. So, for example, both John Sandford Dyason, a professional meteorologist and William Ashcroft, RA, made coloured drawings included in the final report.

6. Letter of 21 Dec. 1883, printed in *Nature*, 3 Jan. 1884, pp. 222–3.

7. See Carol T. Christ, *The Finer Optic: The Aesthetic of Particularity in Victorian Poetry* (London: Yale University Press, 1975) for an excellent discussion of

the particularity of Hopkins's observations and the way in which he captures their effect: 'It is this primary apprehension, in which objects appear in their most immediate reality, that Hopkins tries to recreate in his poetry' (p. 143).

8. Alfred Thomas, SJ, *Hopkins the Jesuit: The Years of Training* (London: Oxford University Press, 1969), 173

9. Ibid. 226.

10. Box 5 folder 3, Boston College.

11. Margaret Miles, 'Vision: The Eye of the Body and the Eye of the Mind in Saint Augustine's *De trinitate* and *Confessions*', *Journal of Religion* 63/2 (Apr. 1983), 125–42, 129.

12. *In epistolam Joannis ad parthos, tractatus* 4.6; see Miles, 'Vision', 134–5.

13. Saint Augustine, *The Trinity*, trans. Stephen McKenna, The Fathers of the Church (Washington: The Catholic University of America Press, 1963; repr. 1970), 496.

14. Saint Augustine, *Confessions*, trans. Henry Chadwick (Oxford: Oxford University Press, 1991), 183.

15. David C. Lindberg, *Theories of Vision from Al-Kindi to Kepler* (Chicago: University of Chicago Press, 1976), 96.

16. Saint Augustine, *Confessions*, trans. Chadwick, 201. See James Finn Cotter, 'Hopkins and Augustine', *Victorian Poetry* 39/1 (Spring 2001), 69–82; and 'Hopkins and Augustine', *Victorian Studies* 31/1–4 (Winter–Fall 2004), 127–43.

17. Elisabeth Schneider, 'The Wreck of the Deutschland: A New Reading', *PMLA* 81/I (Mar. 1966), 117, 116; Alison G. Sulloway, *Gerard Manley Hopkins and the Victorian Temper* (London: Routledge and Kegan Paul, 1972), 182–4.

18. Anon. *The Edinburgh Review or Critical Journal* for July 1877 to October 1877, vol. 146, article II, pp. 31–67.

19. The Revd Charles F. S. Warren, *The Authorship, Text and History of the Hymn 'Dies Irae'*, with Critical, Historical and Biographical Notes, reissue (London: Thomas Baker, 1902, first published 1897). Moses Stuart, *A Commentary on the Apocalypse*, 2 vols. (Edinburgh: Macmillan, Stuart and Co., 1847). Richard Chenevix Trench, DD, *Sacred Latin Poetry*, Chiefly Lyrical, Selected and Arranged for Use, with notes and introduction, 2nd edn. (London: Macmillan and Co., 1864).

20. See Frances Greenacre, *Francis Danby 1793–1861* (London: Tate Gallery, 1988), 99.

21. Latin: who has the power to condemn both soul and body to hell.

SELECT BIBLIOGRAPHY

Ash, Russell, *Victorian Masters and their Art* (London: Pavilion, 1999).

Ball, Patricia, Appendix 'An Uncollected Letter from Hopkins to *Nature*, 30 October 1884', in *Science of Aspects: The Changing Role of Fact in the Work of Coleridge, Ruskin and Hopkins* (London: Athlone Press, 1971).

Beattie, Susan, *The New Sculpture* (London: Yale University Press, 1983).

Beevers, David, the Revd David Hutt, and Christopher Rawll, *All Saints, Margaret Street* (London: Pitkin Pictorials, 1990).

Brown, Daniel, *Hopkins' Idealism* (Oxford: Clarendon Press, 1997).

Coe, Brian, *The Birth of Photography* (London: Spring Books, 1976, 1989).

Comyns Carr, J., *Frederick Walker* (London: Chiswick Press, 1885).

Dowling, Linda, *The Vulgarization of Art* (Charlottesville and London: University of Virginia Press, 1996).

Du Maurier, Daphne (ed.), *The Young George Du Maurier: A Selection of his Letters, 1860–67* (London: Peter Davies, 1951).

Gell, William, *Pompeiana: The Topography, Edifices and Ornaments of Pompeii, the Result of Excavations since 1819*, 2 vols. (London: Jennings and Chaplin, 1832).

Goldman, Paul, *Victorian Illustrated Books 1850–1870: The Heyday of Wood-Engraving* (London: British Museum Press, 1994).

Graves, Algernon, *The Royal Academy of Arts: A Complete Dictionary of Contributors and their Work from its Foundation in 1769 to 1904* (London, 1906).

Hamblyn, Richard, *The Invention of Clouds: How an Amateur Meteorologist Forged the Language of the Skies* (London: Picador, 2001).

Hatt, Michael, 'Near and Far: Homoeroticism, Labour and Hamo Thornycroft's Mower', *Art History* 26/1 (Feb. 2003).

Higgins, Lesley, *New Catalogue of the Hopkins Collection at Campion Hall, Oxford*, in *HQ* 18/1–2 (Apr.–July 1991), 9–44.

Hopkins, Gerard Manley, *The Letters of Gerard Manley Hopkins to Robert Bridges*, ed. with notes and Introduction by Claude Colleer Abbott (London: Oxford University Press, 1935; 2nd rev. impression 1955; repr. 1970).

—— *The Correspondence of Gerard Manley Hopkins and Richard Watson Dixon*, ed. with notes and Introduction by Claude Colleer Abbott (London: Oxford University Press, 1935; 2nd rev. impression 1955; repr. 1970).

Hopkins, Gerard Manley, *Further Letters of Gerard Manley Hopkins, including his Correspondence with Coventry Patmore*, ed. with notes and Introduction by Claude Colleer Abbott (London: Oxford University Press, 1938; 2nd edn. rev. and enlarged 1956).

—— *The Sermons and Devotional Writings of Gerard Manley Hopkins*, ed. with an Introduction by Christopher Devlin (London: Oxford University Press, 1959).

—— *The Journals and Papers of Gerard Manley Hopkins*, ed. Humphry House, completed by Graham Storey (London: Oxford University Press, 1959).

—— *Gerard Manley Hopkins: Journals and Papers*, ed. Giuseppe G. Castorina (Bari: Adriatica Editrice, 1975).

—— *Gerard Manley Hopkins, The Major Works*, ed. Catherine L. Phillips (Oxford: Oxford University Press, 1986, 2002).

—— *Gerard Manley Hopkins, Selected Letters*, ed. Catherine L. Phillips (Oxford: Oxford University Press, 1990).

—— *The Poetical Works of Gerard Manley Hopkins*, ed. Norman H. MacKenzie, Oxford English Texts series (Oxford: Clarendon Press, 1990).

Hopkins, Manley, *Spicilegium Poeticum: A Gathering of Verses by Manley Hopkins* (London: The Leadenhall Press, Ltd, n.d.).

International Exhibition of 1862, The Illustrated Catalogue of the Industrial Department; British Division vol. i, printed for Her Majesty's Commissioners (London: Clay, Son, and Taylor *et al.*, n.d.).

Johnson, Alice M., 'Edward and Frances Hopkins of Montreal', *Beaver* (Autumn 1971), 4–19.

Johnson, Paul, *Cathedrals of England, Scotland and Wales* (London: Weidenfeld and Nicolson, 1990).

Maas, Jeremy, *Gambart: Prince of the Victorian Art World* (London: Barrie and Jenkins, 1975).

MacGregor, Arthur, *The Ashmolean Museum* (London: The Ashmolean Museum in conjunction with Jonathorne Publications, 2001).

Manning, Elfrida, *Marble and Bronze: The Art and Life of Hamo Thornycroft* (London: Trefoil Books, 1982).

Masheck, J. D. C., 'Art by a Poet', *Hermathena* 108 (Spring 1969), 24–35.

Ormond, Leonée, *George Du Maurier* (London: Routledge and Kegan Paul, 1969).

Palgrave, Francis Turner, *Descriptive Handbook to the Fine Art Collections in the International Exhibition of 1862*, 2nd edn. rev. and complete (London: Macmillan and Co., 1862).

Parker, John Henry, *An Introduction to the Study of Gothic Architecture* (Oxford and London: John Henry Parker, 1849).

—— and James, *A Hand-book for Visitors to Oxford* (Oxford, 1858).

—— *A Hand-book for Visitors to Oxford* (Oxford: James Parker and Co., 1875).

Prettejohn, Elizabeth, 'Aesthetic Value and the Professionalization of Victorian Art Criticism 1837–78', *Journal of Victorian Culture* (Spring 1997), 71–94.

—— (ed.), *After the Pre-Raphaelites* (Manchester: Manchester University Press, 1999).

Reid, J. A., 'Arthur Hopkins, R.W.S.', *Art Journal* (July 1899).

Rossetti, Dante Gabriel, *Letters of Dante Gabriel Rossetti*, ed. Oswald Doughty and John Robert Wahl (Oxford: Clarendon Press, 1965).

Ruskin, J., *Modern Painters*, in *The Works of John Ruskin*, ed. E. T. Cook and Alexander Wedderburn, 39 vols. (London: G. Allen, 1903–12).

Saint Augustine, *Confessions*, trans. Henry Chadwick (Oxford: Oxford University Press, 1991).

Sinnema, Peter W., *Dynamics of the Pictured Page: Representing the Nation in the Illustrated London News* (Aldershot: Ashgate, 1998).

Street, George E., *Notes of a Tour in Northern Italy* (London: Waterstone and Co., 1986, repr. of 1855 edn. published by John Murray).

Sulloway, Alison G., *Gerard Manley Hopkins and the Victorian Temper* (London: Routledge and Kegan Paul, 1972).

Thomas, Alfred, SJ, *Hopkins the Jesuit: The Years of Training* (London: Oxford University Press, 1969).

Thompson, Paul, *William Butterfield* (London: Routledge and Kegan Paul, 1971).

Thornton, R. K. R. (ed.), *All My Eyes See: The Visual World of Gerard Manley Hopkins* (Newcastle upon Tyne; Ceolfrith Press (Sunderland Arts Centre), 1975).

Weyand, N., SJ, and R. V. Schoder, SJ (eds.), *Immortal Diamond* (London: Sheed and Ward, 1949).

White, Norman, *Hopkins: A Literary Biography* (Oxford: Clarendon Press, 1992).

GENERAL INDEX